UNSUITABLE

ELEANOR MEDHURST

Unsuitable

A History of Lesbian Fashion

HURST & COMPANY, LONDON

First published in the United Kingdom in 2024 by
C. Hurst & Co. (Publishers) Ltd.,
New Wing, Somerset House, Strand, London, WC2R 1LA
© Eleanor Medhurst, 2024
All rights reserved.

Distributed in the United States, Canada and Latin America by
Oxford University Press, 198 Madison Avenue, New York, NY 10016,
United States of America.

A Cataloguing-in-Publication data record for this book
is available from the British Library.

ISBN: 9781805260967

This book is printed using paper from registered sustainable
and managed sources.

www.hurstpublishers.com

Printed and bound in Great Britain by Bell and Bain Ltd, Glasgow

For Lilith, and for me.

CONTENTS

PART FOUR
MIRACULOUS MASCULINITY

PART FIVE
LESBIAN POLITICS, POLITICAL LESBIANS

LIST OF ILLUSTRATIONS

Every effort has been made to trace copyright-holders; the publishers and the author would be pleased to rectify any omissions in subsequent editions, should they be brought to their attention.

1. Sappho and Erinna in a Garden at Mytilene, 1864, Simeon Solomon. Tate, purchased 1980. Photo: Tate.

2. *Reverie*, or *In the Days of Sappho*, 1904, John William Godward. Getty Museum Collection / public domain.

3. Natalie Clifford Barney with dancers in togas, c. 1900s. © Archives Charmet / Bridgeman Images.

4. *Christina, Queen of Sweden*, 1653, Sébastien Bourdon. Photography: Anna Danielsson / Nationalmuseum, Sweden (CC BY-SA.)

5. *Kristina, queen of Sweden*, later seventeenth century, Wolfgang Heimbach. Nationalmuseum, Sweden / public domain.

6. *Anne Lister of Shibden Hall*, 1822, probably by Mrs Taylor. Wikimedia Commons / public domain.

7. *Anne Lister of Shibden Hall*, c. 1830, Joshua Horner. © Calderdale Borough Council / Bridgeman Images.

8. *The Rt. Honble. Lady Eleanor Butler & Miss Ponsonby 'The Ladies of Llangollen'*, c. 1870, J.H. Lynch. Llyfrgell Genedlaethol Cymru—The National Library of Wales / public domain.

9. *Seitō* members at a New Year party, 1912, published in *Seitō* vol. 4, no. 2 (February 1914).

10. Political caricature of *Seitō* members, *Dalliance in the Yoshiwara* (*Yoshiwara tōrō*), published in *Tokyo Puck*, 1 August 1912.

11. Natalie Clifford Barney, c. 1890, photographed by Frances Benjamin Johnston. Library of Congress / public domain.

ix

LIST OF ILLUSTRATIONS

12. Cover art for Édouard Bourdet's play *The Captive*, published by Brentano's, 1926.

13. Natalie Clifford Barney and Renée Vivien, c. 1900. © Archives Charmet / Bridgeman Images.

14. *Una, Lady Troubridge*, 1924, Romaine Brooks. Photo: Smithsonian American Art Museum / Art Resource / Scala, Florence.

15. Suzy Solidor at a sailor-themed masquerade ball, 1926. Photo: Studio D. Wasserman.

16. Radclyffe Hall and Una Troubridge, 1927. Fox Photos / Stringer via Getty Images.

17. Madge Garland and Dorothy Todd, c. 1930. Madge Garland papers, courtesy of Royal College of Art Special Collections.

18. Patrons of the Eldorado club, Berlin, late 1920s or early 1930s. Courtesy of BPK.

19. Berlin's 'transvestite' community at the Eldorado, 1929. Photo: Herbert Hoffmann / Ullstein Bild Ltd. via Getty Images.

20. Ma Rainey, 1920s. Wikimedia Commons / public domain.

21. Mabel Hampton, 1919. Mabel Hampton Collection, Lesbian Herstory Archives / Digital Culture of Metropolitan New York (https://dcmny.org/do/458e415a-ab85-4100-a449-5df061e6a47b).

22. Ira Jeffries, 1948. Mabel Hampton Collection, Lesbian Herstory Archives / Digital Culture of Metropolitan New York (https://dcmny.org/do/60454f22-160746bb-8409-d172911335e3).

23. Two women at the Gateways, London, 1953. Photographer unknown.

24. Margaret 'Peg' Woffington as Wildair in *The Constant Couple*, c. 1740, printed by Hogarth. University of Illinois Theatrical Print Collection / public domain.

25. *Carte de visite* of Ella Wesner, c. 1872–5, photographed by Napoleon Sarony. Wikimedia Commons / public domain.

26. Postcard of Vesta Tilley, 1906, published by Rotary Photo EC. Cornell University Library / public domain.

27. Print of Gladys Bentley, date unknown. Collection of the Smithsonian National Museum of African American History and Culture / public domain.

28. Postcard of Gladys Bentley, c. 1940, distributed by Harry Walker Agency. Collection of the Smithsonian National Museum of African American History and Culture / public domain.

29. Stormé DeLarverie with the Jewel Box Revue, 1958. Schomburg Center for Research in Black Culture, New York Public Library.

30. Vera 'Jack' Holme driving Edith Craig and Emmeline Pankhurst, 1909. LSE Library via Flickr / public domain.

31. Suffragette Ethel Smyth, late nineteenth century, photographed by Aimé Dupont, published in *The Critic*, vol. 42. Wikimedia Commons / public domain.

32. *Christopher Street*, 1978, Bettye Lane. Schlesinger Library, Harvard Radcliffe Institute / courtesy of Gary O'Neil.

33. *Clio (Portrait of Dorothea Smartt)*, 1989, Maud Sulter. Photo © Victoria and Albert Museum, London / artwork © Maud Sulter.

34. Gay rights demonstration, Trafalgar Square, London, c. 1972. LSE Library via Flickr / public domain.

35. Hand-printed 'DYKE' t-shirt, 1980s–90s. From the Lesbian Archive & Information Centre, Glasgow Women's Library. Photo: Eleanor Medhurst.

36. Display case from Brighton Museum's *Queer Looks* exhibition, 2018. Photo: Eleanor Medhurst.

INTRODUCTION

Fashion history is about people. Clothing is made by people, worn by people, tucked carefully into drawers or thrown across the floor by people. Fashion is what those clothes become when they are situated within a culture—when they mean something, whether trendiness or the lack of it, age, heritage, class, status, gender or sexuality. Often, these meanings are not clear-cut, the boundary lines between them blurred or purposefully challenged. Other times, the categories that encompass fashion help us illustrate who we are (or who we are not). For lesbians, whose very existence subverts the categories of gender and sexuality, fashion can be a conscious statement, a deliberate veil or an everyday expression of a reality that is not the social norm.

Lesbians might dress in any number of ways. Despite this, we remain separate from most understandings of womanhood, rooted as they are in heterosexuality and the roles of 'wife' and 'mother' (though, of course, lesbians can play these roles too). In turn, 'fashion'—for women, so entrenched within a feminine ideal—and 'lesbian' are sentiments that seem to conflict with one another. In the words of Elizabeth Wilson in her 2013 essay 'What Does a Lesbian Look Like', 'until the last decade or three "lesbian style" might have been laughed out of court as an obvious oxymoron. The popular idea of the lesbian was precisely that of a woman with *no* style'.[1]

In her 1981 essay 'One Is Not Born a Woman', Monique Wittig argued that lesbians are not even women because 'woman' is a constructed category based on the availability of people to men; so, 'by its very existence, lesbian society destroys the artificial (social) fact constituting women as a "natural group"'.[2] If the existence of lesbians destroys or at least questions heterosexuality being the default in our societies, then lesbianism also destroys heteronormative ideas of fashion and dress.

Unsuitable is not a chronological story, an A to B to Z of lesbian clothing styles. This is partly because, for much of history, lesbians have had to hide themselves in a way that has made it impossible for new 'trends' to arise as they do in mainstream fashion, evolving from those that came before. It is also because lesbian fashion is not one monolithic force, but depends on time, place, status, wealth, friendships, sexual preferences and gender expression. I use the term 'lesbian fashion' as a way to collect these stories, but their possibilities are near endless.

As Elizabeth Wilson's essay points out, the study of lesbian fashion history is hardly well-trodden ground. Of course, I'm not the first writer to research the clothes worn by lesbians in the past or to argue that they matter. Still, this work has been far from comprehensive, and there has never been a book devoted to the topic; broader lesbian histories only briefly discuss clothing or self-expression through fashion. I would not have been able to write this book without such vital research, and my bibliography is an extended thank-you note. I hope that this book can start a new chapter in lesbian fashion history's life, one where we reflect on the connections between different lesbian communities but also their differences, one where non-mainstream clothing and style is still acknowledged as fashion. I hope that it helps even one person feel part of something bigger, the heirlooms of lesbian history nestled in their own wardrobes and draped over their shoulders.

I began to realise that we needed a history of lesbian fashion while I was a student, trawling through my university library to find meaning in the dress of the famous lesbian diarist Anne Lister (the subject of Chapter 3). And later, when I dived into the world of lesbian slogan t-shirts, I could only find snippets of a lesbian style landscape to compare them to. Even when queer fashion is the focus, lesbians take up a limited amount of space. Yet lesbian fashion is crucial to understanding queer history and women's history—these stories are ripe for the picking, bubbling underneath the tidy surface of acceptable historical 'fact' and desperate to emerge. I am a firm believer that lesbianism deserves a space in which it is the focus, a space to be celebrated and valued for its unique perspective on the world.

Kit Heyam, author of *Before We Were Trans: A New History of Gender*, writes: '[t]o anyone who accuses me of rereading the past

from a perspective that's biased towards finding trans history, I would say: you're absolutely right! But I would also say that I'm no less objective than any other historian'.[3] I'm often asked, upon introducing myself as a 'lesbian fashion historian', if I'm a historian of lesbian fashion or a fashion historian who is a lesbian. The answer is, of course, both. The history that I write is coloured by my own eyes and my own life, and I think that this makes it all the stronger. Lesbian lives are what shaped the fashions in this book, after all; for many readers, lesbian lives will shape how these stories are read.

It is important to remember that history is written in the present. I use the word 'lesbian', despite it only having held its current meaning for approximately a century, because we are not living in the past. These are histories, yes, but we tell them from the present and they will continue to exist in the future. The bestselling novelist Emma Donoghue, in her history *Passions Between Women*, argues for the use of 'lesbian' as the best term to convey historical love between women, regardless of their particular context. 'Lesbian does not have the specific connotations of such terms as tribade, hermaphrodite, romantic friend, Sapphist and Tommy,' she writes, 'and so can encompass them all'.[4] This book accounts for differences in understandings of sexual or gender identities, but insists that each story belongs in a historical lesbian narrative nonetheless. 'Lesbian', therefore, is used not as a strict label for historical figures, but as a means for reflecting on their lives—and their clothing—from a modern lesbian perspective.

Many of the people featured in the coming pages may unquestionably be called 'lesbian' and proudly claimed the label in their own lifetimes. Others might have used different labels or none at all, but remain part of a heritage that informs the lesbian present; in some of these cases, the term 'lesbian-adjacent' is helpful for describing these figures' proximity to lesbian life and culture, in the present and the past. My use of 'lesbian-adjacent' is in many ways inspired by Judith M. Bennett's 'lesbian-like'; she insists that 'lesbian' is not a restrictive term for historical figures because it is not a restrictive term in the present, and can encompass many ways of being.[5] She continues:

> I am suggesting not the use of "lesbian," but instead the use of "lesbian-like," a hyphenated construction that both names "lesbian" and

3

destabilizes it. The "lesbian" in "lesbian-like" articulates the often-unnamed, forcing historians who might prefer otherwise to deal with their own heterosexist assumptions and with the possibility of lesbian expressions in the past. Yet at the same time [...] the "like" in "lesbian-like" decenters "lesbian," introducing into historical research a productive uncertainty born of likeness and resemblance, not identity.[6]

In this book, I have chosen 'lesbian-adjacent' to expand the space in which non-lesbian identities and possibilities can exist alongside lesbian ones. Many of the figures in the coming chapters are undoubtedly part of a lesbian (fashion) history, but I do not want to minimise the other histories—particularly trans histories—to which they also belong.

Terminology is a tricky thing. One of my primary motivations for using the term 'lesbian' is that I know from my own experience that many lesbians are ashamed of the label, or have been at some point in their lives. 'Gay woman' is preferred by some (myself included, for a short time) while others favour 'queer'. Claiming the word 'lesbian' can be an achievement or an awakening, and it is a word steeped in history (see Chapter 1). Occasionally, however, I describe the figures in this book in other ways. I use terms such as non-binary or transgender (often shortened to 'trans') while exploring figures who transgressed gender norms or expectations of gender in their own time, and reflecting on how they might be understood in the present. I also use 'sapphic', a label claimed today not only by women who love women, but also by some non-binary people. At times, I also include (and explain) words no longer widely in use or favour, but which were used in the past, such as 'invert' and 'trans-vestite'. At various points, I discuss the use of certain pronouns ('he', 'she' or 'they') and why I've chosen to use them. I don't pretend that my interpretations are the authority, and if you understand any of the figures discussed differently from how I have described them, I encourage you to embrace your own perspective. These are real people who lived expansive lives, after all; they are ultimately not ours to label, but only to try and understand.

It is particularly important to me that trans histories are repre-sented within lesbian fashion history. I have said that histories must not forget the present from which they are told, and I have kept the

context of the early 2020s in mind throughout this book. Trans experiences are irrevocably intertwined with lesbian experiences, and trans narratives appear numerous times in these pages. There is a fine line between butch lesbian history and transmasculine history, so they belong to both of our communities.[7] Kit Heyam explains this sentiment perfectly in *Before We Were Trans*: 'trans and butch experience have long coexisted, and have been easier or harder options for individuals depending on multiple factors including race and class'. They argue that 'the solution is not to vigorously defend our respective territories, but to work together to dissolve the borders—and to admit more people to the land we hold in common'.[8] It's also important to note that there is space for transgender women in lesbian fashion history, though they are harder to find. For example, Chapter 7 focuses on the clothing worn by possible trans lesbians in interwar Berlin.

'A' history of lesbian fashion is, by definition, not the only one. I am aware that the ground I've not covered is larger than what I have. In many ways, this is a good thing; there is so much left to explore and share, whether by myself or by others. But I am particularly aware of the limited geographic scope of this research. I am a white historian, born and raised in the United Kingdom. I have written about the clothing and self-expression of lesbians of colour in the West (and have remained conscious of the privilege that I hold while speaking about these communities or individuals). Yet, I am an independent researcher with limited resources and no funding, and I only speak English. All the stories in this book are European or North American, with the exception of Chapter 4, which focuses on Japan in the 1910s. Largely, this is because of the research that exists on or related to lesbian fashion, the paths that were open to me to follow. In the future, I hope to work towards a far more global study of lesbian fashion and its history. But I must be clear: this book is not it. Instead, it is a beginning.

The scope of this book has been constrained by the sources available to me in other, similar ways. Representations of class, for example: the further back in time we explore the less evidence is available from anyone outside of the elite. Other than the near-legendary poet Sappho, some of the earliest sources include Queen Christina, a seventeenth-century Swedish monarch, and Anne

Lister, a wealthy landowner. These individuals' clothing can be deciphered through drawings, paintings, letters and personal diary entries, things that very rarely exist or survive for the working-class women of eras past. From the mid-twentieth century onwards, the balance is much more even, with surviving testimonies or photographs of working- and middle-class lesbians.

* * *

This book is divided into four equal parts, with the first half separated from the second by Part 3, which I like to think of as an interlude. Part 1, 'We Were Always Here', addresses lesbian fashions that emerged in contexts before and outside of what is broadly accepted as the beginning of 'lesbian history' in early-twentieth-century Europe and America. This is when the 'lesbian' figure began to be named, the label becoming an identity. Before (and outside of) this context, possible 'lesbians' were not quite recognised, referred to with terms like 'tribade' or 'romantic friend'. The early twentieth century in Europe and America was the beginning of what women's studies scholar Martha Vicinus calls a 'historical timeline' of lesbian history.[9] Part 1 explores clothing choices made by 'early' lesbians or lesbian-adjacent people, with chapters focused on the poet Sappho, as well as her legacy in lesbian culture since her death; Queen Christina; Anne Lister; and the women behind *Seitō*, a Japanese feminist publication that ran from 1911 to 1916.

Part 2, 'Paris to Harlem', encapsulates a single decade in lesbian history—albeit a long one, with the ideas and ideals attributed to the 1920s often reaching beyond the decade itself. This period was influenced by the boyish fashions of modernism, as well as by many women having experienced new freedoms during the First World War. Lesbian and wider queer cultures thrived across the world. Chapters 5 to 8 explore four lesbian scenes that flourished in the interwar years: Paris, and its thriving community of lesbians; London, the home of British *Vogue* and its sapphic editors; Berlin, particularly the overlap of lesbian communities with those known as transvestites, and the possibility of transgender lesbians; and New York City, where the Harlem Renaissance flourished through the work and lives of Black performers and 'lady lovers'.

Between Parts 2 and 4 is this book's interlude. Part 3 is split into only two chapters—butch and femme identities are widely recognised within lesbian history, and this means that I neither wanted to over-represent them nor ignore their monumental importance. Butch/femme identities and relationship dynamics had their heyday in the mid-twentieth century. Chapter 9 uncovers the fashion cultures of butch and femme at their favourite haunt, the lesbian bars, while in Chapter 10 I briefly take a moment to put the femme—in very simple terms, a feminine lesbian identity—in the spotlight. Though such figures appear in other chapters, they are often less visible than their more masculine counterparts. I reflect on why this is, and the unique potential and perspectives of feminine lesbian fashions.

Part 4, 'Miraculous Masculinity', honours the masculinity that so many lesbians or lesbian-adjacent individuals exude in their dress and their actions. Chapters 11–14 are not only about masculine fashions, however, but also entirely male ones: clothes recognised socially and culturally as men's, with the wearers being understood as cross-dressers or performers—no matter their gendered reality. The first two chapters explore gender-swapped roles in the eighteenth century, and the male impersonators of British and North American music halls in the late-nineteenth to mid-twentieth century. The second pair of chapters highlight two individuals: Gladys Bentley, a male impersonator of the Harlem Renaissance and beyond; and Stormé DeLarverie, who bridged the gap between male impersonation and drag king performances during her lifetime (1923–2014).

The final part of this book takes lesbian fashion into the twenty-first century, stopping at other periods along the way. Congregated under the banner of 'Lesbian Politics', Part 5's chapters consider lesbian social and political organisation and the clothes that define it, how clothes can be a central part of specifically lesbian activism, and how fashion can be activism simply by being worn on lesbian bodies. Chapter 15 explores 'The Lesbian Threat of the Suffragettes' in the early twentieth century; Chapter 16 jumps from the first to the second wave of feminism, spotlighting the dress codes of the lesbian feminist movement in the 1970s and eighties, as well as those who broke from them. Chapter 17 explores the role of

t-shirts in lesbian activism from the 1970s onwards, and the final chapter focuses on lesbian fashion that, in our own century, may be seen as liberatory.

Unsuitable is not a book about making space, but demanding it. This is what lesbians throughout history have done with their clothing, whether by wearing trousers in a society that shunned them for doing so, wearing dresses and makeup for other women's attention, or pinning a violet to their lapel as an ode to Sappho. It is not a book about hidden histories, but histories that have been purposefully ignored or erased. It is about bringing lesbian histories back to life, dragged out of the grave by the sleeves of their smartest suits. We will be buried no longer, not under dust or dirt, media scorn or made-up husbands. This is a book about clothing and love and lesbian possibility. It is a book that, I believe, is long overdue.

PART ONE

WE WERE ALWAYS HERE

We were always here—and by 'we' I mean, of course, lesbians. It is our clothes that tell our story and drag us from the realm of forgotten memory back into that of the living. The concept of 'a lesbian' may have changed through time, but there are similarities between each historical moment and our own. Women who loved women in whichever way their situation allowed, across centuries and continents, race, status and gender expression, link together in a continuous, tangled strand throughout history and into the future. Imagine a daisy chain, with each fibrous stem a life in a lineage that eventually forms a garland: a lesbian history. Imagine that the petals of its flowers are the clothes worn by these lesbian bodies. They might be different shades or sizes. Fashions change and so do people's preferences, but when our bodies, sexualities and loves are private, it is our clothes that are public. So, if we were always here, then it is our clothes that attest to it.

These first four chapters are about lesbian fashion before and outside of the usual boundaries of 'lesbian history'. They take us to settings before the popularisation of the term 'lesbian' (though not before its existence). They take us to times when sex between women was considered impossible, leading to the glorification of 'romantic friendship', a predecessor to lesbian identity and relationships that certainly existed but was by no means the only option. We visit a moment when social and medical conceptions of lesbianism and homosexuality were at last beginning to bloom, and when a named lesbian identity could no longer be denied in Western contexts. We consider this moment in Japan, a country often assumed to be separate from such discourses: Japan's borders

9

opened to Western traders in the mid-nineteenth century after having been closed for two hundred years. Japanese culture, so clearly defined and preserved, quickly gathered influences from the West, including the study of sexology and its conceptions of homosexual and 'invert' identities. Early-twentieth-century Japan is rarely included in a timeline of lesbian history, yet it illustrates that lesbian history cannot be rigidly defined.

I say that we were 'always here' because the phrase implies a kind of persevering. In times and places outside of what may be accepted as lesbian history, lesbian fashion perseveres. The clothes within it exist in incredibly specific fashion contexts—lesbian looks emerged independently in place upon place—but although each is unique, they are not entirely isolated. These clothes let us imagine a tactile lesbian past. Through descriptions of them (often by the wearer's own hand or by those who knew them) or paintings, drawings and photographs, lesbian lives are illustrated. They build in our minds like masterpieces. I write because I cannot reach out and touch.

There are four chapters in Part 1. The first celebrates the sartorial legacy of Sappho, an Ancient Greek poet from the island of Lesbos and the basis for the words 'lesbian' and 'sapphic'. Evidence of love between women is rife in the fragmentary remains of her work, but it is not just her words that have lasted through the millennia. Sappho is associated with a specific look, and—particularly in the last few hundred years—it has become a visual shorthand for lesbian desire. The second chapter is a dress history of Christina, Queen of Sweden in the seventeenth century. The way that Christina dressed was continuously remarked upon throughout her life, during her ten-year reign and after her abdication. In her lifetime and in the centuries since her death, she has repeatedly been imagined as a lesbian, her clothing being primary evidence for these claims.

Chapter 3 is about Anne Lister, known as the 'first modern lesbian' and the inspiration for the popular television series *Gentleman Jack*. The clothes that feature in her diaries, spanning from the early nineteenth century until the dawn of the Victorian period in 1840, fit uncomfortably into the feminine fashion cultures of upper-class England. Anne knew that she was different, and though she did not explicitly connect her love for women with her unusual dress sense in her writing, that does not mean the connection was not there in her

mind. In Chapter 4 we focus on 1910s Japan, specifically the Tokyo-based feminist publication *Seitō* and the women who wrote for it. Two writers in particular, Hiratsuka Raichō and Otake Kōkichi, were the figureheads of this lesbian fashion moment—and a couple.

These four stories are fragments of a lesbian fashion history, incomplete like Sappho's remaining poetry. However, unlike Sappho's poems, they are not all that we have. They are a beginning, an unconnected history that lays the groundwork for the many, varying possibilities of lesbian fashion through the ages.

TUNICS AND VIOLETS

SAPPHO AND HER AFTERLIVES

Sappho: the original lesbian. At least, this is how she's often imagined in the twenty-first century. Yet, her identity and the desires expressed in her poems have been debated for thousands of years, with homophobia and lesbophobia having been rife since well before they were named concepts. Sappho was born around 630 BCE and is revered for her poetry, her talent leading to her reputation as the 'Tenth Muse' or 'The Poetess'. The love that she professed for women in her verse could not be erased, despite the efforts of multiple generations; lesbians today read her words and embrace them, learn them, recite them, or post them online. These actions are a refusal as much as they are a celebration.

One such poem is Fragment 94. Anne Carson's translation of it is a favourite of modern lesbian Sappho fans. Among its stanzas are lines that refer to clothing and appearance (and accessorising with violets, which I revisit in Chapter 5) as well as desire and sexuality:

> For many crowns of violets
> and roses
> at my side you put on
>
> [...]
>
> and on a soft bed
> delicate
> you would let loose your longing[1]

Sappho's iconic status informed the image that we now associate with ancient lesbianism. It differs from our vision of lesbians dotted

through later centuries, because it exists in retellings and interpretations. We have no evidence of the clothes that Sappho wore, with the earliest portraits dating from well after her death. Occasionally, garments or accessories are referenced in her poems themselves— but we cannot be sure if she wore anything of the same kind. She mentions, in one fragment, 'robes' and 'necklaces'.[2] In others, we hear of a 'purple robe', and 'hair / bound with purple'.[3] The colour is a recurring motif, if not represented by robes or hair bindings then by violets, Sappho's favourite flower. Violets are consistently worn or held by women, if not in the crowns of Fragment 94 then as the 'violets in her lap' that appear over and over, across multiple poems.[4]

Sappho is an echo. When we close our eyes and imagine women who loved each other in ancient Lesbos, dressed in tunics and garlands of violets, we remember our history. In the words of Ella Haselswerdt in her essay 'Re-Queering Sappho', 'one can imagine oneself into the blank space on the page'.[5]

Sappho's identity has been much debated, but the realities of her life aren't really the point. Sappho is as much a part of lesbian and lesbian fashion history as any other person in this book, even if her life is out of reach to us in so many ways. Haselswerdt discusses the patriarchal gaze that, thanks to the long male domination of classical studies in the West, has coloured ideas of Sappho and her lesbianism: 'a narrow and masculine misunderstanding of the nature of queer female erotics, a condescending assumption of naïveté about the nature of identity and identification, and the uncritical transmission of the deeply misogynistic ancient reception of the Poetess'.[6] We can see this in action in a 1920 translation of Sappho's work by Arthur S. Way, who declares in his introduction:

> Readers who know something of the passionate attachments between girls at school and college, of their adoration for each other and their teachers, will not think it strange that we find evidence in these poems of similar links of love between Sappho and some of her girl-students.[7]

For all his distant condescension here, reading on makes it clear that his dismissal of Sapphic woman-loving is actually rooted in much stronger emotion, threaded through with homophobia and misog-

yny: those who imagine her as a lesbian 'cast the filth gendered in their own souls upon the robes of Sappho—these wallowers in foulness who thought that they could defile the stars with bespatterings from their sties!'[8]

If lesbianism is the filth that coats Sappho's robes then her image shines all the brighter for it. In a fantastic article about the Poetess on the website Making Queer History, writer Laura Darling announces that 'she is a symbol. Despite the efforts of biased academics, she will remain that for many years to come'.[9]

Paintings and pamphlets

Sappho is thought to have lived around 2,600 years ago. Most iconography of her that we recognise today is far more recent, mostly from the eighteenth and nineteenth centuries. However, her image was already being shaped only a few hundred years after her lifetime. The earliest source that acknowledges rumours of Sappho's homosexuality—but then dismisses it as slanderous—is a biography of her from the 300s BCE: 'she has been accused by a few of being undisciplined and sexually involved with women'.[10]

Sources like these began Sappho's long straightwashing. Classics expert Flora Doble describes how 'in ancient scholarship, Sappho was [...] portrayed as a promiscuous heterosexual woman, with her contemporary male poet Alcaeus of Mytilene portrayed as a possible lover'.[11] There is evidence that the two interacted, but nothing indicating a romantic relationship. There are similarities in their writing styles, but all too often this is attributed to a relationship rather than, for example, Sappho leading poetic trends.[12] The painting *Sappho and Alcaeus* by Lawrence Alma-Tadema (1881) represents the supposed relationship, a heterosexual romance that was invented for Sappho after her death.

Other men have been suggested as Sappho's lovers: her supposed husband was Kerikles from the island of Andros, which translates to 'Penis from the island of Men' in Ancient Greek slang. Kerikles was, then, certainly a joke as well as a fantasy—probably one mocking Sappho's lesbian reputation. Another 'lover' is Phaon, a ferryman blessed with good looks by the goddess Aphrodite. Considering that Sappho was real and Phaon more likely the stuff of legends, this

romance is also hard to believe, particularly since the first mentions of it occur hundreds of years after Sappho's lifetime.[13]

Despite these efforts, Sappho's lesbian image prevails. The majority of paintings that aim to depict her do not include men. Some, like Simeon Solomon's famous *Sappho and Erinna in a Garden at Mytilene* (1864), even picture her in a romantic position with other women. This painting (Figure 1) centres around two women, one kissing the other; Sappho is easily identifiable as the figure doing the kissing. She wears a crown of laurels in her hair, a symbol of triumph. Perhaps this was intended to suggest her mastery of verse and her reputation as 'The Poetess', or perhaps her triumphs with women. By her side rest a scroll and a lyre, the tools of her trade. They are secondary, though, to the relationship between the two women, dressed in matching tunics with fabric that appears almost liquid, a reinterpretation of the 'soft linen robe' described in one Sapphic fragment.[14] Their kiss is replicated by the birds above them. This painting represents all the symbols associated with Sappho the famous poet, and intertwines them with her lesbian love. Simeon Solomon, the painter, was a gay man. He consistently painted images of same-sex desire throughout his career, which was cut short after he was arrested on two occasions for sodomy. He recognised queer love that has been continuously erased. He painted it back into history.

The same imagery reappears time and time again in representations of Sappho. The paintings of John William Godward, twenty years Solomon's junior, never feature Sappho explicitly, but embrace the Sapphic aesthetic of Ancient Greek women in long tunics, sitting on marble benches with dark hair framing their faces and nature framing their figures. *Reverie*, or *In the Days of Sappho* (Figure 2) is frequently used in contemporary media to represent her, but the woman featured is not her. Instead, it is Sappho's distinctive aesthetic that is present in Godward's work. The image of the Poetess stretches past the bounds of her poems or even her own life, becoming a trope or a trend, an enduring lesbian presence.

Sappho's image and influence also, of course, appear in the works of female artists. There are times when successful woman artists have been compared to her, as if only one woman throughout history might ever be a master of her own craft. The Swiss Angelica

Kauffman was an eighteenth-century painter and one of the founders of London's Royal Academy in 1768. Among her many artworks are two which reference Sappho: *Sappho Inspired by Love*, in which Sappho is shown writing poetry with the consultation of Cupid, and *The British Sappho*, a portrait of another extraordinary woman, Mary Robinson.[15] Mary was a celebrity of her time, largely known for her short-lived affair with King George IV while he was Prince of Wales. But her life was much more than this—in her earlier years she was an actress, frequently donning trousers on-stage in 'breeches roles' (see Chapter 11), and in 1780 she turned to poetry and political writing, publishing a pamphlet on women's rights in 1790.[16] Mary's nickname, 'The British Sappho', validated her quality as a writer and prized her writing over the more scandalous part of her life. Sappho was 'The Tenth Muse', after all.

A less well-intentioned comparison to Sappho can be found in the life of the sculptor Anne Seymour Damer (1748–1828). Though Anne mostly lived a quiet life, by the end of the eighteenth century she was steeped in rumours about her love for women, as 'not just a Sapphist, but the epitome of Sapphism'.[17] In British society publications, Anne's name (usually just 'Damer') was repeatedly used to represent lesbianism—perhaps, in this context, even more than words like 'Sapphist'. The first occurrence of this kind was in 1777, followed a year later by an anonymous pamphlet titled *A Sapphick Epistle*, which directly addresses the 'most beautiful Mrs D———'.[18] Similar suggestive whisperings flew for the following two decades.

In the midst of it all, Anne met the writer Mary Berry, when Anne was forty and Mary twenty-six. We don't know if the nature of their relationship lived up to the rumours, but the two women certainly loved one another; they soon began cohabiting, and travelled together extensively. In 1793, Anne carved a bust of Mary in bronze, the only sculpture of a woman that she ever created with this expensive material.[19] In the centuries since Anne's death, the comparisons to Sappho haven't ended, but have become celebratory rather than derisive—as in a 2020 article that titles Anne 'the "Sappho" of sculpture'.[20]

Mary Robinson and Anne Damer were not the first in this position. Since at least the 1600s, women who love women have been compared to Sappho or called Lesbian (referring to Lesbos).

Emma Donoghue writes of 'a long-standing Sapphic tradition of lesbian culture; this is not a twentieth century invention'.[21] She gives examples: Seigneur de Brantôme's *Lives of Gallant Ladies* (early seventeenth century) represented *Dames Lesbiennes* as women engaged in the act of tribadism (the term of the era describing sex between women, derived from the Latin *tribas*, meaning 'to rub'). This meant that *Lesbiennes* referred to women who had sex with women, even if this was understood as a practice, and not yet an identity. That said, a lesbian or bisexual identity was hardly something many men would write about in this period—men were the audience and sex between women was represented to either titillate or be scorned.

Donoghue also discusses William King's poem *The Toast* (1736). This text represents something closer to a lesbian identity and, uncoincidentally, is coloured more by scorn than titillation: 'So centred is King on Lesbos as the origin of this sexuality that he uses the word "lesbian" much as it is used [today], describing "Lesbian Loves" among women called "Tribades or Lesbians"'.[22] Less direct references also appear in historical records, particularly throughout the eighteenth century. The woman-loving French actress Mademoiselle de Raucourt became known as the 'young priestess of Lesbos' in a political pamphlet from 1776, a title gained after she rejected various male suitors and was seen leaving female lovers' residences.[23]

This book is not a history of lesbian language, but the long legacy of the 'lesbian' idea, starting with Sappho's women-loving reputation, was built with an aesthetic. The words 'lesbian', 'sapphic' and 'sapphist' had already been in use for centuries by the time they began to gain global recognition around the turn of the twentieth century as words for homosexual and queer women. Her name became a claim rather than a label, turned over by lesbian tongues seeking to find a place in the world. Sappho's image was also captured by lesbians as her story was retold and reclaimed.

Worship in the garden

Sappho's renaissance took place in Paris. The French capital was the go-to destination for modernist lesbians in the first decades of the twentieth century, so much so that their community became known

as 'Paris Lesbos'. As H. J. E. Champion writes, 'this period wit-
nessed the beginning of the construction of the modern lesbian iden-
tity through a performance of "Lesbian" identity'.[24] It is here, then,
that 'lesbian' made its final shift, from a comparative description to
a label of identity. Sappho was the absent leader of this movement:
the prolific lesbian biographer Diana Souhami notes in *No Modernism
Without Lesbians* that 'role models for lesbians were few' in modernist
Paris. For her 'heirs' in the city, 'Sappho was evidence that such
desires were time-honoured, that there were always women who felt
as they did, whose emotions were pure and lifestyles self-willed, not
prescribed or dictated by men'.[25] Sappho's right-hand woman in the
realm of the living was Natalie Clifford Barney: writer, poet, heiress
and loud, proud lesbian. Natalie used the word lesbian with intent,
constructing the Lesbos of her dreams with her relationships, her
writing, and the way she spent her money. When Natalie's father
died in 1902, she acquired her inheritance—with it, she bought a
house in Neuilly on the outskirts of Paris. This house became the
centre of Paris Lesbos, which Souhami describes:

> In homage to Sappho, [Natalie] staged *tableaux vivants* in the garden.
> In *Cinq petits dialogues grecs* ('Five short Greek dialogues'), she
> sketched her rules for Sapphic love: women were to relinquish ties
> to family,—husbands, children and country—and instead write,
> dance, compose and act on their love and desire for each other.[26]

Natalie and her broad circle, which included notable lesbian and
woman-loving figures like Colette, Renée Vivien and Eva Palmer
(later Palmer-Sikelianos) engaged in physical celebrations of Sappho,
performing and making love.

> [Natalie] and Eva Palmer wrote and produced *Equivoque*, which
> extolled Sappho's life and incorporated her writing. [...] Eva, Renée
> and Colette—who was light-hearted about her lesbian affairs—and
> others danced in gauze togas around an incense-burning altar. In one
> tableau, the dancer Mata Hari rode, naked except for a crown, into
> the garden on a white horse with a bejewelled harness.[27]

The imagery of Sappho that had been created over centuries was
whole-heartedly embraced by lesbian bodies, in clothing and in
actions. Women dressed in togas per the popular imagination of

Ancient Greek dress, and in more accurate tunics (Ancient Greek women wore a folded tunic called a *peplos* or a *chiton*). They danced and kissed. H. J. E. Champion writes that 'Barney was not content to use Sapphic imagery only in her writing, she was also determined to physically recreate the Sapphic feminine sphere'.[28] (See Figure 3.)

Into the 1920s, a distinctive lesbian dress code began to form that was the antithesis of flowing Sapphic tunics (see Chapter 5). But without this early cultural and aesthetic lesbian idolisation of Sappho in Paris, these later lesbian spaces and styles may never have had the chance to exist. In Paris Lesbos, Sappho was well and truly reclaimed by lesbians, her image performed for the lesbian gaze in a new version of the previous centuries' painterly aesthetics of tunics and togas. The women of Paris Lesbos refused to allow Sappho to fade into the heterosexual canon.

The future nation

After Natalie was evicted from her Neuilly paradise by her landlord (there had been complaints about the parties she'd thrown in the garden), she moved to 20, rue Jacob in Paris, the site of her famous salon. This is where she stayed until the 1960s. The salon was held from 4pm to 8pm every Friday for decades and, to quote Champion, was 'a reconstruction of how Barney imagined Sappho's community and rue Jacob was a metaphorical island in the middle of Paris; Lesbos in miniature'.[29] It thrived, and the image of Sappho lived on. In 1972, a British lesbian publication edited by Jackie Forster was named after the Poetess, the successor of the more ambiguously-titled *Arena Three*. The magazine ran until 1981 and was instrumental in weaving together disjointed lesbian communities and isolated lesbian women across the United Kingdom in the 1970s.[30]

In July 1978, the Equal Rights Amendment March took place in Washington, D.C.; one of the lesbian demonstrators attending was dressed as Sappho, captured forever on film underneath a banner reading 'RITES FOR THE LESBIAN NATION'. The 2022 Special Issue of *Women's History Review* focused on the concept of the Lesbian Nation. Starting with Jill Johnston's 1973 book of the same name,[31] the issue went on to cover lesbian communities in the Netherlands, Australia and Poland, the influence of Black nationalism on lesbian

politics in the seventies, and H. J. E. Champion's article 'Remembering Sappho'. These writers understood the lesbian nation as fluid—much like Sappho's poetry and image. The issue's editors wrote that 'the history of the "lesbian nation" is always both transnational and national', and the same could be said of what Sappho of Lesbos has come to be.[32] These concepts are tied together by Champion at the end of their piece, when they describe how 'lesbian nations', created 'through the act of "remembering" [Sappho]', 'not only filled in the historical map but forged a path into the future for lesbians to come'.[33] When a demonstrator wore a long tunic and a sash announcing the name 'Sappho' in 1978, she insisted on lesbianism having a history rather than allowing it to be labelled a modern invention. This was remembering done through clothing. As in the lesbian histories that narrate the rest of this book, it is our clothes that cement our presence.

Sappho's legacy continues in the twenty-first century: take Sappho's Club, an online store that sells enamel pins in the shape of violets, referencing not just Sappho herself but the women of Paris Lesbos who also claimed the flower.[34] In the 2016 song 'Sappho', Frankie Cosmos (Greta Kline) expresses her longing for a female friend and the desire to be longed for in return. The lyrics ask the subject of the song whether she's reading the works of the Poetess, presumably to stand-in for a more direct question—such as 'Do you like girls?'[35]

Sappho founded the global lesbian nation, even if only because it would not be 'lesbian' without her. Just like her name, the clothing associated with Sappho is shorthand for an entire culture. If we know what lesbian history looks like—how it dressed—then we can picture it and recognise it, from Sappho to Natalie Barney in the 1900s, the magazines and marchers of the 1970s and sapphic culture in the social media age. No matter the decade, century or millennium, there is a thread that stitches our lesbian lives together. It can be powerful to gaze back to where it started.

2

CHRISTINA OF SWEDEN, GIRL KING

Christina, Queen of Sweden was born on a cold December night in 1626. Her father was the renowned warrior King Gustav II Adolph, her mother the beautiful German Princess Maria Eleonora; the couple had been married for six years and did not yet have a living child. Gustav was restless and Maria Eleonora lonely, until Christina's birth signalled a change—but not an uncomplicated one. The story goes that though the castle in Stockholm rang loud with shouts of joy at Christina's birth, they were misplaced, with the revellers having been mistakenly informed that the newborn child was a healthy baby boy. This was how Christina met the world: to joy and laughter, taken-back promises and high expectations, wrapped in gender confusion and debate around her sex. These themes persisted throughout her life and after it. Instead of running from them, Christina pinned them to her shoulders, adorning her-self in a self-mythology as grand and sparkling as her royal gowns and rich velvet coats.

Christina's right to inherit the throne was secured by her father, who did not believe another heir was forthcoming. After his death during the Thirty Years War in 1632, little Christina became King of Sweden, under a regency—she was officially crowned King, her title, but was generally referred to as Queen. She became ruler in her own right when she came of age in 1644, and abdicated in 1654, not long after the end of the Thirty Years War. Numerous reasons were given for Christina's abdication, but one of the strongest was a constant pressure for her to marry and produce heirs while she sat on Sweden's throne; this was something that she did not want and would never do. She once said, 'I could not bear to be used by a

man the way a peasant uses his fields'.[1] A few years later, explaining her decision to abdicate, she said the following:

> I am telling you now [...] it is impossible for me to marry. I am absolutely certain about it. I do not intend to give you reasons. My character is simply not suited to marriage. I have prayed God fervently that my inclination might change, but I simply cannot marry.[2]

This refusal to wed—though no doubt inspired by her unwillingness to submit to someone else's power, as a wife—is one of many reasons why Christina has been taken up as a historical icon of lesbian possibility and gender non-conformity. The quote about praying to 'God fervently that [her] inclination might change' could have come out of any number of tragic queer stories, especially in the twentieth century. There is also strong evidence that Christina loved women romantically and was attracted to them, one example being her relationship with her lady-in-waiting, Ebba Sparre. She called Ebba 'Belle', as Christina's biographer writes, 'in compliment to her loveliness'.[3] The two women frequently slept in the same bed, and Christina is recorded to have made suggestive comments about their relationship and about Ebba herself.[4] In 1656, after Christina had moved permanently away from Sweden and was a thirty-year-old ex-monarch living in Rome, she wrote what can only be described as a love letter to Ebba:

> How happy I would be if I could only see you, Belle, but though I will always love you, I can never see you, and so I will never be happy. I am yours as much as I ever was, no matter where I may be in the world. Can it be that you still remember me? And am I as dear to you as I used to be? Do you still love me more than anyone else in the world? If not, do not undeceive me. Let me believe it is still so. Leave me the comfort of your love, and do not let time or my absence diminish it. Adieu, Belle, adieu. I kiss you a million times.[5]

It is no wonder that Christina's woman-loving reputation proceeded her, especially since Ebba was not the only woman to whom she made such declarations. For example, when Christina was introduced to the Marquise Elisabeth de Castellane while in Lyon, also in 1656, she proclaimed to the Marquise that if she were a man, she

would 'fall at your feet, submissive and languishing with love'.[6] Near the end of her life, she took the beautiful young Angelica Quadrelli into her household, along with the woman's mother and equally beautiful sister, and spent a large portion of her time in their company.[7] On the whole, women were not the people Christina preferred to surround herself with—but certain women, or favourites, held her captivated.

There is evidence that Christina also had romantic, if not sexual, feelings for men throughout her life, most notably her long-time companion Cardinal Azzolino. But Christina's actions are not the only aspect of her life that has been read as lesbian. Her image is often seen as the most compelling evidence. This image has been constructed, like the bricks that form a palace, into a marvel, her lesbian reputation shaped by forces outside her control. Novelist Sarah Waters writes about this, noting the 'gossip' about Christina during her lifetime, and linking it to depictions of her in the early twentieth century. Waters explores Parisian pamphlets of the 1660s that aimed to undermine Christina's 'intellectual and political standing' by accusing her of lesbianism after her abdication; the forged, passionate letters between Christina and various women published in 1761 in *Lettres secrètes de Christine, Reine de Suède*, when Christina was long dead and buried; and lesbian journalist and novelist Margaret Goldsmith's 1933 biography *Christina of Sweden*, in which Christina was presented, for the first time in a historical account, as 'exclusively lesbian'.[8] Even later, Christina's image continued to be questioned and altered: in 1965, her tomb was exhumed in order to inspect her skeleton for signs of hermaphroditism, or what we would now call intersex characteristics. The investigation was led by a male professor of anatomy, Carl-Herman Hjortsjö, who concluded that Christina's skeleton suggested that she had been a 'natural woman'.[9] This conclusion only echoes Christina's own words, when she laughed at her embarrassed guards after exposing herself in a carriage accident in her older years, saying that at least they now knew that she was 'neither Male nor Hermaphrodite, as some People in the World have pass'd me for'.[10]

Above all this, though, descriptions of Christina's attire have shaped her sapphic image. Whether she was a lesbian or not, she certainly wasn't a typical seventeenth-century woman, and her life

has far stronger links to queer possibilities than to any form of heterosexual culture, past or present. And when it came to her clothing, her image was forged by herself. These are choices that she made. Perhaps she would have shunned the term 'lesbian', or perhaps she would have laughed and winked in our direction—either way, when we place her sartorial story into the narrative of this book, we are giving her another space to occupy, another crown to wear. I do not believe that she would protest too much.

Dressing a Girl King

What clothes did Christina wear? To answer this question, we must first imagine the fashion landscape of seventeenth-century Sweden. As with most European countries at the time, this was nationally specific. Garments had their own shapes, their own words, and their own traditions. However, Christina's lifetime (1626–89) coincided with a shift in this tradition, as a unified high-fashion culture began to arise among Europe's nobility. Christina was far from insignificant in this shift. Unable to inhabit the role of warrior like her father, she used her adult decade on the throne to spearhead Sweden in culture instead of in warfare. Though unable to leave the country during her reign, she invited foreign cultural figures—largely from France—to Sweden, and used them to infuse the country with 'splashes of imported foreign color'.[11] Fashion historian Julia Holm has researched the Swedish Royal Wardrobe's account books from the years of Christina's reign, and concluded that while Christina enthusiastically dragged the modern fashions of Paris into Sweden via her own royal wardrobe, she was not trying to erase Sweden's own clothing culture: 'Swedish fashions were important to [Christina]', writes Holm, and 'simply following French fashion was not an option. At the same time, in purchasing and using these garments, she connected herself with the modern context of French court fashion'.[12]

Christina was a King but not a warrior, an adult just come of age after the regency of her girlhood. Her image was carefully—or at least deliberately—constructed as she navigated this uncharted terrain. The most famous garments from her lifetime are those that she wore to her belated coronation in 1650, and these paint an

image of the Girl King better than any. Her outfit bowed to Swedish traditions while ushering in French fashions. Its largest part, the coronation robe, had been made in Paris years before the coronation itself and had been tucked away in storage. The robe was purple velvet, lined with ermine, trimmed with pearls and decorated with a pattern of solid golden crowns. It was twelve feet long.[13] The robe still exists, though missing the pearls and crowns— these were removed and sold in the eighteenth century, a testament to the expense the garment had represented to the Swedish court a hundred years before.

It was important to Christina that her coronation attire was her own. Though the basics of the outfit kept to tradition, it was bigger and, in Christina's eyes, better than the robes worn by her predecessors. Christina was asserting her position as King, as Queen, as the monarch who would take Sweden into the cultural future of Europe, and what better way to do so than on an occasion where all eyes would have been on her? Julia Holm writes about Christina's use of clothing to legitimise herself as a woman ruler, in a role that had only ever been occupied by men:

> Her choice of garments suggests that she was well aware of what was required of her, considering the white and silver colour of the *klädning* [a suite of clothes] as well as the design of the cloak, which had strong similarities with the coronation robes of previous male monarchs. By using Erik XIV's crown, she marked her function as a king and a legitimate heir in the Vasa dynasty. Christina also placed herself in a European fashion and cultural context by purchasing the *klädning* and the cloak in Paris. This strategy seems to have been successful since the cloak was used by several male monarchs after her.[14]

It was not only Christina's coronation that provided a perfect canvas for the construction of her royal self. Literal canvases were another place in which the Girl King came into being. The two most famous paintings of Christina, both by Sébastien Bourdon, were painted in 1653 (the year before she abdicated). One of these (Figure 4) was an intimate portrait, a bust against a simple black background. In this portrait she balances between masculine and feminine; she is painted wearing an off-shoulder black gown, but her shoulders are

not bared. Instead, underneath the dress she wears a white men's shirt, tied at the collar with a black ribbon in the style of male fashion at the time. Art historian Inga Lena Ångström Grandien has commented, 'By wearing a dress with allusions to men's attire, whilst at the same time not hiding her femininity, [Christina] presents herself as both [...] king and queen'.[15] Christina used her clothes with purpose during her time on the throne, and whether a coronation or commissioned portrait, she paid close attention to the details. She had a reputation to uphold, or rather, to build. Her self-image was a responsibility that she carried upon her head like her crown—it is no wonder that she threw it away upon her abdication, at last dressing to fit her mind rather than her title.

Swedish or Parisian, male or female

Christina was always straddling a boundary line when it came to her self-presentation. Her clothing hovered in a no-man's land; she was sometimes a leader and other times an outsider. She dressed herself to fit 'into the cracks', a recurrent theme in the history of lesbian fashion.[16] Christina is a ring in a family tree of lesbian fashion, where the branches are continually being discovered. We know that she is part of this heritage because of her clothing and its differences. We know this by reading and imagining, but also by conjuring her garments into our minds and carefully hanging them together on an imaginary rail. We were always here: these clothes attest to it.

Christina's personal style has been repeatedly described as 'cross-dressing', but this is not the whole truth. The way that she dressed, sometimes very masculine, other times more conventionally feminine, and on many more occasions a mixture of both, was not a crossing of two distinct gendered fashions but rather a woven, tangled knot between the two extremes. In her youth and during the decade when she sat on the throne, her wardrobe was more feminine than at other points later in her life—but even so, she was a regular horse rider, and riding wear for women of this period was essentially one and the same as for men. Ångström Grandien writes about this in relation to Sébastien Bourdon's second 1653 painting of Christina in which she poses on horseback,[17] well known to be the monarch's favourite portrait of herself: 'A distinctive equestrian costume for

women was first introduced in the 1640s, but tailored in the manner of men's dress: a fitted jacket worn over a long skirt, often worn with a masculine hat'.[18] When she abdicated the throne and travelled to Denmark, en route to her dream of Rome, she reportedly changed into men's clothing, donned a sword and cut her hair into the chin-length style popular among men at the time. She had grasped free-dom—or what felt like freedom to a home-grown Queen of the snowy north—for the first time, and would not be restricted by any part of the royal wardrobe she had grown up in.

A particularly evocative description of one of Christina's post-abdication outfits can be found in a letter written by the Duc de Guise in 1656:

> She wears a man's wig, very heavy and piled high in front, hanging thickly at the sides and fair at the ends. The top of her head is a mass of hair; at the back it looks vaguely like a woman's *coiffure*. Sometimes she wears a hat. Her bodice is laced crosswise at the back. It is made almost like a man's vest, with her shirt showing all the way around between it and her skirt. The skirt is very badly fastened and not very straight. She always wears a lot of powder and lots of face cream, and she hardly ever wears gloves.[19]

Christina's male garments were always paired with a skirt of some kind, but this often goes unobserved in the many accounts of her masculine clothing—if a writer was gleefully describing the Queen's shocking appearance, why would they describe its most conven-tional part? Here, the Duc de Guise mentions Christina's skirt because it is messy and, like the rest of her attire, it does not con-form. His description does not suggest that she is overwhelmingly masculine. Instead, a bodice 'made almost like a man's vest' and a 'man's wig' combine with the (ill-fastened) skirt and the almost-ladylike *coiffure*. Christina is certainly out of the bounds of accept-able femininity, but she has not crossed into a fully male wardrobe. Instead of reading her in de Guise's image as unintentionally disor-derly, I want to suggest an alternative: imagine Christina with the world at her feet like a child presented with a paint box. Never one for convention, she has taken the colours and painted herself, leav-ing handprints on the walls, smudges of colour mixed together. Her appearance is tongue-in-cheek rather than something to be pitied.

Christina never abandoned her more feminine clothing when she left Sweden; she only gained the freedom, without the pressure of the throne and the opinion of her subjects, to revisit them as and when she wanted. The Duchesse de Montpensier, also known as *la Grande Mademoiselle*, once wrote that she 'had heard so much about [Christina's] bizarre clothes that I was frightened to death I would burst out laughing when I saw her'.[20] Yet on the occasion of their meeting Christina was wearing 'a skirt of gray silk and a flame-colored bodice of fine wool, both finished with gold and silver lace. Attached to her skirt was an embroidered kerchief with a flame-colored ribbon and a little braid of gold, silver, and black'.[21] It is no surprise to me that Christina's attire was perhaps more cohesive for this first visit by *la Grande Mademoiselle* than as described by the Duc de Guise. Though Christina and *la Mademoiselle* are not recorded to have had any kind of relationship or even deep regard for one another, it is possible that Christina had hoped to impress the other woman on their first meeting—she was beautiful and clever, after all. Who knows what could have blossomed?

Disorderly and free

When Christina threw away her careful image, the result was not always well regarded. Though the Duc de Guise was not outright disapproving, there's no doubt that he presented Christina as an oddity because of her appearance. Other accounts are less favourable, or more.

In 1652, two years before Christina's abdication, she met a special envoy from King Felipe IV of Spain, Don Antonio Pimentel de Prado. His presence was important to Christina, since Catholic Spain was instrumental in planning her journey to Rome. Christina may have been the monarch of Protestant Sweden, but she converted to Catholicism when she finally reached the city of her dreams in 1655. With Pimentel came a chaplain, Manderscheydt, who spent hours in Christina's company teaching her about the Catholic faith. This is how he described her:

> There is nothing feminine about her except her sex. Her voice and manner of speaking, her style, her ways are all quite masculine. I see her on horseback nearly every day. Though she rides side-saddle,

she holds herself so well and is so light in her movements that, unless one was quite close to her, one would take her for a man.[22]

This description was written while Christina was still on the throne. At this point, it was not strictly true that there was nothing feminine about her—we know from Holm's research of the Royal Wardrobe account books that Christina owned numerous gowns (överkjortel) and sets of what we can only assume were feminine clothes (klädning), as well as fashionable French-style accessories made of ribbons and lace known as favörer.[23] Still, the boundary lines of femininity were stricter in the seventeenth century than the twenty-first, and (in Manderscheydt's eyes, at least) Christina had broken free of them. To him, this was not a bad thing.

In 1656 the Swedish Queen visited the French court. Veronica Buckley, Christina's biographer, brings this meeting to life: 'In contrast to the beautiful, trailing silk gowns of the French ladies, she was wearing a short skirt, revealing her ankles, and a man's shirt fastened with vague decorum at her neck' (see Figure 5).[24] Buckley then quotes from the memoirs of one of said French ladies, Madame de Motteville, who wrote that Christina 'looked like a sort of Egyptian street girl, very strange, and more alarming than attractive'. De Motteville soon finds, however, that 'from one moment to the next, my impressions had completely changed—I realized I liked her'.[25]

In this example, it is the observer from Christina's own time who shows more regard for Christina's appearance than her modern biographer. Christina was a surprise and an anomaly; this did not mean that she wasn't striking, or that people did not like her. Some would have been appalled, but others saw the intent behind Christina's self-expression.

Christina was, perhaps, an early example of the clothing culture of lesbian feminism that emerged three hundred years later (see Chapter 16). She may not have had the same political motivations as lesbian feminists of the 1970s and eighties, but deliberate 'ugliness', or in Christina's case, disorderliness, is a connecting thread between them. In both the 1650s and the 1980s, there were traits that equalled appropriate femininity: subservience, tidiness, delicate clothing, fashionable makeup, skirts. Where lesbian feminists pulled on their jeans and dungarees, Christina wore skirts that showed her ankles with men's shirts. Lesbian feminists cut their hair while

Christina shaved hers off and donned a man's wig. Both were ridiculed, but not always. Christina's place in lesbian fashion history is not quite so anomalous as it might first appear.

* * *

Clothing was undoubtedly important to Christina, and she used it throughout her life to be one thing or another, or another still. Her clothing was varied, irreducible to the ever-present phrase 'she dressed in men's clothes'. The clothes that she chose to wear were influenced by the level of respect that she had for a person, or whether she needed to gain theirs. There were times when it seemed that she did not care about her appearance at all, but this in itself was a testament to what she valued about herself. Christina may have loved beautiful things, but I do not think that she saw herself as one of them. Instead, she saw herself as interesting, and it is this rather than any other trait that comes through most strongly in her dress.

Christina may not have always been well-regarded, but there were people who regarded her well. She was a novelty, a mystery, a fount of possibility. When people saw her they did not soon forget her, and they certainly did see her, as she toured cities at her leisure and walked their streets on foot. Parisians rallied to catch a glimpse of her and the most undesirable Romans—'Thieves, Assassins, and Debauch'd Women'—flocked to Christina's quarter of Rome in her later life.[26] In the 2020s, our culture is populated with phrases like 'celebrity crush' or 'queer icon', and though I am not suggesting a direct equivalent in Christina, something similar is not impossible. Christina herself represented the possible, at least when it came to dress and gender and love for women. Sarah Waters reflects on Christina's '*liminality*: her resistance to categorization, her tendency, in fact, to cross category, whether national, religious, sexual or sartorial'.[27] Christina is exactly that: liminal. She exists in the cracks and somehow also outside of them. She has been dead for centuries, and yet her legacy remains, reinventing itself time and time again.

3

ANNE LISTER

DIARIES AND DRESS

Anne Lister is known to us in the twenty-first century as 'the first modern lesbian': a diarist, an entrepreneur, a woman who married another woman and wrote all about it in code. She was born in 1791 in Yorkshire in the north of England, and died in 1840 aged forty-nine while travelling through Europe with her wife, Ann Walker. Anne was perpetually interested in the world and what it could offer her, and more ambitious than was proper for a woman—at least, her ambitions leaned very much in the wrong direction, away from wifedom and motherhood and towards travel and business.

She first travelled abroad in 1819 at age twenty-eight on a trip to Paris with her beloved aunt. In the years between this first exploration and her last in 1840, she visited Switzerland, Denmark, Belgium, the Netherlands, Germany, Sweden, Finland, Norway, Russia, and finally Georgia, where she died of a fever. This was the period, during her thirties and forties, in which she flourished, each domino in her life falling into place. She was married (in all but law) in 1834 and officially inherited her home, Shibden Hall, in 1836. She opened two coal mines on the Shibden Hall Estate in the following few years.

Anne was a complicated person and a complicated figure in lesbian history, adhering to the status quo even while breaking it. Proud of her position as a landowner and businesswoman, she exploited the working-class tenants of her estate and the workers in her collieries for her own profit and social gain.[1] Yet, on a personal level, her lifestyle rebelled against the social order of Georgian Britain.

Anne always loved women. She wrote quite plainly in 1821 that 'I love, & only love, the fairer sex & thus beloved by them in turn, my heart revolts from any other love than theirs'.[2] The rest of her diaries—all five million words of them—support this claim, repeatedly capturing the intimate moments of her relationships, her personal worries and triumphs, alongside the ins-and-outs of her professional manoeuvres. Large portions of the diaries were written in code, which Anne called crypthand; the code was first cracked by her distant relative John Lister, the last inhabitant of Shibden Hall, decades after Anne's death. John, though encouraged by a friend to burn the diaries, instead hid them behind wall panelling at Shibden, where they remained until after his own death. The content of the diaries' crypthand wasn't made known until a century later, when historian and teacher Helena Whitbread published a book on Anne's life and loves, *I Know My Own Heart*.[3]

From the work of Whitbread and others, we know that Anne's most significant relationship, though not always easy or amicable, was with Mariana Lawton (née Belcombe), spanning twenty-one years. We know that her chain of relationships with women was a long and sometimes winding one. We know that Anne held power that many women, even of her class, were unable to grasp. Women in the early nineteenth century had limited rights and limited opportunities. Most were entirely at the mercy of their fathers, brothers or husbands; even the wealthiest single women could find themselves homeless if their father died, with the inheritance passing to the next man in the family. Subservient wife and daughter were not only roles expected of women but ones they often had no choice but to fulfil. Mariana, Anne's great love, knew this. Her marriage to a man, breaking Anne's heart, was motivated by the need for financial stability—something that Anne could never quite understand. Anne, with no surviving brothers or male relatives to challenge her inheritance, lived comfortably at Shibden Hall for most of her life, before officially inheriting the estate in 1836.

Armed with a rare and precious freedom, Anne searched for years for a companion who would commit to her. She found such a person in Ann Walker, an heiress in her own right, who committed to Anne with not only her heart but her assets. 'She is to give me a ring & I her one in token of our union', Anne declared in her diary

in February 1834, with the pair exchanging rings two weeks later.[4] On 30 March of that year—Easter Sunday—the couple took the sacrament together at the Holy Trinity Church in York, as close to an official wedding as they were able to have.

Much of the commentary on Anne's writings has centred around lesbianism and her navigation of it within nineteenth century British society. She is repeatedly referred to as 'masculine', but the specific ways that this masculinity was constructed have slipped to the sidelines. Anne's garments, and her own words about them, are crucial to lesbian fashion history. It's often debated whether Anne Lister should be referred to as a lesbian, due to different language and conceptions of female same-sex relations during her lifetime. In 1998, Jack Halberstam presented Anne as a 'female husband' (see Chapter 11), writing that 'the presumption that [historical masculine women] simply represent early forms of lesbianism denies them their historical specificity and covers over the multiple differences between earlier forms of same-sex desire'.[5] Over two decades later in *Before We Were Trans*, Kit Heyam discusses the complexity of not only Anne's own sense of her identity but the ways that she's recognised in the present. Using they/them pronouns for Anne, Heyam concludes that 'Anne's relationship to their gender [...] was by no means simple or easy to categorise'.[6]

Still, Anne's repeated twenty-first century rebirths, in biographies, documentaries and television dramas, have mostly understood her as 'lesbian'. Though she never called herself this, lesbianism remains integral to her story, because stories are read by their readers. As Jessica Campbell writes, 'calling Lister a lesbian can do real work in the present':

> Identifying Lister as a lesbian is an immediately comprehensible way of communicating to a broader public that this woman in the early 19th century loved other women—romantically, sexually, and throughout her entire life.[7]

Clothing can represent the inefficiencies of a hetero-normative culture, one defined by gender binaries and dressed in suits and skirts. Anne Lister's clothes are a window to her heart. When we consider what she wore and why she chose to wear it, it is easier to see the ways that she was different, and the ways that she strived not to be.

Most descriptions of her outfits are from when she was a younger woman, before the period dramatised in *Gentleman Jack*. Her worries about her clothing were at their peak before she became an heiress, and before she met Ann Walker, the woman who would become her wife.

All black, no rainbows

> Went in black silk, the 1st time to an evening visit. I have entered upon my plan of always wearing black.
>
> Anne Lister, 2 September 1817.[8]

There was a fashion for black clothing in the nineteenth century. Unfortunately for Anne, this fashion was not directed at women. She lived most of her life in what is commonly considered the Regency era in Britain, from the 1790s to the late 1830s.[9] At first, the period's neoclassical style often embraced more neutral palettes than in the eighteenth century, but as the years went on colour returned to women's wardrobes in full force (excepting mourning dress).[10] For men, on the other hand, a sombre palette prevailed and by the 1830s had taken root. John Harvey describes in *Men in Black* how 'one can see colour die, garment by garment, in a very few years'.[11] So, Anne's adoption of an entirely black wardrobe was a striking marker of her difference.

This style choice of Anne's is usually interpreted as masculine. Rebecca Jennings, in *A Lesbian History of Britain: Love and Sex Between Women Since 1500*, explains that 'As she grew older, Anne increasingly adopted a masculine style, dressing entirely in black and assuming "gentlemanly" manners'.[12] While this is true, there is more to be said. The items that Anne describes as being black are feminine in fabric and form.

In April 1823, when Anne was in her early thirties, she described one such outfit: 'My dyed satin made into a slip. A striped black gauze over it, prettily trimmed around the bottom. Blond around the top. I looked very well'.[13] Trimmings may not have been a staple in Anne's wardrobe, but they definitely were not entirely absent, even when she wore black. They were a nod to the femininity that she, as an upper-class socialising woman, was expected to exude.

However, Anne's black clothing still stands out against the colourful femininity of her contemporaries, which we can see in a dress from a few years later, held in London's Victoria and Albert Museum. This dress from Anne's era is made of yellow, green and red striped silk, repurposed from a late-eighteenth-century garment.[14] It represents the 'rainbow style' popular in women's clothing in the 1820s,[15] and a mile away from the 'striped black gauze' Anne Lister describes herself wearing. It is closer to a description of a dress she gave to her sister Marian in 1819: 'a green & yellow shot Italian gauze evening gown'.[16] Upon making the decision to dress only in black, Anne rid herself of colour, finding new homes for her old, brighter garments; in 1820, she continued the purge, giving a 'green silk skirt' to Marian and 'brown silk shoes' to her aunt.[17] These items, whether bright or muted, symbolised a fashionable femininity that did not belong to her.

Anne explained this separation from fashionability to a companion, Miss Hall, in 1821: 'Said what a bad figure I had & explained a little my difficulty in dressing myself to look at all well. Told her that, for this reason, I always wore black'.[18] This was not a lack of care for the clothes she wore: this was evident in the 'black silk' from 1817 and the pretty trimmings on the outfit from 1823, as well as the smart black skirts on show in her 1822 watercolour portrait (Figure 6). Instead, fashionability—so steeped in feminine expectations—may have been simply thought unattainable by Anne, discomfited as she was by her 'bad' female figure.

In many ways it was not Anne's womanhood, but her non-conformity to womanhood, that created hurdles in her life. She constantly made efforts to increase her social status, arranging fashionable additions to the Shibden Estate as well as her coal operations.[19] It was only through establishing respectability that she could live as she did, culminating in her union and cohabitation with Ann Walker. But it was not always a balance that she was able to maintain. Though sexual relations between women have never been explicitly criminalised in Britain, the concept was not entirely invisible. In the eighteenth century, relationships between women had gone to court surprisingly often, though with the accusation of fraud rather than sexual deviance (more in Chapter 11). During Anne's lifetime, many of the men in the courts and parliament would have

been aware of the possibility of love and sex between women, though anxious to keep it from their wives and daughters.[20] Most of their cultural references would have been the same as Anne's—classical texts such as the Sixth Satire of Juvenal, which referred to sexual activity between women, though in derogatory terms.[21] Lesbianism, whether named or otherwise, was certainly recognised, but very much under the radar.

Anne's transgressions, including her relationships and her colour-shunning dress sense, brought these possibilities further to the surface: clothes became a way to see the unseen. Some scholars, for example, believe that Anne's motive for wearing black was to mourn the loss of her relationship with Mariana after the latter's marriage. Dannielle Orr notes how Anne's decision to wear all black occurred in 'the first year after Marianna's marriage, when Anne was attempting to deal with her grief'.[22] Anne makes no allusion to this in her diaries, but it is easy to accept as a possibility. Most examples of black dresses from this period are explicitly for the purpose of mourning, after all.

Umbrellas and braces

Anne was unable to dress entirely in men's clothes, and she never wrote that she wanted to. Occasionally, she wrote in her diaries that a stranger mistook her for a man. However, we might assume that these exclamations were reproaches at her less-than-ideal level of femininity, rather than genuine mistakes. She never dressed in male fashions or even overtly male garments, according to her diaries— and her diaries were detailed enough that to exclude them would have been strange. Passing as a man was never on the agenda for Anne, although it was a position taken up by other lesbians, especially when it came to working-class lesbian marriages. In Anne's life, as explained by Anna Clark, 'passing as a man would have meant that Anne would give up her respectable position as an heiress, and with that, the possibility of an independent livelihood'.[23] So even when, as on 18 September 1818, 'Some men & women declared I was a man',[24] it was only certain features of Anne's dress and appearance that gave this impression. One of these was a leather strap on her umbrella, which she described half a year later: 'She mentioned

on the moor my taking off the leather strap put through the handle of my umbrella, which made it look like a gentleman's'.[25]

'She' is a Miss Brown—although not a very significant player in Anne's life, she is referenced in relation to clothing multiple times—who as a fashionable woman herself, would have had knowledge of gentlemen's accessories. She recognised the leather umbrella strap as such. She asked Anne to remove it, as if to make their private walk together more socially acceptable. To quote Anna Clark once more, 'Anne's masculinity signalled to lovers that a woman could sexually desire other women, in a way both threatening and alluring'.[26] We can see both of these ways in Miss Brown's actions; she is nervous about what Anne Lister's masculinity could mean for their relationship, hence asking for the umbrella strap to be removed, and yet she still meets with her. Anne possessed a unique allure and Miss Brown was far from immune to it.

Anne suited the ambiguous line between masculinity and femininity. She didn't wish to dress as a man and yet felt uncomfortable in highly feminine outfits. Cast your mind back to Queen Christina, who lived two centuries before Anne in Sweden, a place that Anne once visited in her travels; remember how her clothing fit into the cracks of gender and how, just as it was lesbian, it was her own. Anne Lister could be a nineteenth-century example of butch lesbianism (although nameless at the time): the specific form of womanhood that is masculine, but does not necessarily pass as male. Joshua Horner's 1830 portrait of Anne in sombre clothing (Figure 7) offers us precisely this 'in-between' feeling. Her wearing of gentlemen's accessories was a choice that she made to validate herself in a time when her self was unacceptable. But the validation of the self does not always have to be seen by others.

On 8 April 1817 we find another example of Anne wearing obviously male accessories, but this time not in company: 'Began this morning to sit, before breakfast, in my drawers put on with gentlemen's braces I bought for 2/6 on 27th March 1809 & my old black waistcoat & dressing gown'.[27] The 'gentlemen's braces' were clearly significant—she had bought them eight years previously and was still wearing them (or at least trying them on). In 1840, *The Englishwoman's Domestic Magazine* declared that 'Braces form a necessary adjunct to a gentleman's wardrobe'.[28] The way that Anne

claimed masculinity with this subtle form of dress is similar to her romantic encounters with women who were already married to men; she appropriated what a man deemed to be his own and liberated it from its patriarchal constraints. It is not about ownership. It is about how these actions signify the possibility of liberation.

Appropriation of higher-class men's dress by lesbians has continued in the two hundred or so years since these anecdotes from Anne's diaries, and many such stories have found a home in later chapters of this book. The way that we twist the clothing is what makes it ours.

Top hats and ribbons

Anne's writing suggests that her wardrobe was far from empty of feminine flourishes. While these are less evident in the diaries themselves, descriptions of brighter colours or ribbons are instead found in her clothing inventories. The more feminine aspects of her style may have been of little consequence to her. It's possible that she included things like ribbons in her wardrobe because it was expected—expensive trims worked to signal her wealth and status, after all—but didn't feel strongly enough about them to describe them in her diaries. Her relationship to fashion changed with age, with the clothing inventories in question dating from 1840, the year of her death.[29] By this point she was forty-nine, a landowner and Ann Walker's wife. She was expressing herself just fine; a little bit of ribbon wouldn't change who she was.

Aside from brighter colours and a bit of ribbon, something that fans of *Gentleman Jack* might be loath to associate with Anne is a bonnet. Instead, the TV show's costuming has led to Anne becoming almost synonymous with the silhouette of a top hat—despite top hats never appearing in her diaries or clothing inventories. This choice was made to create a visual shorthand for lesbian fashion, with garments that may have been read as subversive by Anne's contemporaries not necessarily having the same effect on the twenty-first-century viewer. The show's costume designer, Tom Pye, has explained:

> My research into Anne Lister told me she wore a small black soft cap, probably created with velvet. I tried a few shapes along these

lines, but it didn't seem to be able to convey an understanding to a modern audience of the power or status that could be achieved with a top hat.[30]

Of course, just because Anne didn't write about them doesn't mean she didn't wear them. I would argue that this is especially true in her youth, as this was when the more masculine elements of her wardrobe seemed at their strongest. It's likely that she wore top hats for riding for most of her life, since they were a common feature of a woman's riding habit throughout the nineteenth century—dress historian Alison Matthews David describes how the fashionable Victorian female rider 'represented the epitome of cultivated elegance and cut a fine figure in her tailored habit and silk top hat'.[31] In this context, then, Anne wearing a top hat wouldn't have been a strange occurrence, and if anything would have been expected.

The kind of hats that Anne wore become most evident when she writes about how other people reacted to her attire. Maybe she didn't wear top hats in her day-to-day life, but that doesn't mean that she stuck to the rules. It is no coincidence that she devoted the most time to describing others' reactions to her clothing when beautiful women were involved. Miss Brown (later Mrs Kelly), the fleeting romantic interest of Anne's who once walked with her unchaperoned on the moor, was described by Anne in 1818: 'Miss Brown, in a white gown & green velvet spencer, looked Kallista'.[32] 'Kallista' refers to Callisto, a lesbian nymph from Greek mythology.[33] Six years later, Anne describes the reception of her own outfit (headwear included) when visiting the now-Mrs Kelly and her husband: 'My new hat & greatcoat on. An India handkerchief around my throat. My usual costume. I wonder what he thought of me. If it was good, she will tell me. He must have been struck one way or another'.[34]

Without context, this quote appears to suggest that she sought Mr Kelly's approval of a fashionable outfit, but this is Anne Lister. We may not know what this 'new hat' was, but while it was unlikely to have been a top hat, it remains possible that it was equally striking, and not the newest feminine fashion of 1824. It was very likely Mrs Kelly who Anne was trying to impress, while simultaneously asserting her position to Mr Kelly, both socially and as a former companion of his wife. In another diary entry from a few weeks later, after a walk with Mrs Kelly, Anne wrote that 'We were talk-

ing of my dress. She said people thought I should look better in a bonnet. She contended I should not, & said my whole style of dress suited myself & my manners & was consistent & becoming to me'.[35] The times when Anne pushes the boundaries of how masculine her dress can be are when she is at her most outwardly lesbian.

In contrast with this earlier interaction with Mrs Kelly is a January 1840 inventory, written by Anne just months before her death, where she lists six different kinds of bonnet, as well as four different caps.[36] No other hats are listed. Among the bonnets and caps, most are black or grey, but one is straw, and at least a couple are decorated with ribbons. Anne's fashion crossed the boundaries of masculine and feminine while still following certain dress codes. Thanks to the writing she left behind, we can examine these gender cracks and the lesbian bridges across them, and for her words I am immensely grateful. So many histories of lesbian fashion are based in conjecture, but Anne's diaries are decisive. They affirm the stories that follow and precede it.

Very odd figures

As to not noticing dress, etc., she supposes me like herself. How she is mistaken.

Anne Lister, 28 February 1823.[37]

While Anne often worried about her own clothing and frequently noted its details in her diaries, it was rare that she paid much attention to the dress of others. There were, of course, exceptions to this rule—usually at the beginning of an acquaintance, when Anne would try to decipher a woman's character with any details she could gather. She might also describe clothing in her diaries if it had made a particularly strong impression, or if the garments in question could somehow indicate a woman's opinion of Anne herself. For instance, at the beginning of her courtship with Ann Walker in 1832, after a morning of kissing on the sofa, Anne was invited to dinner by her new lover. She noted that Ann W. 'had put on an evening gown' for the meal.[38] Ann W.'s feminine fashionability, in this instance, could be seen as an affirmation of her feelings for Anne, and her desire to impress the more masculine woman.

Anne makes similar observations about Mariana's feminine apparel, though we may assume that Mariana's appearance was so well-known to Anne that it seldom warranted description. Yet, in September 1826, Anne stayed for a short time in Paris with her married on-and-off-again lover. Mariana was a tourist in the city (while Anne planned to stay for a longer period) and made the most of it: Anne writes that Mariana 'bought a beautiful "satin chaconné rose" [...] dress' and a 'lilac silk' bonnet.[39] These are telling details. Mariana's adherence to fashion, especially in its favourite city, was a mark among the many in her favour. Though Anne's self-expression leaned away from femininity, she certainly appreciated its charms. In fact, in 1825, Mariana joked that it could hardly be any other way—that Anne could and would not settle, romantically, for another woman too like herself. '[T]wo Jacks would not suit together', said Mariana, speaking of Isabella 'Tib' Norcliffe, one of Anne's former lovers. Tib was the woman who had introduced Anne and Mariana, and was a much more masculine character than Mariana herself.[40]

Although Anne associated mostly with women, there was never a community of lesbians around her. She did, however, meet and know some other lesbians throughout her life (other than her own lovers), and there are two notable examples of this in her earlier diaries. The first is Sarah Ponsonby, one of the Ladies of Llangollen. The Ladies, Sarah and her companion Eleanor Butler, famously left their native Ireland to run away together, moving to Llangollen in Wales in 1780. Their house, Plas Newydd, was situated on the outskirts of the village and over the rest of their lives garnered a reputation for hosting a range of intellectuals and artists. They certainly loved one another, and though the nature of their relationship seems obvious to many modern observers, during their lives they were largely seen, and often idolised, as the epitome of platonic love between women. Anne's diaries and correspondence make clear her own perception, however: seemingly musing on her own desire for a life partner, she wrote after her visit that 'I could have mused for hours, dreampt [sic] dreams of happiness, conjured up many a vision of... hope'.[41] The gender and sexuality professor Chris Roulston sees this visit to the Ladies' home as one based in longing, 'a form of pilgrimage, the recognition of an achievement

that has remained beyond her grasp'.[42] It would be another decade before Anne began her relationship with Ann Walker, the woman she would marry, after all.

Whether Eleanor and Sarah are interpreted as lesbians or otherwise, Anne's account of her meeting with Sarah (Eleanor was unwell) is full of clues about lesbian dress during the period. To someone like Anne, seemingly aware of favoured lesbian fashions, the clothes worn by these women said more about them than could be politely expressed with words. It makes sense, then, that the first thing she writes about Sarah on 22 July 1822 is a description of her clothing:

> In a blue, shortish-waisted cloth habit, the jacket unbuttoned shewing a plain plaited frilled habit shirt—a thick white cravat, rather loosely put on—hair powdered, parted, I think, down the middle in front, cut a moderate length all round & hanging straight, tolerably thick. The remains of a very fine face. Coarish white cotton stockings. Ladies slipper shoes cut low down, the foot hanging a little over. Altogether a very odd figure.[43]

'Odd', because she has not taken care to keep her wardrobe up to date with the fashionable femininity of the 1820s. This could be attributed to her age, or her seclusion from fashionable society, but the most obvious reason—in hindsight, or with the lesbian eye of Anne Lister—is her detachment from a heterosexual life that would demand more conformist dress. The outfit described here seems particularly mismatched, especially when compared to the most famous portrait of the Ladies of Llangollen (though this was an image produced after their deaths, and may not be wholly truthful—perhaps constructed to make their appearances more typically masculine, to fuel rumours about their oddities). In the portrait (Figure 8), both ladies seem neater, wearing all black or dark shades, jackets buttoned up and top hats placed on their heads. But at the time of Anne's meeting with Sarah, her partner Eleanor was unwell, which might account for a state of preoccupied disarray.

Another lesbian of Anne's acquaintance was a lady from her own local town of Halifax, Miss Pickford. Anne's descriptions of her similarly imply a general air of unfashionability, with Anne asserting her shock at their first introduction that Miss Pickford 'cares nothing

about dress; never notices it'.[44] This is a big leap from Anne's own attitude. On 7 March 1823 she writes: '[walked] home with Miss Pickford... I wish she would care a little more about dress. At least not wear such an old-fashioned, short-waisted, fright of a brown habit with yellow metal buttons as she had on this morning'.[45] Like Sarah Ponsonby, Miss Pickford includes a riding habit in her costume. These were conventionally fashionable, but only when worn in the correct social context: that is, riding. When worn by Miss Pickford and Miss Ponsonby, the outfits have distinctly masculine connotations. The high collars and military-inspired stripes on the bodice of many habits are the closest that women's clothing came to replicating men's. They allude to sport and activity, even when there is none.

On 1 June 1823, Anne wrote approvingly that Miss Pickford was wearing 'Neat gros de Naples silk mourning & bonnet & she looked better, more feminine than in her habit'.[46] Anne knew that Miss Pickford was a lesbian. She had admitted it in confidence, though Anne did not confide the truth of her own affairs in return. It's possible that Anne's dislike of Miss Pickford's masculine clothing was because she preferred to surround herself with more feminine women—but it's also possible that it grew from a fear that Miss Pickford's difference would be noted by others and make its way back to Anne. Though Anne was proud of her love for women, she still had to keep it secret. For lesbians, there is an irremovable link not only between dress and identity, but between identity and safety. Particularly in nineteenth-century Britain, there was a limit to the rules a lesbian woman could stretch with her clothing, without risking—depending on her situation in life—ostracisation, persecution, or being labelled insane. Sex between women may not have been illegal, but when a woman had little or no control over her life she could be accused of other crimes, or handed over to an asylum by a male relative. Anne had more immunity to this fate than others. Yet, while she bent the rules every day, she was constantly conscious of her limits. For Anne Lister, non-conformity had to be worth something; she had to want what she was chasing, and she was not chasing Miss Pickford. Like her careful finances, Anne weighed each of her personal choices. Over and over again, through nearly all of our history, lesbians have had to find a balance between

expressing their identity to others like themselves and expressing it to those who could not be allowed to know. There was a fine line between security and vulnerability. Anne Lister walked it. Only those with even more power could strut along it with confidence.

4

LITERARY LOVERS

1910s JAPAN

Lesbians, feminists, and woman-lovers of all kinds have often been aware of the threads that link them to others in the past, sometimes honouring these 'herstories' with the names they choose for their spaces or creations. The first issue of the literary magazine *Seitō* was published in Tokyo in 1911. Named after the Bluestocking Society of eighteenth-century England—a literary women's group who we might now call 'proto-feminist'—the publication was run by women, for women, promoting equal rights through literature. It ran for five years, pushing against backlash from the mainstream press and the Japanese government. It was created by a group of five women and contributed to by over one hundred, including Hiratsuka Raichō and Otake Kōkichi, whose lives and clothing narrate this story.

This is a curious stopgap in lesbian history, before the so-called roaring twenties and outside of the most acknowledged lesbian societies in Europe and North America's cosmopolitan cities. The setting of early twentieth-century Japan, with its own metropolis of Tokyo, is no less important. In this setting, unique and diverse, deliberate stylistic choices formed pins pressed into the sprawling map of lesbian fashion history.

Seitō emerged into a changing Japan. It was the end of the Meiji period of rapid industrialisation and modernisation (1868–1912), and the country was in the midst of transition from inward- to outward-looking. Half a century earlier, Japan had opened its doors to trade with the world, and now not only commodity goods but

47

ideas, fashions and prejudices from Europe and the US were steadily creeping in. Japanese people, while embracing change on the one hand, were holding tight to their own culture on the other, and the responsibility of this culture-conservation and cultural display landed on the shoulders of women.

While Japanese men were encouraged to take up the shirts and trousers of Western fashion, women were expected to wear traditional Japanese garments as a 'reassuring, visual image'.[1] The kimono, especially, was proper female attire, though it had only taken on the name and form of 'kimono' in the Meiji era; it was a newer version of an older Japanese garment, the *kosode*, which had been universal and unisex during the Edo period of feudalism (1603–1867).[2] At the turn of the twentieth century, just as Japanese girls were entering schools and colleges en masse for the first time, a new doctrine emerged to keep them on the path of traditional, patriarchal values: *Ryōsai kenbo* ('good wife, wise mother').[3] Some women, of course, did not want to be told what to do or what to wear. 'New Women' were springing into action across the globe, from Suffragettes in the UK (see Chapter 15) to dancers and radicals in Harlem (Chapter 8) to the *Seitō* society in Japan, captured in Figure 9. 'New Women' everywhere were admired or respected by some and demonised by others—most commonly in political cartoons. Fashion was vital to this, because clothing was how they could be marked as different in illustrations, a tool that could be twisted to mock and dissuade other women from the same path.

The sartorial politics of 1910s Japan was not only attempting to preserve appropriate femininity, but a whole history and culture. The language of garments, also, was unique. There is the *yukata*, a more casual style of kimono typically worn around hot springs and in the summer, worn by both men and women though usually in different colours, and with different *obi* (belt) placements.[4] There's also *hakama*, which exists in two distinct forms: the *andon hakama*, which is essentially a wide skirt, devised for women, and the *umanon hakama*, split in two and more trouser-like, which is typically worn by men.[5] *Hakama* of any kind being more practical garments than the kimono, *umanon hakama* were introduced as school uniforms in the late nineteenth century, coinciding with the opening of the first girls' schools in Japan. The masculine *hakama*, though, was criticised

as a uniform for girls due to being 'linked to the samurai class', and 'some considered the practice tantamount to cross-dressing'.[6] It was this concern that led to the skirt-like *andon hakama*.

How does lesbian fashion fit into this landscape? Let's return to Hiratsuka Raichō and Otake Kōkichi, both feminist writers and lifelong political activists. Raichō was born in Tokyo in 1886. She was a prominent figure in the Japanese peace movement, and worked towards shaping the Japan of her dreams through her writing and lecturing until the end of her life in 1971. Kōkichi was seven years younger than Raichō, born in 1893 in Osaka. Her achievements aren't widely recognised, though her life and work were in many ways revolutionary; she was a Marxist as well as a feminist and lesbian, and she taught her daughters to value equality and independence, also. The two women's lives were only briefly entwined, but it was an entanglement with long-lasting effects on both of their legacies—their year-long relationship was immortalised in the stories that Kōkichi wrote for *Seitō* about her passionate feelings for Raichō, as well as Raichō's retrospective essay, 'Ichinen Kan' ('One Year').

Though Raichō was one of the founders of *Seitō* and Kōkichi only a contributor, together they were central targets for attacks on the publication by the mainstream media and wider society. This is because, as Wu Peichen writes, they 'transgressed what was supposed to be male territory'.[7] An in-depth study of Kōkichi suggests that 'The young, outspoken, masculine Otake Kōkichi appeared at the time to be a perfect bogeyman for social conservatives to demonise and make the face of the kind of dangerous, pathological, modern femininity coming out of women's colleges'.[8] Imaginings of this new femininity were steeped in a new cultural fear: *dōseiai*. This was a new term for homosexuality in Japan, and one that often related to love between women. It was not only a new term, but a new conception—at least, in public and in language. Before the 1910s, the predominant term for same-sex love in Japanese was *danshoku*, which applied only to male same-sex love.[9]

So, *Seitō*'s publication coincided with what is often considered the beginning of modern lesbian history, and Japan was not exempt from this new dawn. Yet the political and personal relationships between women and their lesbian significance in this period have

seldom been studied. We were always here, everywhere, but 1910s Japan marked the opening of a lesbian floodgate of writing and style. This partly emerged from the imported European concept of sexology and the works of its leading scholars[10]—but also from a new sphere of Japanese women's schools and colleges and the close female friendships that were possible within them. A newspaper article from 1911 listed a selection of words that schoolgirls used to refer to 'passionate love' between themselves, apparently trying to expose the phenomenon. The words included:

> 'goshin'yu' (intimate friends), 'ohaikara' (stylish, from the English term 'high collar'), 'onetsu' (fever or passion), 'ome' (possibly a combination of the words for 'male' and 'female'), and 'odeya' (an honorific attached to the Japanese version of the English word 'dear').[11]

The public fear of and disgust for *dōseiai* soon reached a fever pitch. Raichō and Kōkichi were easy targets. Their personal relationships, their feminist ideals and their clothing all pinpointed them as different. Most damningly, they had taken their ideals onto the streets: in 1912, Raichō, Kōkichi and another *Seitō* member visited Yoshiwara, an entertainment district—very much not something done by respectable women. They hired a geisha for the evening, to talk privately with her about the needs of geisha within the women's movement, as 'an act of cross-class solidarity'.[12] In the mainstream press, the trip was transformed into something else: an indulgence, a deviance, a transgression. Shortly afterwards, articles and cartoons were published in numerous Japanese newspapers that condemned and satirised the *Seitō* women, but particularly Raichō and Kōkichi. They were unambiguous. This was true of both their clothing and their written words, with neither woman hiding their sapphic passions during their relationship.

Woman was the sun: Hiratsuka Raichō and Otake Kōkichi

Though in the later decades of her life Hiratsuka Raichō became known for her role in the Japanese peace movement, in the early twentieth century she was the public face of Japanese feminism. This was not an easy position to occupy, and she was publicly

labelled as bisexual and as a sex addict, both claims that sought to defame her and the work of *Seitō*.[13] When words weren't enough, her reputation was caricatured in illustrations. In a political cartoon (Figure 10) that depicted the *Seitō* members meeting with the geisha, Eizan, in 1912, Raichō is wearing a *hakama*, combined with spectacles and an open book in her hand, which Jan Bardsley suggests symbolise 'the New Woman's intellectualism and love of literature'.[14] I think it is more likely that they're meant to represent Raichō's masculinity. Raichō's 'bookishness' in this cartoon says as much about her perceived failings as a 'true' Japanese woman as does her lack of a traditional kimono. It shows her association with female education—still a new and contentious concept in Japan—and, through her work with *Seitō*, her prioritisation of it over being a wife and mother. The cartoon's depiction of the *hakama* is an accurate portrayal of what Raichō customarily chose to wear, though I have found no confirmation as to her preferred style of *hakama*. It is possible that she wore the *umanon* divided *hakama*, ordinarily worn by men, as she is consistently referred to as a cross-dresser.[15]

The *hakama*'s association with girl students is another marker of Raichō's refusal to conform, which she all but confirmed in her autobiography *In the Beginning, Woman Was the Sun*. She writes about her clothing in the years after she graduated college:

> Despite my mother's objections, I still wore a hakama though I was no longer a student. I found an obi [kimono belt] too constricting and besides, a hakama was better for zazen [sitting meditation]. I kept my hairstyle simple, parting my hair to one side or down the middle, twisting it into a bun in the back, and fastening it with two imitation tortoiseshell combs.[16]

Recall Anne Lister, who worried about her 'bad figure' when dressing. Raichō, for whom feminine garments were too constricting, seems to have experienced a similar conflict. Perhaps she simply refers to bodily discomfort; perhaps she refers to a more psychological kind of unease, and the feelings of inferiority that heavily gendered clothing might give to those whose gender marks them as second-class. Shortly after this statement, she writes that 'I sometimes wonder whether my parents were disappointed to have a

daughter who never consulted them or asked their opinion, who never showed interest in what she ate or took pleasure in receiving a new kimono'.[17] Raichō's *hakama* could be read as a conscious rejection of the role of wife and mother, focusing her energies instead on women-led communities and relationships with women, as in the girl-centric environments of schools and colleges. This choice was notable even to her contemporaries at *Seitō* such as Tamura Toshiko, the feminist novelist who hovered for a time around the possibility of a relationship with Raichō. In Toshiko's story 'Nikki' ('Diary'), she describes Raichō's appearance, emphasising her masculine qualities by focusing on her tendency to wear *hakama* and wooden clogs.[18]

I cannot label Raichō as a lesbian because she had a long-term, seemingly passionate relationship with a man, and, later in her life, consciously shunned any association with a queer identity or lifestyle, crafting her image into one that could have a legacy in late-twentieth-century Japan. Still, I see the way that she dressed as a fashioning of lesbianism—there are enough links between her life and lesbian history, culture and community that it is impossible to separate them.[19] The strongest link is, of course, Raichō's relationship with Otake Kōkichi. This relationship, with both women presenting and acting in a masculine way, is sometimes described with the term *danshoku*: essentially, that the pair were more like male lovers than lesbians.[20] Their relationship was short-lived, from 1911 to 1912 (starting when Kōkichi was eighteen and Raichō twenty-five), but it had a lasting effect on both of their lives. Though in later years Raichō described it as one-sided on Kōkichi's side, her May 1912 essay 'Marumado yori' ('From the round window') affirms the mutuality of their love. Published in *Seitō*, the essay tells us '[h]ow passionate my kisses and hugs were to make Kōkichi become part of my world',[21] continuing later:

> I put all of Kōkichi's letters and postcards into boxes in order. I cannot even put myself together. There are twenty-nine letters and thirty-eight postcards that I have received since November 30 last year. The night of the thirteenth is unforgettable [the night they spent together for the first time]. I selected the letters including the express ones delivered after that night and read them again.[22]

Fig. 1: *Sappho and Erinna in a Garden at Mytilene* by Simeon Solomon, 1864, watercolour on paper. A rare example of a Victorian painting which centres Sappho's love for women.

Fig. 2: The Sapphic aesthetic was one loved by painter John William Godward, seen in his 1904 work *Reverie*, or *In the Days of Sappho*, oil on canvas.

Fig. 3: Sappho's Parisian rebirth: Natalie Clifford Barney surrounded by dancers dressed in togas, c. 1900–07, Neuilly.

Fig. 4: The Girl King is a magnetic force in *Christina, Queen of Sweden* by Sébastien Bourdon, 1653, oil on canvas.

Fig. 5: Images of Christina became less grand as she aged, but her striking mixture of masculine and feminine attire prevails in this painting of an older ex-monarch: *Kristina, queen of Sweden*, by Wolfgang Heimbach, oil on paper.

Fig. 6: This watercolour portrait of Anne Lister was most likely painted by a Mrs Taylor, in 1822. Anne's diary entries from November 1822 describe the sitting, and call the painting 'an admirable likeness [...] capital' —but on 30 August 1823, she complains, 'Mrs Taylor's sketch of me, like a person afraid of speaking. Too foolish looking. Could not bear it. Not at all characteristic.'

Fig. 7: *Anne Lister of Shibden Hall*, by Joshua Horner, c. 1830, oil on canvas. This is the most formal of the surviving images of Anne, who was often known for her 'mannishly' sombre clothing.

Fig. 8: The most famous representation of the Ladies of Llangollen, Eleanor Butler (right) and Sarah Ponsonby. Since this lithograph was printed c. 1870, after the Ladies' deaths, their outfits were imagined, and their faces copied from previous portraits.

Fig. 9: Members of the *Seitō* team gather together at a New Year party in 1912. Hiratsuka Raichō sits on the far right. Those with a visible *obi* (belt) are most likely dressed in kimono, while others, including Raichō, may have been wearing *hakama*.

吉原登楼（『東京パック』1912. 8. 1）

Fig. 10: A political caricature from *Tokyo Puck* of *Seitō* members, including Hiratsuka Raichō, visiting a geisha in Tokyo's entertainment district, 1912. *Seitō* took its name from England's eighteenth-century Bluestocking Society.

By the end of 1912, this passionate love was over—at least for Raichō. The year had been a formative one in Kōkichi's life. She had occupied a scandalous position at *Seitō*, and some of its most boundary-breaking writing and excursions can be attributed to her. It was Kōkichi who, intending to write about sex workers' needs in the women's movement, had organised the visit to the Yoshiwara geisha, Eizan, which later became satirised in political cartoons. Kōkichi, too, wrote repeatedly about her love for women, and particularly her love for Raichō: 'Whether I am enslaved or have to sacrifice, if only the embraces and kisses do not disappear, I will be happy'.[23]

Another piece, from after the dissolution of their relationship, has its title addressed specifically 'To Raichō', with Kōkichi writing that 'My woman's run away'.[24] Most badly received, however, was 'the five-coloured sake incident'. This refers to a story that Kōkichi wrote for *Seitō* in which a half-fictional Raichō drinks a 'colourful, layered cocktail' with a young man, presumed to be an avatar for Kōkichi herself. Public drinking in Japan was a heavily symbolic masculine pastime during this period, and Kōkichi's story brought shame not only to *Seitō*, but to Raichō, too.[25]

Kōkichi's time with *Seitō* was a whirlwind in every part of her life. After the geisha and the sake scandals, she was called to be expelled from the magazine (though she continued to create feminist translations and woodcut cover designs for a short period after ceasing her written contributions).[26] Shortly afterwards, she was diagnosed with tuberculosis and, in a devastating double blow, finally lost her relationship with Raichō—who began an affair with the man she would later marry, a friend of Kōkichi's, while they were both visiting the convalescing Kōkichi.[27]

Despite her devastation, Kōkichi's life did not end here. Nor did her place in lesbian fashion history, or her contribution to lesbian culture in Japan.

* * *

Otake Kōkichi, unlike Raichō, has been referred to time and time again as lesbian. Shortly after the end of their relationship, in an introduction to Raichō's translation of sexologist Havelock Ellis' *Sexual Inversion in Women*, Raichō even refers to Kōkichi as a 'con-

genital sexual invert' (see Chapter 6). This characterisation pathol-
ogised Kōkichi's sexuality while distancing Raichō from it.[28]
Though Kōkichi married a man and had two daughters, they later
divorced on the grounds that Kōkichi was a lesbian, with her hus-
band explicitly using the English loanword *rezubian* in his argu-
ment.[29] Their separation was also caused by ideological differences
that had grown more and more opposed over time, Kōkichi's views
being in line with Marxist feminism and her husband becoming a
Nationalist. Her politics was the product of seeds sown in her
youth, when she was a member of *Seitō* and in love with Raichō.
Kōkichi's first daughter, Akira, was named with the Japanese char-
acter for sun, thought to be a reference to the opening lines of the
first ever issue of *Seitō*, written by Raichō: 'In the beginning,
woman was the sun'.[30]

Kōkichi fit a lot of life into the years between leaving *Seitō* in
1912 and her death in 1966. In 1913, she published her essay 'A
Gathering of Geisha' in *Chūō Kōron* magazine, completing the work
that she'd set out to do when she organised the *Seitō* members'
excursion to Yoshiwara. She raised two opinionated and indepen-
dent daughters, often by herself, while writing feminist fairytales
for a magazine named *Funa*.[31] She began writing for another publica-
tion, *Women's Art*, and during the Second World War devoted her
energy to women's space and creativity once more: she started a
salon in her own home, where women could come together to work
and exist. Those in regular attendance made up a 'who's-who of
notable Queer women artists and writers', including other ex-
members of *Seitō*—even Raichō, despite the messy break-up from
many years before.[32]

Kōkichi always stayed true to herself—'I just can't be dishonest
about myself' is how she phrased the notion in a teenage letter.[33]
From her introduction to feminist writing when she first discovered
Seitō in her girlhood, she knew that she wanted to live uncon-
strained. She wrote to the publication, and wrote to them again and
again, until all of the women at *Seitō* knew her name. Or, they
would have known her name had it stayed the same, as she tested
out one and then another until she found the right fit in Kōkichi
(usually, but not always, a male name). She knew early on that she
wanted something different from life, which very much included a

love and deep admiration for women. In 1935, she wrote the following as a reflection on her first meeting with Raichō in 1911:

> I had wanted to meet her for so long that I dared not look at her face. She spoke in a shushed voice that seemed to enfold me. I summoned my courage and raised my head.

> She was sitting upright, her shoulders drawn back, her small hands, so like ivory, folded on her lap. She was breathtakingly beautiful, her features even and refined. [...] So this is the woman herself, so this is the woman herself. I tensed up, as though I were paying homage to a graven image.[34]

Kōkichi once described how she dressed in her youth: 'I wore the male student's hat, straightened my mantle's collar, put on the dark blue *tabi* [traditional Japanese socks] and a man's wooden clogs, and smoked while I walked with my sister'.[35] In this description, she was very clearly and purposefully wearing men's clothing: dark blue was often used for male garments, and the 'I' at the start of the sentence was '*boku*', a pronoun usually used by boys or young men. Smoking, too, was not typical behaviour for women. Kōkichi was also fond of wearing men's *yukata*, dressing in them throughout her life despite backlash from her husband.[36] Raichō, in her autobiography, conjures Kōkichi's fashioned self for the reader:

> My first impression of Kōkichi was of a boyish young girl with a nicely rounded face. She wore a serge hakama, a matching kimono, and a haori [jacket] of dark blue Kurume cotton, a man's outfit that became her tall but well-fleshed figure. [...] She looked dashing in her man's kimono and hakama, and sometimes she wore a man's kimono, with a narrow sash tied low on her waist, and a pair of leather-soled woven sandals. Striding into the office, her arms swinging, she would say whatever was on her mind, burst into song, and laugh out loud in her big voice.[37]

The garments worn by Raichō and especially Kōkichi are repeatedly described as men's clothing. But we have to remember that men were not wearing these clothes at this time—at least, they were encouraged not to. In early 1900s Japan it became popular for men to dress in Western-inspired fashions, while women were urged to

wear kimonos. The dress of Hiratsuka Raichō and Otake Kōkichi is a statement and reminder of the power that Japanese women did and did not have, and that they could or could not claim.

The case of Japan in the 1910s splits off from the central story of recorded lesbian and lesbian-adjacent fashion, because the masculinity that people like Raichō and Kōkichi were claiming was one that no longer belonged to men. Perhaps this made them more of a threat; they were creating something new with the clothes on their bodies, and men were not a part of it. This was a lesbian look—or, perhaps, the look of *dōseiai*—that marked a place and time that was simmering with unique, radical possibility. The activism of the *Seitō* society reached further than the pages of the publication. It walked the streets of Japan with every step of its members' clogged feet.

PART TWO

PARIS TO HARLEM

THE LESBIAN 1920s

The 1920s could be considered the apex of lesbian history, yet the period's sprawling cultures and influences cannot truly be limited to the length of a decade. The 'long 1920s', beginning in the years following World War One and ending in the 1930s, was a period characterised by a freedom of expression that now seems ahead of its time. For some, this lingered until the outbreak of World War Two in 1939. For others, like those in Germany, it ended sooner, with the Nazi Party seizing power in 1933. Lesbians could not, of course, live completely openly during this interwar period, but in some communities, in some cities, they came close. Clothing particularly lent itself to the creation of a lesbian culture that flourished across the world. Modernism was in full bloom, and with it came a general acceptance of women wearing garments considered masculine, such as tailored jackets and ties, complete with cropped haircuts. These styles were championed and fed by lesbians who loved them, printed in magazines both lesbian and not, including British *Vogue* and the German lesbian publications *Die Freundin* and *Frauenliebe*. They were captured in painted portraits by artists like the talented American lesbian, working in Paris, Romaine Brooks. They were toyed with and sung about by the queer blues singers of the Harlem Renaissance. Fashion, in the long, lesbian 1920s, became shorthand for more, signalling that a community existed— one that need only be reached out and claimed.

In Part 2, we travel across the world. Three of our stops are in Europe: Paris, London and Berlin. The last is in Harlem, New York

City. Two of these communities are populated with lesbians from wealth, while in the others we can remember working class lives through the venues lesbians visited and the histories that have been relayed and carefully preserved. We begin in Paris, the best-recorded historical setting for lesbian culture before the mid-century. As we've seen, it was the home (or at least the favourite holiday location) of many famous lesbians. Writers, artists, entrepreneurs, heiresses, models and poets all lent a hand to the creation of Paris Lesbos, many of them relocating to the city from America or Britain. It is no surprise that such an artistic community developed codes of dress and appearance, among them the monocle and bunches of violets.

These Parisian lesbians were rivalled in their modernity by a particularly influential couple in the UK. Chapter 6 tells the tale of British *Vogue*'s modernist rebirth between the years 1922 and 1926, spurred forward by the ambitions of its editor, Dorothy Todd, and fashion editor, Madge Garland. Though the couple only ran the magazine for four years, their influence on fashion lingered for much longer. Chapter 7 takes us back to mainland Europe, focusing on a specific sphere of lesbian fashion in interwar Berlin, that of people who called themselves and were known as transvestites. This is, I believe, an especially important part of any history of lesbian fashion. Our last stop is in Harlem, a neighbourhood of New York City and a centre of African American life and culture since the early twentieth century. Chapter 8 spotlights some of the lesbian stars of the Harlem Renaissance like Ma Rainey and Jackie 'Moms' Mabley, as well as the working-class lesbians who made up the bulk of the district's Black lesbian population, some of them unnamed figures that appear in the testimonies of lesbian activist-historian Mabel Hampton.

This part of the book seeks to tell the sartorial story of the long lesbian 1920s, but in truth this was a time of many stories at once. The differences in class and privilege across and within these chapters show us the varying stakes of lesbian dress. There are times when fashion is a plaything and times when it means the difference between safety and arrest. And the story may start in Paris, but it does not finish there.

5

PARIS LESBOS

THE SAPPHIC CAPITAL

From 1909 and for sixty years afterwards, within the walls of 20 rue Jacob on Friday afternoons, lesbians met and mingled, talking about art and literature and life. There were sometimes men in attendance, but they knew that the space was not theirs. It was a space dedicated to friendship, but love and desire also found a home in the portraits and photographs of beautiful women which lined the walls, and on the luxurious chairs and couches.[1] The wealthy and bohemian lesbians of Paris and the world flocked together at Natalie Barney's literary salon, where they could be the majority, even if just for a while. Diana Souhami describes the scene in *No Modernism Without Lesbians*:

> High collars and monocles, though not de rigueur, were clues. So was brilliantined short hair, a white carnation or sprig of violets pinned to a jacket lapel, a ring on a pinky finger. Beyond such badges of allegiance, an appraising glance of recognition was universally understood.[2]

The salon, in the 1920s, was a jewel in Paris' modernist crown—for literature, yes, but also for style. These fashions had rich, sprawling lesbian lives of their own, stringing together the people and places of interwar Paris Lesbos.

Let us begin with Natalie, so outside of the lesbian modernist fashion tradition that we must expand our definition of it. This may partly have been a result of her elite status. Just as earlier heiress Anne Lister profited from the freedoms of her financial indepen-

59

dence, Natalie's wealth gave her a certain level of immunity to societal homophobia, an immunity that she enjoyed to its fullest. She declared, at the beginning of the century, 'I am a lesbian. One need not hide it or boast of it, though being other than normal is a perilous advantage'.[3] While so many other lesbians in her circles and at her salons dressed in what might be defined as a masculine style— and this was generally fashionable for women at the time—Natalie constantly followed her heart, whether it ached for jewels, dresses or women. Her hair would hang loose in curls or waves, or be piled atop her head. She dressed in furs and expensive jewellery, sometimes in fancy dress, sometimes in nothing at all. Sometimes she wore the high collars and tailored suits that the women around her largely favoured,[4] and sometimes voluminous dresses with great big puff sleeves (Figure 11). Natalie's long-time housekeeper, Berthe Cleyrergue, was interviewed about Natalie and her salons in 1979, recalling how 'Each month we held a great reception of 100–150 persons. Otherwise we would have receptions ranging from fifty to seventy-five at the maximum'.[5] For her great receptions, recounted Berthe, Natalie had a preferred mode of dressing:

> There were very important couturiers, such as Madeleine Vionnet, who was a very good friend of Miss Barney and who made incredible dresses. Miss Barney always wore white for her receptions. At these great receptions she was always in white and always wore dresses by Madeleine Vionnet. But she was seated in a chair, right at the door of the dining room, over there, and when the people came she did not get up. They came over to greet her in her special place. She was surrounded.[6]

This conjures a theatrical picture, but Natalie was, in the words of Berthe, 'not at all frivolous'.[7] Vionnet's dresses were modern and classic all at once, pioneering the fitted, bias-cut style that became widespread in the 1930s while harking back to the simple tunics of Ancient Greece—no wonder Natalie liked them. Still, Natalie adorned in slinky white Vionnet creations is hardly representative of the larger culture of Parisian lesbian fashion that existed around her.

The public figures of Paris Lesbos made up a tight-knit community, each major player separated by a couple of degrees at most. The attendees of Natalie's salons made up a landscape of modern-

ism: from writer Gertrude Stein and her life partner Alice Toklas to booksellers Sylvia Beach and Adrienne Monnier; the socialite Dorothy Wilde and the English Lady Una Troubridge; Natalie's lovers Romaine Brooks and the writer Lily de Gramont, both under the lingering shadow of their departed predecessor Renée Vivien. Modernism was a movement based on changing attitudes to art, literature, theatre and fashion, full of gender non-conformity along-side non-conformity in everything else. Popular understandings of the movement far too often focus on the successes of its men, rather than its thriving networks of women (and people whose personal relationships to womanhood might have been strained, even if their personal relationships with women were not). The clothes that decorated this modernist lesbian culture are collected and cele-brated within the pages of this chapter.

The language of violets

In 1926 a shocking play took to the stages of Paris and New York. It was Edouard Bourdet's *The Captive*, about Irène, a young woman in a false engagement with a man but in love and in a real relation-ship with a woman. Throughout the play, Irène's love interest leaves her gifts of violets. Their relationship ends in the final act, also narrated with an exchange of violets. As a sign of support and recognition, women in the Parisian audiences began to wear the flowers pinned to their lapels.[8] At least, this is how the tale has been passed down.

The cover of Bourdet's script (Figure 12) features a lovestruck woman cradling a bunch of violets to her cheek, the picture com-pleted with a repeated background motif of the flowers.[9] They were such an important and memorable part of the lesbian relationship in the play that violet sales dipped throughout the United States in a mass homophobic response. *The Captive* only ran for a year in New York, and yet seven years after its close, in 1934, *Harper's Bazaar* reported that 'Way back in the violet county last year they were still cursing this play as the knell of the violet industry'.[10] Whether or not the legend of a lesbian violet craze inspired by the play is true, we do know that lesbians were in the play's audiences and were not shy about it. Mabel Hampton, a Black lesbian who lived in New

York all through the interwar Harlem Renaissance once recounted her experience of seeing *The Captive* to her friend Joan Nestle, co-founder of the Lesbian Herstory Archives:

> I talked to a couple of my friends in Jersey City about the play, I carried them back and paid their way to see it, and they fell in love with it. There was plenty of women in that audience and plenty of men too! They applauded and applauded.[11]

Back in Paris, straight audiences were generally less scandalised than some in New York, while lesbian audiences were just as receptive. In the French capital, of course, violets were part of the lesbian vernacular already; what had Bourdet been inspired by, after all? Paris Lesbos had already put the poetry and aesthetics of Sappho at the forefront of its ethos, and Sappho drew on the imagery of violets repeatedly, as we've seen with Fragment 94.[12] While Sappho references violets in other surviving fragments, it is Fragment 94 that is renowned for its homoeroticism. Its violet garlands or crowns prelude a lesbian longing, a desire that takes place on a soft bed. Natalie Barney's lover Renée Vivien had been nicknamed the 'Muse of Violets' before her death in 1909—Renée pinned violets to her chest during her saddest moments, but also championed them in happier times.[13] Novelist Colette once recalled how 'Whenever she gave me any of her books, she always hid them under a bouquet of violets or a basket of fruit'.[14] Though Renée didn't live to see Paris Lesbos in the twenties, she continued to influence sapphic literature and the lives of the women she had loved; an iconic photograph keeps her forever preserved in splendid masculine contrast to Natalie's full-length dress (Figure 13). Why should Renée's love of violets, fuelled as it was by Sappho, not also remain?

If you could manage a monocle

Violets were not the only lesbian accessory to reach beyond France's borders in the twenties. In Katrina Rolley's fantastic interviews with British lesbians about their dress between the wars, one of her respondents, Ceri, mused that 'if you could manage a monocle, that was very popular'.[15] Ceri, being from an upper-class background, would have been familiar with the international, bohemian culture

of lesbian fashion. Lady Una Troubridge, English aristocrat, 'invert', and lover of the writer Radclyffe Hall, is one possible link between the British and French lesbian cultures of monocle-wearing.

In 1924, Una posed for a portrait by Romaine Brooks (Figure 14). Romaine's paintings were, in the reflective words of novelist Truman Capote, 'the all-time ultimate gallery of famous dykes', and Una's portrait is iconic among them.[16] She wears a monocle tucked securely underneath her right eyebrow, accompanied by a sharp, short haircut, a high, white collar, a tailored jacket and two adoring dachshunds. But, as cultural historian Laura Doan has pointed out, 'we should be cautious in pinning down the cultural significance of monocles, short hair, and cigarettes to any one effect' and 'when Troubridge arrived for the sitting in her "get-up," [...] she was displaying the very latest [mainstream] fashion trend'.[17] While modernism may not have existed as it did without lesbians, it was not only lesbians involved in the movement; monocles may have been a lesbian fashion symbol, but they were also just a fashion symbol. This was the case in the early 1920s when Romaine painted Una—but even a few short years later, as trends changed but lesbians clung onto the sartorial freedom that modernism had promoted, her look was less in demand. In fact, after Natalie's housekeeper Berthe Cleyrergue came to the job in 1927, she recalled that Una 'dressed like a man with her monocle and her tie and all that. Everyone stared at her'.[18]

Una continued to wear a monocle while it became a symbol of upper-class eccentricity rather than fashionable, feminine modernity. This was a natural transition—the monocle's invention is credited to a German baron, Philipp von Stosch, who supposedly required a singular eye-glass to study antiques in the early eighteenth century. Though von Stosch died in 1757, by the beginning of the nineteenth century the monocle had travelled across Europe and reached London, becoming popular among aristocratic men in the early 1800s. By the end of the century, however, in 1898, *The Penny Illustrated Paper and Illustrated Times* declared that 'the single eye-glass is the latest fashion among pretty girls in London'.[19] It took a couple more decades for the monocle to reach its full potential, but it slowly became a sign of rebellion for rich young women of the early twentieth century. Laura Doan suggests that the ways that it

could be read as an accessory were numerous, denoting 'class, Englishness, daring, decay, rebellion, affectation, eccentricity—and possibly, but not necessarily, sexual identity'.[20]

The monocle, then, was more likely to be a symbol of class than of lesbianism, but most of the key figures in Paris Lesbos came from upper-class backgrounds, or at the very least were sponsored and supported by rich friends and patrons. Working-class lesbians could rarely be so open as the likes of Natalie Barney, and if they were, their lives and legacies were less likely to be recorded. The working-class lesbian experiences of the interwar period that do remain accessible are largely due to lesbian researchers and activists who have worked hard to make them so, such as Katrina Rolley's interviews, or the work of all those involved with the Lesbian Herstory Archives in New York. When one of Rolley's working-class interviewees, Eleanor, was asked if lesbians ever wore monocles she replied, 'oh no—no, I don't think so. They were very expensive, I expect'.[21]

The final thing that cemented the monocle as interwar Paris's favourite lesbian adornment was Le Monocle nightclub, captured in all its glory on the front cover of this book. Le Monocle opened sometime in the twenties on the Left Bank, at 60, Boulevard Edgar Quinet. The lesbian activist Barbara Bell visited the club in the early 1930s, and remembered in 1988 how 'it was exactly what I'd dreamt of and we were welcomed and were a great success [...] We went every night to meet and gossip and learn another trick or two'.[22] Le Monocle's owner was the fabulously butch Lulu de Montparnasse, who did the future lesbian world an incredible favour by inviting the photographer Brassaï to the club one night in 1932. His photographs, more than any testimony or written record, are what have allowed Le Monocle to become a cornerstone of Parisian lesbian history and, perhaps, helped monocles to garner their reputation. Women dance with each other and hold one another, kiss each other and exist in joyful, unbridled community. Recurring figures appear within the photographs. A Black woman in a long, sheer dress faces another woman, presumably her lover, dressed in some kind of uniform. A woman in sailor attire kisses another in a tuxedo with slicked-back short hair. At least five monocles are visible in the crowd, accessorising amused lesbian faces and marking

what may have been affiliation with the club, or the lesbian culture that had accepted monocles as a tiny part of itself: a shining, glittering truth.

Rather masculine

Beyond accessories, whole outfits were also worn as an expression of lesbian identity or community. As with monocles, it was not only lesbians who took up these styles, but the high collar in particular—typically a stiff wing-collar shirt, such as that worn by Una Troubridge in her portrait—had garnered a lesbian reputation before the twenties even hit. Recall the dictionary of words used by Japanese schoolgirls in the 1910s to refer to love between each other; one of these was *ohaikara*, derived from the English term 'high collar'.[23] A high collar had to be appropriately dressed, and a tailored suit was usually its mate, though always with a skirt rather than trousers. In Paris, it was illegal for a woman to wear trousers unless given permission by the police. This law was not formally rescinded until 2013.[24]

Una Troubridge was not the only icon of high collars and tailored suits. Romaine Brooks' self-portrait from 1923 has a similar visual narrative. She wears a tall, dark hat that shades her eyes, atop a long black jacket and a high white collar. She was 'rather masculine' and the portraits that she painted often matched, including that of the gender non-conforming artist Gluck and of Lily de Gramont.[25] There was also Gertrude Stein, who dressed in collars that were not so much high as they were practical: 'she liked loose comfortable clothes with deep pockets and she wore sandals over her socks in winter [...]. Comfort dictated what she wore, but she cared about the quality of the silk of her shirts, the provenance of the brooch at her throat, the way her neck scarf was tied'.[26] Gertrude and her partner Alice B. Toklas were a permanent twosome: 'Little Alice B. is the wife for me' wrote Gertrude in 1921.[27] Berthe Cleyrergue remembered the couple from Natalie Barney's salons:

> Gertrude Stein and Miss Toklas were not only invited for the receptions, but for the lunches. We always invited Gertrude Stein for the lunches because she was an astonishing personage—physically and in every way. At first I was frightened of her. She frightened me.

She dressed very strangely with long skirts that trailed along the
ground and her short cropped hair. I took her for a man.[28]

Sylvia Beach, founder of the iconic Shakespeare and Company book-
shop and the publisher of James Joyce's *Ulysses*, can also be included
in this list of mannish dressers. She was less masculine in style, per-
haps, than either Gertrude or Romaine, but very much in the same
tradition. Typically, Sylvia dressed in tailored jackets, skirts, smart
shirts, trilby hats and sensible shoes. Her clothes were practical for
her work in the busy shop, and complemented those of her lifelong
love Adrienne Monnier. Clothing defined the opening scene of the
couple's relationship: when Sylvia first visited Adrienne's own
bookshop, a gust of wind swept Sylvia's hat off her head and into the
street. Adrienne jumped into action and rescued it.[29]

Gertrude, Alice, Romaine and Sylvia were all American-born, but
they lived and built their communities in Paris Lesbos—full to burst-
ing with 'mannish' style, though to many it was Americanism rather
than lesbianism, or even modernism, that encouraged it. 'They are
not men, they are not women, they are Americans', declared the
artist Pablo Picasso, and it was perhaps this mindset that set the cogs
of modernist fashion into motion.[30] After the First World War, the
world was ready for a change in women's appearances that it had
been less sure about before. Internationalism allowed the blame for
mannish, modern fashions to shift onto someone else's shoulders,
meaning that no one could really be blamed at all.

Not for sailing

One final fashion trend that radiated from Paris Lesbos, spreading
across the seas to port towns and parties, was a fondness for sailor
uniforms: the drunk and giggling alter-ego of more typical modern-
ist fashions. For a start, they were rarely worn outside of a house
party or club, though in 1931 the photographer Barbara Ker-Seymer
documented her queer circle dressed in sailor style while on holiday
in Toulon.[31] Barbara was one of the Bright Young Things, the
always-rich and often-queer community of (usually young) people
who gathered in London in the twenties. The Bright Young Things,
with their costumed holidays and infamous Sailor Parties forever
painted sailor uniforms with a queer brush, if they were not already

so coloured by the sexual exploits of actual sailors.[32] However, in Paris the sailor uniform took on a particularly lesbian tint.

In 1926, at the Moulin de la Galette in Paris, a sailor-themed masquerade ball took place. A lively photograph from the night (Figure 15) captures two-dozen revellers, all dressed in varying intensities of sailor attire; Breton striped shirts and berets are common, sometimes paired with a sailor collar and a wide-leg trouser, less often with a skirt or dress. Towards the centre is a smiling woman with a sharp, bobbed haircut. This was Suzy Solidor, a French lesbian *chanteuse* (a singer and performer) and the 'most painted woman in the world'. 225 recorded portraits of Suzy were created by notable artists, the best known being a nude by Tamara de Lempicka.[33] The photograph from the 1926 masquerade is a teaser of what was to come later, for in the 1930s Suzy opened her own nightclub called La Vie Parisienne, where she regularly performed, often in sailor costumes. As historian of visual culture Andrew Stephenson explains, 'Solidor's cross dressing stage persona keenly exploited the sailor's lusty reputation for different erotic ends and gained her the reputation of being "The Madonna of the sailors"'.[34]

Suzy may not have been part of the inner circle of Paris Lesbos, but she can't be entirely removed from it. She sang sea shanties, but also recorded an album titled *Paris-Lesbien*.[35] She gave lesbians in less literary circles access to an identifiable and—at least for nightlife— achievable look. 'Co-opting sailor wear in Parisian lesbian woman-only bars or on the stage at lesbian cabarets', writes Stephenson, 'clearly registered it for those aficionados in the know as a conspicuous form of lesbian self-identification'.[36]

The lesbian 1920s reached across the globe, just as real sailors travelled from port to port. The clubs and salons of Paris were just one of the homes of lesbian fashion favourites. Brassaï's 1932 photographs from Le Monocle capture both sailor uniforms and monocles, alongside tuxedos and fashionable bias-cut dresses on the bodies of the club's patrons. Across continents, the same styles reappear. Take Mabel Hampton, who was photographed in a sailor outfit in New York City in 1919. A working-class lesbian, Mabel was part of New York's queer port culture. The waterfronts of New York were brimming with queer communities throughout the inter-

war period, whether made up of performers like Mabel, sex work-
ers or sailors.[37]

Paris Lesbos and its members are often treated as the be-all and
end-all of lesbian culture in the twenties. The influence of other
cities, writers, artists and performers is often undervalued, along-
side the clothes that these communities wore and favoured—even
while they entwined with the fashions of Paris Lesbos, and with
those that developed throughout the rest of the twentieth century.

THE QUEER MODERNISM OF BRITISH *VOGUE*

Across the English Channel another lesbian culture was stirring. The British edition of *Vogue* magazine was its guidebook—at least, for lesbians of the middle- and upper-classes. *Vogue* etched its title onto the twentieth century's fashion landscape as a taste leader: a fount of the modern and the stylish. Though the magazine's life began in North America in 1892, its modernist reputation is thanks to the lesbians whose community thrived out of the London office in the 1920s. Among them were the editors Dorothy Todd and Madge Garland, but the legacy that they left on fashion was not written by them alone.

American *Vogue* had been sold in the UK for years before a separate British edition launched in 1916. This was out of necessity, since importing magazines became impossible during the First World War and the British public were never too keen on blindly following American fashion advice. The first recognised editor of British *Vogue* was Elspeth Champcommunal, who was rumoured to have been bisexual and in a long-term partnership with American modernist publisher Jane Heap.[1] It was not Elspeth, however, who set the modernist cogs in motion at the magazine, but the next editor: Dorothy Todd. Dorothy officially took over in 1922 and was at the helm until 1926; her partner, Madge Garland, was at her side as fashion editor for most of this time. Together, as described by the pair's contemporary, Rebecca West, they 'changed "Vogue" from just another fashion paper to being the best of fashion papers and a guide to the modern movements in the arts'.[2]

Throughout the 1920s, British people were experiencing enormous shifts. The cultural, political and economic landscapes were

all vastly different from even a decade previously. British industry had been all but decimated by the First World War. Thousands of soldiers had no jobs to return to, especially because the jobs that remained had been taken by a new workforce of women—who in 1918, after years of campaigning (see Chapter 15), had gained the right to vote. This right was only granted with certain conditions, including being over thirty, which wouldn't change until 1928.[3] The political parties being voted for had shifted, too; the Labour Party had taken over from the Liberals as opposition to the Conservatives, and in 1924 formed their first (minority) government. They facilitated programs like the mass building of public housing, though the country was far from wealthy in the aftermath of the 'Great War'. This first Labour government didn't last long, thanks to concern that it would steer the country in the direction of the USSR— which, in the early twenties, was becoming increasingly visible on the world stage.

Yet, British society was also experiencing a collective kind of relief as it entered the new decade. There were things to do and think about that weren't just war, or even mass unemployment: seaside holidays were rapidly gaining popularity, as was the radio, which became a widespread form of entertainment after the launch of the BBC in 1922. Motoring became a hobby, and the number of 'motorised vehicles' (mostly cars) in the country rose from 300,000 to well over a million by the end of the decade.[4] Artists, writers, designers, musicians, theatre-makers, and modernists of all kinds had also found a new lease of life, spearheading the concept of the 'roaring twenties'. They could be spotted all over London, at bohemian house parties or glamorous clubs, or even on the pages of glossy magazines.

When placed within the context of British *Vogue*, modernism became almost a code for queerness. As Christopher Reed writes: 'Vogue's frequent allusions to styles and mores associated with emerging sexual subcultures not only kept insiders abreast of developments in these communities, but encouraged a wider audience of fashionable women to identify with a "modern" openness to new ideas'.[5] We know that modernism was not solely a lesbian movement, but that lesbians flocked to it and helped create it. If *Vogue* was a fashion authority, modernism its champion and lesbians its

editors, then surely we can also claim that there was no modernist fashion without lesbians. Dorothy and Madge were not masterminds of the movement, but they were, perhaps, the players that pushed modernist ideals, styles and culture across the board: with British *Vogue*, they gave modernist lesbians in high collars and Eton Crops a curtain of fashion to live and love behind.

Fashions for inverts

The lesbian significance of Dorothy and Madge's *Vogue* editorship was part of a larger landscape of new ideas about lesbianism in 1920s Britain. During the interwar period, the label 'sexual inversion' gained popularity as a way of classifying and describing homosexuality. For female inverts there were two separate labels, the 'congenital' invert and the 'pseudo' invert, sometimes known as the active and the passive partner. This theory was, in the words of the sexologist Havelock Ellis, based on 'the need for a certain sexual opposition'.[6] The active 'congenital' invert was understood as possessing innately masculine qualities, while the passive 'pseudo' invert was far more feminine. To a modern audience, these terms and understandings might seem limiting or even offensive. There were, indeed, lesbians at the time who were adamantly against them—one of Katrina Rolley's interviewees from 1995, Eleanor, said, 'I don't like invert. Lesbian is the right word'.[7] For others, however, 'inversion' gave a label to a feeling that had long existed inside of them, unarticulated. It was not only a term, like 'lesbian' or 'sapphist', but a description of a relationship dynamic that validated same-sex attraction in a wide sea of heteronormativity. For these inverts, it was a liberating concept. Still, the strict passive/active, masculine/feminine divide of theoretical inversion was not always the reality.

The most famous invert couple of the interwar period involved two prominent British society figures, Radclyffe Hall, who was in early middle age in the 1920s, and Lady Una Troubridge, seven years her junior. Radclyffe's best-known work, *The Well of Loneliness*, was considered the first openly lesbian novel; it was promptly banned in Britain after its publication in 1928. Una, famously painted by Romaine Brooks, is best known today for her relationship with Radclyffe, but was also a sculptor and translator. In

Rolley's article 'Cutting a Dash', she unpacks the complexities of invert self-styling in the context of their relationship:

> [A]t the age of twenty-one, Radclyffe Hall inherited a substantial private income. This income allowed her to live independently from her family and to discard the 'feminine' clothes chosen by her mother in favour of tailor-made styles. Radclyffe Hall's wealth and independence later allowed her and Una Troubridge to disregard public opinion and appear together in clothes which announced, to an informed viewer, their respective roles within a lesbian relationship.[8]

To those in the know, Radclyffe and Una's clothing cemented their status as an invert couple, the proper 'pseudo' and 'congenital' pair. In many images of the couple—Gladys Hynes' 1937 painting *Private View* is one example, as is a famous photographic portrait from 1927 (Figure 16)—Radclyffe wears a smart, tailored suit jacket with closely-cropped hair and perhaps a hat, while Una wears a dress and high heels with her hair in a longer, bobbed style. In these portraits, Radclyffe always wears a skirt with her suit, the one line remaining between appropriate and inappropriate masculinity for a modern woman of the interwar period. There was a limit to how open the couple could be; to many, as long as they stayed within the fashions of the twenties, Radclyffe and Una were merely smart and stylish. A Mrs James recollects how, in the 1930s, 'they cut a tremendous dash as a pair'.[9] Their style—and their wealth—overshadowed their sexuality. A staff member of Radclyffe's literary agency believed that the couple were 'platonic friends who had a mission to help "those poor people"'.[10] Inversion was at once both a 1920s norm and entirely unfathomable.

Still, there were times when the couple crossed the line. In one photograph, taken at Crufts dog show in 1923, both Radclyffe and Una wear trousers, hats and long coats, cradling dachshunds in their arms. Just as Anne Lister and Queen Christina were able to respectably wear men's hats while riding, the one place where femininity could be left behind was a sporting environment, particularly one with appropriately upper-class credentials like Crufts. A year later, Una posed for her Romaine Brooks portrait, which shows her dressed in the most fashionable modern, mascu-

line attire of the time. After Radclyffe's death in 1943, Una began to dress in a more masculine manner, and even in Radclyffe's own clothes: 'she had her hair cut short, stopped wearing make-up, and adopted male dress to the point where she was, on occasions, mistaken for a man'.[11] Clearly, the codes of inversion were more of a language of representation even to those who firmly believed in them than a strict rulebook for lesbian life. Self-identifying inverts existed side by side with lesbians who didn't believe in the codes of inversion, like Madge and Dorothy, and invert style (and literature) overlapped with and sometimes seeped into the pages of British *Vogue*.

Genius and decoration

Dorothy 'Dody' Todd was born in 1883 in London. Although born into money, after her father's death when Dorothy was nine, her mother Ruthella steadily drained the family purse—usually at European casinos. While Dorothy grew into a more self-reliant lifestyle, she was far from frugal, and had learnt some of the thrills of financial risk-taking from her mother. Dorothy was incredibly well educated for a woman raised in the late nineteenth century, and as a child had insisted on being taught Latin and Greek. In her early adult life, she appears to have lived as an artist in New York, though records of her are scarce. By 1922, she was working at the *Vogue* offices in that city, primed to take over the British editorship across the pond.[12]

Dorothy had a string of relationships with glamorous young women before meeting Madge, but it was Madge who made the biggest impact. Madge was born in Melbourne in 1896, making her thirteen years younger than Dorothy. Her family moved to London when she was two, and she had a traditional (and privileged) upbringing. She went to finishing school in Paris, but always longed for a more academic foundation; part of what drew her to Dorothy was her intelligence, and the knowledge that Dorothy had garnered through her expansive education.[13] On reaching adulthood, Madge rebelled from her parents' wishes, intent on making a name and a living for herself. She wouldn't take no for an answer—for days she petitioned the publishers of British *Vogue* at their doorstep, finally

manoeuvring her way into an assistant role at the magazine's 'dingy little office' in 1920.[14]

When Dorothy took over as editor, Madge was swiftly promoted. It's unclear whether their relationship began before or after this promotion, but the two developments certainly went hand-in-hand. Madge's position as British *Vogue*'s fashion editor 'was favouritism', as Nina-Sophia Miralles writes in her history of the magazine, 'but Dody had never been too hung up on morality'.[15]

Still, just because Madge's promotion came from her own girlfriend does not mean that it was undeserved: 'The resulting Brogue [British *Vogue*] that Madge and Dody triumphantly worked on together for four short but glorious years is an avant-garde masterpiece'.[16] Madge was forever grateful for the opportunities that Dorothy helped her grasp. Many years later, near the end of her life, she reflected on their relationship, saying: 'I have no regrets at all. [Dorothy] fostered me and helped me. She opened many doors. [...] I owed her more than I could ever repay'.[17]

In the 1920s, Madge and Dorothy hosted extravagant parties at their flat in Chelsea (then a bohemian neighbourhood), an extension of the salon-like atmosphere that they curated in the pages of *Vogue* itself. They were taste-makers of the highest level. In 1972 Rebecca West remembered Dorothy as 'a fat little woman, full of energy, full of genius'.[18] Mid-century butch and femme lesbian culture is something that I'll cover later in this book, but Dorothy was as much a precursor to a butch identity as any. Virginia Woolf, who had a tumultuous working relationship with both Dorothy and Madge for years, was wary of Dorothy's overt masculinity.[19]

The essayist Peter Quennell lived downstairs from the Chelsea flat in his childhood. In 1976 he recalled memories of Dorothy, Madge, and ballet choreographer Frederick Ashton, who was their friend and housemate:

> My fellow lodgers were an interesting collection—a short, square, crop-headed, double-breasted, bow-tied lady, the editress of a famous fashion magazine, and her more decoratively apparelled friend and colleague... and Freddie Ashton, now Sir Frederick, the doyen of British Ballet, then a gay and energetic young dancer.[20]

Dorothy is often described as stylish, particularly when the person describing her views her favourably. Lisa Cohen, Madge Garland's

biographer, writes: 'she wore a uniform of a suit—the jacket with a velvet collar, the skirt a fashionable length—with a fresh flower in her buttonhole every day'.[21] I have been unable to find any surviving photographs that capture these aesthetics, with the only images available showing a lighter Dorothy, dressed in white blouses and soft vests. Even in these, though, her hair is short and slicked-back.

If Dorothy was masculine, Madge was feminine. Miralles describes her as having 'the languorous look of a blonde ghost'.[22] She was committed to her career and constantly on-trend, wearing Chanel sheath dresses in the twenties and 'enormous black satin skirt[s]' in the fifties.[23] Even her floral surname was a choice, taken from her husband only after Gertrude Stein announced that Madge's maiden name of McHarg was dreadful.[24] Madge had not wanted to marry at all, and had only done so when she became unable to financially sustain herself early on in her *Vogue* career, demanding marriage from family friend Ewart Garland yet refusing to even wear a wedding band. She crafted her place in the world of fashion as much as the pages that she edited. As Madge's biographer Cohen puts it, 'Her clothes were also a way to be adorned in a whole series of relationships: the exchange between high fashion and interior decoration in the 1920s, the artistic and commercial traffic between London and Paris, the sexual fluidity of the time'.[25]

Dorothy and Madge, captured together in just one surviving photograph (Figure 17), worked to create a *Vogue* that was both glitteringly queer and appealingly mainstream. The magazine existed almost on two levels: one that was labelled 'modern', and an under-layer, made up of everything that modernism was born out of. Fashion became one with art and literature, and garments became more overt tools of self-expression and idea-expression than ever before. In a 1925 editor's letter, Dorothy wrote that '*Vogue* has no intention of confining its pages to hats and frocks. In literature, the drama, art and architecture, the same spirit of change is seen at work'.[26] Christopher Reed finds that, by 'Casting off sexual mores like out-of-date corsets, *Vogue*'s extensive coverage of literature and the arts became a guide to an emerging canon of queer modernism'.[27]

Of course, it was not just the culture that was queer, but the people making it. Gay literary critic Raymond Mortimer wrote a regular column for British *Vogue*, always signed with his name,

unlike many of the fashion columnists. The famous queer photographer Cecil Beaton contributed on numerous occasions, at the request of Madge, who remained his friend and posed for his camera well after the end of her editorship.[28] Virginia Woolf wrote for the magazine, as did her sometime-lover Vita Sackville-West. Painter Marie Laurencin's artwork was published in the magazine, which praised her as a 'sister of Sappho'.[29] Lesser-known artist Eugene McCown was featured for his 'interesting', intimate portraits of undressed men.[30] By promoting queer modernism in the pages of British *Vogue*, this lesbian editor power-couple became one of the most important style authorities of early 1920s Britain.

The fashions advertised in the magazine have to take their fair share of credit for the queer picture that it painted. Yet the artistic and literary aspects have received a fraction more attention than the clothing—unsurprisingly, because the fashions featured in *Vogue* belonged to women. In Madge's own words, written in the magazine *Britannia and Eve* in 1930, 'the more mundane occupations of women are universally condemned as frivolous'.[31] The sapphic modernists of the twenties may have nestled in the bylines of each issue, but perhaps only the fashion pages, led by Madge, can be considered the domain of lesbians. For example, one 1923 feature titled 'The Small Neat Coiffure Is the Favourite of the Mode' shows four illustrations of women with short hair, surrounding a photograph of 'Dora Stroeva, the famous French cabaret singer, whose severe coiffure is particularly becoming'.[32] A range of short haircuts were fashionable for women in the 1920s, including the shingle, a cropped style with a tapered back as typically worn by men; the bob, which rose to popularity for the first time in interwar Europe and America; and the Eton Crop, the shortest style and Dorothy Todd's favourite, closely-cropped and usually styled with men's products.[33] These hairstyles were following a long legacy of lesbian short hair that had been living on the sidelines and under the radar. In the 1920s, they went mainstream. The choice to use Dora Stroeva as their public face brought them back into a lesbian canon—Dora's stardom stemmed from her performances at the lesbian-themed evenings of Parisian nightclub Le Boeuf sur le Toit.[34]

The aftermath

Fashions come and go, and the veil of modernism could only last so long. The Bright Young Things of 1920s London, whose parties were glistening queer utopias for the rich and bohemian, began to age and tire. The scandal and banning of *The Well of Loneliness*, Radclyffe Hall's ode to sexual inversion in women, brought attention to the sartorial codes that inverts favoured. British *Vogue* continued—but Dorothy Todd and Madge Garland were no longer at the helm as they had been, together, unfazed. For a while, the style status quo had shifted... but soon it had gone too far.

In 1926, Dorothy Todd was fired from British *Vogue*. She had, according to American editor Edna Woolman Chase, made the magazine into something that it was not, and to its publisher Condé Nast, *Vogue*'s image was everything.[35] The magazine was making losses, attributed unquestioningly to Dorothy's editorship rather than the precarious financial situation in Britain following the First World War. Dorothy had done her best to combat these losses, to make fashion accessible and appealing to British women by cutting the magazine's price and writing features on how to save money. Unfortunately, it was not truly *Vogue*'s profits that were the problem but Dorothy, and everyone associated with her. After she was fired, Madge allegedly walked out in protest—though other sources say that she, too, was fired.[36] Dorothy tried to sue Condé Nast for breach of contract, but was told that her 'private sins' would be exposed if she did so. These 'sins' might refer to her lesbianism. They might also, however, mean the existence of Dorothy's illegitimate daughter Helen, raised as her niece, the details of whose paternity are unknown. Perhaps it was both—but Dorothy's lesbianism, if not Madge's, was far from a secret in the late 1920s; a 'joke' twisted the words 'pederast' and 'sodomy', playing on Dorothy's surname: 'What is a Sapphist? A Doderast who practices Todomy'.[37] Madge herself thought that lesbianism was the issue, writing in 1982 that 'in the days when homosexuality was a criminal offence [Condé Nast] was not above the direct threat of disclosure to avoid paying up for a broken contract'.[38]

Dorothy tried to work her way back into the fashion world, but never held any kind of editorial position again. Madge, on the other

hand, wrote for other publications until being asked to return to the position of fashion editor at British *Vogue* in 1934, where she stayed until the beginning of the war in 1939. Their relationship eventually crumbled—their reputations were in tatters, Dorothy's drinking and spending stretched Madge's limits, and the contents of their Chelsea flat were seized by bailiffs. Madge cut costs by moving to Paris for a while, which was cheaper than London, before returning to the British capital in the thirties, when she 'lived the fullest life'.[39] She loved women continuously, with lovers (or sometimes very close friends) including Frances Blackett Gill, one of Britain's first female solicitors; photojournalist and model Lee Miller; and novelist Ivy Compton-Burnett. Dorothy also never lost her charm, even if her other merits had long gone—at the end of her life in the 1960s, she wooed a young Italian woman in Cambridge, who left her husband to be with her.[40] By that time, Dorothy had not published anything for decades. Her 1929 book *The New Interior Decoration* had been dedicated to Madge Garland.[41]

Dorothy Todd's fashion history legacy is indisputable, despite only being in action for four years. Nina-Sophia Miralles writes that 'In a sense, Dody belongs among the early twentieth-century patrons such as Gertrude Stein' and that 'her contribution to the British arts scene was invaluable'.[42] Yet until recently she has been largely unacknowledged, her homophobic dismissal from *Vogue* tarnishing her name for almost a century.

Madge Garland, by contrast, continued to leave her mark on fashion in Britain for the rest of her life. Before her return to British *Vogue* she had edited for two other mainstream British publications, *Britannia and Eve* and *The Bystander*, and she had started appearing as a fashion expert on television. During and shortly after the Second World War she worked with the Board of Trade and the Council of Design to help make good clothes accessible in times of scarcity. In 1948 she joined the Royal College of Art (RCA) and created its School of Fashion, which *Harper's Bazaar* called 'first thing of its kind' in England and 'the first official recognition of fashion as a serious industry'.[43] Many years later, when she retired from the RCA, she wrote books about fashion history. Despite all this, during her lifetime Madge's place in the fashion world remained publicly unconnected to the queer cultures that she had promoted and participated in under Dorothy's editorship at *Vogue*.

Madge's biographer, Lisa Cohen, was one of the first writers to bring Madge and Dorothy's achievements back into the public eye, as a part of lesbian fashion history in all its variety and complexity:

> No single narrative defines lesbians' relation to fashion. If Todd's trajectory seems [...] to support the common assumption that lesbians have been excluded from [...] mainstream fashion history, Garland's career and extraordinarily chic life suggests another model altogether—although one that still cannot be understood apart from the pressures and pleasures of all sorts of closets.[44]

To be in *Vogue* is to be fashionable, and a century ago, lesbians led the way. Throughout so much of our history we've been hidden in the shadows or on the outskirts, even in the times when we've been bold. British *Vogue* of the early 1920s took a lesbian culture in fashion, art, literature and theatre and gave it credence. On its pages, fashions favoured by lesbians hadn't made it to the mainstream, rather lesbians *were* the mainstream—even if not everybody knew it. Fashion history has never been a story told only by straight bodies, whether dressed in towering high heels or sleek tailored suits. Sometimes, however, we must remind the world that we were really there, and at the very top. Lesbian history is built upon rediscovery and the insistence that there is always more to find.

7

THE COMPLETE APPEARANCE OF A LADY

TRANS LESBIANS IN WEIMAR BERLIN

Germany's Weimar Republic lasted from 1918 to 1933, and its 'Golden Twenties' between 1924 and 1929 were the height of this economic, social and artistic boom. New movements in the arts and architecture were being spearheaded, often congregated in the Bauhaus, a modernist arts school whose influence continues today. Intellectuals of all kinds were given the space to thrive, including Albert Einstein, who won the Nobel Prize for Physics in 1921. Expressionist cinema broke new ground with iconic films such as *Nosferatu* (1922) and *Metropolis* (1927), and performers like Marlene Dietrich winked at anyone who found their performances shocking. This atmosphere created small pockets where sexual and gender non-conformity could flourish, and the hub of this new culture was Berlin. The German population, emerging from years of inflation and economic decline, relocated en masse from the country to the cities in the early 1920s. Berlin, as the capital, offered freedoms and communities that could not be found in more rural areas.[1] It was particularly enticing for lesbians and anyone else whose sexual or gender identity didn't fit within the constraints of normality, such as those who would come to call themselves transvestites.

Throughout the 1920s, Germany's homosexual and transvestite populations created a culture of organisations, publications, clubs and bars that gave all kinds of queer people a voice and a home like never before. Berlin had already boasted a large male homosexual subculture before the First World War, but it now expanded to a broader spectrum of people. In 1919, the German physician and

81

sexologist Magnus Hirschfeld founded the Institute for Sexual Science in Berlin. The institute would be ransacked in 1933 by the Nazi Party, the groundbreaking research stored within its walls burned in the street. Before this tragic destruction, however, it played a crucial role in Berlin's queer culture, with Hirschfeld's work popularising terms such as 'third sex', 'transvestite' and 'transexual'. Hirschfeld even successfully argued for certain individuals to be issued 'transvestite passes' by the police—meaning that the holders could not be arrested or harassed by police on the streets.[2] The institute was far from alone in its community-building, with the German Friendship League beginning in 1919 to promote civil rights for sexual minorities. Both the league and its offshoot organisation, the League for Human Rights, boasted memberships in the thousands and published seminal magazines for audiences of gay men, lesbians and transvestites.[3]

Meanwhile, lesbians, buoyed by the global 'New Woman' trend of the early twentieth century, created a culture of their own. The German new woman was christened the *Garçonne*, a version of the modern, masculine woman that was also popular in France and Britain. German women embraced the short *Bubikopf* hairstyle, akin to the shingle or Eton Crop, and tuxedo jackets paired with tailored skirts.[4] The German look was also informed by its own lesbian landscape. *Garçonne*, often known as *Frauenliebe*, was one of the most popular lesbian magazines in 1930–32.[5] Another was *Die Freundin*, published by the League for Human Rights in 1924–33. Clubs, too, were vital, allowing a physical lesbian subculture to flourish. Some of the most popular included Damenklub Violetta, Monokel, and Club Monbijou West, but Ruth Roellig's 1928 book *Berlins Lesbische Frauen* ('Berlin's Lesbian Women') captured a moment when the city housed fifty lesbian clubs.[6] The clientele of Berlin's bars was often overlapping, with lesbians frequently attending some of the most popular gay clubs and bars, like Eldorado and the Toppkeller.[7]

One kind of solidarity is particularly notable in the lives, loves and styles of Weimar Berlin's lesbian subculture: between lesbians and transvestites. For most people defined as 'transvestites' in interwar Berlin, we cannot know what their relationship to their gender truly was. It might have been that they cross-dressed as a form of gender transition, but it is equally possible to have been only a pre-

ferred style of clothing. For lack of better labels, both 'female trans-vestites' and 'male transvestites' were aligned with lesbian culture during this period. 'Female transvestites' (people socialised as women wearing male clothing) were naturally aligned with lesbians, many of whom already dressed in a masculine way. Historian Angeles Espinaco-Virseda lists the many terms used during the Weimar period:

> The labels for lesbians expanded to include 'masculine lesbian', 'femi-nine lesbian', 'transvestite', 'Mannweib' (literally, 'Man-Woman' but suggesting a masculine woman), 'Männin' ('Butch'), and 'gleich-geschscheltlichliebende *Frau*' ('same-sex loving woman'). The variety of names for women suggests the instability of lesbian identity.[8]

Yet, there was another kind of transvestite, one who did not nor-mally dress in the masculine fashions favoured by many lesbians: those socialised as men who wore traditionally feminine clothes.

'Male transvestites' could be seen in lesbian clubs or among les-bian groups at clubs with a broader clientele. They were frequent readers of lesbian magazines, including *Frauenliebe* and *Die Freundin*, both of which began transvestite supplements during their prime.[9] The cover of *Die Freundin*'s 8 June 1932 issue featured a photograph captioned 'This is a male transvestite, inconspicuous and well dressed—indistinguishable from a woman'.[10] This coverage, which also included opinion pieces and first-person accounts, suggests a possibility reflective of today's realities, just described in the past with terms that are not quite our own. Transgender lesbians are an important and cherished part of lesbian communities in the twenty-first century. The lingering memory of transvestites and lesbians in interwar Berlin indicates that this is nothing new.

The lesbian fashion cultures of interwar Berlin could have taken the spotlight in this chapter without ever a mention of transvestites or the possibility of trans lesbians at all. This, however, would be nothing but erasure. Lesbians and transvestite communities during this period were intertwined, in venues, in print and in relation-ships. There were lesbians married to 'male transvestites', some of whom took on traditional masculine and feminine roles in a reflec-tion of their respective masculine or feminine appearances.[11] A lesbian reader of *Die Freundin* named Hans Irmgard Markus shared

her story of marrying a man against her will. The man in question had found a preference for feminine clothing—and activities deemed feminine, such as housework—and Hans declared that the relationship between them had become 'like one that usually occurs between girlfriends'.[12] One contributor to the transvestite supplement in *Die Freundin* wrote that although they were not feminine and had no inclination to be so, they still felt like a woman... perhaps even 'more womanly than some real women'.[13] This writer may have felt more aligned with the masculine women that filled Berlin's lesbian venues.

It makes sense that every kind of style favoured by the lesbians of Weimar Germany would also be popular within the transvestite community that shared so many of the same spaces. The trans lesbian history—and the trans fashion history—of interwar Berlin is unmissable in any whistle-stop tour of the lesbian 1920s, illuminated by the lights of clubs like Violetta and Eldorado as we pass them by.

I read and re-read

Frauenliebe and *Die Freundin* could exist simultaneously in Weimar Germany not just because of their large, captive audience of lesbians (and transvestites) but also because of the 'remarkably different ideological underpinnings' of the two magazines, as Cyd Sturgess notes.[14] They explain how '*Die Freundin* attempted to create a sense of normativity through a strict adherence to middle-class morality while *Frauenliebe* renounced the bourgeois restrictions of the middle class to promote ideals of *Körperkulter* ["Body Culture"]'.[15] *Körperkulter* could be defined as a sort of care and keeping of the human body—a prioritisation of sensuality. Despite their differing points of view, both publications featured fashion-related content and articles for, about and by transvestites, both in and outside of their respective transvestite supplements.

Die Freundin, the more strait-laced of the two magazines, was limited in its promotion of frivolous fashion trends. Instead, fashion was posited as a topic for debate. In 1928, a spirited discussion titled 'For or Against the Bubikopf', the short, modernist women's hairstyle, continued over multiple issues.[16] A similar article appears in

a 1929 issue of *Frauenliebe* titled simply 'Der Bubikopf'.[17] The author, Marg Arnold, writes of her dislike for the word itself (literally 'boy-head'), but how the haircut liberates the wearer from excess. The *Bubikopf*, in her eyes, stands above all other hairstyles because it combines both practicality and aesthetics.[18] Fashion advice and criticism by and for lesbians was wanted and needed, even if, during the 1920s, popular women's fashions and those favoured within lesbian communities were largely one and the same. A 1926 cover of the mainstream German periodical *Ulk* captures this: an illustrated woman in a suit, tie, and monocle strides across the page without a care in the world.[19] However, mainstream trends like the *Bubikopf* being discussed and affirmed within the pages of a lesbian magazine would make them more affirming, in turn, for a lesbian to wear.

But, of course, it was not only lesbians reading *Die Freundin* or *Frauenliebe*. It was quite possibly the transvestite audiences of both magazines who engaged most with the fashion content, and certainly most transvestite-related content—both in and outside of the dedicated supplements—included style advice and commentary. One article, published in *Die Freundin*'s supplement *Der Transvestit* in November 1924, mused on transvestites' often-difficult relationship with the German police. Most altercations concerned clothing and outward appearance. The article makes the point that while 'there is no provision in German legislation that makes wearing clothes of the opposite sex a punishable offence', police action could be and was taken 'on the grounds of gross mischief'.[20] Certain kinds of clothing worn by certain kinds of bodies was, in the eyes of the police, a disruption of the peace. With this in mind, the article considers how transvestites could wear their preferred 'gender' of clothing in more subtle ways, limiting it to men's or women's underwear.

In 1928, *Frauenliebe* gave pride of place to a piece titled 'How Should the Transvestite Dress?', printed at the front of the issue. The article, by a contributor named Maria Jung, offers advice for transvestites, focusing on an ideal of discretion and what we would now call 'passing'. The first sentence of the piece answers the title question: 'Above all, as inconspicuously as possible!'[21] But Jung's advice continues: 'It is improper for a gentleman, going out as a

lady, to awkwardly apply makeup and powder, or spray strong perfume around him'; 'If you cannot move discreetly in high heels, you should do without them and be content in low heels'. Jung tells the reader, strictly and succinctly, how 'clothing should be simple, elegant and above all modern' and that 'elegant gloves and a dainty handbag are self-evident, they complete the picture'.[22] The article was well-received, as sternly worded as it was. A handful of issues later, Jung was re-commissioned to write a follow-up piece, this time titled 'Practical Hints for Transvestites'.[23]

It is telling, I think, that so many transvestites sought advice and community within these lesbian magazines, even if, as historian Katie Sutton points out in her book *The Masculine Woman in Weimar Germany*, many of these expressions and identities were staunchly heterosexual (and, in all likelihood, akin to being cisgender):

> Many of the male-to-female transvestites who contributed to the transvestite supplements were also at pains to point out the large proportion of heterosexuals in their ranks, with estimates ranging from 35 to 99 percent. By insisting, in sometimes quite homophobic fashion, upon the 'real' masculinity of heterosexual transvestite men, who succumb to their inner femininity only in private but have wives and families in public, they sought to counter powerful cultural stereotypes of the effeminate, homosexual male transvestite.[24]

Yet such people did not make up the entirety of the lesbian magazines' transvestite audience, and a 'male transvestite' affiliation with those magazines suggests an identification with lesbian culture, identity and sexuality. Espinaco-Virseda makes this very point, showing that transvestites remained associated with lesbian publications even after the League for Human Rights set up a specifically transvestite-focused magazine.[25] Though we may only be able to find a few concrete examples, trans lesbian history can certainly be found during this period. This means that the fashions of Berlin's lesbian bars, which made their way into print in Germany's lesbian magazines, were undeniably part of a trans lesbian fashion history.

As evidence, we need look no further than an article written for *Frauenliebe* in 1929 by a self-proclaimed transvestite named Emmy Müller, who was said to have 'just passed [her] fiftieth year'. Titled

'The Lifestyle of a Transvestite', it offers a short autobiography of Emmy's life.[26] Though Emmy was assigned male at birth, which she references by calling herself a man, I have chosen to refer to her with she/her pronouns. This aligns with not only the life experience described in the piece, but also the name she signed it with. Emmy describes her and others' deep feelings about feminine fashions: 'Our longing, our drive to wear the clothing of the opposite sex comes from the depths of our soul. It is an effort to give the outer man the face that the inner man has been wearing since birth'.[27] She recalls how, as a teen, she would try on clothes belonging to her teacher's wife and wistfully look at her reflection in the mirror. She writes that at age twenty-one she was given a woman's shirt edged with lace by her landlady, which Emmy treasured and wore for years. She tells us how, at age twenty-three, she married a woman. Over time, Emmy opened up to her wife, and together they built Emmy the feminine wardrobe of her dreams, which she would wear in the presence of her wife though not outside.

In the mid-1920s, middle-aged Emmy discovered *Frauenliebe*. 'I read an article', she writes in her piece for the very same magazine, 'and the ignorance fell like a veil. I read and re-read the article; it contained so much that I could relate to myself'.[28] After the encouragement of finding this community of transvestites and—one assumes—lesbians, Emmy began living more openly. She 'resigned [herself] to [her] destiny and endeavoured to procure everything that belongs to the complete appearance of a lady'. She then went out in public, first to walk the streets, then to a ball attended by 'like-minded people'.[29] She did not live permanently as a woman, writing that she had worked her way into a 'respected position in public life'. By the time Emmy had discovered any kind of community or had unearthed the bravery to leave the house as a woman at all, her public life was already established—she would hardly have given it up, especially with a wife and possibly children to support. However, there is a passion in her words, a clue in the nom de plume 'Emmy Müller'. Points of her life string together like a necklace of pearls: a love for women's clothing; a loving and understanding wife; a lesbian magazine. Emmy's article, surviving in the archive, is a connecting thread between gender, sexuality and fashion in the queer subculture of 1920s Berlin.

Like-minded people

The ball that Emmy Müller attended was far from a rarity. In 1928, in the very same issue of *Frauenliebe* that printed Maria Jung's 'How Should the Transvestite Dress?', the magazine published a half-page advert for the lesbian club (or *Damenklub*, ladies' club) Violetta, listing their upcoming events. One of these was the very first club meeting to 'organise' transvestites on 16 February. The event was to begin at 8pm and include a lecture, socialising, and dancing.[30] It is hardly surprising that Violetta was hosting such an event: the club's owner, Lotte Hahm, was one of many in Berlin's lesbian community who also defined herself as a transvestite, and constantly dressed in masculine clothing. She owned several of the city's lesbian bars and clubs. The following year, Lotte helped establish the transvestite group d'Eon (named after the famous eighteenth century French soldier and diplomat who lived as both a man and a woman, the Chevalier d'Éon).[31]

Nightlife that catered to transvestites was not limited to specific evenings, either. In Clayton Whisnant's history of queer identity and politics in modern Germany, he suggests that all forms of transness were at the centre of Berlin's queer scene, itself 'a world in transition'. 'Clubs were full of men wearing powder and rouge' he writes, 'as well as short-haired women in tuxedos'.[32] Eldorado was the most famous club of them all, but there were others that fit into more specific niches of class, gender, or atmosphere. Sometimes there was a specific dress code. One event at Violetta, held on 4 August 1928, boasted the title 'Monokelfest'. If attendees did not already have a monocle, they would receive one on arrival, with an advert in *Frauenliebe* announcing that 'every woman gets a monocle for free!'[33] Even when no dress code was mandated, Berlin's lesbian clubs had a certain look. Ruth Roellig's lesbian guide to Berlin described the typical patron's outfit at the time:

> Mostly they dress slim, often very elegant in shape, in a black cloth costume consisting of a tight jacket, with a silk shirt underneath collars, cuffs and ties. What are these now? An obligatory monocle, a little extravagance that has found its way into the upper classes.[34]

The masculine women's style popularised by 1920s modernism, featured on the covers of magazines like *Ulk* and discussed in *Die*

Freundin and *Frauenliebe*, became real on the bodies of clubgoers. Whether completed with a monocle, jacket or collar, however, the picture that Roellig painted of Berlin's lesbian scene was overwhelmingly masculine. This was not the whole truth. One selection of photographs from Berlin's famous Eldorado—all from the same night, judging by people's attire—capture a group of beautifully dressed individuals recognised in the archives as transvestites. They all present themselves—through their clothes, hair and makeup—in an incredibly feminine way. It is thought that one of the women who appears in the photos (Figures 18 & 19) was not a transvestite, and that the group represents a mixture of transness and lesbianism. Despite Roellig's assertions, the kinds of self-expression, identification and community found within the queer clubs and bars could not be reduced to one single type.

Cyd Sturgess has argued that femininity found itself fashioned in the lesbian magazines through the words and bodies of those 'who were not biologically female'.[35] This was equally true of Berlin lesbians' physical spaces. Photographs from Eldorado, likely from the early 1930s,[36] preserve a story. We may not know the lives of those pictured, their relationships with one another or, indeed, their gender or sexuality. We know what we see: five feminine people, dressed to the nines; dark dresses that sweep the floor in velvet or silk, adorning a dancing couple; thin eyebrows, painted lips, smiling faces; a monocle tucked beneath the brow of a woman in pearls with carefully finger-waved hair; a wedding band on a ring finger; an Adam's apple under the shadow of a pointed chin. All these parts are pieces of a whole, a gloriously painted image of community, transness, style, and love between women.

IN THE LIFE

LADY LOVERS OF THE HARLEM RENAISSANCE

The Harlem Renaissance, unlike so much of the lesbian culture in Europe's interwar clubs, bars and salons, provided community to those not born into privilege. For many Black lesbians, their challenge to hierarchy stemmed purely from their existence; resistance was a means of survival. The Harlem Renaissance is the proud name of a period when African-American cultural creativity flourished, from poetry and literature to music and dance. It lasted from approximately 1920 to 1935, and radiated out from the New York City neighbourhood. The renaissance's star burned bright and fast, but Harlem's queer communities did not die with it, keeping their own fires burning for decades. This period linked those communities to the others scattered across the world in the long 1920s, forming the beginnings of a queer culture with a global reach.

Eric Garber's essay 'A Spectacle in Color' commemorates the queer culture of Harlem in the Jazz Age: 'black lesbians and gay men were meeting each other on street corners, socializing in cabarets and rent parties, and worshipping in church on Sundays, creating a language, a social structure, and a complex network of institutions'.[1] This network of people and places was known as being 'in the life'—going to the right parties, the right performances, living in the right apartments and neighbourhoods. These were not 'right' because they were trendy or socially-relevant, but because they were safe. Of course, even this was not always the case, and there were times when these spaces were raided: when the attendees or inhabitants were caught, arrested and sent to prison, sometimes

without any evidence or reason except the policing of perceived deviance. Still, they persisted. Sometimes they thrived.

From famous blues singers to lawful lesbian weddings, clothing was instrumental in navigating authenticity and acceptability for Harlem's women-loving women. Though fashion was far from the driving force behind the Harlem Renaissance, a history of lesbian fashion cannot be written without the stage costumes of queer 'bull-daggers', or 'B.D. women', or the lesbians and their 'friends' who dressed up for private parties.[2] It was these figures who needed the rules to be changed and who lived every day changing them. It was these figures who took words like 'bulldagger' and weaved them into their lives, asking 'So what?'. In a song which has become known as a lesbian resistance anthem, 1928's 'Prove It on Me Blues', singer Ma Rainey swept away the whispered accusations of the heterosexual masses and displayed them with a wink and a shrug. 'They say I do it, ain't nobody caught me', she crooned, 'sure got to prove it on me'.[3]

The spotlight

Ma Rainey (1886–1939) was the 'Mother of the Blues'. She was born Gertrude Pridgett in either Georgia or Alabama, and had been performing since her teens, only donning the moniker 'Ma' Rainey after her marriage to Will 'Pa' Rainey in 1904. Her career reached full bloom in the twenties (see Figure 20); in 1923 she signed a contract with Paramount Records, and over the next five years recorded over 100 songs and collaborated with musicians from across the jazz and blues landscape. In 1925, when Rainey was at the height of her fame, she was allegedly found in a state of undress with her chorus girls when Chicago police raided a party—she was promptly arrested.[4] In this tale, Rainey was bailed out the next day by her friend and possible lover, fellow blues singer Bessie Smith.

The story gained credibility after the release of 'Prove It on Me Blues' three short years later. The song used clothing to sketch the image of the B.D. in everything but words. 'It's true I wear a collar and a tie', sings Rainey in the third verse, reflecting her outfit in the illustrated portrait advertising the song: collar and tie, complete with waistcoat, fedora and suit jacket. Two thin women decked out

in the knee-skimming hemlines of the twenties flapper stand by Rainey's side, visible flirtation from head to toe. Indeed, it is at the toe where the lesbian imagery comes into focus; while Rainey's hat and jacket might be mistaken for a man's by the police officer drawn in the background of the advert, her tailored skirt and low-heeled shoes signpost her femininity. Like Radclyffe Hall, who was photographed just one year earlier in a near-identical outfit in Britain, clothing is at once a means to identify and disown, the collar and tie at war with the skirt beneath them.

Ma Rainey was one B.D. woman, but other figures loom large. Gladys Bentley was perhaps the most infamous lady lover of the Harlem Renaissance. Bentley—a name that suits the wearer better than the more feminine Gladys—was a male impersonator who shook the world with each performance, each confident cross-dressed step both on the stage and off. We will return to Bentley in Chapter 13, but it is impossible to write any history of 1920s Harlem without a tip of the hat in her direction. Meanwhile, Bessie Smith, Ma Rainey's possible lover, was the 'Empress of the Blues', the highest paid Black entertainer of the era, and is repeatedly rumoured to have been a B.D. woman who had love affairs with other women.[5] According to Lillian Faderman in her landmark history *Odd Girls and Twilight Lovers: A History of Lesbian Life in Twentieth-Century America*, 'Bessie Smith's lesbian interests were well-known among her show business intimates, although she was a married woman and took pains to cultivate that image as well'.[6]

However, Allison K. Hammer disagrees with this characterisation of discretion in their article on the B.D. culture in which Bessie and Ma Rainey lived and worked: 'Rainey and Smith were outrageous in their choice of dress and lifestyle, and I theorize this *outrageousness* as an expression of *outrage*'.[7] This outrage grew out of the constant discrimination that Ma Rainey, Bessie Smith and Gladys Bentley faced throughout their early lives and their careers—discrimination for being Black, for being women, for being queer, for being poor, for being all of the above and more.

But a life on stage is different to one on the streets or behind closed doors. For all that B.D. women and those aligned with them broke boundaries, there was always a certain public image being cultivated. If a performer could not profit from crossing boundaries,

or if their audience expected something different from them, then their image was decided. Some famous performers of the Harlem Renaissance only ever dipped their toes into the suggestion of lesbianism while in public, and it was when they left the stage at the end of the night that they submerged into 'the life' completely.

Jackie 'Moms' Mabley's career was built on jokes about loving young men, but her private life was openly lesbian. A retrospective on Jackie's career in *Ebony* magazine from 1974, a year before her death, entwines her on-stage persona with her life story, apparently unaware of the differences. While capturing her time on the 1920s New York comedy circuit, as well as her later rise to stardom, the article lingers on the 'professed penchant for young men' that 'has become her trademark'.[8] Yet, it also allows us to glimpse behind the curtain, with Jackie's own quoted words perhaps an oblique reference to love that could not speak its name: 'I tell them (young people), "Don't let the old folks tell you about the good old days." What good old days? I was there. The best time is now, when you can go out with who you want, love who you want and marry who you want'.[9]

Jackie's love for women might have been hidden in her public image, but she was far from in the closet. In fact, to many, it was her clothes that kept her out of it. Once her performances were over, she would retreat to her dressing room to change out of the house dresses of 'Moms Mabley' and into the trousers and shirts that defined Jackie—or, as she was sometimes known, Mr. Mabley. The dressing room was a place of safety and transformation in more ways than one, with fellow performer Norma Miller recalling in a 2013 documentary how she once shared the space with Jackie for two weeks—'she and I and her girlfriend'.[10] A festive portrait, taken some time in the 1920s, shows Jackie smiling in a shirt and blazer with her hair cropped close. It is a far cry from the stand-up persona of Moms Mabley, or even her glamour shot publicity photos of the 1940s. The lady lovers of the Harlem Renaissance might have dominated New York's stages, but often their time to shine only began once the spotlights switched off.

Anything they wanna do

It was at parties that those 'in the life' felt most at ease, but they varied with class, location, and the people who attended. For Edna

Thomas, parties symbolised awakening. Edna was a Black stage actress, ambitious and elegant, most famous for her role as Lady Macbeth in the mid-1930s. She was forty-one in 1928 when she danced with another woman at a Harlem party, the specifics of which are tantalisingly veiled in her only recollection of it. What we do know is the feeling that coursed through Edna as she danced: in 1937, a woman named Mary Jones took part in a study on homosexuality by Dr George Henry, and historians have deduced that Mary was, in fact, a pseudonym for Edna.[11] In the study, she recalls this party with intense emotion. She describes how 'something very terrific happened to me—a very electric thing. It made me know I was a homosexual'.[12] This party was not the only one that made an impression on Edna's life, however—another party, at the home of Black heiress A'Lelia Walker, was where she met her life partner and 'very great love', Bright Young Thing Olivia Wyndham.[13]

A'Lelia Walker's parties knew no bounds, and they were full of potential. The oral histories of the Lesbian Herstory Archives capture the scenes found there, including in the recollections of the archives' long-term contributor, Mabel Hampton (1902–1989). Mabel was determined and inquisitive, and had been carving her own path through life since childhood, when she'd run away from her abusive aunt and uncle. She began to work as a performer in Coney Island as a teenager, promptly discovered the joys of lesbian life, and never let them go. She may have been an outsider in A'Lelia's world of wealth and luxury, but she had inside knowledge of the lesbian landscape of the Harlem Renaissance and beyond. Because of her work as a dancer, her social circle was wide and diverse.

At the time of her visit to A'Lelia's, Mabel had been seeing a white woman named Ruth.[14] Ruth knew A'Lelia, or at least knew of her parties, and asked Mabel one night if she'd like to go 'slumming'—'slumming was you'd go to some place, go to somebody's house, and they'd be having a party', Mabel explains.[15] The party that they found defines a particular kind of lesbian fashion within the walls of the privileged and passionate: one without many clothes involved at all.

'I'll never forget', recalled Mabel in 1983, sixty years after the event in question, 'I had a grey dress on with a white fur coat, short

coat, I can't forget that. Because I had to take them all off, so naturally I wouldn't forget!'[16]

> [Ruth] says 'will you take off your coat', I says 'yes'. So I took off my coat. The dress was all in one piece, I was like, 'do I have to take off the dress, too?' She says 'uh-huh'. And she goes taking hers off, she took hers off, I took mine off! And I had nothing on but stockings, slippers and [a slip].[17]

Though Mabel seemed hesitant at first, she 'stayed all night long' and she and Ruth 'had ourselves a nice time'.[18] They could be free at A'Lelia's—anyone could. 'There was men and women, women and women, and men and men. [...] They wanna do anything they wanna do, they go ahead and do it. See?'[19]

A'Lelia Walker was the daughter of Madam C. J. Walker, a Black female entrepreneur recorded as the first woman in America to become a self-made millionaire with her haircare products for Black women, the first of their kind to be widely sold. A'Lelia inherited her mother's fortune, which funded the most desirable parties of the Harlem Renaissance and the safe space that they represented. It also funded the aesthetics that defined these parties, the nudity and expensive underwear, the towers of pillows and endless streams of food.[20] In the midst of it all was A'Lelia, sometimes dressed in lingerie, other times in her signature jewelled turban and favourite riding crop.[21] We do not know if A'Lelia was part of the queer communities that she opened her doors to, but in many ways the spaces that she provided cement her as a figure of lesbian and queer history, no matter what romantic relationships or sexual encounters she may have chosen to pursue. In the words of Eric Garber, 'A'Lelia adored the company of lesbians and gay men' and thus 'her parties had a distinctly gay ambiance'.[22]

A'Lelia's place was not, however, the only gathering spot for the queer populations of Harlem, and working-class lesbians in particular carved their own niches. Rent parties were hosted in private apartments, where guests paid admission to—as the name suggests—help pay the host's rent. These parties were open to the public, but often this just meant a wider circle of queer women. Sometimes, certain rent parties were called 'women's parties', as in a 1928 report by a vice investigator, who observed that 'the

women were dancing with one another and going through the motions of copulation'. One attendee, questioned about her sexuality, replied brazenly 'Everybody here is either a bull dagger or a faggot and I am here'.[23]

For the dress code of Harlem's rent parties, I turn once more to the extensive oral histories left by Mabel Hampton in the careful hands of the Lesbian Herstory Archive. Speaking to her friend and interviewer Joan Nestle, Mabel (Figure 21) recalls how the women in her community called themselves a number of things, among them 'bulldagger', 'butch', 'lady lovers' and 'stud'.[24] These terms all referred to the more masculine woman in an earlier iteration of what we might now call butch/femme culture. The 'other ladies'— the more feminine partners in a lesbian couple—were either 'my friend' or 'my wife'.[25] Mabel specifies that 'mostly we heard [the label] "stud" when we went to a big party!'[26] In another interview, she expands on the sartorial definition of 'stud' within her community and at these parties:

> 'Stud' comes from the part of, the way they dressed, I think. You see? Because they dressed masculine, and with short hair and things like that. But I didn't care, I kept my hair, I didn't bother with the hair. I just like the suits and the pants and the shoes... and I didn't want to be tied down to anything. I just wanted to be myself.[27]

Dressing in 'suits and pants' was something that, to many lesbians, was confined only to parties. Mabel herself and the other studs would bring a suitcase of masculine clothes with them to change into on arrival, particularly trousers; it was too dangerous to wear them in the streets.[28] Rent parties were a place where lesbians could be open not only in their relationships and sexuality, but also their dress. You can almost imagine women like Mabel who flocked through the streets to a place promising an evening's freedom, paying their entry at the door and finding a space to change, transforming into the stud that their friends and girlfriends recognised. 'My favourite outfit when I was young was a suit', Mabel remembered in 1988, 'Nobody knew what you was when you had a suit on'.[29]

* * *

Once a party ended—or when the theatre closed—the streets had to be walked once more. The outdoors of Harlem in the twenties and thirties may not have been the haven of lesbian self-expression that certain venues strived for, but queer Harlem spilled into the city just as its influence reached across the world. Recall Eric Garber's words that 'black lesbians and gay men were meeting each other on street corners, socializing in cabarets and rent parties, and worshiping in church on Sundays'.[30] The street is a recurring landscape in a history of Harlem's lesbian fashion, a road well-travelled as well as a meeting point. Sometimes, lesbians walked through the streets to another public place Garber mentions: church.

Churches were vital to many in the neighbourhood's lesbian communities, and not only for worship and community. Although same-sex marriage was not legalised in the state of New York until 2011, this could be a non-issue; if a lesbian couple was made up of a masculine and a feminine partner, and if the masculine partner dressed and physically looked sufficiently masculine, they could pass as a man in the marriage proceedings. Not much paperwork was needed to obtain a marriage licence in the early decades of the twentieth century, and simply masculinising a first name could do the trick.[31] Other times, a gay male friend might apply for a marriage licence as a surrogate for one half of a lesbian couple, while the ceremony itself was more open—some vicars were willing to marry same-sex couples, and some were 'in the life' themselves. This was the case for a couple Mabel Hampton remembered who wed in 1938, at the furthest tail end of the Harlem Renaissance. One of these women was called Florence, while her partner's name is lost to history. They were married by the Reverend Monroe, a gay man working at a church on 114 Street and St Nicholas Avenue.[32]

Both the wedding party and the guests were dressed to the nines, with around thirty or thirty-five people in attendance, all of whom were women. Mabel wore a white suit and a dark tie, while her own 'wife', Lillian—whom Mabel had met six years earlier— looked 'like a fashion plate'.[33] The masculine bride (probably Florence) 'looked so much like a fella you couldn't tell her apart' and wore white trousers, while her soon-to-be wife donned a white wedding dress, white shoes and a veil.[34] They both looked the part: their matching outfits were worn with pride, a badge of authentic-

ity in an ever-growing tradition of white-clothed weddings. This was an event that celebrated one couple's love, but it was significant for their community as much as for themselves, an act of both defiance and possibility.

Being openly different in public was always a risk, and yet to the Black, queer population of Harlem it was a risk worth taking. In Saidiya Hartman's book *Wayward Lives, Beautiful Experiments*, she imagines the intimate lives of the Harlem Renaissance's outcasts and heroes, especially women, and describes this population's life on and off the streets with a care and admiration that refuses to be confined to the page. She writes of 'the young women whose lives unfolded in the streets, cabarets and tenement hallways', young women who had 'serial lovers, husbands in the plural, and women lovers too. [...] Young women who preferred to dress like men'.[35] There are many figures of the Harlem Renaissance to whom gender was inconsequential, to whom non-conformity was just another fact of a resistant life. The Black lesbians who walked through the streets of early-twentieth-century Harlem wanted freedom of every kind. Even the label 'lesbian' was rarely used, too restrictive—too white—for the varied stories of women who loved women and women who dressed in men's clothes, creating a life for themselves against a looming history of slavery and the continuing racism of the everyday.

Bulldaggers and bulldykes, 'B.D. women', studs and butches, wives and friends: these titles began to sketch out a new reality for the lady lovers of the Harlem Renaissance, starting from the margins and refusing to stop. They dressed in fedoras and blazers, wedding dresses and lingerie. Each of these individuals took to the street, the church, the stage and the bedroom, carving out a revolution, steadily wearing a path through the ground.

Fig. 11: A typically 'feminine' Natalie Clifford Barney captured by pioneering woman photographer Frances Benjamin Johnston, c. 1890—a little before Natalie embraced her calling as Sappho's right-hand woman.

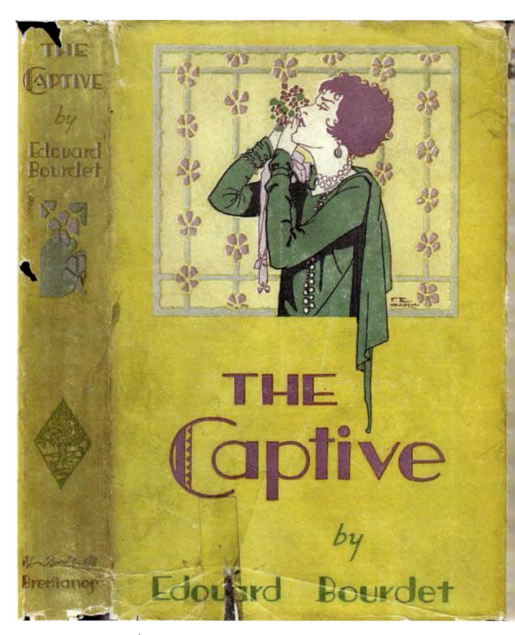

Fig. 12: The cover of Édouard Bourdet's 1926 play *The Captive*, which was performed in New York and Paris and used violets to symbolise a lesbian relationship.

Fig. 13: Natalie Clifford Barney (seated) posing with one of the most significant of her many lovers, poet Renée Vivien. Otto Studio, Paris, c. 1900.

ig. 14: Romaine Brooks' iconic por-
rait of *Una, Lady Troubridge*, 1924, oil
n canvas—complete with monocle
nd high collar. 2024 © Photo Scala,
lorence.

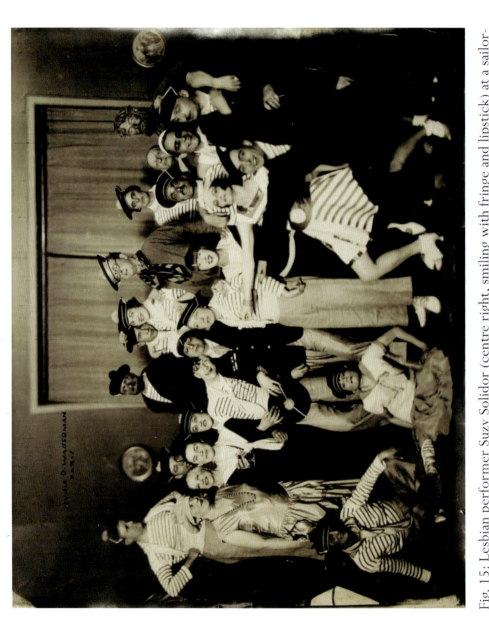

Fig. 15: Lesbian performer Suzy Solidor (centre right, smiling with fringe and lipstick) at a sailor-themed masquerade ball, held at the Moulin de la Galette in Paris, 23 June 1926.

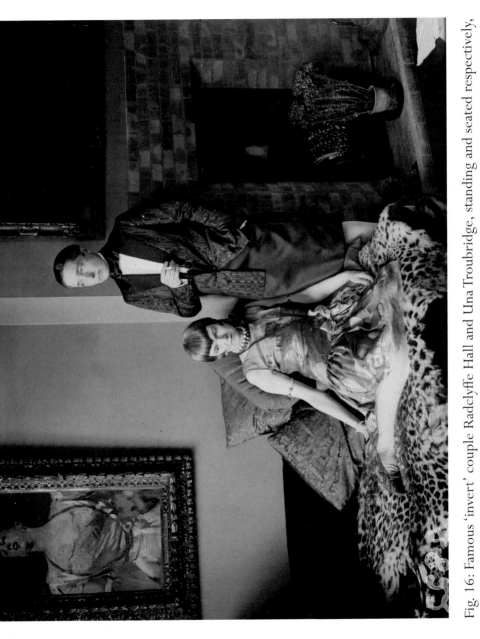

Fig. 16: Famous 'invert' couple Radclyffe Hall and Una Troubridge, standing and seated respectively, pose in complimentary masculine and feminine outfits, 1927.

Fig. 17: Madge Garland (left) and Dorothy Todd, possibly on holiday, c. 1930. This is the only known photograph of the couple together.

Fig. 18: Patrons of Eldorado, a club on Berlin's Motzstraße frequented by queer people in the 1920s and early '30s. Some (possibly all) of the people in this photograph were 'transvestites'—and the two people dancing might be a lesbian couple.

Fig. 19: Members of Berlin's 'transvestite' community photographed by Herbert Hoffmann at the Eldorado, decked out in pearls and even a monocle, 1929.

Fig. 20: Ma Rainey, blues performer and
the singer of 'lesbian resistance anthem
'Prove It On Me Blues', 1920s.

Fig. 21: Mabel Hampton, 1919:
dancer, cleaner, activist, historian,
lesbian. Here she wears a sailor cos-
tume, possibly for a performance, in
New York City. Via https://dcmny.
org/do/458e415a-ab85-4100-a449-
5df061e6a47b.

PART THREE

A BUTCH/FEMME INTERLUDE

No lesbian history could be complete without the presence of butch and femme, and certainly not a history of lesbian fashion. These two identities, largely though not entirely defined by their 'look', are perhaps the two most famous kinds of lesbian existence. They go hand-in-hand—quite literally, with many butches and femmes having paired themselves together in couples. Butch and femme is a widely covered topic in writing about the lesbian past, so I come to it only as an interlude.[1] This is a pause in our story, a brief wave to butch/femme as we traverse other moments in lesbian fashion history.

It is hard to pin a definition on butch or femme. Hopefully, over the coming pages the nuances of both will shine through. For now, however, I'll describe them in their most basic form: butch refers to a lesbian who dresses and acts in a masculine way, and femme to a lesbian who is feminine in their style and manner. What encompasses 'masculinity' or 'femininity' is, of course, a matter of opinion—but then, so too are the labels butch and femme understood differently by many of the people who wear them. They are not, either, confined to lesbian culture. Butch has been and is used by other queer people, though usually as a description of style more than an identity. Though 'femme' originates from the French word for woman, it is not used this way in English, except sometimes to sell a t-shirt on the high street.[2] Instead, it has come to mean 'people who are feminine'. This is usually in order to include transfeminine non-binary people or feminine gay men, among others, in conversations and communities that might otherwise be limited to women.[3] While 'woman' is a gender, 'femme' is a description of gender expression, and the categories do not necessarily overlap.[4] Femme

is a label that has become so widespread that its meaning is hazy. There is a certain power, then, in taking time to return to a specific meaning of femme, as I will do in Chapter 10.

Butch and femme are not the only words describing lesbians who embrace either masculinity or femininity, and who often gravitate towards one another in romantic or sexual settings. The most significant alternatives are stud and fem. 'Stud' is sometimes used by Black lesbians who are masculine, though, like butch, its meaning can differ between individuals. Mabel Hampton, who we met in Chapter 8, was in community with Black lesbian studs in New York City from the 1920s, and the use of 'stud' persisted in America into the mid-century. But by the early twenty-first century, many Black lesbians preferred alternatives, including 'aggressive', which became a favoured term for the masculine partner of a femme.[5] 'Fem' often appears within working-class lesbian communities, where the spelling of the French-derived 'femme' might not have been obvious, since both are pronounced the same way in English; butch and femme, too, though, were largely embraced by working-class lesbians in the mid-twentieth century.

Chapter 9 will take us to butch and femme clothing cultures in their most famous haunts: the lesbian bar and club scene of the mid-century. Then, Chapter 10 takes a moment to focus on the significance of femme fashion. This moment is an important one, since feminine clothing—often considered to be one and the same as 'mainstream' women's fashion—is too often invisible in descriptions of lesbian aesthetics. Despite this, lesbian femininity and the femmes who make it their own are guiding lights in fashion's lesbian history.

LOOKING 'RIGHT'

THE MID-CENTURY LESBIAN BAR

Like the clubs of the twenties, the lesbian bars of the mid-twentieth century were havens, though not always safe ones. The social and political landscape of the postwar years was very different from the interwar period. The world stage was shifting: the US became increasingly important as a global power due to its rapidly growing economy, while the UK was slow to financially recover from the war, despite an improvement of British living standards because of the National Health Service. But in both countries, life was a bleaker prospect for women and minority groups than it had been in the twenties and thirties. There was a widespread glorification of 'traditional' gender roles and nuclear families, made up of housewives, patriarchs, and obedient children. Queer worlds like those that had found space to blossom between the wars were now more restricted than ever. But the closet doors had opened and they couldn't be closed again—the existence of gay men and lesbians was public knowledge, yet far from publicly accepted.

From the end of the Second World War until the late 1960s, bar culture looms large in lesbian history, particularly in North America. These bars' patrons and their outfits linger in photographs and memory, telling perhaps the most famous story within lesbian fashion history: butch and femme. Lesbian bars and clubs were more than places to drink—they were homes for those who went to them. They could be butch and they could be femme, they could be lovers of women, they could be sexual beings and independent creatures. There was too much drink and there were strict codes; there

103

were fights and police raids.[1] The bars persisted, because they were not only wanted, but needed.

In New York, a law known as 'the three-piece clothing law' made lesbian life outside of the bars incredibly difficult for butch lesbians, or any gender non-conforming person. Laws like these had existed across the US in the nineteenth century, initially to combat people dressing in disguise to commit crimes. The New York version, first passed in 1845, mandated that people wear a minimum number of 'correct' garments for their sex—which in the postwar period, easily lent itself to the persecution of visible queerness.[2] Rusty Brown, a lesbian interviewed for a 1983 oral history, remembered how 'you had to have three pieces of female attire'. A butch could wear trousers and a man's shirt as long as they were supplemented with other garments, like a woman's coat or underwear. For Rusty, this was difficult:

> At the time I was young, I had nothing on top so what the hell was I going to put in a brassiere? I'm not exactly the type for lace panties. And if I'm wearing pants [trousers], I sure as hell don't need a pretty coat. So there goes your three pieces of female attire.[3]

For butches, it was dangerous to express themselves with clothes they felt comfortable in except when behind closed doors—even in times and places where homosexuality had a slightly freer reign, as we saw with the Harlem Renaissance. Of course, to some dressing butch on the street and in the world, rather than just at a party or a club, was worth it; to others there was no point in ever pretending to be other than they were, marked out as butch by their gait, their manners or their hair just as much as by their clothing. Rusty recalled how she 'had been arrested in New York more times than I have fingers or toes, for wearing pants and a shirt'.[4] Others shifted between selves, becoming visible only in the spaces where they had room to be. As the pioneering historian Lillian Faderman writes in *Odd Girls and Twilight Lovers*, twentieth-century bars 'were a particular relief for many butch working-class women because it was only there that they could dress "right." [...] It was after work, at night, in the bars, that butches could look as they pleased—where it was even mandated that they should look that way'.[5]

Despite this, butch lesbians continued to be butch lesbians when dressed in skirts. There were certain ways of dressing that, while appropriately feminine for the eyes of the law, had butch connotations when seen by other lesbians. In the bars, butch and femme identities often came with strict dress codes. This was specifically butch fashion, not general masculine fashion, and it drew on a thread stitched and tugged by previous generations whose lesbian masculinity was not diluted by a lack of two-legged garments, from Queen Christina to Radclyffe Hall. According to historian Alix Genter, in 1940–60s New York, 'butch-femme emerges not as a system of rigid specification, but as one that was flexible, forgiving, and accommodating'. She gives the tailored skirt as an example:

> Postwar women's styles encompassed two distinct silhouettes: full skirts with a snug waistline, like the stereotypical 1950s poodle skirt, and narrower 'pencil slim' skirts [...]. Although equally socially acceptable, when dressing for work or school, butches of this era favored skirts of the slimmer variety for a more tailored and less feminine look. Understanding that women wearing slacks was simply not appropriate in certain circumstances, they made a clear distinction between skirts and dresses, preferring to wear skirts since they could be paired with a more unisex style of top, such as man-tailored collared shirts. If forced to concede to certain aspects of feminine style, the attitude seemed to be, 'Well, at least I wasn't wearing a dress'.[6]

Genter mentions students at Brooklyn's Bay Ridge High School, nicknamed 'Gay Ridge High', where young working- and middle-class white butches developed a trend of dressing in 'long, pleated skirts with their man-tailored shirts, sometimes with a vest or coat on top'.[7] Another example is Ira Jeffries, a Black working-class butch from Harlem (Figure 22), who 'was ecstatic' to buy a man-tailored, women's suit upon receiving the first paycheck from her first summer job.[8] And two white butches, Miriam Wolfson and May Brown ('the butch of the century', according to Miriam), were also living in New York in the 1950s, and embraced feminine dressing.[9] Photographs of the two from Miriam's personal collection capture a vision of lipstick, fur coats, and long pencil skirts.[10]

The realities of butch lives and clothes outside of the lesbian bar scene makes what happened within it all the more extraordinary. Clearly, not all butches needed the bars for sartorial expression, being happy to create their own language of fashion which walked the tightrope of acceptability. The styles that emerged within the bars had specific, lesbian meanings—meanings formed by the presence of femmes. Joan Nestle, one of the Lesbian Herstory Archives' founders, has written extensively about the history and meanings of butch and femme, from a femme perspective. She argues that 'We labeled ourselves as part of our cultural ritual' and that 'the words stood for complex sexual and emotional exchanges'.[11] Developing this idea further, she writes: 'In the past, butch has been labeled too simplistically the masculine partner and femme her feminine counterpart. This labeling forgets two women who have developed their styles for specific, emotional and social reasons'.[12] The dress codes so often seen in lesbian bars were not, always, truly about clothes. Clothes, instead, were a means to express community and difference, push and pull, attraction and competition.

Not everybody within butch and femme culture felt innately like a butch or a femme, but many (in the US, especially) dressed like one anyway. It was a way to live, love and be safe for a while. It was a dichotomy used in generations before, by pseudo and congenital inverts and by studs and their wives. As one butch woman observed in Faderman's *Odd Girls and Twilight Lovers*, 'we were too busy trying to survive in a hostile world [to] have time to create new roles for ourselves'.[13] She was talking about masculinity and femininity in relation to traditional heterosexuality. Perhaps, however, we could interpret her a different way: that butch and femme was not a continuation of a heterosexual narrative, but rather a distinctly lesbian one.

The Gateways

Much writing about butch and femme, including in this book, focuses on North America and especially New York City. Butch and femme reached far beyond the bounds of the United States, but different cultural contexts created different outcomes; for example, in the interviews conducted by Jane Traies for her British lesbian history *Now You See Me*, only seventeen per cent of respondents ever

identified as butch and thirteen per cent as femme.[14] But there is one place in the UK where butch and femme were prevalent and records of their style cultures survive en masse. These accounts from a single location allow us to imagine a bigger, brighter picture— though, of course, one place cannot speak for them all. Let us turn to the Gateways, a club in London's Chelsea whose life has been recalled by its patrons in Jill Gardiner's history of it, *From the Closet to the Screen*.

Ted Ware opened the Gateways in the 1930s, and it became a women-only venue in 1943. It remained open until September 1985, when it hosted an enormous closing party. The club, by the fifties, was mostly run by Ted's wife, the glamorous and imposing Gina, and her long-time best friend (who many members of the club assumed was her partner), Smithy. The club was made famous in the 1960s by its appearance in the film *The Killing of Sister George*, starring Beryl Reid, Susannah York and Coral Browne. Unlike so many of America's lesbian bars—and unlike many of its neighbours and competitors in London—the Gateways was largely safe from intrusions by the police. It was a members' club rather than a bar, and as such held a certain respectability, but it also benefited from the no-nonsense attitude of Gina Ware, who banned members for any conduct that might give the club a bad name.[15] Photographs and recollections from different time periods at the Gateways show a changing spectrum of lesbian fashion, but mid-century lesbian styles (in other words, butch and femme) persisted at the club longer than they did elsewhere.

René, one of Jill Gardiner's interviewees, remembered how 'There was a big dividing line in lesbians' at the Gateways: 'One butch always knew another butch because it was a mirror image of yourself: shirts or casual sweaters, trousers, and jacket. The femme wore skirts, blouses, high-heel shoes, earrings and make-up, and carried a black patent leather handbag'.[16] There were specific codes for butch and femme, no doubt depending on the bar, club, city or country, but these were far more precise than simply 'masculine' or 'feminine'. Note the 'black patent leather handbag' of the femme—a code, within the Gateways, not simply for fashionable femininity from the (heteronormative) world outside, but for lesbian femininity, even femme-ininity.

After all, looking 'right' meant more than fitting in. Dressing butch and femme was a carefully balanced equation whose end result was romantic or sexual triumph. Bars or clubs like the Gateways were never just places to go, but places to meet other lesbians. As Gardiner acutely points out, 'The main concerns of a woman coming on to the scene were how to be accepted [...] and how to find a girlfriend. The first step was to get the right clothes'.[17] Esme, a femme-presenting Gateways regular of the sixties, recalled:

> I had straight long hair, and I would wear a black slim-line cotton skirt, a colourful blouse with a nice flowery pattern and black stockings and stiletto-heel shoes, and make-up. [...] I used to feel wonderful, very feminine. You had more of a chance if you looked really femme.[18]

It was far from just Esme playing the game. Jo remembers how 'We went to a men's shop and bought men's clothes. I wore a tie, whatever was fashionable'.[19] Sam, who did not quite fit the typical butch mould, was very aware of it: 'When I first went to the Gates, a lot of the really feminine women didn't want to know me. Some women were only attracted to very butch dykes, so if you fancied one of them, you had to match the image'.[20]

Of course, knowing the benefits of dressing a certain way did not take the joy out of the garments themselves. Rather than remembering their reception, many of Gardiner's interviewees focused on their favourite clothes, or styles that were favoured more widely. Lesley explained:

> Winkle-pickers were fashionable, these black pointed shoes that turned up at the end. It was easier to do the twist in them. There was one outfit I used to wear a lot with black drainpipe trousers, winkle-pickers and a mauve v-neck sweater, with a tie and a white shirt. That was almost a uniform.[21]

Jane, in contrast, remembered the feminine outfits that she preferred, with 'very short dresses, very high-heel shoes, long hair flicked up. It was Dusty Springfield, it was all long hair and eyelashes and legs'.[22]

Although the butch and femme looks at the Gateways were often clear-cut—the sweaters and trousers of the butch, the (black) hand-

bag, high heels and stockings of the femme—the feelings that defined both butch and femme could vary. Some felt that this dynamic only existed to encourage acceptance from the hetero-sexual masses. Jo, for example, suggested that 'Fitting into certain types of roles in the way we dressed maybe made it easier for straight people to accept us and for us to accept ourselves'.[23] Others were butch because it felt true to themselves and their gender expression, in a way we could read as a kind of trans-masculinity: a real affinity with the male gender. Ricky recalled how 'A lot of butches in those days did not see themselves as women: they saw themselves as men or something similar', and that 'people used to bind their boobs with elasticated bandages or girdles'.[24] Others were whole-hearted in their butch identity, but very adamantly women: Janet would go to the Gateways with her gay brother, James, who told Gardiner, 'I made Janet this dark red wool trouser suit. She was never trying to pass as a man: for her the point was to look like a butch lesbian'.[25] Sandy Martin, meanwhile, said that she 'never felt like a man. I felt butch. Butchness in a woman is quite camp'.[26]

There were also those at the Gateways who neither identified nor presented as butch or femme. Though their numbers increased at the end of the 1960s and into the seventies and eighties, they were not impossible to find earlier on. In a famous photograph taken at the Gateways in 1953, for example, two women hold each other in an embrace (see Figure 23). While we can see hints of butch and femme self-fashioning, such as hair length and a cinched, belted waist on the woman who might have been femme, both are dressed in trousers and a shirt or jumper. There was also Sheila, who recalled to Gardiner that she and her partner 'both dressed the same'.[27] Meanwhile, Kathy (known as 'Kathy the dancer') some-times dressed in masculine clothes, but as 'fancy dress, like we dressed up on stage. [...] I looked boyish but cheeky'.[28]

As the years moved on, patrons were at first seen as suspicious for dressing too far outside of the butch/femme dichotomy: Tash was kicked out on suspicion of taking or carrying drugs, a suspicion informed by her wearing 'crushed pink velvet flares and a purple mirrored shirt and sandals'.[29] Eventually, the Gateways did change—but even when leather and jeans, kaftans and mini-skirts made their way through its iconic green door, it continued to hold

a certain reputation. 'The Gateways', said Bea, 'was all about being smart. It was about glamour'.[30] This is something that could not, perhaps, be said for the lesbian bar scene as a whole.

Class and visibility

It was often the case that butch and femme dress codes, as well as lesbian bar fashions that existed outside of them, were classed. As Faderman points out in *Odd Girls and Twilight Lovers*, mid-century Anglo-America was a time of multiple lesbian subcultures, which varied with both class and age.[31] There were places where class was not a barrier to entry, or even a deterrent, and where clientele was mixed: the Gateways had 'lady bank managers[,] school teachers and prostitutes all mixing' according to a regular, Jo.[32] This could also be the case with American lesbian nightlife, though this was often out of necessity in a country so large and with such a dispersed population. The Cave was the only lesbian bar in 1950s Omaha, Nebraska. Betty, a high school teacher at the time, recalled for Faderman middle-class women in smart, conservative dress on one side of the room, and on the other, working-class butches in t-shirts 'with cigarettes rolled in their sleeves' and femmes in lipstick and high heels.[33] Even at the Gateways, lesbian unity would only go so far, with upper-class lesbians socialising in cliques—such as a group that other patrons nicknamed the 'Yacht Club Boys', who wore blazers and monocles in the upper-class lesbian styles of 1920s Europe.[34]

It was not rich women or respectable middle-class lesbians in skirt suits and formal dresses who carried the risk of lesbian bar culture on their backs. In a bar setting, of course, danger could always lurk—to be a lesbian in the US at this time was anything but safe. The Lavender Scare was part of the McCarthy era, a period beginning in 1950, characterised by the persecution of those who were or who were thought to be communists by the US government. While this policy was known as the 'Red Scare', it was not only communists being hunted; the historian David K. Johnson coined the term 'Lavender Scare' to highlight the heavy-handed persecution of both gay men and lesbians at this time. By November 1950, Johnson notes, security officials in the US Department of State reported firing

an average of one employee every day on the charge of homosexuality.[35] Middle-class lesbians, many of whom worked for government bodies, had their careers under severe threat, affecting their family life, social life, sometimes marriages and possibly housing. Being found in a lesbian bar could be a social death.

For lesbians who presented simply as feminine women, this risk dramatically reduced once they were back in heterosexual space. For butches and femmes (who were disproportionately working-class), it was not so simple: many, like Rusty Brown, were seen as lesbians whether in the bars or not. Butch/femme couples particularly, in Joan Nestle's words, 'made lesbians culturally visible—a terrifying act for the 1950's [...] when there was no Movement protection for them'.[36] The bars, no matter their clientele, were largely secret and underground, and often at risk from the police. This was before the Gay Liberation movement, which grew into being in the 1960s, or the Stonewall uprising of 1969, generally accepted as the movement's jump-start.

From the earliest years of the mid-century until the end of them, butch and femme and their fashions acted as the scapegoat for the wider lesbian community. A 1948 issue of early American lesbian publication *Vice Versa* published a poem by editor Lisa Ben, titled 'Protest'. In it, Ben recoils from butch fashion as a fundamentally illegitimate style for a lesbian, who is supposed to be attracted to the 'fairer sex' and thus reject anything to do with men. She describes parts of a butch's masculine self-expression with disdain, listing 'borrowed shoes', with 'tresses shorn' and 'beauty masked in graceless, drab attire'. In Ben's eyes, this is a pitiable attempt to 'bow, reversely, to Convention!'[37]

From the 1960s, both butches and femmes were viewed with suspicion by political lesbians involved in the women's movement. As Nestle wrote in the early eighties, 'a radical, sexual, political statement of the 1950's appear[s] today as a reactionary, non-feminist experience'.[38] Femininity—even the specific lesbian femininity of femme lesbians—was thought to oppress women by making them look and act in certain ways for male satisfaction.[39] By the same token, butches were seen as 'outdated', conforming to patriarchal ideas about fixed gender roles. The butch/femme model of dress and identity came under fire from those with this 'binary-

rejecting' perspective on feminism. I will explore the fashions of the lesbian feminist movement in Chapter 16, but even in its early days it distanced itself from the butch/femme image of lesbianism that had been most prevalent before it.

Butches were first condemned for being too obviously different in political lesbian spaces. *Arena Three*, a British lesbian publication run by the Minorities Research Group (MRG), received letters of complaint about members attending meetings in masculine cloth-ing; in August 1963, the group debated the motion 'That this house considers the wearing of male attire at MRG meetings is inappropri-ate'.[40] Though the motion failed—by a slim margin of votes—'the wearing of male attire' remained a contentious issue.

Butch and femme relationships and aesthetics signalled a refusal. They were a refusal to stay quiet or to stay home. Though many people did and continue to equate butch/femme with heteronorma-tive gendered roles, butch/femme was never that—it was always distinctly lesbian. Sometimes, butch/femme culture was an unwanted authority, a model for lesbian relationships and style that not everyone resonated with. But it had its reasons to be so. There was the risk of undercover police in US bars, which meant that patrons might hesitate to interact with anyone who did not adhere to the dress and behavioural codes of butch and femme.[41] Butch and femme were also simply convenient. As seen in the Gateways, they created a dynamic, one that could be slipped into for a night, a relationship, or a life. To be butch or to be femme was complex, but it was also simple, sometimes as much about whom a person wanted to sleep with as who they wanted to be.

10

A NOTE ON FEMMES

Butches stand out in lesbian history far more than any femme. When we look back into history, hunting for difference from the heterosexual norm, it is masculinity in women—or those perceived as women—that we notice, a flag speared into the earth that tells us where to look. Femininity is a subtler figure in the lesbian past; there is a reason why so many femmes appear in our histories on the arms of butches. There, they become visible. But even without butches, as Rhea Ashley Hoskin and Katerina Hirschfeld put in their femme manifesto, 'No, we're not invisible. You're just not looking'.[1]

There are, of course, notable historical lesbians who were more feminine than masculine, but even then, their clothing is rarely given attention—expressions of femininity, largely in style, seem to be considered separate to lesbian history, rather than intertwined with it. Hoskin suggests that 'femme occupies both the center and the margins, and is ostracized within many of the communities that femme might yearn to call home'.[2] Femininity as a whole is devalued, and consequently underrepresented. In the same way, in many lesbian histories, (possible) femme lesbians have not been valued as individuals because their femininity has not been considered noteworthy. They often exist in the lesbian narrative despite their femininity, rather than because of it. It's certainly rare that they're celebrated for it.

Still, femmes have always been desirable. Recall how some butch patrons of the Gateways in London would play into the popular butch/femme aesthetics of the time in order to get a femme's attention, and vice versa. Mabel Hampton, talking about her lesbian life in New York City in the 1920s and beyond, remembered the women

who were known as 'wives' or 'friends', describing how 'I always wanted them near, have them near me'.[3] The 'pseudo invert', an identity claimed by the likes of Lady Una Troubridge, was loved by many a 'congenital invert', like Radclyffe Hall. Natalie Barney was the star of Paris Lesbos, its citizens congregating around her at receptions she held decked out in the finery of couturier Madeleine Vionnet. And, in the case of fashion and its history, femmes have been hugely influential, as we've seen with Madge Garland. In her essay 'What Does a Lesbian Look Like?' Elizabeth Wilson muses, 'that such an iconic fashion leader should have been a lesbian paradoxically suggests how very queer it can be to seem straight, and that for a transgressive woman extreme elegance could be the queerest thing of all'.[4] This sentiment is echoed by LGBT historian and activist Madeline Davis: 'Women who look and act like girls and who desire girls. We're just the queerest of the queers'.[5]

Of course, a specific kind of 'femme-ininity' reigns supreme in lesbian history: that of the butch/femme mid-century bar scene, and its often very specific markers, like the black handbag, the bouffants and beehives.[6] There were times when femme fashions simply followed mainstream female fashions, but at others they diverged noticeably. The negativity towards femmes later in the twentieth century was not only due to butch and femme being considered parodies of heterosexual roles, but also because of lesbian feminist disdain for and resistance to heteronormative fashion, full stop. 'With flat shoes, baggy trousers, unshaven legs and faces bare of makeup', wrote Inge Blackman and Kathryn Perry in the 1990s, 'their style combines practicality with a strong statement about not dressing for men'.[7] This attitude could lead to conflict and active vilification of femmes. Silva, a British lesbian interviewed in Jane Traies' *Now You See Me: Lesbian Life Stories*, recalled with regret that in the eighties she had 'talked about those "lipstick lesbians," and looked down on feminine lesbians, and all those labels we used to give one another…'.[8] Femmes, through association with fashion, were considered an enemy to the lesbian cause.

* * *

Femininity has an inherently different shape in a lesbian context. For instance, in the mid-century the feminine partner in a lesbian couple

often took on the role of 'breadwinner' at a time when heterosexual society almost never saw households with women as the sole earner. By dressing in a traditionally feminine way, or in a way that aligned with social expectations, working-class femmes were more likely to find work than butches. As Joan Nestle puts it, a femme's appearance 'allowed her to cross over into enemy territory to make economic survival possible'.[9] This unique femme skill, of masquerading as 'normal' for personal or community gain, has been defined most accurately, perhaps, by the Black lesbian writer Jewelle Gomez in a 1998 article: 'We are in a war for liberation', she declared. '[B]utches are the front-line troops and femmes are the tactical guerrillas'.[10]

Meanwhile, some other kinds of femme expression never passed for traditional (heterosexual) femininity. Black femme lesbians, particularly within the working-class bar scene of the 1950s, were certainly feminine but, Kerry Macneil explains, 'may not have been read as such' by white Europeans and Americans, whose ideas of femininity 'were informed by white patriarchal culture'.[11] The Black lesbian poet Audre Lorde acknowledged this in *Zami: A New Spelling of My Name*—a 'biomythography' in which she chronicles how:

> By white america's racist distortions of beauty, Black women playing 'femme' had very little chance at the Bag. There was constant competition among butches to have the most 'gorgeous femme' on their arm. And 'gorgeous' was defined by a white male world's standards.[12]

And so, as has often been the case within the lesbian feminist movement, when it comes to femmes the experiences of Black lesbians have been largely glossed over.[13]

The equation of femme identity with whiteness is not the only problem; lesbian femininity is also overlooked when viewed from a straight perspective. Arlene Istar described in the 1990s a specific brand of femme-ininity that did not pass as heterosexual:

> Although I enjoy wearing skirts, I often wear pants. I rarely wear makeup (although I do have a fetish for nail polish), and I proudly wear my facial hair. [...] I do not fit anyone's stereotype of a feminine woman, any more than I fit anyone's stereotype of a dyke.[14]

For Istar, this 'mixed' look was in fact at the very heart of her lesbianism: 'I suppose that's what being a femme-dyke means. The

boys think I'm butch, and the girls think I'm femme'.[15] The nineties wasn't the first time that femmes had deliberately blurred the lines between butch and femme fashions. The historian Alix Genter outlines the 'creative strategies' used by femmes in New York during the postwar decades, dabbling in visual butchness 'to "prove" themselves before returning to their preferred feminine styles'.[16] She tells the story of Jessica Lopez, a student at Bay Ridge High School, 'who went to school in a man-tailored shirt with her hair tucked up into a hat' in order to get the attention of a group of butches. Jessica's plan worked, and with her lesbianism acknowledged, she returned to her favoured 'tight skirts and dresses with nylons, makeup, and her long hair down'.[17]

Femme-ininity is unfixed. It can look butch or it can put on butch clothes, it can mix femme mannerisms with a sensible shoe and a pair of trousers, or be dressed to the sparkling nines in lipstick and heels but ready to fight at a moment's notice. Being a femme is about desire: for the erotic and the romantic, sometimes, but often for a way of being. Even by lesbians, feminine clothing is so commonly seen as nothing but a trinket for male eyes—but femme identity, wrapped in its dresses, heels, hairspray and lipstick, is nestled securely in the lesbian past and woven into its future.

When femininity is reworked and reclaimed on the lesbian body, and by other feminine queer people, it takes on vastly different meanings. When femininity is worn by a lesbian and desired by a woman, it is the opposite of a patriarchal tool. Paula Austin, writing in the nineties, declared in her essay 'Femme-inism' that 'I am a black self-identified femme. My hair hangs in loose curls a little below my shoulders. I often wear makeup, and I like high heels, although I seldom wear them'. She finished with a firm statement: 'My femme-ininity does not make me victimized. I have a choice in what I look like and who fucks me'.[18] Femme-ininity may have evolved and changed over time, metamorphosing from an identity with clear dress codes in the 1940s and fifties to one with an abundance of expressions in the twenty-first century, but it is lifted up by its history. Each femme who has claimed and worn it has contributed their personal power to the term. Femme is liberation. It cannot be anything else.

PART FOUR

MIRACULOUS MASCULINITY

Masculinity, on the lesbian body, is a thing of wonder. It is a fight against the odds and the norm, a way of living for a woman—or someone socialised as a woman—that shifts the structures that confine them. While femininity and androgyny fight their own battles and reap their own joys, masculinity remains integral to any history of lesbian fashion, recurring across the globe. From Anne Lister's all-black wardrobe in nineteenth-century Yorkshire to New York City butches over a century later, where lesbian fashion goes, masculinity follows.

In many of the stories I've told so far, lesbian dress straddles the boundaries of gender. In Part 4, I turn to style that is entirely masculine, sitting firmly on one side—but no less subversive when it comes to ideas of what masculinity means, and who it belongs to.

These chapters explore masculinity worn for performance. Occasionally, these performances weaved through people's real lives, not to entertain but to pass as a man. At times, this embracing of a male appearance was for specific, temporary reasons; other times it was because an individual wanted to live permanently as a man—but in the written record, most of these narratives (both fictional and those based on sensationalised fact) were portrayed as involving a kind of disguise. Such stories, or the ways they are told, are tied to contemporary understandings of lesbianism, sapphism, or other kinds of women-loving and gender-transgressing. More commonly (at least, in the historical record), a performance of masculinity was recognised as a 'costume' for entertainment. It is these stories that make up the bulk of Chapters 11 to 14. Even here, though, the lines of fiction and reality are blurry, with allowances made for the stage crossing into the everyday world.

We begin in the eighteenth century and end in the twenty-first, spanning centuries of cross-dressing, male impersonating and drag. The first chapter, on cross-dressing in the 1700s, covers two kinds of masculine performance that could, and often do, have entire books dedicated to them: breeches roles and female husbands.[1] Chapter 12 continues into the nineteenth and twentieth centuries, spotlighting the male impersonators of Britain and North America. Performers like Annie Hindle, Ella Wesner, and Vesta Tilley were part of a tradition based in music hall and variety shows. Then, Chapters 13 and 14 move from roles and careers to specific individuals, and the clothing that adorned their lives. The first is Gladys Bentley, a Black American blues singer of the early twentieth century. Gladys was renowned for her wardrobe, and among the most successful male impersonators ever to perform. We finish with Stormé DeLarverie (1923–2014), an LGBTQ+ activist. Stormé worked as a male impersonator for just under fifteen years, but her life encompassed so much more. The clothes that she wore, ever-masculine from the 1950s onwards, illustrated her life but could never define it.

More than at any other point in this book, the following four chapters blur the line between lesbian fashion histories and queer and/or trans ones. These stories overlap with and affect one another in the past and the present. In some examples—particularly in the case of female husbands—the people mentioned might have understood themselves as something more akin to trans than as lesbian women. I am not attempting to posthumously label any of the people whose lives and dress I describe, only to place them in a certain historical narrative: one that is inclusive and celebratory and always, ever visible. Each of the people and every garment mentioned helped to progress lesbian fashion history, but none are limited to it. They are, after all, the main characters in stories of their own, and in miraculous, masculine lives.

BREECHES ROLES AND FEMALE HUSBANDS

CROSS-DRESSED BRITAIN IN THE 1700s

In eighteenth-century Britain there was a fascination with cross-dressed women. It had been stirring for a while, and there was of course a mammoth history of those assigned female at birth wearing traditionally male garments. There are many reasons why such a person might dress in men's clothing: employment, freedom to travel, gender identity or lesbian sexual opportunities, to name only a handful. But, as Norena Shopland points out in *A History of Women in Men's Clothes: From Cross-Dressing to Empowerment*:

> Taking into account similar results in other languages and other time periods, the total number of women cross-dressing is incalculable—mainly because we are restricted to those women we know about—many thousands more will never have been caught or talked about publicly.[1]

So, we are left with only the most visible kinds of cross-dressing to tell its stories: public-facing, and eighteenth-century. The century's boom was, in many ways, unique to Britain, though as we'll discover, there were famous cross-dressed women (and gender-ambiguous individuals) throughout Europe during this period.[2] In England, specifically, there were no laws against cross-dressing or sexual encounters between women. People who cross-dressed in order to pass as men could be taken to court for fraud if they worked in a male-only profession or married a woman, but the wearing of men's clothing was not in itself a criminal act.[3] This is part of the reason why a culture of women in breeches was able to thrive. Whether in

the shape of fancy-dressed revellers, costumed actresses or people who may not have been women at all denouncing petticoats to live as a man, masculinity was up for grabs.

Reflecting on this moment, it is through others' words that we see these bold claimants of a clothing culture that did not belong to them. I have placed an emphasis on stories that appeared in the popular press and mainstream publications, or else on the stage, a spectacle to be consumed. Books, newspapers, pamphlets and magazines are staples within fashion research, but they are not always entirely reliable sources. In the words of fashion historian Lou Taylor, commentary from this era 'is all too easily prone to distortion, prejudice, exaggeration, social resentment and even jealousy'.[4] Still, even if many records might not be entirely accurate on what was worn, the public nature of and response to stories of 'women in men's clothing' is, I believe, just as important a part of lesbian fashion history.

It goes without saying that there was a vast opposition to this growing phenomenon. From fraud cases against those who were caught 'passing' to angry poems about cross-dressing entertainers, they were never easy shoes to walk in; yet for many it was worth the risk, whether for an evening thrill or a lifetime. Different kinds of cross-dressing bloomed into public consciousness throughout the eighteenth century. While some consumers viewed these with revulsion or morbid fascination, others idolised women in breeches, including female actors. Breeches roles, sometimes known as breeches parts, were when women dressed as men or boys on stage for the theatre or opera. This could be as part of the performance's narrative, with a female character dressing as a man as a disguise—Viola in Shakespeare's *Twelfth Night*, for example—but they were sometimes male characters intended to be played by women.

The term 'female husbands' describes an entirely distinct yet connected experience, of real people who rejected womanhood (in appearance and/or on a personal level). They were fictionalised and caricatured in published stories and the press, but the term 'female husband' has come to mean so much more than sensationalistic writers could have dreamed, encompassing at once the spectacle made out of these stories and, once again, the public desire to consume them. It also describes the gender and sexual transgressions of those

who lived as men and who married women, at once remarkably brave and entirely ordinary.

All of this existed against a backdrop of wildly popular masquerades, which sprang into life in 1717.[5] These were, in essence, fancy-dress parties, where cross-dressing was both common and acceptable. Their existence, and the persistent presence of cross-dressing at them, suggests the ever-widening appeal of gender-blurring dress during this period: gender was fashionably in flux. Though those taking part in the trend were not always lesbians—or even lesbian-adjacent—the fashion for cross-dressing during masquerades was part of a broader culture of women in men's clothing that allowed more explicit queerness to find a home. After all, the breeches-clad legs of the dashing young women at masquerades would have inevitably caught the attention of other dressed-up girls. Some of those caught eyes would have known exactly what they were looking at.

I use 'lesbian' to talk about these broad concepts and expansive identities in much the same way that I have done throughout this book. The cross-dressing narratives and realities of the eighteenth century are part of lesbian fashion history from where we look back at them today, but only as an interpretation of the past, rather than a restrictive label. It is undeniable that histories of cross-dressing are innately tied up with transgender histories. It is also true that viewing them through one lens does not prevent us from switching to another—or looking through both. There are many ways to think of cross-dressing histories: Shopland suggests the terms 'cross-dressing, cross-working and cross-living', Jack Halberstam favoured 'female masculinity', and Ula Lukszo Klein focuses on 'sapphic possibilities' in *Sapphic Crossings*.[6] Placing these histories, for a moment, within a history of lesbian fashion is just one more way to understand them, and to understand lesbian lives today.

Double power to please

It is 1740, and Margaret 'Peg' Woffington is on stage at Drury Lane in London, playing the role of Harry Wildair in *The Constant Couple*. She is the second actor ever to play the role, and the first to play it as a breeches role (Figure 24). Her character is a rake, and popular among the public. Peg is a woman, twenty years old, and widely considered beautiful.

Imagine, for a moment, that you are a woman attracted to other women seated in the audience of Drury Lane. Or, perhaps, you are someone who has always lived as a woman but have never felt comfortable as such, or at ease with the skirts that shroud your legs. Imagine you look up to the stage before you and see Peg Woffington clad in breeches, a wolfish smile on her feminine face, ever the leading man. Peg herself was entangled in relationships with various men—though how scandalous these were in reality versus in exaggerated unofficial memoirs is up for debate.[7] Peg, making a name for herself with breeches roles like Wildair, Sylvia in *The Recruiting Officer* and more, represented possibility. She represented difference, a vision of what it looked like for a woman to wear men's clothing, to captivate women and be celebrated nonetheless. She was not alone in her proclivity for breeches roles, but she was celebrated for playing them in a way that no one else could hold a candle to.

One anonymous poem from the time of Peg's run as Harry Wildair reflected on the specific allure that she held in male attire, in contrast to a role where she dressed in women's clothing, Polly in *The Beggar's Opera*. It focuses on Peg's power, in double-legged garments, to please the women as well as the men in the audience:

Peggy, the darling of the men,
In Polly won each heart;
But now she captivates again,
And all must feel the smart.

Her charms resistless conquer all,
Both sexes vanquished lie;
And who to *Polly* scorn'd to fall,
By *Wildair* ravish'd die.

Wou'd lavish nature, who her gave
This *double power* to please;
In pity give, *both* to save,
A *double* power to ease.[8]

Though the poem's probable intention was to indicate, at once, Peg's visual appeal and her talent in the breeches role—she played a man so well that even women fell for her—its effect is one of overwhelming sapphic potential. Her charms 'conquer all', and

though it is by the male character Wildair that the female half of the audience are said to be 'ravish'd', the poem never removes Peg's portrayal of him from her womanhood. She is constantly referred to with 'she' and 'her' pronouns; there is no pretence that her attractiveness to women is by them mistaking her gender. This poem is far from the only one of its kind, with a couplet from another announcing that, upon Peg's donning of breeches:

Each sex, were then, with different Passions mov'd,
The Men grew envious, and the Women loved.[9]

Breeches are presented as a switch: wear them, and women love you. But then, surely, the love that women should have for men can be altered with ease, the social position of manhood defined solely by their trousers. This reading of the poem bubbles beneath the surface, an impossibility but an obvious conclusion. After all, it's unlikely that the poem's intention was to suggest that Peg appealed to women simply for her own self—that women can and do attract other women. Either way, the reception of her breeches roles undeniably made room for lesbian possibility, bringing it onto the stage with her and letting the spotlight illuminate it. A spark like that is always seen by those in the crowd who are looking.

In other cases, the women who wore breeches on stage did not only represent possibility, but fact. While Peg Woffington appears to have only engaged in relationships with men (though who can say exactly what went on behind closed doors?), others, quite publicly, had different tastes. Mademoiselle de Raucourt appeared for the first time on stage in Paris in 1772. She was immediately admired and praised for her talent as well as her beauty. Art historian Mary D. Sheriff tells us that 'contemporary descriptions suggest she was a powerful woman with force and energy, of an antique beauty rather than a feminine grace and charm'.[10] Her beauty led to a host of admirers, but, in contrast to most actresses of the period, de Raucourt refused to sleep with the male fans who approached her with promises of financial security. For a time, this garnered de Raucourt a public image of purity... but this didn't last, quickly giving way to a quite different reputation: that of the 'young priestess of Lesbos'.[11]

De Raucourt's story is long and complex, irrevocably intertwined with the French Revolution. She appears in pamphlet after

pamphlet between 1789 and 1799 as a figurehead among Parisian lesbians—a community scorned by many revolutionaries as a legacy of the old regime. They 'associated sex between men and sex between women', explains Jeffrey Merrick, 'with aristocratic privilege or turpitude'.[12] Cross-dressing was part of how these pamphlets illustrated de Raucourt's character and those of others like her. In *Correspondance secrète, politique, et littéraire*, essentially a French gossip rag, de Raucourt's cross-dressing was connected to her sexual exploits. Another publication, *Chronique arétine*, reported in 1789— the year of the revolution—that she was seen leaving the home of a female lover 'disguised as a man, after having attempted to fulfill that role with her loving mistress'.[13] This meant that when de Raucourt created a breeches role for herself, a countess disguised as a soldier in her play *Henriette*, she was met with heavily critical reviews. This was flaunting her lesbian lifestyle too loudly. In this context, breeches were innately tied up with lesbian self-expression and sexuality.

Yet, despite de Raucourt being condemned and satirised by the intellectual elite, she remained the darling of swathes of the French public. When the clergy of her parish refused to bury her body after her death in 1815, a crowd broke down the doors to the church. A riot sprung up in defence of her name. Her body ended up buried at Père Lachaise, the largest cemetery in Paris (and, at the time of writing, the most visited in the world).[14]

They would live as man and wife

In different ways, Peg Woffington and Mademoiselle de Raucourt captivated their respective audiences with their performances, personalities, and breeches-clad legs. Another cross-dressed figure went even further, winning the title of the nation's sweetheart— though only after his death and the publication of a heavily fictionalised account of his life. After the death of Giovanni Bordoni, born and posthumously known as Catterina Vizzani, there was a public outcry demanding Giovanni's canonisation as a saint.

Giovanni, to borrow Shopland's term, cross-lived. Born in Rome in 1718, at age fourteen Giovanni (then Catterina) fell in love with a girl, Margaret, who taught her embroidery. She began wearing

male clothing in order to court Margaret, but fled upon the relationship's discovery, assuming the name Giovanni Bordoni. Giovanni then began work as a vicar's servant in Perugia, where he was supposedly 'the best seducer of women in that part of the country'.[15]

Giovanni's story twists and turns until his eventual death in 1743, a result of being shot in the leg after eloping with another girl. After his death, another Giovanni—Giovanni Bianchi, a surgeon and professor of anatomy—conducted an autopsy on the body, later using his findings to publish a work titled *The True History and Adventures of Catherine Vizzani*. The book was so successful in Italy that it was translated into English, though tarnished with a brush more disapproving than the Italian original. Notably, in the book's introduction translator John Cleland writes that Giovanni was 'so far from being inferior to *Sappho*, or any of the *Lesbian* nymphs, in an attachment for those of her own Sex'.[16] Once again, someone who dressed in male attire is publicly compared to Sappho and the women of Lesbos who centre in Sapphic poetry. Once again, the narrative of the cross-dressed woman overlaps with lesbian history—or, at least, one of its precursors: Lesbian history, with a capital 'L'. And, as it often does when it comes to masculinity in historical figures recorded as women, that narrative overlaps with trans histories.

Today, an online project named 'Vizzani Bordoni' seeks to recognise Giovanni as a historical example of a trans man: 'It is impossible to determine the precise way Bordoni identified, as he never gave a personal account of his gender, but there are several instances where the text portrays Bordoni as identifying as a man'.[17] Giovanni is a branch in the queer timeline that reaches out to a hundred possibilities, just as Peg Woffington or Mademoiselle de Raucourt must have sparked the fire of sapphic possibility in so many of their audiences. Breeches, clothing, cross-dressing: these are the matches; the tinder; the friction.

As Giovanni's story suggests, there were circumstances where cross-dressing entered the public eye off-stage. Sometimes, such cross-dressers were wrapped in a neat label: 'female husbands'. The first to be given this label was immortalised in Henry Fielding's 1746 pamphlet *The Female Husband: or, the Surprising History of Mrs. Mary, alias Mr. George Hamilton, Who was convicted of having married a Young Woman of Wells and lived with her as her Husband. Taken from Her*

own Mouth since her Confinement. This was based on a true English story but written with substantial artistic licence. The real Mr Hamilton went by Charles, not George, and despite the long title declaring the tale as being from Charles' 'own mouth', it deviates considerably from the surviving court records of Charles' case after his arrest (as with Giovanni, I am using 'he/him' pronouns to reflect Charles' real-life choices). No matter the details, the image of Hamilton as painted by Henry Fielding created a name for a new genre of both real people and storybook figures, regarded socially as women but choosing instead to live—and dress—as men. As Jen Manion's 2020 history of 'female husbands' explains:

> While not the first person assigned female to live as a man and marry a woman, Hamilton was the first person to do so who was characterised as a 'female husband'. This designation took on a life of its own in the ensuing decades, creating a catchy, memorable, and succinct way to describe transing gender and same-sex love all at once.[18]

In Fielding's version of events, George Hamilton marries three different women, consecutively, before eventually being found out by his third wife. Yet there is no evidence that Charles Hamilton married more than one woman: Mary Price from Wells, in Somerset. After two months of marriage, Mary reported Charles to the authorities for the crime of impersonating a man. We cannot know the realities of the situation; Mary may have decided against the marriage and found an easy way out, she might have become tired of pretending or, as she asserted in court, she may really have only just discovered that Charles was not entirely who he said he was. This is possible, with young women of the period hardly having been supplied with a detailed education on sex and biology, but it is also difficult to believe: Mary testified that the couple had frequently been sexually intimate.[19] The outcome of the trial, of course, embraced the narrative of Charles' deception. He had to be in the wrong. To rule otherwise would be an endorsement of sexual and gender diversity, which may sneak through in the press and on stage, but certainly not in the eyes of the law.

Outside the courtroom, though, Charles was most often given favourable coverage, especially when it came to the clothes he

wore—or the success with which he cross-dressed. *The Bath Journal* described Charles' male clothing as stylish and admirable: 'very gay, with Perriwig, Ruffles, and Breeches'.[20] He seemed to wear these garments well and with confidence, apparently being 'bold' in manner, and his fashionable adoption of male attire helped sensationalise the story further.[21] He was not an obvious transgressor, and blended in with the communities around him. The clothes he wore 'signalled conventional English styles', according to Manion.[22] Fielding lingers on his outfits at various points, too, though the specifics are entirely imagined:

> The poor Female Bridegroom ['George' Hamilton] whipt on her breeches, in the pockets of which, she had stowed all the money she could, and slipping on her shoes, with her coat, waiste-coat and stockings in her hands, had made the best of her way into the street, leaving almost one half of her shirt behind, which the enraged Wife had tore from her back.[23]

The clothes, both in fiction and reality, very much made the man. To others reading accounts of the story in the press, Charles/George's outfits were what turned him into a threat—an imposter, the like of which could be lurking in their own neighbourhood. To some readers, his clothing may have signalled possibility once more. I wonder how many people who we might include in a lesbian or a trans history found out about Charles/George Hamilton, whether through the press or Fielding's pamphlet, and saw him as an inspiration?

Female husbands were not the only fictionalised or semi-fictionalised version of cross-dressers. Writers other than Fielding also attached the word 'female' to titles typically reserved for men.[24] *The Female Soldier* (1751) chronicles the adventures of Hannah Snell, who lived and worked as a soldier under her brother's name, James Gray, her alleged motive being to find her absent husband. She revealed herself as a woman upon leaving active duty, sold her story for publication and, notably, received an army pension. Accounts like these didn't necessarily depict their characters negatively, as we can see from heroic titles like *The Female Soldier*, or *The Life and Adventures of Mrs Christian Davies* (1740). At least, any negative associations could be outweighed by 'positive' plot points or character traits, such as fighting for the British Empire or searching for a lost husband.

Straight reporting of real-life female husbandry could be similarly tolerant. James How (1716–80), formerly known as Mary East, spent thirty-four years by the side of an unnamed wife, with whom James ran a well-regarded public house in Poplar, London. An article about them was published in *The London Chronicle* in 1766, its long title beginning, 'The FEMALE HUSBAND'. James and his wife, called 'Mrs. How' in the piece, are presented as morally pure, even though it is acknowledged that James originally lived as a woman; there is no mention of romantic love between them, and James' gender transgression is presented as a logistical matter, not one of identity or deep feeling. Instead, the reason for the thirty-four years of dedicated partnership between the couple is carefully explained away in the article's opening paragraph:

> About 34 years ago a young fellow courted one Mary East, and for him she conceived the greatest liking, but he going upon the highway, was tried for a robbery and [...] was afterwards transported; this so affected our heroine, that she resolved ever to remain single. In the same neighbourhood lived another young woman, who had likewise met with many crosses in love, and had determined on the like resolution; being intimate, they communicated their minds to each other, and determined to live together ever after; after consulting on the best method of proceeding, they agreed that one should put on man's apparel, and that they would live as man and wife in some part where they were not known.[25]

This explanation is possible, but certainly no more believable than many other possible reasons why Mr and Mrs How might have chosen to spend their lives together.

James seemed to live comfortably in male attire: shortly after setting off with Mrs How, he purchased 'a man's habit'. He does not, in *The London Chronicle*'s narrative, wear women's clothing again until he goes to court. James' court case, unlike Charles Hamilton's, did not find him in the role of accused but accuser: after an acquaintance from his youth blackmailed him with the threat of exposing his past as a woman, James 'applied to the bench of Justices for advice', giving up his hard-won identity as James How as a result.[26] For the hearing, James 'dress'd in the proper habit of her sex; now again under her real name of Mary East'. Apparently, 'the

alteration of her dress from that of a man to that of a woman appeared so great, that together with her awkward behaviour in her new assumed habit, caused great diversion to all'. Women's clothing may have been the 'proper' attire for James, but it was clear even to his contemporaries that living (or at least, dressing) as a man was far more natural for him. Crucially, this was not seen as a flaw; the article confidently characterises James as 'honest', with an 'unblemished character'.[27] This favourable narrative was only possible, however, because James and Mrs How's relationship was presented as entirely platonic, their life choices purely practical.

There was a fine line between acceptability and depravity for the female husband. Someone raised as a woman could be praised for donning breeches and living as a man if their story was sufficiently romantic, their lifestyle filled with hard work, their relationships with women (supposedly) sexless. In reality, of course, this was not always the case. 'Female husbands' were presented in the press as existing on a dichotomy of virtuous and vile, but only a handful ever *were* presented by the press. The examples that we have are only one side of each story. We might imagine the people who never got caught—those who weren't preserved in pamphlets or court records, whose lives were complex, private and queer.

12

VARIETY

MUSIC HALL, MALE IMPERSONATION
AND A TURNING CENTURY

Victorian Britain is often remembered as a period of stony-faced sobriety, tight-laced corsets and rigid gender distinctions. Frivolities are rarely depicted in this landscape, but in reality entertainment was more accessible and affordable than ever before. The industrial revolution had caused people to flock to bustling towns and smoky cities, creating an urban working class that was desperate to let loose. Bawdy performances, cheap alcohol and mixed company were in demand, and the small pubs and taverns that had for centuries hosted musical performances for working people would no longer cut it. Gradually, they gave way to larger venues—like the music hall.

The UK, as chronicled in the previous chapter, had a history of cross-dressing for entertainment, but male impersonation took off as its own speciality in the late nineteenth century, as part of the music hall phenomenon. Music halls were, as the name suggests, originally open halls with standing audiences, but in the 1890s they transformed into theatres with tiered seating in the interest of audience safety.[1] Music hall culture thrived across the country, from London to industrial towns in the north of England, with spectators ranging from middle-class thrill seekers to working-class men and women. The range of different acts at each show provided escapism for these diverse audiences.

The profession of male impersonation, on stage and usually in the form of stock character types, was often a fruitful one. But I believe

131

that for many male impersonators, their chosen career path was more than a way to earn a living; it was a way to express themselves, to dress as they preferred and to woo the kinds of people they wanted to woo. Being a male impersonator meant that any difference from the norm, whether gender, sexual, or even just aesthetic, could hide behind the curtain of the theatre and theatricality.

Annie Hindle was a male impersonator born in England in the 1840s, who began performing at the age of six. In 1868, she moved to the US—bringing all that she learned on the British stage with her, and quickly making a home for herself in the hearts of many women. The popularisation of male impersonation in the US can be pinpointed to Annie's debut.[2] Throughout the 1870s it thrived, and by the turn of the century was a staple in American variety theatre. Variety, like the British music hall, was an accessible form of entertainment, later being taken over by and becoming known as vaudeville. There was great overlap between male impersonation in Britain and North America; often, the acts were even the same, with performers relocating like Annie, or touring abroad.

Legions of male impersonators remain prominent in the historical record, and many more linger in the margins. In this chapter, we will meet just a handful, who, through their personal lives, their impact on their audiences, or both, overlap into a history of lesbian fashion. Some male impersonators used their clothing, their platform, their image and, sometimes, their name to live a life that was distinctly non-heterosexual. Others, no matter who they loved or married, were undeniably loved by women.

Annie, the first of the US male impersonators, was a confirmed woman-lover. Ella Wesner, the second and perhaps most successful US male impersonator, has been followed by rumours of a lesbian elopement. Florence Hines, who has been called the leading Black male impersonator in the nineteenth and turn of the twentieth century, is little-known but full of possibility. Johnstone Bennett and Blanche Selwyn twisted the norm in their own ways, and in the UK male impersonators continued the craft into the 1940s and fifties. From world-renowned Vesta Tilley to lesbian-audience favourite Ella Shields, cross-dressing stage actresses Eva le Gallienne and Gwen Lally, British male impersonators in particular took to the music hall and carried on beyond it.

Overt and covert in American variety

Annie Hindle was approximately twenty when she moved to the US in 1868. She had been performing as a male impersonator before this, though on smaller stages. Moving to America was Annie's chance to not only relaunch her career, but to launch male impersonation as a genre across the Atlantic. It was a big dream, but she achieved it. Though Annie was the first, she did not sit unchallenged for long; soon, Ella Wesner was making a name for herself across the country. Ella, previously a ballet dancer, had met Annie while performing in 1869, and was very probably inspired or even encouraged by Annie and her career.[3] Ella's own life as a male impersonator began only one short year later, in 1870, when she took her trousered legs to the stages of New York City.

As with female husbands and masculine people seen socially as women, male impersonators like Annie and Ella transgressed and transcended the boundaries of gender. They also, in many cases, openly loved women or other gender-transgressors. But the male impersonators I am discussing did not to our knowledge live or understand themselves as men—so I will largely be referring to them as women. I recognise this label as malleable, and as actively deconstructed by male impersonation itself. Its performers, recognised as women by so much of their contemporary world, used their lives on the stage (and sometimes off) to question what the boundaries of gender really meant.

Annie Hindle was 'blonde, about five feet six with a plump form, well-shaped hands, small feet and closely cropped hair', reported the *New York Sun* in 1891, 'which on or off the stage, she parted on the side, brushing it away from the temples just as men do'.[4] She played a number of stock characters, primarily the 'swell' or 'man-about-town', whose main characteristic was his distinctive, enviable fashion sense. For this reason, Annie frequently dressed in luxurious fabrics and cuts, branding herself the 'Roi de la Mode': the 'King of Fashion'.[5] The 'swell', while often the object of admiration, could also turn into a character of contempt, particularly in periods of economic decline; in these instances the role aligned more strongly with another stock character, the 'dude', 'fop' or 'dandy', whose mannerisms and clothes leaned towards the effeminate. The 'swell'

twisted gender and sexual norms in an interesting way—they were people perceived as women by the audience, but were envied by men. They were fashionable, and they were admired by women.

Annie married a man, fellow performer Charles Vivian, not long after her arrival in the US. This appeared, even at the time, to be only a way of assisting Annie's career, and they split a few months after the wedding. In the world of variety, this was hardly shocking; what was more so was Annie's report that her husband had been physically abusive.[6] For the rest of her life, Annie's true passions were clear. Gillian M. Rodger's insightful history of American male impersonation, *Just One of the Boys*, tells the fascinating story of Annie's oft-wedded life, mostly to women. The most famous wedding took place in 1886, when Annie married her dresser, Annie Ryan, using the name Charles Hindle. Annie Ryan was 'a pretty little brunette of 25 […] who made friends wherever she went'. She dressed in her 'traveling costume' for the wedding, while 'the female groom', now in her forties, wore a men's suit.[7] The *New York Clipper* described the marriage in simple terms: 'On Sunday night, Annie Hindle, under the name "Charles Hindle," was quietly married to Annie Ryan of Cleveland, O., who for the past five years has been travelling with him or her as a maid'.[8] The marriage had become public knowledge and the press were rapt, apparently hounding the Annies for interviews, but Annie Hindle's career survived unscathed. Clearly, to be a male impersonator gave a certain level of cover: gender ambiguity made room for socially-permissible same-sex marriage.

The couple stayed together until Annie Ryan's death in 1891. Her funeral, attended by a number of well-known figures from the variety circuit, prompted more discussion of the Annies' relationship in the press. One article—first printed in a local paper with the title 'The Wife of a Woman', and resurfacing a month later in *Vanity Fair* as 'Marrying a Maiden! Can a Woman Legally Marry a Woman?'—paints Annie Hindle in a positive light, however strange the author thought her actions might be. The marriage is confidently presented as a 'romance', with Annie Ryan portrayed as Hindle's 'faithful companion'.[9]

A year later, in July 1892, the *Chicago Daily Tribune* reported: 'Annie Hindle, the celebrated male impersonator, became again,

for the second time in her life, a married woman Sunday, June 26, in Troy. Miss Annie Hindle became not the wife, but the lawful husband of Miss Louise Spangehl'.[10] Annie met Louise in Troy, New York, while performing there. It is notable that the *Tribune* names her Annie's second spouse—completely erasing her husband Charles Vivian from decades before. He may not be the only one missing: Gillian Rodger has 'found additional marriage records that suggest that Annie Hindle had been using the name Charles in order to marry women from as early as 1868', the year of her arrival in America.[11] These include a marriage between a Charles Hindle and a Nellie Howard in December 1868—the name of a jig dancer Annie Hindle had been working alongside at the time—and between a Charles Hindle and a Blanche Du Vere in November 1870. During this month, Annie was working with a variety performer named Blanche De Vere at the Metropolitan Hall in Washington, D.C.. Notably, in 1871 Blanche De Vere also became a male impersonator, changing her name to Blanche Selwyn.[12]

Blanche and Annie's possible whirlwind romance is a marvellous thing to imagine. What ensued—Blanche Selwyn's own male impersonating career—is just as interesting. Blanche, like Annie, favoured the 'swell' character. Even more so than the 'King of Fashion', however, Blanche's wardrobe was praised. 'Her singing is good, style dashing, costuming superb, and changes fair', applauded the *New York Clipper* in 1872.[13] Blanche Selwyn, unlike other male impersonators who could be and were mistaken for men on a regular basis, was more obviously a woman in figure; she was bigger with more curves than others, and she favoured 'well-cut suits' and 'richly embroidered waistcoats', her shape and her close-fitting outfits making her more legible as a cross-dressing woman to an audience who saw gender in black and white.[14] Her incredible fashionability on stage meant something different: Blanche Selwyn, playing the 'swell', was an enviable figure, a masculine figure, and a female figure all at once. Her command of male clothing was irremovable, in the eyes of the audience, from her womanhood. This is a rare thing, indeed.

* * *

But what of Ella Wesner? Ella, inspired by Annie, went on to surpass her, touring England between 1876 and 1880 to great acclaim as 'The New York Beau' and returning to a fruitful career in the US for the next decade.[15] Ella, too, has been followed by the story of a famous lesbian love affair. Though the details here are less clear than Annie's marriages, we know that Ella ran away—or, perhaps, eloped—to Paris in 1872 with Helen Josephine 'Josie' Mansfield. This dramatic flight followed in the wake of an unfortunate love triangle between Josie and two wealthy men, Jim Fisk and Edward Stokes, which ended in Fisk being shot and killed by Stokes. Josie, escaping the press, and Ella, supporting Josie with friendship or something more, were happy in Paris for six months. After this, Ella returned to her career in the US, which continued to thrive. The possible elopement was public knowledge, however: in 1891 the *New York Sun* mused that 'the only romance in [Ella's] life was her well-known escapade with Josie Mansfield, the notorious'.[16]

Ella's reputation didn't suffer from her months at the side of another woman. Like Annie, if anything, it added to her eccentric appeal. Being a male impersonator gave her a free pass to love women, and for women to love her—it was all just an act in the eyes of the public. In fact, after one of Ella's performances in San Francisco, a reviewer noted that if women were allowed into Ella's venues 'they would all fall in love'.[17] This was only an appropriate comment to make because Ella performed so well. If women were falling in love with her, it was her masculinity which they adored. Her image was immaculate, captured in cabinet cards made to be shared, complete with top hat and matching velvet waistcoats and tuxedos (Figure 25). She would, according to the *New York Clipper* in 1870, have been able to 'easily walk Broadway in male attire without her sex being suspected'.[18] Perhaps she did: her image, so celebrated and shared, was most likely not only an act. In fact, it stretched beyond the grave, with a final request to be buried in male clothing.[19]

It was not entirely unusual for a performer's public image to be so masculine, yet so embraced. Johnstone Bennett was not explicitly a male impersonator, but was an actor and vaudeville performer who dressed in male clothing both onstage and off of it. She was born in 1870 and died young in 1906, but made an impression during her

lifetime. Johnstone chose her own name, a mixture of her two adoptive mothers, Mary Bennett and, after Mrs Bennett's death, actress Sibyl Johnstone. While Johnstone's personal relationships are largely unknown, her gender expression and particularly her clothing deserves recognition. Her specific look and the way it was received can help us to imagine the specifics of male impersonators' wardrobes, even if she didn't perform as one herself. An opinion piece in the *Detroit Free Press* described Johnstone as follows:

> She has more scarf-pins than any Manhattan club swell, and a short time ago she had stolen from her fourteen sets of cuff-buttons and studs enameled to match the shirts of colored linen, stiffly starched and glossy, in which Miss Bennett's heart delights and which, worn with a smart vest and coat and a severe tailor-made skirt, give her a very mannish look.[20]

These skirts, according to *The Tennessean* in 1896, were not only tailor-made but had 'trouser pockets'.[21] Of course, male impersonators did not wear skirts on stage, but trousers. Accounts like these, of the masculine clothing worn off stage, show the lines that were still in place for people seen as women when it came to their dress. Some male impersonators, practised as they were with the mannerisms expected of men, might have worn trousers and passed as men with ease. Even for those whose masculinity was considered successful and theatrical—like Johnstone—a suited, booted, masculine outfit still had to be accompanied by a tailored skirt. This continued for many more decades, in many more contexts, such as Radclyffe Hall in the twenties, or the butches who walked New York streets in the middle of the twentieth century. The shirt-and-tailored-skirt combination is a certifiable lesbian tradition.

'Hi Waiter! A Dozen More Bottles' was in the repertoire of many male impersonators, including Ella Wesner and Florence Hines, reported to be the most successful Black male impersonator of the late nineteenth century. Part of the song goes:

> Lovely woman was made to be loved,
> To be fondled and courted and kissed;
> And the fellows who've never made love to a girl,
> Well they don't know what fun they have missed.
> I'm just the fellow who's up to the times,

Just the boy for a lark or a spree
There's a chap that's dead stuck on the women and wine,
You can bet your old boots that it's me.[22]

For a male impersonator to perform this song, as Gillian Rodger notes, meant that the number 'became a challenge to the men in [the] audience'—the performer 'claimed to be at least their equal when courting women'.[23] Florence Hines, as a Black male impersonator, added another layer of subversion to the song. In fact, any performance of the 'swell' character by a Black artist chipped away, however little, at the status quo; as Kathleen B. Casey writes, 'the tuxedo with tails, cane, cape and a top hat countered the image of the ragged, shoeless plantation slave' that was popularised by minstrel shows, a form of racist entertainment that usually included blackface.[24]

We know only a little about Florence Hines, and her relative invisibility is not unrelated to her race. She was clearly a talented performer, likened to famous white colleagues in the white press, and praised as foremost among 'Black male impersonators'.[25] The divide between Florence's popularity and legacy is stark. For years, she was stated to have the highest salary paid to any Black female performer. But historian Hugh Ryan has found that he can 'only locate a single photo of her'.[26] What we do know about Florence places her firmly not just in the canon of male impersonation, but the history of lesbian fashion. The specifics of her costumes—other than the one, low quality photo that survives—may be lost, but we know their effect. If she was such a popular performer, and taking on the same numbers as others like Ella Wesner, we can imagine what she would have worn. Let us place Florence, in our minds, in a velvet waistcoat and tuxedo like those worn by Ella.

We also know that Florence Hines loved women or, at least, that she was publicly assumed to do so. In 1892, she was working as part of a groundbreaking venture for Black performers, *The Creole Show*. At this time, perhaps the height of her fame, a local newspaper published an article implying a relationship between Florence and a female co-star, a singer named Marie Roberts. The paper's report declared that 'the utmost intimacy has existed between the two women for the past year, their marked devotion being not only noticeable but a subject of comment among their associates on the

stage'.[27] Who knows how many other such reports we may have had in our hands if Florence's life and career had been recorded and preserved like those of her white contemporaries. What we see may only be a glimpse, but it is a tantalising one.

Beyond the music hall

The lesbian possibilities that stood on stage beside the male impersonators of the British music hall and the American variety show remain spotlit in the public imagination, partly thanks to fictional accounts weaving the two together—in particular, Sarah Waters' 1998 novel *Tipping the Velvet*. The main character, Nan, expresses a sentiment that I am certain beat within the heart of many real-life audience members on seeing a male impersonator for the first time: 'I never saw a girl like her before. I never knew there were girls like her...'[28] Even when there is no evidence that a male impersonator loved women, or there is even evidence that seems to point in the opposite direction, nothing can erase what male impersonation could have meant to those who watched the performances of someone like Vesta Tilley.

Vesta was perhaps the most famous male impersonator of all time, and the highest paid woman in Britain in the 1890s. Vesta Tilley was a stage name, and she lived her everyday life as Matilda Alice Powles—and later, upon her marriage to Conservative Member of Parliament Walter de Frece, as Lady de Frece. During the First World War she leaned heavily into soldier roles to promote enlistment. Her off-stage identity was far from subversive, but her on-stage presence remained so. The male attire that she wore in her performances ranged from immaculately tailored suits complete with top hats to the loose-fitting uniforms of a sailor, and her outfits are captured in cabinet cards spanning the length of her career (Figure 26). Some show her in the most fashionable female garb of the day, with jewels and furs, enormous hats and cinched waists. The contrast between Vesta's on- and off-stage appearances made her performances more popular, if anything, the transformation being part of the appeal. Modernist literature expert Allison Neal points out that this was a balancing act: 'appearing too much like a man' could destroy the 'subversive and transgressive nature

of the drag act' for music hall-goers.[29] The audience loved not just the male performance, but also the fact that it was a woman who was performing.

One theatre scholar has described Tilley's stage presence as 'the vision of an Adonis',[30] suggesting that Vesta's many female fans saw her only as a beautiful man, and loved her for this reason. This may, of course, have been true in some cases. In others, I believe it is impossible—especially if we consider the on/off-stage divide in Vesta's appearance. Think back to Nan from *Tipping the Velvet*, so enamoured by the sight of a 'girl' dressing and acting as a man. Consider all the women that Annie Hindle wooed as America's first male impersonator. Vesta Tilley amassed so many female fans not because they saw her as the perfect man, but as the perfect woman, even as a possible gender transgressor—or, in Neal's words, as 'a glimpse into a lesbian eroticism that otherwise would be impermissible in public view'.[31]

In the late 1940s, near the end of male impersonation's diminishing reign, women who called themselves lesbians made up the fanbase of the last music hall impersonators. One former patron of London's lesbian club the Gateways remembers that, back in 1947, before heading to the nightclub:

> We used to go to the Chelsea Palace Theatre on Saturday nights and see any male impersonator that appeared there, like Jeanette Aidi or Ella Shields. It was music hall, and Ella Shields would be top of the bill. She was dressed up in a top hat and tails, with a cane. She would do her comedy routine, her impersonations, and sing 'Burlington Bertie'.[32]

Ella Shields had moved to Britain from the US and pursued a career in male impersonation until 1929, though she emerged from retirement for a music hall reunion show—presumably the one Sheila and her friends attended—from 1947 to 1951. If she was so popular with lesbian audiences in her later years, it's likely that she would have been a lesbian favourite in her earlier life, too. If this was the case with Ella, then why not with other male impersonators?

The British scene spread further than the music hall, especially during the interwar years at the peak of Ella's career. There was, of course, the pantomime, with its many principal boys played by

women (including Vesta Tilley), but traditional theatre also continued to embrace women in male roles. Eva le Gallienne was an often-cross-dressed English actress who played opposite her female lover on multiple occasions. In 1928, Eva took the titular role in *Peter Pan*, with her girlfriend, Josephine Hutchinson, playing Wendy. Only one year before this, in 1927, the couple had been publicly incriminated by Josephine's husband during their divorce proceedings, and for a time afterwards Josephine became known as Eva's 'shadow'—a term implying the pair's lesbian relationship.[33] Their romance onstage in *Peter Pan* was not any less well received for these rumours. In fact, four years later they acted opposite each other again, in a fictionalised account of author Jane Austen's life. In *Dear Jane*, Eva and Josephine played the novelist and her sister, Cassandra, respectively. Though in these roles neither actress crossdressed, their semi-public relationship added to the performance once more. The possibility of an incestuous relationship between Jane and Cassandra is one that has often been speculated upon, and in *Dear Jane*, where the sisters run into the darkness together at the play's end, this tradition continues.[34] Eva and Josephine, with their 'shadow' relationship and previous roles as lovers, were far from a subtle choice.

While Eva and Josephine's relationship reached the public eye, others remained hidden, even if in plain sight. Gwen Lally, actress and pageant master (leader of dramatisations of historical events, a popular phenomenon in early-twentieth-century England), was in a relationship spanning decades with fellow actress, Mabel Gibson. The two worked together on both pageants and traditional stages, and in 1928 played Princess Katharine and Henry V (Gwen in the male role) in Shakespeare's *Henry V*.[35] The couple are recorded to have lived together for forty years, and apparently were open about their relationship with their family: Gwen's niece-in-law, Angela, has described how Gwen 'was fairly open about her sexuality within the family and lived with her partner … Mrs Gibson'.[36] As an actress, Gwen always wore trousers. In 1934 she told the press that she could 'claim the distinction of being the only actress who has never worn skirts on the stage', and in 1916 a reviewer noted that 'this lady is so accustomed to male parts, and presents them with such fidelity, that her sex is frequently mistaken on the stage'.[37]

Gwen also favoured masculine garments in her everyday life. Playwright George Bernard Shaw called her 'a pageant in [herself]: a George Washington pageant'—referring to her short, white, curled hair.[38] She was tall and androgynous, with a pointed nose, sharp cheekbones and a gentlemanly poise. Gwen's distinctive style was not especially notable during the height of her acting career in the 1920s, when masculine fashions were popular among all women. It was the continued wearing of these styles until her death in 1963 that marked Gwen out. This difference meant that she, like so many other performers both before and after her, was largely labelled as eccentric.

This is the domain of a male impersonator or cross-dressed actress. If eccentricity rules, queerness goes unnoticed, and lesbian relationships become an act or a novelty. When it comes to lesbian fashion, male impersonators are our historical heroes. They stand out, telling us where to look and what to see. If their audiences could speak to us, I am sure that they would say that this is nothing new.

13

GLADYS BENTLEY

A SARTORIAL HISTORY

Gladys Bentley: blues singer, tuxedo wearer and lady lover. In the words of Saidiya Hartman, 'Bentley was abundant flesh, art in motion'.[1] In the words of Bentley herself, in 1952 when she had left the stage and all that came with it, she was 'a big, successful star— and sad, lonely person'.[2] There are many ways to read Bentley's life, but mine is, of course, through clothing. Her outfits were already impactful when they were first worn and paraded around the streets of New York City, but they did not stop there, having continually influenced queer culture and fashion ever since.

Gladys Bentley was born in 1907 and lived until 1960. She ran away from her home in Philadelphia at age sixteen, to a new life in New York. She quickly auditioned with a Broadway agent and recorded eight record sides before ever having been on stage—but that was where her career took off. It began in earnest, by chance or fate, when she got her first job as a club pianist after the previous (male) pianist left without warning. Recalling the moment later in her life, she described how she

> finally convinced [the club owner]. My hands fairly flew over the keys. When I had finished my first number, the burst of applause was terrific. One of the white customers walked over, handed me a five dollar bill and said: 'Please play something else. We don't care what it is. Just play. You're terrific'.[3]

Her salary rose quickly, and her name—as well as her sometime stage name, Barbara 'Bobbie' Minton—rose even faster. She became

143

ingrained in New York's nightlife and personified the queer Harlem A-List. She was well-known as a 'bulldagger' and famously had numerous female lovers. At one time, she was married in a civil union to another woman, speculated to have been a white woman. Every day of her life, she crossed the boundary lines that defined race, class, sexuality and gender in the first half of the twentieth century.

Throughout this book, gender has been in flux; lesbian history has never been confined to people who use the pronoun 'she', as evidenced by female husbands like Giovanni Bordoni and James How. With Bentley, the situation is unclear, and since lesbian identity, history and fashion are always and forever tied to gender norms and expectations, I will pause here for a moment. So far, I have referred to Bentley with she/her pronouns, because this is what was done while Bentley lived (at least, in the media) and in most retrospectives about Bentley's life. But other writers, including Saidiya Hartman, have chosen to use 'he', at least while discussing the height of Bentley's fame. This does not deny Bentley's lesbianism or place in lesbian history, but acknowledges Bentley's specific masculinity.[4]

In 1957, when Bentley was fifty, the Black American writer Alfred Duckett published an article called 'The Third Sex', about the allegedly 'fascinating and unbelievable' phenomenon of lesbianism. He writes about Bentley: 'In her private life, she readily admits, Miss Bentley was a "man" and the husband to a number of women, both coloured and white'.[5] If Bentley was indeed living as a man privately, then this supports any usage of 'he' and 'him'. However, in Bentley's autobiographical article 'I Am a Woman Again', published in *Ebony* magazine in 1952, we are told that, 'Like a great number of lost souls, I inhabited that half-shadow no-man's land which exists between the boundaries of the two sexes'.[6] This, in my eyes, seems an indication that they/them pronouns might be appropriate to use.

Because I don't have one solid answer, throughout the rest of this chapter I will fluctuate between 'she' and 'they'. I do not want to deny the possibility that Bentley may have identified as a man, or—had they lived today—as non-binary, but I still want to understand their masculinity as part of a lesbian history, and as part of lesbian fashion. They were consistently referred to as a 'bulldagger' or 'bulldike', and their presence within lesbian history has

already been firmly established. Bentley was primarily a musician, but it is their clothing that has preserved their image, pristine and shining, for a century.

Bentley the icon

Photographs, usually taken for publicity and distributed on post-cards and similar ephemera, depict Bentley in outfits typical of their performances at the peak of their career. Usually, these outfits consist of a tuxedo, complete with top hat and cane (Figure 27). Bentley describes their dress from this period in 'I Am a Woman Again': 'From Harlem I went to Park Avenue. There I appeared in tailor-made clothes, top hat and tails, with a cane to match each costume, stiff-bosomed shirt, wing collar tie and matching shoes. I had two black outfits, one maroon and a tan, grey and white'.[7] The white outfit mentioned by Bentley is captured in many photographs, striking and bright from top hat to tails. From the fit to the sheen on the fabric to the gloved hands, one on a cane, the other in a pocket, the outfit is flawless. It would not have been easy to pull off, but Bentley's difference was their strength—at least for a time. They were seen as a masculine woman, a male impersonator, and an unabashed lesbian. They couldn't be avoided, in their glossy, expensive costumes and equally fantastic street clothes. They were Black and fat and so talented, so captivating, that they left their audiences begging for more. As Regina V. Jones says in 'How Does a Bulldagger Get Out of the Footnotes?', they 'physically occupied a privileged space exuding a confident, Black lesbian masculine sexuality'.[8]

Bentley knew difference, as well as talent, was the unique selling point cementing their audiences. They knew that although, in their words, 'I had violated the accepted code of morals that our world observes [...,] the world has tramped to the doors of the places where I have performed'.[9] But Bentley existed beyond the walls of the club: they walked the streets of Harlem in men's clothing, with pretty women on their arms; they visited the opera with a woman known as their 'wife', while 'wearing a full dress suit' (with their wife 'elegantly gowned').[10] They knew the culture they were part of, the queer underworld at the helm of which they stood.

'Throughout the world there are thousands of us furtive humans who have created for ourselves a fantasy as old as civilization itself', they wrote in 1952. 'Some of us', they continued, 'wear the symbols and badges of our non-conformity'.[11] These 'symbols and badges' could be literal, like the Sapphic violet lapel pins in Chapter 5, but Bentley most likely referred to clothing styles that defied gender expectations. Bentley, in tuxedos and top hats, wore their non-conformity for the world to see. By doing so, they inspired queer people of all kinds, alongside the modern female husbands of the Harlem Renaissance. They could do all this, at least for a time, because their fame made them near-untouchable.

Yet, this moment was fleeting. Bentley became too well-known, and as the United States edged towards McCarthyism and the mid-century, the governmental and public fear of Black, queer deviance grew. Though her trousered legs had been a sensation, by 1940 Bentley was no longer allowed to wear trousers for her act at Joaquin El Rancho, a bar where she frequently performed. It had become a 'perceived fashion transgression'.[12] As she herself said above, the sartorial image of Gladys Bentley was what signposted her for deviance, or homosexuality, more than any of her private actions, or even the suggestive lyrics that she sang. Her proud, loud relationships with women began to be noticed, and as homosexuality became increasingly taboo, the U.S. House Committee on Un-American Activities investigated Bentley. Her difference was no longer a desirable trait.[13]

There was a limit to how much masculinity Bentley could possess within one lifetime. When it was hers it was hers alone, but at other points it was up for grabs. Sometimes, she had to shape her masculinity and her identity with pieces and remnants of past or future lives. A headshot with Bentley in her black tuxedo, a top hat and bow tie clearly captures her lipstick and shaped eyebrows, the femininity of which helped to make her image less troublesome to the gender expectations of the world. Earlier in her career, before her fame transformed her tuxedos into armour, she wore skirts for her acts. She describes how 'I wore immaculate white full dress shirts with stiff collars, small bow ties and skirts, oxford[s], short Eton jackets and hair cut straight back'.[14] A photograph of Bentley with her friend Willie Bryant in 1925 matches this description almost

perfectly. She wears a suit jacket, a shirt and tie, fedora, oxford shoes and—of course—a tailored skirt. This was perhaps the look that sat the most comfortably within a long lineage of butch/stud/bulldagger/invert dressing, where a skirt is the caveat making a blazer and bow tie allowable. In this, Bentley exists alongside so many other remarkable figures whose outfits appear within the pages of this book.

Bentley's tuxedos were so unusual that they were, for a time, acceptable as a spectacle. Tamer, skirted outfits never held the same appeal, appearing only mannish, not quite male impersonation. Bentley the celebrity did not exist without trousers, top hat and cane. But it is hardly surprising that once Bentley's lifestyle, both on-stage and off, came under suspicion, it was her trousers that had to be the first to go.

Bentley the woman?

Bentley ended her career married to a man, wearing women's clothing and declaring in *Ebony* that 'I Am a Woman Again'. By the fifties Bentley was finding it increasingly difficult to work in the way she once had, due to censorship and growing concerns about the morality of her lifestyle. I do not believe for a second that Bentley became 'Woman Again' because she wanted to. Rather, she had to: it was the only option to preserve her career. After all, Bentley's 'becoming' woman implies that she was not previously a woman. In many ways, of course, this can be understood as a kind of detransition. In other, related ways, we may understand the womanhood Bentley proclaims to have returned to as a social category rather than a gender identity. 'Woman', here, means being an *acceptable* woman. For most of Bentley's life, this could not have been further from their experience.

Though written decades after Bentley's death, French author and philosopher Monique Wittig's essay 'One Is Not Born a Woman' can help us to make sense of the transformation that might otherwise seem the great mystery of Bentley's life. As I mentioned at the start of this book, Wittig argues that lesbians are not women, because they do not conform to the societal role that women are expected to play;[15] that lesbians, by not choosing or wanting rela-

tionships with men, are actively separate from the male-female dichotomy fuelled by male domination over and ownership of women within heterosexual society.[16] Whether or not you agree with her, this idea helps us to think about how lesbian fashion exists outside of heterosexual discourses on fashion and dress.

Of course, Wittig was writing in 1981, in France—Bentley's *Ebony* article was published in 1952, in the US. Wittig was white, while Bentley was Black—a difference that prevents Wittig from capturing the complexities of Bentley's life in a time and place organised around racial discrimination and built on slavery. While Wittig's conception of lesbianism is free from the structures that keep women subordinate to men, for Bentley to tear down the same structures left her exposed and therefore vulnerable. It is unlikely that Bentley saw becoming 'Woman Again' as a choice. She acquiesced to all the rules that she had spent her life and career shifting because the price of doing otherwise was all at once too large to pay. She would not have been allowed to continue unmaking the category of woman— so much so that entire audiences could see a different way of living. By becoming 'Woman Again', Bentley implied that difference can be cured. This is the narrative, at least, of the article published in *Ebony*. Behind closed doors, Bentley may have continued existing exactly as they always had, and the intricate realities of Bentley's sexuality or gender may never be known to us. We do know, however, that Bentley knew what must be done to survive.

In the *Ebony* article, Bentley is pictured in long dresses, with shoulder-length curled hair adorned with flowers and a full face of make-up. In many images, she is surrounded by men, which serves to make her feminine attire even starker. She describes how a doctor had prescribed her with female hormones, which would 'affect me greatly'.[17] Her difference, her love of women, and her fashion all had to go. Saidiya Hartman considers Bentley as having 'nothing feminine about him; it was more than glamour drag, more than a woman outfitted as a man, as several of his wives, both white and coloured, could attest'.[18] If Bentley was not in drag when they performed, nor out in New York in the 1920s, thirties and forties, it was on the pages of early Cold War *Ebony* that they were in drag, ready to convince a world that was against them that they were something acceptable, harmless, and cured.

Gladys Bentley's clothing shaped her image throughout her life, but an image is a fragile thing. It can be eradicated at the literal drop of a hat. If becoming a woman—a heterosexual woman—was the only way to live in a changed world, then this is what Bentley did. But 'becoming' only reaffirms what Bentley knew throughout her life: that 'becoming' can be undone, and the way that we are known is fluid.

What remains, no matter how many hats are dropped, is Bentley's influence. In *Wayward Lives, Beautiful Experiments*, Hartman reflects on how Bentley affected so many other people, including Mabel Hampton: 'Mabel', writes Hartman, 'learned a lot from [Bentley] about claiming a space in a world that granted you none'.[19] Bentley represented the power of the presence of a Black bulldagger. Bentley represented a link in a chain of drag kings and male impersonation. Bentley represented how our clothing can shape our place in the world and how, though sometimes we dress to quieten ourselves, the times that we were loud live on.

14

STORMÉ DELARVERIE AND THE DAWN
OF THE DRAG KING

'Who's Stormé?' Stormé DeLarverie asks the camera in the short film *A Stormé Life*, filmed half a decade before her death in 2014. 'I'm a human being that's survived', she continues, before adding, crucially: 'I've helped other people survive'.[1] This view of her own life fits neatly into the legacy that has become tied up with her name, as the alleged 'Stonewall Lesbian' who prompted the crowd to fight back against the police at the 1969 Stonewall uprising, the supposed catalyst for the gay rights movement in the US. Stonewall was, however, only one night in Stormé's long and incredible life, and the stories told about it now are often nothing more than a game of whispers.

Stormé's role at Stonewall is unclear, and seems to be purposefully so: she once asserted that 'it was never anybody's business', another time saying that it really was her who 'threw the first punch', and another still teasing that 'I know who [did], but I'm not going to say'.[2] But it was the rest of her life, all those other nights of all those other years, where her survival matters most. Nights upon the stage, dressed as a man and performing for a crowd; nights with Diana, her partner of twenty-six years; nights patrolling the streets of New York City, protecting those in her community— those are the nights that Stormé DeLarverie survived.

Stormé (pronounced as 'Storm', but she also went by the nickname 'Stormy') was born in New Orleans. For most of her life she gave 24 December 1920 as her date of birth, but the 1930 and 1940 censuses list her age as six and sixteen respectively, making her year of birth 1923. Chris Brennan Starfire, creator of the dedicated archive storme-delarverie.com, believes that 'the change was a

choice [...] made over time', citing a document from 1955 when Stormé listed her year of birth as 1921.[3] As with her role at Stonewall, Stormé did not make it easy for the details of her life to be known. Her mother was Black, a servant in her white father's household, and she grew up with a foster family, the Webers. In her early life, she was close to her foster family, though she lost contact with them as she aged. She graduated in 1942, moved to Chicago by 1943 and had, by that year, met the love of her life, Diana.[4] Little is recorded about Diana, but she was an aerialist and a dancer, and she died in 1969—only a month or two after Stonewall. Stormé 'always carried her photograph'.[5] Stormé had already been performing as a singer when she started her life with Diana, but by the later 1940s she found relative success as the vocalist 'Stormy Dale'. Stormé's feminine-presenting 'Stormy' era is immortalised in newspaper clippings, as well as headshots taken by the photography company Bloom Chicago. In these photographs, her hair is long compared to the close-cropped style she sported throughout her later life, and decorated with an oversized flower. She wears pearls on her wrists and neck, and a glamorous black tulle dress. In every way, this contrasts with the appearance curated by Stormé in the following decades, both on and off the stage.

Little is known about Stormé's life between the late 1940s and mid-1950s, though we might presume she continued working as Stormy Dale. According to her web biographer Starfire, in 1962 *Jet Magazine* reported that, a decade earlier in 1952, Stormé filed for the annulment of a marriage to an air conditioning engineer named George S. Freeman.[6] The magazine's report may or may not be factual, but even if it is, the context of this marriage is lost to us. Either way, Stormé's life was about to take a very different turn.

In 1955, Stormé joined the Jewel Box Revue. The Jewel Box was an oft-relocating club run by Doc Benner and Danny Brown, but the Revue was their pride and joy, 'a family-friendly show featuring the cream of the crop of female impersonators in the 50s and 60s', touring not only the US but its neighbouring countries, too.[7] It was the first professional show featuring both male and female impersonators in North American history.[8] The Revue marketed itself as having twenty-five men and one girl (or woman)—Stormé was the one woman, and the emcee, replacing the last in a rotating door of

male impersonator emcees.[9] Stormé's run with the show lasted almost fifteen years, from 1955 until 1969.

When she started the job, she says in *A Stormé Life*, 'somebody told me that I couldn't do it and that I would completely ruin my reputation, and that [...] didn't I have enough problems being Black?' Of course, to Stormé, being a performer, being masculine, and being Black were all innate parts of her, and 'I didn't have any problem with it, everybody else did'.[10] Her time at the Jewel Box Revue did anything but ruin her reputation. It was here that Stormé's image was immortalised. She lived for almost a century, in different jobs and cities and styles of dress, but the period between 1955 and 1969 is the one from which we have the greatest wealth of photographs. At the Jewel Box Revue she was also at her most glamorous and visually appealing, at least to a queer audience look-ing for past icons and role models. Both on and off the stage, Stormé shone: in promotional photographs she wears sleek tuxedos, topped with a moustache, but she looks equally enthralling in tailored suits and fashionable, skinny ties as she reclines on a bench or leans against a tree trunk in New York's Central Park. Her iconic suited look was captured most famously by photographer Diane Arbus, in the 1961 portrait 'Miss Stormé DeLarverie, the Lady Who Appears to be a Gentleman'.

Still, even after Stonewall, Stormé had decades of life ahead of her. Neither the Jewel Box Revue nor the uprising defined her. She retired from the Revue on 7 September 1969, after Diana's death.[11] For the rest of her life, she held her loved ones close—those she gathered together and inspired, and often called 'her babies'.[12] They were queer people of all kinds, who Stormé met on the streets that she walked 'like a gay superhero', in the building that was her home, the Chelsea Hotel, or in her role as a bouncer for LGBTQ+ clubs, particularly the lesbian bar Henrietta Hudson.[13] This was more than a job to Stormé; it was a vocation. Her friend Robert West's short biography of her life, published online while Stormé still lived, in 2013, says:

> She was employed as security, but I soon found out that the type of 'security' Stormé resonates went far beyond ensuring order in a bar. She herself has said, 'I see a lot of things in my position as a bouncer,

but please don't call me that. I consider myself a well-paid babysit-ter of my people, all the boys and girls'.[14]

Stormé DeLarverie made the world a better place. In many ways, she did this through her conscious actions, protecting queer New York every moment that she could. She also changed the world, however little, by doing something she may have scoffed at: simply being herself. Stormé DeLarverie, the one girl in the Jewel Box Revue, the male impersonator who wore her tailored attire both on and off stage as if she were born in it, was yet another figure in a long chain of possibility. Stormé apparently never called herself a lesbian, though she loved women, and she was indifferent to the pronouns used for her, once saying that people should use 'Whatever makes YOU feel the most comfortable'.[15] Stormé is a part of lesbian fashion history because she provided a model (and, often, the safe spaces) for lesbians to love whoever and dress however they desired.

Drag and the daytime

Stormé was a male impersonator while she performed with the Jewel Box Revue. While she retired from the role in 1969, she remained within the beating heart of New York's queer community until the early 2000s. She may not have been active as a titled drag king, but her life oversaw the transition from the long-established art of male impersonation to drag almost as we know it today, testa-ment to the unbroken line between the lesbian, queer and trans past and present. Around the turn of the twenty-first century, she sat on drag panels, appearing onstage to applause and calls of 'werk!'.[16] Of course, there is more to male impersonation and drag king perfor-mances than looks alone. Yet, this book is a history of fashion, and so I bring us back to Stormé's clothing.

One photograph from Stormé's expansive personal collection, now held by the New York Public Library, captures her between three female impersonators in Chicago, 1958. It is likely that the photograph (Figure 28) was taken before a show—all four perform-ers look immaculate, without a hair out of place or a bead of sweat in sight. Stormé wears a classic black tuxedo, complete with satin lapels, pocket square, bow tie, and the hint of a cummerbund at the waist. Although already immaculately masculine, the outfit becomes

a costume by the addition of a moustache, suave and pencil-thin, seemingly drawn on. The outfit ticks all the boxes for a modern male impersonator: enviable, high-quality, and very slightly identifiable as false.

As for her clothing off the stage, photographer Avery Willard, author of *Female Impersonation* (1971), captured Stormé's style in both photos and words: 'Storme now always dresses like a man' he wrote, 'which is undoubtedly why she is so convincing on stage. She has twenty pairs of boots [and her] collection of men's suits is impressive'.[17] For Willard, Stormé's everyday dress informed her performance as a male impersonator. For Stormé, it was the other way around. After beginning her role at the Jewel Box Revue—presumably the point when she first cut her hair short, the final line for many people between being perceived as a man or a woman—she recalled, 'I tried to do the proper thing. You know, wear men's clothes onstage and wear women's clothes on the street. I got picked up twice for being a drag queen!'[18] In this version of events, Stormé's decision to wear men's clothing in her day-to-day life was purely a practical one. I suspect that this wasn't the whole truth, but it is interesting that it was gender conformity, rather than nonconformity, which led Stormé to be harassed by the police.

Stormé wears a suit in her Diane Arbus portrait. She sits on a bench, cross-legged and confident, her simple attire the very thing that makes her a spectacle. This is evident in the title of Arbus' photograph, 'The Lady Who Appears To Be A Gentleman'. Lesbian or otherwise, Stormé is legible as butch. As such, her masculinity is a sign of her difference, but only when her 'proper' (to borrow a word from Stormé herself) gender is known to the viewer. But just because a role is perceived to be played does not make it role playing. Stormé DeLarverie's masculinity offstage was entirely her own, her suits not parodying the language of white, heterosexual men, but claiming it. Her suit and tie, polished shoes and wristwatch belonged fully to her.

The performance and cultural studies scholar Evan Mitchell Schares reads Arbus' photograph as if it were a chapter in Stormé's biography. He comes to the same conclusion as I do—that Stormé could not be contained by the rules of gender and dress in mid-century North America. He proposes that through her 'feminine

embodiment of masculinity' she made a crack in the hierarchy that favours the white and the male, simply by wearing masculinity so well: 'DeLarverie strikingly rends mid-century gender expectations by the very nature of achieving them'.[19] Of her own understanding of gender, and how rigid the boundaries between male and female really were, Stormé explained things simply. 'Women and men think pretty much the same' she once said. 'I hear both sides of the story—for I am one and I mimic the other'.[20]

Street smarts

Stormé did not walk through the world unchallenged, and her confidence in masculine attire only attests to her strength. To be strong was the only way to exist as a Black, butch woman—a description I use for Stormé because it fits how she was perceived both in and outside of her community, whether or not she would have defined herself the same way. Audre Lorde, in the groundbreaking *Zami: A New Spelling of My Name*, emphasised how crucial strength was for someone like Stormé in the mid-twentieth century:

> To be Black, female, gay, and out of the closet in a white environ-
> ment [...] was considered by many Black lesbians to be simply sui-
> cidal. And if you were fool enough to do it, you'd better come on
> so tough that nobody messed with you.[21]

Not only that, but Stormé ensured that nobody messed with her 'babies' either, the queer youths of New York. In an interview with Kirk Klocke from 2012, Stormé spoke about her intolerance for any kind of 'ugliness', or discrimination:

> I can spot ugly in a minute. No people will even pull it around me
> that know me. They just walk away. And that's a good thing to do
> 'cause I'll either pick up the phone or I'll nail you. There's no rea-
> son—if you don't like where you are, God gave you two feet. Go
> somewhere else.[22]

Recall how Stormé didn't think of herself as a bouncer, but a 'baby-sitter'. If she was a babysitter, she was the toughest in the world—most babies don't face the threat of physical and verbal abuse as they walk the streets alone, after all. To some, Stormé's presence could

be threatening. To others, this was what made her a welcome sight. In Robert West's 2013 article about Stormé's life, he wrote that 'In Stormé's presence I always felt safe, encouraged, and compelled to respect not only those around me but my own place in this world'.[23] Her soft and welcoming soul was protected by her exterior, which—particularly in her post-Jewel Box, post-Stonewall years— she wrapped in her own kind of modern-day armour. Stormé's street clothes were crucial in her fight against 'ugliness'.

For many, a leather jacket conveys a certain image, of someone ready for a fight and not taken down easily:

> One early morning, Stormé was on the subway. Two young toughs boarded the car and attempted to mug a sleeping passenger—the only other occupant. Stormé got up and protested, and just then the train stopped. One of the toughs exited in a hurry, because he didn't like the looks of this guy in the leather jacket and boots. The other one, however, swaggered over to Stormé saying, 'Say, Buddy, wadda ya buttin' in fer?' Calmly, Stormé explained that what he was doing was wrong, at which the tough pulled a knife and said, 'What if I use this on you?'

> Stormé, still calm, put her hands into her leather jacket pockets and replied, 'Well, then, I guess I'D [sic] just have to kill you!'[24]

Stormé's unflappable strength, and the 'young toughs' reading her as a man, was not only rooted in her demeanour, but also in her clothes, specifically the leather jacket and boots. A couple of portraits of Stormé by photographer Avery Willard—one published in his book, another now at the New York Public Library—show her with the black leather lapels and shoulders of her jacket shining under Willard's studio lights, a smooth, worn layer between the world and Stormé's inner self. Beneath the lapels, the collar of a shirt emerges, either corduroy or a striped fabric; above, what appears to be a neckerchief in a paisley pattern. This is one of a triad of outfits in Willard's photographs of Stormé. Each look is markedly different, seemingly a representation of Stormé's different selves: her stage self, her street self, and her softer, personal self. Other photos capture Stormé in a three-piece suit, or a white collared shirt beneath a checked, v-neck, mohair jumper. There was a setting and a need for each of these garments, and each of

these looks. Evan Mitchell Schares describes the woman in the leather-jacket photographs as 'a formidable take-no-prisoners Black butch lesbian activist'.[25]

Stormé's streetwear was not limited to leather jackets. As she grew older and her hair whitened, she continued walking the streets like a 'gay superhero'. We see her later life in snapshots—stories from those who knew her, and photographs. One such image, by lesbian photographer JEB (Joan E. Biren), captures Stormé outside LGBTQ+ bar the Cubby Hole in the 1990s. Stormé wears a denim jacket with the collar turned up and the sleeves rolled. Her belt is leather, as is what was likely a gun holster, strapped around her hips. A flower is pinned to her shirt and she wears, as in many photographs, rings on her little fingers.

Robert West 'viewed Stormé's insistence on arming herself and being ready to rumble not as a commitment to vigilante justice but as a manifestation of the desire to survive. It sometimes seems that she thinks our survival is somehow predicated upon hers, parental instincts if ever I've seen them'.[26] In so many ways, from her location outside a site of queer life and joy, to the gun she kept to guard the community she loved, Stormé's image here is a manifestation of queer survival, determination, and love. The pinky rings are, to me, perhaps the most significant part of the picture, recorded as a symbol of lesbian identity and community since at least the 1920s.[27] Their presence on Stormé's fingers insist that her community is one that has always existed. One that, just like her, has survived.

* * *

Stormé DeLarverie made an impact on the world around her every day. Like so many other male impersonators, she inspired people to live and love how they pleased. She was miraculous in her masculinity, but also in many other ways—as a queer elder, a performer, a lover, a 'babysitter', a drag king. She was miraculous because, as she said herself, she survived. She helped others survive. It is no surprise that, after learning of Stormé's existence, so many people cling to it. It is no surprise that article upon article names her the 'Stonewall lesbian' and a hero. As a community, we need heroes, and they are hard to find—not because they did not exist, but

because we have not been permitted to see them. When it comes to Black, butch heroes, finding them is even harder.

Stormé's career as a male impersonator was, in retrospect, perhaps more heroic than the punch she is said to have thrown outside the Stonewall Inn. It certainly matters more to people, a reflection of their dreams for the future in a mirror made of the past. In 2019, drag king Beau Jangles wrote of Stormé's legacy in the drag magazine *Louche*: 'The history of all the amazing Black and brown stars from the past is obscured, and when you dig it up there's something exciting and validating about [it]'.[28] Stormé's life wasn't even that far in the past: she passed away in May 2014. Many retrospectives, including Robert West's, were written while she was still alive— but Stormé DeLarverie bridged the gap between a history of cross-dressing that stretches back hundreds of years and the drag culture of the 2020s, which exists online and in surviving clubs and bars. Every photograph, every performance, every quick take-down of 'ugliness' was part of that bridge. Stormé DeLarverie was not a legend or a hero, but proof and protector of queer existence.

LESBIAN POLITICS, POLITICAL LESBIANS

You might think that lesbian activism belongs only to recent history, the final decades of the twentieth century and the beginning of the twenty-first, illustrated by banners, marches, megaphones and pamphlets. But activism can mean many things and has never been limited to one moment—and when fighting for a lesbian cause, the lesbian self and lesbian outfits are put on display. Many lesbian activists use or have used their look as a political tactic: certain garments or styles send specific messages, giving the wearer a non-verbal 'voice' when they take to the streets in t-shirts printed with bold messages, or in quasi-uniforms that mark them as part of a larger movement. Simply living while dressed in particular ways can be a kind of activism, too. If activism means direct action to fight for social or political goals, then fashion is an integral part of it—if we are seen, then so are the clothes that we wear. Existing and being perceived as a lesbian is lesbian activism, because it makes visible what many would prefer remained invisible.

The final part of this book begins with the crucial role of lesbians within the women's suffrage movement, specifically British 'suffragettes'. This story matters because of the perceived threat and subsequent denial of their presence, both at the time and in histories of the movement. We then move to what might be considered the 'face' of lesbian activism: lesbian feminism. This movement was initially an offshoot of the wider women's movement but became increasingly distinct throughout the 1970s and eighties, and came with a specific, assumed dress code, sometimes called the 'dyke uniform'. Chapter 16 will also explore deviations from the lesbian feminist mainstream, and the specificities of Black lesbian feminism and its relationship to dress.

Next, and in many ways related, we come to lesbian t-shirts. Used as wearable banners or billboards for a movement or community, t-shirts have a long history within LGBTQ activism. The stories in Chapter 17 include the Lavender Menace and the Lesbian Avengers, lesbian activist groups from the seventies and nineties respectively, as well as t-shirts printed with words such as 'dyke', worn as a declaration of identity. Finally, we end with the way that lesbian fashions might be perceived today as liberated under a growing narrative of sartorial choice and diversity. This chapter, which contains the most recent stories in this book, also contains its most personal reflections, on the lesbian fashions around me as well as the ones I've followed myself.

In many ways, all lesbian fashion is activism; in many other, conflicting ways, lesbian fashion is not activism at all. We all get dressed, and we all have a way that we prefer to present ourselves. From Anne Lister's fashion worries to Stormé DeLarverie's tailored suits, clothing is at once both individual, and a reflection of where and when we live. In a world where lesbianism has never been the norm, any self-presentation that is seen as lesbian is a statement. Whether intentional or otherwise, activism is a constant presence in lesbian history, and remains such even in the present day.

THE LESBIAN THREAT OF THE SUFFRAGETTES

The name 'suffragettes' was invented by the British press. Though intended to be derogatory, it was claimed and used by the women's movement itself and organisations such as the Women's Social and Political Union (WSPU). The suffragettes have, rightly, gone down in history—their campaigns were instrumental to women gaining the right to vote in the UK, a process that started in 1918 for women over thirty who owned property. Yet, the story of the suffragettes is more complex than the way that it is often told. There were more suffragette groups than only the infamous WSPU, and many of those fighting for women's suffrage were not suffragettes at all.

The suffragettes were the militant branch of the movement, emerging in 1905 and mockingly christened with their feminine title by the *Daily Mail* in 1906.[1] Their actions—breaking windows, setting post boxes alight, and more—undeniably drew attention to the cause, but were not universally approved of within the wider movement. Membership rifted and split. The suffragettes were immortalised by their actions as well as their principles, but those who fought in other ways remain in the historical margins. In histories of the suffragettes, the main character is almost always the WSPU, headed by Emmeline Pankhurst and her daughter Christabel (the other Pankhurst daughters, Sylvia and Adela, played distinct roles before breaking away). Other important figures, such as the lesbian couple Eva Gore-Booth and Esther Roper, who broke allegiance with the Pankhursts over the WSPU's rising dependence on militancy, are rarely given a moment in the sun.

It has been more than a century since the suffragette movement came to its acknowledged conclusion when the first British women

gained the right to vote in 1918, and the suffragettes have become mythologised. There is a set history of the movement; it is shockingly straight (and white, and middle-to-upper-class, and able-bodied).[2] Its mythologisation is partly down to the way suffragettes have been written about, but has been greatly boosted by the celebration of the suffragette aesthetic. As we will see, this aesthetic was very deliberately built, and was entirely entwined with clothing.

Lesbianism was always a threat to the suffragette movement. Members being accused of lesbianism at the beginning of the twentieth century, even in subtle terms, could undermine it. 'Aggressive masculinity', a lack of 'feminine charm' or being a spinster were all accusations that followed the suffragettes and often suggested lesbianism or relationships between women.[3] However, these accusations were consistently countered by the hard work of the suffragette brand, which prized elegance and femininity among its members. In the decades since the women's suffrage movement, lesbianism has continued to be a weapon—one either used or defended against. The most prominent example of this has been the public disagreement between historians Martin Pugh and June Purvis.

Pugh, writing a history of the Pankhursts at the turn of the twenty-first century, delved into the diaries of prominent suffragette Mary Blathwayt. These diaries had specific implications for the sexuality of several named suffragettes and the relationships between them. Mary wrote about a selection of activists who stayed at the Blathwayt family home, known as a suffragette safe house, including Annie Kenney—the working-class figurehead of the WSPU—and Christabel Pankhurst. While Christabel is described as an object of desire for many suffragettes, Annie's actions take centre stage. 'Annie slept with someone else again last night', Mary wrote in one entry. 'There was someone else in Annie's bed this morning' reads another.[4] Pugh interprets this 'sleeping with' as obviously sexual in nature, culminating in a 2000 article in *The Observer*, provocatively titled 'Diary Reveals Lesbian Love Trysts of Suffragette Leaders'.

In many ways, his reading was justified. Of course, 'sleeping with', especially in relation to women in the early twentieth century, may well have meant only sleeping in the same bed. But Mary Blathwayt's diaries are not the only evidence for passionate relationships between suffragettes. Annie Kenney has been repeatedly

Fig. 22: Ira Jeffries, 1948: the young butch is captured here on her sixteenth birthday in New York City, with (from left) two friends, her girlfriend Snowbaby (17), and her lesbian mother, Bonita Jeffries. Via https://dcmny.org/do/60454f22-1607-46bb-8409-d172 911335e3.

Fig. 22. Two women hold each other at the Gateways, a London lesbian club, in 1953.

I play the part of Sr Harry
Wildair to Night yr is humble Servt

Margaret Woffington

From the Original by HOGARTH in the possession of AUGUSTIN DALY, Esq.

Fig. 24: Eighteenth-century Irish actress Margaret 'Peg' Woffington, dressed in male
costume for the 'breeches role' of Wildair in Farquhar's *The Constant Couple*, c. 1740.
Process print from painting by Hogarth.

Fig. 25: A *carte de visite* (a collectible photo card) of famous American male impersonator Ella Wesner, photographed by Napoleon Sarony, New York City, c. 1872–5.

Fig. 26: A postcard of famous British male impersonator Vesta Tilley, pictured in two of her male costumes and one feminine look. Rotary Photo EC, 1906.

Fig. 27: A silver gelatine print of Gladys Bentley, world-famous male impersonator of the Harlem Renaissance, in her iconic tuxedo, top hat and tails (date unknown).

Glady Bentley

Fig. 28: A postcard of Gladys Bentley in a white top hat and tails, reading 'Gladys Bentley: America's Greatest Sepia Piana Artist, Brown Bomber of Sophisticated Songs', c. 1940.

Fig. 29: Male impersonator Stormé DeLarverie before a performance with the Jewel Box Revue, surrounded by three of her female impersonator co-stars. Roberts Show Club, Chicago, 1958.

rumoured to have been in love—and possibly in a relationship—
with Christabel Pankhurst. Annie was, as she herself described,
entirely drawn to Christabel upon first meeting. With the promise
of meeting Christabel again for tea a week later, Annie wrote that
she 'lived on air. I simply could not eat. It was as though half of me
was present. Where the other half was, I never asked'.[5] Lyndsey
Jenkins argues that '[i]nterpreting Annie Kenney's relationships
with other women as simply romantic both oversimplifies them and
overlooks her own interpretation of their meaning and signifi-
cance', but I do not believe this is a wholly fair assessment.[6] Some
descriptions of relationships as romantic or sexual can trivialise
them, of course—we need only look to the 'lesbian love trysts'
sensationalised by *The Observer* to see proof of this. A considered,
lesbian perspective on a relationship like Annie's with Christabel
would, I believe, be entirely different. To quote the lesbian artist
Sarah-Joy Ford:

> Even though relationships, intimacy and love between women
> clearly threaded through and bolstered the suffrage movement,
> lesbian histories have been argued over, glossed over, and their life
> altering intimacies pushed aside as an irrelevance to the canonical
> narrative of women's activism in the UK.[7]

Sexual and romantic relationships between women do not negate
the close bonds of friendship, community and political solidarity
that also thrive between them. The lesbian potential of these 'life
altering intimacies' probably drove women's suffrage further for-
wards, rather than hindering it.

The most famous response to Martin Pugh's assertion of lesbian
relationships between the suffragettes came from the feminist his-
torian June Purvis. Purvis, in reviews of Pugh's work and in her
own 2002 biography of Emmeline Pankhurst, made clear that
Pugh's claim was not without agenda. She likened his reading to
that of a previous male scholar, George Dangerfield, who, writing
in 1935, had aimed to condemn the suffragettes to a history of
villains and fools. For Dangerfield, Purvis wrote, both suffragette
militancy and lesbians 'appeared as a symptom of [...] social and
individual' decline.[8] Lesbianism, for such historians, was used as
evidence to support the supposed degeneracy of women's rights

campaigners. Purvis argued, not without reason, that Pugh was following in Dangerfield's footsteps, and that lesbianism was used in Pugh's work to paint the suffragettes in a negative light. She also pointed out a clear bias in whose sexuality Pugh questions and whose he does not:

> Pugh does not discuss Sylvia [Pankhurst]'s close relationship with an American woman, Zelie Emerson [...] but assumes that Sylvia, who had an affair with Keir Hardie, the founder of the fledgling Labour Party, is heterosexual. For Pugh it is Sylvia, the feminine socialist feminist who cries easily, who is the heroine of the Pankhurst family.[9]

There's a simple conclusion to this back-and-forth: that whoever the lesbians in the women's suffrage movement were, they were the 'bad guys'—or, at least, not the heroines. Still, Purvis does not deny the existence of lesbians in the suffrage movement, citing Mary Allen, Rachel Barrett, Eva Gore-Booth, Vera 'Jack' Holme, Evelina Haverfield and Christopher St. John.[10] She also reads the 'close friendship' between Emmeline Pankhurst and suffragette composer Ethel Smyth as a kind of unrequited love on Ethel's side (one of Ethel's close friends, Virginia Woolf, once mused that 'Ethel used to love Emmeline').[11] Some of the leading figures and household names in suffragette history might well have been lesbians—or loved women in a way that makes them part of a lesbian history.

As the writer Hilary McCollum explained in a 2017 talk, 'I think you could categorise [many of the leading suffragettes] as at least "lesbian-like," if not lesbian', since 'their lives were dedicated to other women and they certainly had opportunities for same-sex love'.[12] After all, sometimes the most lesbian parts of a life are not the things that go on behind closed doors, but those on display to the world. We may never be certain about whether members of the women's suffrage movement were in romantic love with each other or had sex with each other. This doesn't necessarily matter; they certainly loved one another. Some of them, too, fit undeniably into a narrative of lesbian fashion, despite the suffragettes having a strongly encouraged dress code. Perhaps, in a history full of silences and guesswork, this is evidence enough for now.

Ties of purple, white and green

A quote by Sylvia Pankhurst tells us that 'many suffragists spend more money on clothes than they can comfortably afford, rather than run the risk of being considered outré, and doing harm to the Cause'.[13] The suffragettes had a strongly encouraged palette and style; to conform to it was to be part of the movement. The colour scheme, immortalised in so much imagery and modern-day merchandise, was purple, white and green. Purple supposedly represented loyalty, and white purity, with green being the colour of hope.[14] Historian Katarzyna Kociolek explains the effect of the three colours:

> The WSPU's colour scheme, badges and sashes on one hand were a public manifestation of political views, while on the other hand they served the purpose of establishing a visual code that helped female activists to forge their new identities of liberated women.[15]

This visual code was immensely helpful to the movement, and the WSPU in particular. Fashion historian Cally Blackman calls the colour scheme 'an early triumph for fashion branding'.[16] High-end department stores, including Selfridges and Liberty in London, showed their support for the movement—and cashed in on it—by selling garments and accessories in the movement's colours. An incredible range of suffragette goods could be bought by those with the funds to do so, including 'tricolour-striped ribbon for hats, belts, rosettes and badges, as well as coloured garments, underwear, handbags, shoes, slippers and toilet soap'.[17]

This association of the suffragettes and their colour scheme with elegance and fashionability was a deliberate attempt to appeal to women with wealth and influence, and to shift the suffragette image into a respectable light.[18] This strategy, and its success, is celebrated in a 1914 edition of the WSPU publication *Votes for Women*: '[h]ow far we have travelled from the days of the comic paper picture of the suffragette in spectacles and galoshes, if to-day there is nothing in her appearance to distinguish her from a Royal Princess'.[19] Anti-suffragette media, particularly political cartoons, may have favoured masculine caricatures of the suffragettes, but this was rarely the reality. While suffragettes were not strictly told to wear clothes fit

167

for a princess, they were certainly encouraged to, partly by leading figures in the movement and the idealised imagery of them circulated on postcards. Style advice was occasionally published in *Votes for Women* and the WSPU's other publication, *The Suffragette*. According to Katrina Rolley, 'WSPU propaganda suggested that even when being arrested the suffragettes retained their elegance and calm' yet 'photographs not reproduced as postcards prove that this was not always the case'.[20]

Despite femininity and fashionability being prized by the WSPU, some members determinedly walked their own sartorial path. One such member was Ethel Smyth, the suffragette composer and 'close friend' of Emmeline Pankhurst (Figure 30). She is described by June Purvis as 'mannish'.[21] Ethel enthusiastically embraced the suffragette colour scheme, wearing purple, white and green in her everyday dress and not just public appearances.[22] But on her, the look took a different form to that promoted in WSPU publications. Sylvia Pankhurst, in her 1931 *The Suffragette Movement: An Intimate Account of Persons and Ideals*, recounted that:

> [Ethel] would don a tie of the brightest purple, white and green, or some hideous purple cotton jacket, or other oddity in the W.S.P.U. colours she was so proud of, which shone out from her incongruously, like a new gate to old palings.[23]

Clearly, the combination of purple, white and green was not limited to feminine fashions.

It was also not solely masculine or eccentric suffragettes whose dress differed from the WSPU ideal. A large proportion of the union's membership was working class, and would not have been able to afford the wares sold in high-end department stores like Selfridges or Liberty. Working-class suffragettes (at least, in WSPU propaganda) had their own aesthetic, defined largely by staged photographs of Annie Kenney.[24] This look involved the clogs and shawls of female millworkers, which Annie was often pictured in, or the practical pinafore smock designed by Annie with Mary Blathwayt and promoted to WSPU members. The suffragette Millicent Price mentioned in her unpublished autobiography that this latter garment

> was very pleasant to look at, and particularly kind to non-corseted figures. [It had ...] a white top to the purple or green slip smocked

fully at the waist. We liked it for the freedom it gave us, and because it was short enough to collect no dust nor did it need a protective binding.[25]

Though working-class women remained integral to the fight for women's suffrage as the years passed, fashionability and respectability became increasingly important. In the earlier days of the movement, before the 1910s, they had been more heavily represented in WSPU imagery. An early membership card, designed by Sylvia in 1906, spotlights working women.[26] Sylvia, as an artist, a socialist and a lifelong campaigner in the labour movement, was in the prime position to shine this spotlight; her illustration shows a group of marching women in clogs, shawls and aprons, one cradling a baby and another gripping a metal bucket, with the central figure holding up a banner reading: 'VOTES'. Notably, in this membership card, neither green nor purple are anywhere to be seen.

Show off to women

The suffragette commitment to respectability was in direct response to the way that the movement was caricatured in the press. In 1906, the first cartoon depicting suffragettes was printed in the satirical magazine *Punch*; the figure in question was 'a gaunt, ugly and violent old woman'.[27] In many more caricatures, suffragettes were shown as unacceptable women, primarily through their clothing. Katrina Rolley describes how, rather than the coiffed hairstyles and flamboyant hats that were fashionable for women at the time, 'the suffragette [in political cartoons] has small, practical, "masculine" hats, and her hair is short, or scraped back into a hard little bun'.[28] As the movement's public image became more fashionable, many political cartoonists changed tactics, and from 1908 excessive femininity was also used to trivialise and mock suffragettes.[29] Despite this, masculinity remained a threat, and as the WSPU's actions grew increasingly militant in the early 1910s, the suffragettes' caricatures turned ever more masculine.

Rolley offers a particularly 'vicious' example from a 1913 issue of *Punch*. 'The short, fat and strikingly "masculine" suffragette', she reports, 'has short hair and wears gloves, a skirt and a tie, a plain tweed skirt, thick stockings and large lace-up shoes—an obvious

contrast to the now tall and slender fashionable ideal'.[30] Some cartoons even suggested to their readers that it was not that suffragettes were naturally masculine, violent, or undesirable, but that being part of the movement made them that way. This was an obvious attempt to dissuade other young women from becoming suffragettes, and is seen most clearly in a 1910 cartoon in the *Daily Mirror*, where 'Miss Fairface Lackvote', so conventionally beautiful at age sixteen, is a stereotypical spinster in tartan and flat shoes by age twenty-two.[31]

It makes sense, of course, that the WSPU's branding worked hard to counter these characterisations. In the same vein, it makes sense that feminist historians like June Purvis have tried to counter characterisations of suffragette history that belittle or skew the movement and its members' lives. However, just as it is—in the words of Hilary McCollum—'ridiculous' to respond to homophobic accusations of lesbianism by denying any lesbianism at all, it is just as nonsensical to argue that no suffragettes were masculine.[32] There are multiple prominent members of the women's suffrage movement who were known or thought to love women, and multiple prominent members who undeniably diverged from the stylistic ideal promoted by the movement's leaders. These individuals were often one and the same.

The suffragette composer Ethel Smyth's penchant for wearing the WSPU's colours was described by Sylvia Pankhurst as 'hideous'. Ethel allegedly never referred to herself as a lesbian, but that does not mean that she was not, or is not part of a lesbian history.[33] We can see her love for women shine perhaps the most strongly in letters left by Virginia Woolf, who became Ethel's devoted friend later in both their lives. Once, Virginia wrote to Ethel that 'I only want to show off to women. Women alone stir my imagination—there I agree with you'.[34] Virginia thought Ethel's own way of presenting herself and talking about her life was at once fascinating and entirely self-absorbed. Although many women may not have found it appealing, within a lesbian context 'hideous', masculine garments are often alluring. Recall Anne Lister's acquaintance Mrs Kelly, who said that while others might think Anne would look better in a bonnet, she thought Anne's 'style of dress' was 'becoming'.[35]

In a photograph from 1912, where Ethel stands on stage to speak at a suffrage meeting, she wears a matching blazer and skirt, both

striped. We cannot know the colour, but we might presume that they were purple or green. She wears a collared shirt and a bow tie. Her hands are in her pockets and her shoes are flat. The women behind her, Emmeline Pethick-Lawrence and Christabel Pankhurst, are dressed considerably more femininely; though 'Votes for Women' signage covers most of their clothes, Emmeline wears what might be a fur-trimmed coat with pearls, and Christabel wears what is likely a silk dress. Ethel's outfit, in contrast, is straight out of *Punch*'s cartoons.

Ethel, bold and confident in her un-femininity, was not alone. The suffragette most noted for her masculine style of dress, though rarely given much attention, is Vera 'Jack' Holme, born in 1881. Anna Kisby's biography of Jack argues that we can see in her life how moments of great social change 'such as the women's suffrage movement and the First World War offered outlets for women's unconventionality. [...] In Jack's case, part of this "stepping outside" was her sexuality—but it was also her dressing differently [...] and engaging in work (as a driver and mechanic) that was traditionally male'.[36] I refer to Jack (her preferred name) with she/her pronouns in much the same way as I have with some other masculine figures in this book, like the male impersonators Annie Hindle and Ella Wesner. These pronouns are a continuation of the language and sources we have available on Jack's life, but their use is not intended to diminish the gender transgressions and explorations that Jack consciously undertook with her name, dress, and actions.

Kisby interprets the masculine nickname, donned in Jack's early twenties, as part of her 'developing a visible lesbian identity'.[37] At this time, working as an actress and singer (and often, in the lesbian tradition, as a male impersonator), Jack's identity seemed to be something she revelled in developing. Her diaries are archived by the Women's Library at the London School of Economics, and though no records from between 1904 and 1914 survive, we can catch a glimpse of Jack's life in the early volumes. In 1903, when she was in her early twenties, her primary romantic relationship was with 'Aggie', probably a fellow actor. The nature of the relationship is captured in a suggestive snippet from April of that year: 'Stayed in bed reading and smoking 'til around lunchtime. Rosie got into Aggie's and my bed. Had great fun'.[38]

Jack became involved in the women's suffrage movement in 1908, and in 1910 or 1911 claimed the official role of the Pankhurst Chauffeur (Figure 29). She was acknowledged as the first female chauffeur in Britain, and largely respected for her work. She can be seen in the foreground of many suffragette photographs, other times hidden in the background, identifiable by her chauffeur's uniform. Kisby describes the significance of Jack's attire:

> Although many suffragettes wore conventional feminine dress, as encouraged and following the example set by Emmeline and Christabel Pankhurst, Holme increasingly adopted a masculine-style dress which was 'excused' by her roles as horse-woman and driver, but which also symbolised her political and social protest.[39]

Jack's preferred clothing remained masculine for the rest of her life. Its next phase, however, was during the First World War, when Jack and her partner Lady Evelina Haverfield ('Eve') joined the Scottish Women's Hospital (SWH). Once again, Jack was in uniform—the SWH's belted jacket, shirt and heavy skirt. Jack and Eve had met during their suffragette years, and remained together until Eve's death in 1920, though in the later years of their relationship Jack is known to have been romantically involved with other women, including the artist Dorothy Johnstone.[40]

They worked together throughout the war, Eve as the head of transport and Jack as an ambulance driver for the SWH in Serbia. Both were celebrated for their relief work—Jack was awarded a Samaritan Cross by the King of Serbia, and a children's health centre was named after Eve.[41] However, their life as a couple remains in the shadows. Artist Sarah-Joy Ford's quilted work *V is for Vera who is Keen on the Fun* aims to bring it into the light. In 2021 she called the quilt 'an intervention into heteronormative commemorative narratives, and a tender attempt at giving voice to lesbian desire, intimacy and memory in the archive'.[42] Its central motif is a 'sapphic monographing' of the initials EH and VH, embroidered. This is a direct reference to Eve and Jack's own lives: the bed that they shared was carved on the sides with the very same initials.[43]

While Jack, Eve and Ethel are central suffragette figures, there were still others in the women's suffrage movement who were in legibly lesbian relationships. Eva Gore-Booth and Esther Roper

were one such couple. Though neither woman has been particularly noted for her clothes, they are important in lesbian and more broadly queer culture in other ways. Eva Gore-Booth was an Irish poet, playwright and activist, for causes including women's suffrage, trade unions, and animal rights (she was a vegetarian from 1900 until her death in 1926).[44] Esther Roper, unlike Eva, was from a working-class background. She became one of the first female students at Manchester's Owens College and founded the university's first newsletter for women before joining the suffrage movement in 1893.[45] Esther once wrote that after meeting in Italy in 1896, the couple were 'rarely separated' until Eva's death thirty years later.[46] They were two of the founding members of the gender studies journal *Urania*. The journal was in many ways revolutionary: its content included celebratory accounts of gender non-conforming individuals and people who we would today call trans, as well as reports of sex changes (sometimes, but not always, medical). Same-sex relationships, particularly between women, were the norm.[47]

If Eva and Esther's activism took form in their academic work, then another group was revolutionary because of their creative endeavours. Edy Craig, Christopher St. John and Tony Atwood (at times known by their legal/professional names, Edith Craig, Christabel Marshall and Clare Atwood) were based at Smallhythe Place in Kent. Their most important work in the movement was the staging of suffrage plays in London, which aimed to spread the word to working-class women.[48] The breadth of this triad's lives is too large to cover here, but they show again that the fight for women's suffrage was never a straight one; it has only been written that way.

* * *

Evidence of the lesbian past is not always visible in towering letters. The word lesbian itself is not always applicable, nor words like bisexual, transgender, sapphist or invert. But our lesbian lives are not new inventions. Lesbian history, a continuing thread of lives and experiences from the beginning of time until the present day, is sometimes visible in text—diaries like Jack's, letters like Virginia's, journals like *Urania*—but other times in clothing, from Jack Holme's love for masculine-tailored uniforms to Ethel Smyth's bow

ties. The lesbians within the women's suffrage movement were integral to it. Despite this, their presence has continually been denied, sensationalised, or used to undermine the cause. Lesbianism was and remains a threat to suffragette history. This does not mean that it wasn't part of it.

UNIFORMS OF THE SECOND WAVE

LESBIAN FEMINIST DRESS CODES

The women's suffrage movement is sometimes called the first wave of feminism. The second wave began in the 1960s, and it was during this period that lesbian feminism was born. For the suffragettes, loving women had been intertwined with their fight for women's rights, but was a private part of their lives rather than a political one. For most lesbians active in the second wave, sexuality was just as important politically as gender. By the 1970s 'lesbian' was an all-encompassing identity, reaching much further than a person's sexual/romantic life. And to declare oneself a lesbian feminist was an affirmation of a worldview that centred women, and was unambiguously political.[1] Lesbian feminism as a distinct movement developed in direct response to lesbian concerns of erasure, and lack of recognition in other activist circles—hetero feminism and the gay liberation movement.

Lesbian feminism began with groups forming, growing, and becoming increasingly visible. In the UK, the Minorities Research Group was founded in 1963 by four lesbians, its affiliated publication *Arena Three* ran until 1972, and there was a wave of interviews and documentaries about lesbianism on British television over the decade. Notable among these was *The Important Thing is Love*, broadcast on ITV in 1971.[2] Throughout the US, too, explicitly lesbian feminist groups, journals, newspapers and bookstores were thriving by the early seventies. One journal, *Lesbian Connections*, was circulated for free from its first publication in 1974 until its mailing list surpassed 5,000 and the publisher was financially obliged to request a small subscription payment.[3]

The lesbian mission, and the lesbian feminist mission, was spreading. Despite this, there had always been tensions between the (largely heterosexual) women's movement and the lesbian feminists within it. These tensions were illustrated vividly by the direct action of the Lavender Menace lesbian group in 1970, formed and named in response to the famous feminist Betty Friedan's use of the phrase in her assertion that lesbians were a threat to the women's movement.[4] Throughout the remainder of the seventies feminism and lesbian feminism became increasingly—though not entirely—separate. Lesbian feminism reached what could be considered its peak in the 1980s; this was also when it began to split into factions of its own, across an intricate web of motivations and aesthetics.

Lesbian feminism has flourished beyond Britain and North America, including in France, India, and Latin America, but the stories and clothing cultures of those movements are outside the scope of this book.[5] As we will see, even focusing on the UK and the US offers up many different dress codes and varying motivations behind them, particularly across dividing lines of race, class, and sexual expression.

The dyke uniform

The clothing worn by lesbians (and by non-lesbian feminists) in the sixties and seventies was easily identifiable. This was very much by design; as with the suffragettes, second-wave feminists realised that their appearance could become a walking manifesto. Though not enforced within the movement, dressing a certain way was certainly expected. Historian Betty Luthor Hillman details this 'androgynous uniform', which became a 'dyke uniform' when worn by lesbians in the movement:

> often consisting of jeans, button-down work shirts, and work boots, often without makeup and bras, and sometimes with short hair— these women's liberationists and lesbian feminists visually displayed their political goal of creating a society free of gender distinctions, defying expectations that men and women ought to 'look different' from each other.[6]

Testimonies from lesbian feminists help paint a picture of the dyke uniform and confirm its wide reach. Silva, a British lesbian inter-

viewed by Jane Traies for her book *Now You See Me: Lesbian Life Stories*, recounted that after being introduced to lesbian feminism in London,

> I could be *myself* and be a lesbian: I didn't have to look [feminine] anymore. Having said that, of course, I got the gear, I looked the part. I cut my hair short, I didn't quite have the dungarees, but almost. I looked like a lesbian, and all the women I was going out with looked like lesbians. They had short hair—and we didn't wear makeup then, didn't wear high heels. I'd been a very femme girl, very pretty, totally into clothes; and for me that was also part of it, because men always used to go for me because I was such a pretty girl. For me to not have to look like that, and still be a sexual being, was really important.[7]

Jo Dunn, another British lesbian feminist whose memories were recorded by the *West Yorkshire Queer Stories* oral history project, experienced the same clothing culture in 1980s Leeds:

> I had curly hair then, which I quite liked [...] So, I didn't, I never had a crop, a crew cut, but like lots of women liked a Sinead O'Connor haircut, but I never did that. But I did have a pair of dungarees for at least two or three years. I had an obligatory pair of Doc Marten boots, [from] the Army and Navy store.[8]

Both Jo and Silva mention dungarees (or overalls) as an integral part of lesbian feminist self-fashioning, whether they personally wore them or not. Jo mentions Doc Marten boots, and Silva notes a lack of high heels. Their interviews bring up memories of short hair or a pressure to cut it short, practical clothing, and faces free of makeup. The dyke uniform sometimes involved exceptions or differences, but its variations were mostly legible as the same overall look. Some lesbian feminists found the aesthetic pressures too restrictive, like Nan from New York who 'liked to wear period clothes, Victorian and 1920s outfits' but whose community decided that she 'was an enemy of the people' because of it.[9] There were whole demographics that found the universal dyke uniform symptomatic of the wider uniformity and exclusivity in the movement.

Despite this, the dyke uniform had its merits. Its garments and styles were crucial because of the way they questioned what made

women valuable. Androgynous styles have often been in fashion, of course, the boyish styles worn by young women of the 1920s being a prime example (see Part 2). But lesbian feminists embraced the fashionable androgyny of the 1970s in a way that was far from mainstream—the lesbian emphasis on practicality and uniformity placed lesbian feminists outside of the trend. Instead, their dress codes embraced women looking 'ugly'. For former 'pretty girl' Silva, ugliness wasn't a defect, but a tool for liberation, removing her from the male gaze. Similarly, an American feminist described her decision to cut her hair short in the Iowa City journal *Ain't I a Woman?* in 1971. She found that, as a result, 'when I walk through the commons, I feel much less on display'.[10] This woman might not have been a lesbian, but what we could call her deliberate ugliness aligned her with the rejection of hetero-feminine beauty standards. Figure 31 shows the 'loud and proud' spirit of lesbian protesters at the 1978 Christopher Street Liberation Day March in New York—complete with t-shirts, shorts, cropped hair and dungarees.

The 'ugly lesbian', fuelled by the dyke uniform and its advocates, has persevered as a stereotype until the present day. For many it is a burden; Melissa Hobbes, writing for *The Sunday Times*, described how she 'was devastated' to realise she was a lesbian in the 1990s 'because I thought I would have to cut my hair off and wear dungarees. I never did go for the ugly lesbian look'.[11] Yet, this kind of ugliness is powerful. It gives lesbians, straight women, and all queer people options. For lesbian feminists, embracing an ethic of ugliness was theory on display. It said that none of us have to be what we are pressured to be—not heterosexual, or gender conforming, or desirable to men, or even beautiful. Instead, we can be different. Instead, we can be more.

Leather and braids: the dyke uniform's outsiders

Of course, for some, the dyke uniform seemed just as restrictive as the feminine fashionability expected by heteronormative society. Rifts within the lesbian feminist movement were caused by clashing political beliefs or priorities, but clothing provides a useful lens through which to consider them. This is especially true of the so-called 'lesbian sex wars'.

The political motivations and personal intimacies of the sex wars could take up a whole book, so I'll limit myself to the basic facts and to the role of style in this story. The 'wars' in question were dis-agreements between feminists—often lesbian feminists—fighting for women's liberation from male violence. On one side stood those who criticised the misogyny of porn culture at the time. On the other side were 'pro-sex' feminists—again, often lesbians—who were also fighting for liberation, only from a different perspective. While anti-pornography feminists argued that porn normalised and reinforced violence against women, pro-sex feminists thought that no type of sex or sexuality was innately bad, and that pornography could in fact be a positive experience for women. They argued that the patriarchy was the problem, not sex itself. As these debates became increasingly heated, clothing—with the dyke uniform on one side—became representative of someone's position within the 'sex wars'. Silva, who 'looked the part' within the lesbian feminist movement, recognised how this stylistic and idealistic divide played out within her own community: 'I remember in those days you could not wear a leather jacket in the [Greater London Council]-funded Gay and Lesbian Centre', she recalled, 'and there was a huge separatist movement which I was on the edge of'.[12]

In that time and place, leather jackets were the defining look of pro-sex lesbians, particularly those actively engaging in the kinds of sexual activities that others were against, like sadomasochism. Often, these lesbians were known as 'SM dykes'. Sabrina, a lesbian who was part of this culture in the eighties, recalled that she 'wouldn't leave the house' without her leather jacket, 'whether it was winter, summer or whatever'.[13] While lesbians like her may not have been welcome in places like the Gay and Lesbian Centre, they had spaces of their own—in London, for example, there was The Bell music bar and the SM club Chain Reaction, both of which were safe havens and sites of congregation. In the US, too, SM lesbians very much embraced leather, which the lesbian historian Lillian Faderman describes as being 'imported into the lesbian community' after being used and worn by gay men. In 1980s San Francisco, Kathy Andrews of the shop Stormy Leather 'made and sold leather specifically for lesbian s/m: leather corsets, leather bras with cut-out nipples, leather-and-lace maid's aprons, leather garter belts' and 'dildo harnesses in black or lavender leather'.[14]

It was not only pro-sex or SM lesbians in their leather jackets (and sometimes leather everything else) who clashed with the typical dress codes of lesbian feminism. Some working-class lesbians felt tensions between their own experiences of the world and the ideologies privileged within the movement. To those who had worked hard to obtain smart or fashionable clothing, the dyke uniform could feel like a step back. As the writer Sue Katz puts it,

> You'd walk into one of the bedrooms [of communal women's houses] to find a huge pile of everyone's clothing and people would just grab out what they wanted. Many working class white and black kids had been strictly brought up to be neat and clean and ironed— in lieu of being expensive and trendy and cosseted. Some of us had precious pieces of clothing we had saved for or splurged to buy and didn't really want to share.[15]

For middle-class lesbian feminists, this way of living was revolutionary; for their working-class sisters, it could be oppressive. For many Black lesbians, the tendency for 'ugly' clothing to morph into 'untidy' clothing was one among a multitude of problems within the largely white, middle-class lesbian feminist movement.

Barbara Smith is a Black lesbian feminist and one of the founders of the Combahee River Collective (discussed in the following section). In an interview with the podcast *Making Gay History*, reflecting on a photograph of herself and her sister Beverly at the 1979 National March on Washington for Lesbian and Gay Rights, she says:

> I'm the one on the right, with my hair braided. And I was thinking as I pulled that picture out. I mean it took hours to get my hair braided, I only did it, like, a couple of times. Because I am so not into the muss and fuss of it all. And I was thinking, like, just seeing the fact that I had my hair braided shows how special I thought this march was.[16]

Barbara knew the significance of this march, that she would be seen, and that she would be a representative of the Black lesbian community—and 'being raised by Black women as I was, you never try to go out looking like you just rolled out of bed'; 'it was particularly important, I thought, for me to look well because the [lesbian] stereotype of course is that no male would want you'.[17]

Lesbian feminism had emerged as a distinct political movement because lesbianism was being ignored within the wider women's movement. Black lesbian feminism emerged because race, and the distinct personal and political realities faced by Black lesbians, was ignored, avoided, or deemed unimportant within the wider lesbian feminist movement. Simple differences like Barbara Smith's attention to her hair and disapproval of 'looking like you just rolled out of bed' illustrate how Black lesbians were fighting against barriers that the typical white, middle-class lesbian feminist didn't consider.

Cultural roots

Lesbian feminism, with the goal of achieving universal lesbian liberation, neglected to account for lesbian experience not being universal. It was difficult for most white lesbians to see that lesbians of colour were not represented authentically within the movement, and many were reluctant to accept that they themselves could be exclusionary or oppressive. As women's studies scholar Kathy Rudy reflected in 2001, '[d]rawing our attention to racism meant putting us white lesbians in the role of oppressor, a role with which [we believed] we had no experience or history'.[18] This is why Black lesbian feminist organising and communities were so important.

At the forefront of these in America and vital within lesbian feminist history was the Combahee River Collective, a Black feminist group composed largely of lesbians, active from 1974 until 1980. The Combahee River Collective, named after an 1853 raid led by Harriet Tubman which freed 750 people at the Combahee River in South Carolina, had a base of members who engaged with the movement in different yet important ways.[19] In 1977, Barbara Smith, Beverly Smith, and Demita Frazier authored a statement, which explained clearly and effectively the collective's perspective. It was groundbreaking. In her 2017 reflection on the collective, *How We Get Free*, Keeanga-Yamahtta Taylor writes: 'It is difficult to quantify the enormity of the political contribution made by the women of the Combahee River Collective because so much of their analysis is taken for granted in feminist politics today'.[20] For example, the now-popular term 'intersectionality' may have been coined by

Kimberlé Crenshaw in 1989 to describe overlapping forms of discrimination within the field of law, but the theory of intersectionality, if not the word itself, had been voiced within the collective's 1977 statement. It expressed 'the idea that multiple oppressions reinforce each other to create new categories of suffering'.[21]

For white lesbians, in general, clothing's personal and political meanings were specific and clear. The dyke uniform revolted against the social expectation of femininity, the supposed androgyny of the look removing the wearer from a materially manifested gender hierarchy. For Black lesbian feminists, the assumption that their experiences would align with a white feminist analysis was another act of oppression and erasure. The politics of dress may not have been the top priority for Black lesbian feminists or any other lesbian feminists. Still, the flattening of experience into one, community-wide 'uniform' was not necessarily appropriate for a movement whose members spanned numerous intersections of race, class, location, age, ability, sexuality and gender.

In 1980s and nineties Britain, Black lesbian feminism became increasingly active. In this context, 'Black' was understood differently from how we might consider it today—it was more akin to the current phrase 'people of colour'. The London Black Lesbian and Gay Centre offered a political definition of 'Black', which was used again in 1993 in *Lesbians Talk: Making Black Waves*, the first book published about the experiences of Black lesbians in Britain:

> descended (through one or both parents) from Africa, Asia (i.e. the Middle East to China, including the Pacific nations) and Latin America, and lesbians and gay men descended from the original inhabitants of Australasia, North America, and the islands of the Atlantic and Indian Ocean.[22]

The Black Lesbian Group, based in London and the first of its kind in Britain, was formed in 1982, though it folded shortly after. In 1984, the Camden Lesbian Centre and Black Lesbian Group formed, with this new Black Lesbian Group largely operating autonomously. The London Black Lesbian and Gay Centre was founded in 1985 by the Lesbian and Gay Black Group, which had originally been known as the Gay Asian Group, then the Gay Black Group. Other milestones include the launch of the Chinese Lesbian Group in 1983, the

Zami I conference in 1985 (the first national Black lesbian conference, held in London), the Zami II conference in 1989 (held in Birmingham), and the founding of organisations outside the capital, such as Nottingham's Black Lesbian Group and Manchester's Black Lesbian and Gay Group, which both launched in 1991.[23]

Many different people made up these groups and participated in these conferences. However, within (and sometimes outside of) these spaces a certain kind of dress flourished, one that celebrated various political Black cultures yet has generally been overlooked by lesbian feminist and lesbian fashion history. A specific term for the wearers of this many-layered style is 'Roots' lesbians. Though I have only encountered the term used in relation to lesbian fashion cultures once, it is a useful description of a wide-ranging selection of styles worn by lesbians of colour with various national backgrounds who chose to embrace their heritage through their dress. Inge Blackman and Kathryn Perry described the look in 1990:

> This style includes headwraps, clothing made out of African fabric, dashikis, saris, punjabi suits, Asian/African jewellery and hairstyles such as dreadlocks, cane/corn rows (maybe with extensions) and unstraightened Afro hair. Mingled with various western fashions, this fusion of styles reflects the tension of belonging to both Black and gay cultures but being prevented by homophobia and racism from complete acceptance by either. It is by maintaining this tension—in part through styles of dress—that many Black lesbians sustain their identities as Black women and lesbians without having to deny one at the expense of the other.[24]

Just as Black lesbian organisation throughout the 1980s responded to a lesbian feminist movement that prioritised white experience, the specificity of Black lesbianism could find a powerful home on the clothed body. In a short 1983 documentary about the London-based Gay Black Group, a female member pointed out: 'we are expected to [...] wash away parts of our identity, so among whites are we expected to [...] bleach out our Black culture? This group re-asserts that culture in a positive way'.[25] Being in a space with people who share your background, struggles or other experiences can allow those parts of yourself room to breathe and exist. For some Black lesbians, clothing was part of that space.

There is hardly a wealth of documentation regarding Black lesbian fashion in the 1980s. Still, some have referred to what they wore and how they felt about it in written or video accounts. Dorothea Smartt, a renowned poet, was both a contributor to the *Lesbians Talk* pamphlets and an interviewee in a 2014 documentary about the Black Lesbian and Gay Centre, *Under Your Nose*. It's in this documentary that she briefly mentions her clothing, saying, 'In those days as well, you know, I wore African clothes. You know? So, there's me, I'd turn up at some gay club, Stallions or something […] in me ting der, and they'd be like "uh, excuse me?"'[26] This is beautifully illustrated by a 1989 photograph of Dorothea (Figure 32), taken by Maud Sulter as part of her portrait series *Zabat*, which features nine creative Black women, each as one of the Greek muses. Dorothea is in the role of Clio, the muse of heroic poetry and history. The Victoria and Albert Museum, which houses the series in its collection, describes how Sulter used 'the conventions of Victorian portrait photography' but that 'the image is transformed with African clothes, non-European objects and, most importantly, by the resolute black woman at its centre'.[27]

Of course, this artistic photograph has been carefully staged, with the clothes most likely chosen by Dorothea and Sulter together. It is not a representation of everyday dress. Still, it is interesting to see Dorothea represented in a way that visibly embraces African culture almost entirely through clothing and hair: from the cowrie shell necklace looped around her neck to the blue-and-white shawl draped across her shoulder, and the beaded locs atop her head.[28] It represents Sulter's artistic vision and talent, Dorothea as a poet and a creative Black woman, and also a moment in time when Black women and Black lesbians in the UK were reclaiming a heritage that the society around them had consistently tried to whitewash— whether national British culture, or 1980s lesbian feminism.

* * *

The dress codes of the lesbian feminist movement, as well as the way that lesbians broke away from them, are a crucial part of this book's story. Though lesbian fashions and styles had existed and even flourished before this point, they had never done so in quite

the same way; butch and femme fashions, for example, were political in the way all lesbian identity is political, but were not a deliberate extension or representation of a social and political movement. In the 1920s, the boyish fashions widely loved and worn by lesbians could be embraced because they were also popular outside of lesbian (or invert) communities. By the 1980s, British and North American lesbian communities were thriving—they weren't and didn't have to be hidden or secret. From publications to social groups, political organisations to clubs, conferences to documentaries, lesbianism was more visible and accessible than ever before.

This meant that the flow of ideas about and influences on fashion and dress moved more quickly and reached more people across the community than it ever had: lesbian fashion had begun to be intentional and worn on a large scale, even if it was never really homogenous. The 'dyke uniform' was intentionally anti-fashion... yet, the way it was worn, shared, encouraged and diverged from meant that it epitomised the story of 'fashion' within lesbian history.

T-SHIRTS

THE BILLBOARDS OF THE BODY

Sometimes garments that aren't in fashion are the most fashion-able of all, and the slogan t-shirt is the figurehead of mainstream anti-fashion. Of course, a slogan t-shirt can take many forms; for every 'this is what a feminist looks like' or 'I heart NY' print, there are other, more niche phrases, declaring personal identities, political affiliations, media interests, or even mistranslated words in foreign languages.

Once underwear, then an American pop-cultural staple, the t-shirt's potential as a wearable blank canvas has made it a universal messaging medium. This grew from the 1960s and seventies, from gay and lesbian activism, as well as the Civil Rights and feminist movements. T-shirts were, writes Lynn S. Neal, 'a billboard for their slogans and a way to support their causes'.[1]

Slogan tees evolved from political badges. While badges have remained relevant in political and activist campaigns, they represent an older era of LGBTQ organising, when it helped to be more subtle. An early badge from 1965 reading 'Equality For Homo-sexuals' could be covered more easily than a t-shirt if the wearer was at risk. This badge and others like it were worn at the 1965 Eastern Regional Conference of Homophile Organizations (ECHO), although most attendees wore badges bearing the more discreet message 'ECHO' instead.[2]

LGBTQ slogan t-shirts blossomed throughout the second half of the twentieth century, partially due to 'branded' activist groups taking them up. By the time of an equal rights demonstration in

early 1970s London, the outfits surrounding the Gay Liberation Front's banner included a woman with 'LESBIAN' printed across her chest (Figure 33). And, of course, it became especially important for queer politics to be materially visible during the AIDS crisis. The first recorded case of AIDS was in 1981, then known as a 'rare cancer' that was mostly affecting gay men in New York and California. As it spread, the term 'gay plague' was popularised in the public lexicon—and though gay men were never the only ones affected by the disease, it was the association with the LGBTQ community that unforgivably stalled government responses to the pandemic.[3] While queer men across the world were witnessing their communities falling to pieces and their loved ones' unnecessary deaths, the public was largely apathetic and conservative, right-wing governments led by the likes of Margaret Thatcher and Ronald Reagan were more than happy to stay silent. It took until the later eighties for AIDS to be taken anywhere near seriously as a public health crisis, and even this was too little, too late.

New York City's Silence = Death Project was founded in 1987. Its iconic design—'SILENCE = DEATH' underneath a pink triangle referencing the Nazi persecution of homosexual men—was created to protest homophobic governments' response to AIDS.[4] The international organisation ACT UP (AIDS Coalition To Unleash Power) also took up the Silence = Death imagery, and t-shirts bearing it can be found in photographs from protests and Prides throughout the late 1980s and nineties.

Similarly, the name recognition of OutRage!, a British group most active in the nineties, was cemented by their logo 'appearing on people's chests in the streets', which 'acted as publicity [...], as well as badges of affiliation and identity for the wearer'.[5] The group's name and logo, 'OutRage!', one member recalls, 'was meant to symbolise that we were out as lesbians and gays and were filled with rage at the injustices which were perpetrated against us'.[6] These t-shirts existed on the premise of community, ongoing activism, and visibility. They stood for the individual self through the specific slogan on each shirt—for example, 'Dyke With Attitude'—but also the movement as a whole, with 'OutRage!' always printed below.[7] Slogan tees were creating a queer presence for not just the wearer, but the absent community too.

188

Lavender menaces and lesbian avengers

Another group, one which used t-shirts as the basis of its activism, preceded both ACT UP and OutRage!: the Lavender Menace. This lesbian activist group, created in response to Betty Friedan's attack on lesbians in the women's movement, refused to accept the subsequent exclusion of lesbians from the Second Congress to Unite Women, held in New York in May 1970.[8] The group came up with a plan to infiltrate the congress and put lesbians and lesbian issues on full display, a plan which revolved around the place where lesbian fashion, lesbian bodies, and lesbian activism meet: the lesbian slogan t-shirt.

Brooklyn-born Karla Jay was an early member of the gay rights movement, and in the years since has penned a number of pioneering works on lesbian history, from Natalie Barney to the Lavender Menace. The latter came with personal experience: Karla was herself a member of the group, and part of the action in 1970. This period was a whirlwind for Karla: in 1968, fresh-faced and idealistic, she had graduated college and began working towards her doctorate. At the same time, she was figuring out her sexuality in a lesbian culture that was still largely confined to the bars, and a feminist movement that was staunchly heterosexual. Despite this, Karla had officially joined the women's liberation movement in early 1969, throwing her lot in with one of New York's primary feminist groups, the Redstockings, who sought to show women the light through 'consciousness-raising' meetings. That summer marked the Stonewall uprisings, but it was the LGBT movement around Stonewall which made the uprisings as significant as they were. This was a movement that twenty-two-year-old Karla was all too happy to be a part of. For the first time, she was in community with not only politically conscious women, but politically conscious women who also liked women, and who might like her.

By May 1970, Karla was no stranger to direct lesbian action, taking part in zaps on women's magazine offices and organising a Wall Street 'Ogle-In' to protest street harassment. Yet, she devotes a chapter of her memoir to the actions of the Lavender Menace, and makes time to describe the importance of the group's clothing. For

the event, members dyed and printed plain white t-shirts until they made up a quasi-uniform of lavender-hued tees bearing the group's name in bold capitals:

> Several Menaces hand-dyed T-shirts in a bathtub. They then silk-screened enough purple t-shirts with the words 'Lavender Menace' for the entire group. No two shirts looked exactly alike; the color of each depended on how long it had been in the tub. All the shirts were the same size, however, since we could only afford one box.[9]

With a bit of advance planning, on the day of the Second Congress to Unite Women the Menaces managed to turn off the lights in the conference hall long enough for the members of the group to line the aisles, wearing their t-shirts. When the lights came back on, Karla stood up from where she sat in the audience, 'unbuttoned the long-sleeved red blouse I was wearing and ripped it off. [...] Then Rita [Mae Brown] yelled to members of the audience, "Who wants to join us?" "I do; I do," several replied'.[10] Photographs from the day capture the Menaces triumphant; dressed in their t-shirts, they pump their fists in the air and sit on the stage, defiantly holding up signs with the tongue-in-cheek message 'the women's movement is a lesbian plot'. The Lavender Menaces are the epitome of reclamation-as-activism, the basis and origin of many a lesbian slogan tee.

The material uniformity of the Menaces presented a strong united front. Lesbians would not be ignored. Creating lasting iconography for the determinedly visible nature of lesbian activism was no easy feat, yet the Lavender Menaces achieved it with a box of t-shirts, a bathtub, and courage. The dramatic way the t-shirts were displayed was, of course, central to their impact. But the phrase 'LAVENDER MENACE' was effective in and of itself, reappropriating a phrase that had been used against them, much like the Nazi pink triangle of 'SILENCE = DEATH', slurs like 'dyke', and many other symbols within LGBTQ visual culture. Betty Friedan was not at the congress on the day, but the attendees would most likely have known the context. The Menaces were reminding everyone there that lesbians were part of the women's and feminist movements, people with a unique perspective and important contributions to the cause. They were not a distraction or a threat, as they had been labelled. They

were not, innately, a menace… though they wouldn't hesitate to become one, if necessary.

* * *

T-shirts continued to be used by lesbian activists throughout the seventies and eighties. In the early 1990s a new group took up the art of the tee: the Lesbian Avengers, who organised the first ever Dyke March in Washington, D.C., on 24 April 1993. The Dyke March was the result of years of lesbian devaluation within wider gay rights activism. In 1973, the New York group Lesbian Feminist Liberation had planned a lesbian march to follow behind the official Pride march in 'an effort to strengthen lesbian identity', but the idea never became reality.[11] So the Lesbian Avengers' Dyke March twenty years later was revolutionary—and it is immortalised, in part, by the t-shirts which were worn.

The Lesbian Avengers' t-shirts were emblazoned with their eye-catching logo, designed by Carrie Moyer: the name of the group in bold, block capitals, encircling the simple outline of a bomb—either white-on-black, or black-on-white. The Avengers were conscious of the power of aesthetics in their activism; in the words of member Kelly Cogswell, founder of the Lesbian Avenger Documentary Project, the group were 'often creating actions for their visual appeal'.[12] The bomb logo printed on the t-shirts alluded to the sometimes-violent nature of direct action, but also to the violence that lesbians can experience, and so the urgency of lesbian activism. Elizabeth Ashburn, writing about lesbian art in 1996, stated that, 'The invisibility of lesbians has made it possible for society to construct a world without lesbians'.[13] The Avengers aimed to construct a lesbian place in the world by being the most on-show dykes possible—through marches, campaigns, and clothing.

An activist's clothes, unlike organised marches or meetings, are worn and seen in public constantly, a quick and efficient communication of a message that might otherwise be drowned out or silenced. Women's studies professor Wendy Chapkis calls this 'a visual shout':

> No, I do not accept the goodness of your goals and expectations.
> No, I will not help you feel secure in your choices. Do I look fright-

ening? Do I look angry? Do I look dangerous? Do you still feel safe in thinking that the system works just fine? Think again.[14]

Activism is, for the oppressed person, always a risk, and wearing an explicitly lesbian t-shirt in the late twentieth century was no exception. If some heterosexual people who saw the bomb-emblazoned Avengers might be prompted to reflect on lesbian issues, some might retaliate against them. But to wear an activist tee is to confront a system and the people who keep it running in the most everyday way possible—by walking down the street.

At the first Dyke March, the Avengers stood in a line in front of the White House and ate fire. Captured in iconic photographs by Carolina Kroon, the Avengers blur and overlap, their distinctive black and white t-shirts standing out from the dark background and their dark trousers, lit from above by the fire which they feed into their mouths. The fire eating was a response to a hate crime against a gay man and lesbian woman, Brian Mock and Hattie Mae Cohens, who had been burned to death in their apartment the year before. The Lesbian Avengers' chant symbolised the fight they waged against homophobia and hatred: 'the fire will not consume us. We take it and make it our own'.[15]

This lesbian presence was bold and undeniable. Kroon's photographs, such striking snapshots of lesbian history, exist as proof that the t-shirts were worn, the fire was eaten, and lesbians were loud, proud and active. This was a vision of the hope for lesbian liberation, a symbol of both action and community worn on the body and made 'our own'.

'Dyke'

A sentiment that appears time and time again in lesbian life stories, testimonies and oral histories is that lesbians were not visible. The British lesbian magazine founder Diana Chapman once said that in the mid-twentieth century, 'We were totally invisible. We didn't exist'.[16] Leo, an older British lesbian interviewed by Jane Traies, recounts the early days of her relationship with life partner UA in the sixties: 'Nobody "saw" us; they didn't see what it was. [...] There was no sort of status for it. There was just the reality of it, and that was unimpeachable; but describing it or talking about it,

well, that just didn't happen'.[17] The lesbian body, in a society where lesbians are not allowed to be present, is not lesbian. It is only a body that is different and shamed or shunned for it.

The word 'dyke' has been and continues to be used as a slur against lesbians, though its exact origin is unclear. The butch lesbian writer Judy Grahn suggests in *Another Mother Tongue: Gay Words, Gay Worlds* that 'dyke' comes from 'bulldyke', which in turn stemmed from the female warrior Boudicca and was used as an insult against (or possible celebration of) strong-willed women.[18] Other sources link it to the term 'diked out', referring to the clothing of a well-dressed man. It's possible that its likely predecessors, 'bulldyke' and 'bulldagger', were popularised by the Black lesbian community during the Harlem Renaissance, as discussed in Chapter 8.[19] 'Dyke' also has geographical meanings, one being a channel or ditch dug in the landscape to take water away from an area. This is, perhaps, the most violent linguistic association, as it implies that a lesbian woman has something missing; that having a vagina makes her love of women lesser than a man's. It is a reduction of the lesbian woman to her genitalia. Though this lineage of the word is trans-exclusionary, offensive language was never designed with inclusivity in mind.

Dykes fight back by becoming a movement or a march, rather than individual women called 'dyke' as they walk down the street. Lesbians can be empowered by embodying a broader culture, with the slur worn proudly across their chests (see Figure 34). In the words of lesbian and queer theorist Teresa de Laurentis: 'if it were not lesbian, this body would make no sense'.[20]

The Lesbian Avengers organised the first Dyke March in April 1993, but they have persevered for years, if often eclipsed by more commercialised Pride events. Alongside photographs or video footage, the t-shirts that celebrated each event preserve their legacy, kept safe in wardrobes and archives around the world.

One, housed by the GLBT Historical Society Archives in San Francisco, commemorates the San Francisco Dyke March on 17 June 1995. The t-shirt's wearer was part of that day's act of space-claiming, like a badge of honour, but the illustrations printed on it also signal a much larger claiming of lesbian space and of Dyke March collectivity. The t-shirt features the Earth, surrounded by four female figures, with the words 'Dyke Rights are Human

Rights', 'DYKE MARCH', and the march's date and location. The symbols are easy cultural messages to understand—the women around the world are shown to be travelling freely. These women, combined with the words 'Dyke Rights', suggest that dyke-hood is global and that 'Dyke Rights are Human Rights' globally, reflecting the theme of the 1995 march: 'A World Without Borders'.[21] The real Dyke March, the t-shirt's imagery declares, is not limited to one city or one day. Lesbians continue to stomp through space and time in the Dyke March t-shirt, with the online archive Wearing Gay History showcasing various moments in its lesbian legacy, including Buffalo, New York, in 2001 and Portland, Maine in 2007.

In 1990, at New York City's Gay Pride, activist group Queer Nation handed out their manifesto, a plea for united, continuous LGBTQ visibility as activism: 'Let's make every space a Lesbian and Gay space. Every street a part of our sexual geography. A city of yearning and then total satisfaction. A city and a country where we can be safe and free and more'.[22] If city streets are temporarily made into 'Lesbian and Gay space' for the duration of a Pride or a Dyke March, reminders of those times and the queer occupation of those spaces keep them in the queer domain by ensuring that the community's claim on them persists. A t-shirt that memorialises specifically lesbian involvement secures the place of lesbians within this domain. It is a shout, a stand and an obstruction. As Sara Ahmed writes in her 2017 essay 'Lesbian Feminism':

> Lesbians know a lot about obstruction. And it might seem now for lesbians that we are going with the flow. Hey, we can go; hey, we can get married. And if you talked about what you come up against now, those around you may blink with disbelief: hey what's up, stop complaining dear, smile. I am not willing to smile on command.[23]

Obstruction, for Ahmed, is standing up for lesbian rights, whether they are assumed or denied; it is asserting the importance of difference when that difference is unwelcome. As I've written about before, the word 'dyke' is a distinct iconographic choice compared to a symbol like the rainbow. A t-shirt reading 'dyke' asserts that, yes, lesbians and dykes are angry, but through no fault of their own. Printed to be displayed proudly across the chest, the word 'dyke' is a powerful message, at once an identity and an accusation.[24] Much

like with the Lavender Menace, the word 'dyke' on a t-shirt puts the onus on the observer to acknowledge lesbian oppression, at the same time as it claims the term as a source of strength.

Another t-shirt housed in the GLBT Historical Society Archives is white, with 'DYKE' printed repeatedly in black ink, the words forming an inverted triangle. This could be considered an emphatic claiming of dyke identity, but the triangular shape adds another layer of meaning, another reference to a lesbian struggle against oppression. The black triangle began being used by lesbian activists in the late twentieth century in the same way that the pink triangle was reclaimed by gay men and the wider gay rights movement. The black triangle was used in Nazi Germany to brand individuals as 'asocial'; the LGBTQ historian Claudia Schoppmann defines this as a 'flexible label' for 'people who did not conform to social norms, yet had not committed any offence'.[25] The category was largely used to oppress Romani people, but lesbians were known to have been marked with the label, alongside other 'asocial' individuals, such as those with mental health conditions and sex workers. (Lesbians, who weren't persecuted systematically in the same way as gay men, are also known to have been categorised with the red triangle: persecuted as political prisoners).[26] Wearing the black triangle alongside the word 'dyke' on a t-shirt graphically links historic realities of lesbian oppression with the people and bodies who remain subject to it, a stark reminder that this is not a liberated world.

'Dyke' t-shirts are not only used to represent struggle—sometimes, they represent joy. A Dyke March that took place in 2017 is a perfect example of this. Dyke Marches, though far from the only situation where lesbian or 'dyke' t-shirts are worn, remain prominent in the lesbian archive because of their high attendance, maximising both material and photographic evidence. A clip of Edie Windsor, posted on the Lesbian Herstory Archive's Instagram account, shows her singing 'When the Dykes Go Marching in' as she walks. She wears a plain black vest, printed with 'DYKE' in white letters. Edie is a modern-day lesbian hero. Her 2013 US Supreme Court victory led to the federal recognition of same-sex marriages, a crucial step to the eventual legalisation of same-sex marriage across the US in 2015.[27] In the video she revels in the 'dyke' label; she and the crowd around her are celebrating their

victories, their dyke lives and all of the dreams that they continue to pursue. Edie was not the only person in this 'dyke' vest at the march; photographs of other dykes wearing the same top were uploaded to Instagram in 2019.[28] The march organisers may have distributed these vests to marshals, but this is not evident purely by sight. What is important about the matching 'DYKE' vest is that dykes claimed it with joy, including it in their activism and community. In this movement of bodies, marching, singing and living, their dyke identity is there in black and white, for all the world to see.

18

THE FASHION OF LIBERATION

Since the final years of the twentieth century, fashion for lesbians has gained the narrative of choice. Many people, both within and outside of the LGBTQ community, might assume that a liberated lesbian's clothing can be whatever they choose; there's no need to conform to a stereotype or fit a community mould. In reality, this is not always the case. Still, it's worth understanding where this narrative came from and what the clothes tell us.

Taking the late 1980s as a starting point and travelling immediately through 1990s 'lesbian chic' into the 2000s, there is an obvious change in lesbian representation and, indeed, self-fashioning. Elizabeth Wilson reflected as early as 1990 that '[i]n the late 1980s it has increasingly seemed that lesbians experience a freedom and a pleasure in dress that is denied, if not to heterosexual women in general, at least to heterosexual feminists'.[1] She pointed to a 'glamour ball', the 'dyke event of the year in London in the Winter of 1986/7', where lesbians congregated in 'frocks, high heels, lipstick and décolletage'.[2] As Wilson notes, these looks were a stark change from the popular 'dyke uniform' that had dominated the lesbian fashion landscape in the earlier part of the decade.

'Lesbian chic', exemplified by k.d. lang and Cindy Crawford's famous *Vanity Fair* cover, where lesbian singer-songwriter lang sits in a barber's chair being shaved by supermodel Crawford, was a specific type of deliberately fashionable lesbian existence—one that idealised a very particular kind of lesbian life and style, while demeaning any other.[3] As Jodi R. Schorb and Tania N. Hammidi explained in 2000, '[i]nitially, lesbian chic held the promise of putting lesbians front and center in both public and political life: finally

some recognition and an image facelift, a long-awaited celebration of our good looks, style, and even marketability'. Yet, 'this "new world" of lesbian style [was] made possible by its exiles'.[4] It is no coincidence that those most represented by the lesbian chic image were middle- to upper-class, young, and white.

While lesbian chic may have gone out of fashion in the 2000s, the idea that lesbians do not have to look like dykes has prevailed, even if one-dimensional stereotypes persist. This is assisted by the shifting social and cultural backdrop of the early twenty-first century. Though the fight for rights and recognition is never a simple path, there has been an obvious positive shift when it comes to legal rights and popular opinion of lesbians and other gay or bisexual people in and beyond the West, though the community continues to experience discrimination and hate crime in high numbers.[5] With this has come a sense of lesbian (and lesbian fashion) opportunity.

Yet as we delve into lesbian fashions of the modern day, it's crucial to remember that for trans people, the appalling reality is that legal and social barriers have not, recently, been progressing positively at all.[6] This means that in the 2020s lesbian fashion—which, as we've seen, has often been one and the same as trans fashion—has regained much of the political urgency that it had apparently lost over recent decades. So much of lesbian fashion is gender nonconforming, and so much of its history is entangled and aligned with trans (fashion) histories. If trans people are under threat, then so are lesbians; if looks associated with them are under threat, then so is lesbian self-expression. This, perhaps, helps to explain why lesbian dress has not only diversified in recent years, but has done so in increasingly deliberate ways.

Ways of doing 'lesbian'

'Liberation' seems to imply 'choice'. I'm not denying that lesbians, like all people, should be allowed and encouraged to choose what clothes they wear and how they style themselves—but I do believe that there is more to the story than this. There is no denying that lesbians of this century have noticed a change in the way that they can dress whilst still being recognised within the community. The majority of records available to me concerning these shifts are from

the UK and the US, particularly Jane Hattrick's research on Brighton-based lesbian appearance between 2005 and 2015;[7] a pair of articles covering between them lesbian and queer women's experiences and views in Britain, Ireland and various US states;[8] and Kelly L. Reddy-Best and Dana Goodin's 2020 reflection on an exhibition from America's Midwest titled *Queer Fashion & Style: Stories from the Heartland* (2018).[9] These four pieces of work are, of course, unable to represent the entire lesbian community's thoughts and feelings on fashion between the years 2005 and 2018. It's particularly important to note that almost all the participants in the three studies were white—the authors explain the reasons for this and the resulting shortcomings of their research, and I cite them aware of their limitations in turn. But this research does clearly show distinct trends within 2000s–2010s lesbian fashion, and offers important snapshots of lesbian fashion's recent history.

The trio of researchers interviewing British and Irish lesbians and bisexual women found in 2014 that, while there was still a lesbian 'look' to conform to or resist, a number of women commented that 'diversity was increasing' and 'lesbian styles were becoming more mainstream and less distinctive', compared with their own memories or ideas of what lesbian fashion used to be.[10] For example, sixty-two-year-old Rachel mused that 'there's more possibility of experimentation, there's more diversity, and there's more ways of doing "lesbian" than there used to be'.[11] Philios, aged twenty-three, described both 'stereotypical sports lesbians' and the 'geeky [or] funky' crowd.[12]

Similarly, Hattrick's Brighton research revisited participants in 2015, ten years after their initial interviews in 2005. Back then, her interviewees, while agreeing that lesbians wore 'many styles of dress', had also recognised a distinct 'uniform'.[13] Tracy S., for example, had said that there was a 'lesbian look', 'though not exclusive to just lesbians. If you dressed a lesbian in the "uniform" then you'd unmistakably see a lesbian but if you dressed a straight woman in the "uniform" you'd see a woman in jeans and a t-shirt'.[14] But, in 2015 Andy said that while a 'boyish' look was fashionable among lesbians, 'there is also an acceptance that lesbians can look like anyone and there isn't a big pressure to conform to a look in order to be recognised or accepted'.[15]

But the new sense of 'freedom to choose' among British lesbians was not felt by all. The 'boyish' look mentioned by Andy in Brighton appears again in the British/Irish interviews: Sally, a twenty-five-year-old lesbian, commented, 'there's a bit of a boyish look going on at the moment, isn't there? And it's sort of short spikey hair, and chunky trainers'.[16] This look had already been noted in 2004 by Rani Kawale, who interviewed twenty London-based lesbians, nine of whom were 'born and/or raised in Britain and originated from South Asia (mainly India and Pakistan)'. She found that the boyish look, or something very similar, was ubiquitous, yet discrimina-tory.[17] For South Asian lesbians, some of whom deliberately chose to wear their hair long as an aspect of their identity, the expected 'look' on the lesbian scene was so pervasive that any deviation from it—particularly when combined with having brown skin—was unacceptable. Kawale recounts the experience of her interviewee Amina, who was then in her twenties:

> Amina […] felt upset and disappointed by not being able to pass as lesbian on the scene and so she performed surface acting by changing her clothing. Having initially dressed as a 'stereotypical straight woman' in 'tiny tops, short skirts, bangles, make up and long hair', she later dressed 'like a dyke' in 'tight tops, big trousers, big boots and no make-up' to visit a particular lesbian bar with this informal dress code. As a South Asian woman she decided to maintain her long hair. This, together with her brown-coloured skin, was not perceived as dressing 'like a dyke' by the white female bouncer at the bar who did not allow her in.[18]

The 'boyish' look is not inherently discriminatory, and it is the case that the most masculine lesbians are often those most frequently discriminated against outside of the lesbian community. However, the expectations around masculine fashion can be a cause for dis-crimination within the community itself. Amina's testimony is now decades old, but more recent voices have described the same kind of pressure.

In the US, research from 2015 into the potential distress caused by associations between clothing and identity found that lesbians and queer women may worry about looking 'not queer enough' if they thought their appearance too feminine: 'Eighteen [of twenty] par-

ticipants' said that they had 'changed their dress or appearance after they were out because they wanted to be more visibly queer to the queer community'.[19] Women who didn't want to wear masculine clothing sometimes felt the need to 'queer it up' in other ways when entering LGBTQ spaces. This might mean the addition of queer symbols—the six-stripe rainbow flag being the most obvious among them—in the form of, for example, jewellery.[20]

In the 2018 *Queer Fashion & Style* exhibition in Iowa, the same themes emerged. One section, titled 'Fitting the Stereotype', showed masculine 'brands, such as Birkenstocks or Doc Martens' and loose-fitting styles like 'flannel shirts, sports team T-shirts, and cargo shorts'.[21] In contrast, outfits featured in the section 'Not Queer Enough' came with stories about how the wearers felt in them, and the measures they took to make themselves feel or be seen as more queer. For example, Emma loaned a red jumpsuit to the exhibition. Though she felt confident while wearing the look to a 'big queer dance party', her core outfit wasn't enough to signal her identity to others in the community—she wasn't read as queer by fellow party-goers until she lifted her arms to show her armpit hair.[22] As Emma said, 'no self-respecting straight woman would have all of this body hair, you know?'[23]

Pink handbags and disco dresses

Most people, when they get dressed, want to wear clothing which is authentic to themselves as individuals. For some, this might mean adhering to certain fashion trends or styles; to others, it might mean dressing in clothing that is practical and comfortable; sometimes—even for those within the two former categories—it might mean being their authentically queer, or lesbian, self. People don't necessarily want to sacrifice the personal integrity of their outfits 'just' to be legibly lesbian, as the mid-century femme Jessica Lopez did at Bay Ridge High, when she came to school in a man-tailored shirt to get the attention of her butch peers (see Chapter 10). When the scope of what lesbian fashion can be is widened, individuality suffers less.

To have a variety of recorded (or archived) outfits labelled as queer, as they were in the 2018 Iowa exhibition, is one way to

recognise the expansive potential of lesbian fashion in the past, present, and future. A range of outfits were on display: Lyadonna's jeans and yellow-and-brown plaid flannel shirt, Emma's short red jumpsuit with gold brocade, Kaitlyn's white lace vintage dress with a fur shawl and Jennifer's shirt, vest and trouser combination, complete with a striped red bow-tie.[24] Emma and Kaitlyn's outfits, categorised within the themes 'Not Queer Enough' and 'High Femme/ Feminine Leaning' respectively, are reminiscent of those of Natalie Barney, Madge Garland, Lillian Foster or Joan Nestle—lesbian dress has always organically included feminine styles, alongside and connected to the masculine fashions that fit the 'look'. And two decades earlier, the V&A's landmark *Street Style* exhibition included mannequins sporting a variety of lesbian outfits, among them Elizabeth Wilson's 'Biba dress worn to the first Gay Liberation Front disco in 1971', 'Inge Blackman's combination of tailored jacket and trousers and African headwrap' and 'DJ Slamma's tank girl inspired clubbing outfit'.[25]

In 2018, I helped to create and donated an outfit of my own to the Brighton Museum exhibition *Queer Looks*. The featured outfits, which were donated by LGBTQ residents of Brighton and the surrounding area, now stand as part of the museum's permanent fashion collection. Though there were limits to what could be collected and the communities that the project was able to reach, the twenty outfits on display—and the photos of the original owners—represent a range of queer identities, ages, backgrounds and activities. There are leather chaps and leather lingerie, t-shirts and jeans, sequinned drag outfits, wedding tuxedos and denim jackets. My own outfit (Figure 35), a pink-and-white vintage tea dress paired with a pastel-pink quilted jacket, pink platform heels and a pink handbag, represented my love of the colour and the femininity that—especially in my late teens and early twenties—was integral to my personal expression of lesbian identity. My style has changed even in the time since I donated this outfit, as style is wont to do, though it remains rare to see me dressed in other colours. I remain proud of the girly, pink outfit displayed behind glass, one day to be stored and remembered as lesbian within the museum's collection. It was authentically my own, and undeniably part of a wider community.

Pink is a colour with baggage. Though it has not always represented femininity, in the 1950s US advertising popularised the insistence on gender distinctions associated with the colour.[26] But when fashions become lesbian—when clothes that may symbolise something other than sexuality are worn on a lesbian body—there is the potential to shift their meaning. Gender norms tell women that they should be feminine, but also that this makes them lesser than men. They then tell queer women that they are inherently unfeminine— but that this makes them lesser too. For a woman to be queer, yet hyper-feminine, is to reclaim and speak with both sites of her oppression.[27] When the lesbianism of an alternative outfit is implicit, as in the case of exhibitions with titles like *Queer Looks*, its subtler meanings are given space to bloom. When lesbian fashion is represented, there is space for the broad, bright spectrum of other meanings that lesbian fashion can hold.

Trending

To be recognised as a lesbian, eschewing femininity or mainstream fashionability is less necessary today than ever before. This is, at least, the case online, where so much of lesbian and LGBTQ communication exists in the 2020s. The internet has, of course, been around for decades. Still, even in the short time since the interviews mentioned earlier in this chapter, I have noticed a change in lesbian signalling and the use of queer fashion online. More than ever, with image- and video-based apps like Instagram and TikTok dominating social media, fashion is on display. What makes this closer to a museum exhibition and less like a twentieth-century jaunt down the street is that it comes pre-labelled. With bios often proclaiming users' gender or sexual identity, career or hobbies, alongside— increasingly—chosen pronouns, it takes one click to find out exactly who a person is. Similarly, hashtags in the captions of a visual post might make the poster's identity obvious. In the same way that a lesbian activist t-shirt makes identity unavoidable to anyone seeing or wearing the outfit, the trappings of social media create the opportunity for a constant assertion of the self. In many ways, lesbian fashion is more recognisable and takes more forms than ever before when it exists online.

For the high number of lesbians visible online, there can be war-ring desires to be individual and true to oneself, but also to fit in and feel a sense of belonging within the community. There is a limit to how far online recognition can stretch, after all—eventually, we all step back into the real world. Through my own practice of sharing lesbian fashion history on TikTok, I have encountered a hunger among the platform's lesbian users for lesbian imagery and codes from the past.[28] I noticed in particular a desire to wear and, more-over, to popularise symbols that could be incorporated into femi-nine and/or alternative-looking outfits. A landmark among these were 'lesbian earrings'—described by various TikTok users as 'big', 'bad', or 'kitschy', including pairs made out of small plastic toys or playing cards, among other unexpected charms.

The trend for 'lesbian earrings' is a new and deliberate formation of lesbian community signalling. Violets, too, are part of this online affirmation of lesbian self-styling, in a modern interpretation of their adoption by Paris Lesbos in the 1920s. Today, violets are being repeatedly incorporated into lesbian looks—and these are then shared and celebrated online, fuelling the trend. Multiple TikTokers have described their own violet flower tattoos, while others have declared that they plan to get one in the future. 'Can this be the new way we find each other?' one user asked.[29] Per tradition, users iden-tifying as femme seem to form the strongest attachments to these lesbian accessories and adornments, since their outfits might other-wise not be read as lesbian. Sometimes lesbian fashion is defined by the changes people make in order to be part of it.

Though online lesbian and queer communities are vast and ever-changing, and research focusing on them is limited, they are sites of congregation for lesbian fashions. They are places where styles and signals can be hashed out, explained and agreed upon; where lesbi-ans can experiment with how they dress and how they want to be seen. Masculine and more androgynous-presenting lesbians find themselves in the same communities, too, such as one user I encoun-tered who associated their style with the 'dyke uniform' of the seventies and eighties. They wrote: 'I wear the butch uniform most days. jeans [sic], plain tshirt, leather jacket etc!'[30] Though there truly do appear to be more ways than ever to 'look lesbian' in the age of social media, there remains an intentionality to lesbian dress.

Fig. 30: Official suffragette chauffeur Vera 'Jack' Holme, driving Edith Craig (front passenger seat), Emmeline Pankhurst (back seat) and others to Scotland, 1909.

Fig. 31: British composer and suffragette Ethel Smyth dressed in masculine attire with a skirt. Photo by Aimé Dupont, late nineteenth century.

Fig. 32: *Christopher Street* by Bettye Lane, 1978. This photograph captures lesbians in t-shirts, shorts and dungarees, holding protest signs, at New York City's Christopher Street Liberation Day March.

Fig. 33: *Clio (Portrait of Dorothea Smartt)* by Maud Sulter, 1989, photograph. Part of Sulter's series *Zabat*, which depicts creative Black women as the nine Ancient Greek muses, the portrait represents lesbian poet Dorothea Smartt as the muse of heroic poetry and history.

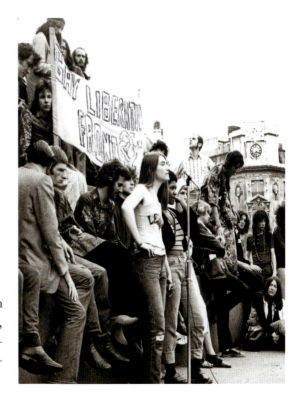

Fig. 34: A gay rights demonstration in London's Trafalgar Square, c. 1972, featuring a Gay Liberation Front banner. The central figure wears a sleeveless top reading 'LESBIAN'.

Fig. 35: Hand-printed 'DYKE' t-shirt black ink on bright orange fabric Probably British, from the 1980s o '90s—found at the Lesbian Archive & Information Centre, Glasgow Women' Library.

Fig. 36: One of the display cases in Brighton Museum's *Queer Looks* exhibition, 2018. The pink outfit (right) was donated by the author.

Sometimes, the easiest way to see this is when somebody suggests the opposite. In March 2022, when a *New York Post* headline declared that '"Dressing like a lesbian" Is Sexy, "powerful" New Trend', the online lesbian community was outraged. The viral article, paraphrasing an earlier, well-considered article by Jill Gutowitz, author of the essay collection *Girls Can Kiss Now*,[31] echoed the language of new generations, but missed its mark on the substance. It was dominated by zingy one-liners such as 'Lesbi-honest, queer fashion is totally in!' and phrases about how models Bella Hadid and Kendall Jenner 'have also stunned in sapphic swag'.[32] As I wrote on Instagram at the time, lesbian fashion is more than just 'sexy' and 'powerful'—though it has always been these things. It is also expansive, and complicated.[33] Anita Dolce Vita put it perfectly on her website DapperQ:

> What sets queer fashion aside from other aesthetics is that it is intentional in challenging harmful binaries and beauty standards, creating emancipatory potential for people of all genders and sexual orientations to dress in a manner that is the most self-affirming. [...] It is so expansive that I cannot put into words the immense diversity, multiplicity, and potential it holds. It is not simply skinny cis women, queer or not, wearing suits.[34]

Lesbian fashion cannot be defined. It takes many forms, some of which I hope to have honoured in this book, and more that I haven't had the chance or space to capture. What the new world of TikTok shows us is that sapphic style is constantly evolving, as seen in 'lesbian earrings', yet still drawn to its history, as shown by violet tattoos. Lesbian fashion cannot be a trend, simply because it has never been only one thing. But, in many ways, it has always been the fashion of liberation. From all-black ensembles to men's *umanon hakama*, high-collared shirts, white wedding dresses, smudged red lipstick and music hall suits... No matter how big or small the diversion from the mainstream, lesbian fashion prioritises parts of the self that many observers would rather not see. If our selves are evidence of lesbian lives, our clothes spell out our history, our stories sewn into the seams.

AFTERWORD

In the mid-1910s, Otake Kōkichi walked the streets of Tokyo in 'her man's kimono and hakama', wearing traditional male garments at a time when Japanese men were dressing in Western suits.[1] Her clothing was a statement; she was not the 'good wife, wise mother' that her culture expected her to be, but neither was she a Japanese man. Kōkichi used the sartorial tools available to her to craft an appearance that was unique and her own, representative of her gendered identity, sexuality, political beliefs, and her constant quest for freedom. Zooming out, it's clear that Kōkichi was not alone. Eighty years later in the 1990s, we meet the contributors to Joan Nestle's *The Persistent Desire*. Among them is Arlene Istar, a lesbian who enjoys wearing skirts and 'proudly' wears her facial hair, conscious that she does 'not fit anyone's stereotype of a feminine woman'.[2] She calls herself a 'femme-dyke', knowingly straddling the boundaries of gendered dress and stereotypes of sexuality with her body and its adornments.

Lesbian fashion so often fits 'into the cracks' of gender, to borrow a phrase from Jack Halberstam.[3] Or, as I suggested in Part 1, it crosses the lesbian bridges between them. Different lesbian fashions may be similar in style or intent, like parallel bridges over a canyon of gender difference. Even when lesbian dress sits firmly in the 'masculine' or 'feminine' camp, as with Stormé DeLarverie, 'the lady who appears to be a gentleman', it remains important. The masculine/feminine cultural divide is tied to the concepts of the heterosexual man and woman. For a lesbian to present themself firmly on one side or another is to subvert the very existence of those categories. No matter the motivation or the context, if gender is a social dichotomy and fashion is gendered, then our clothes as women who love women (or as people who do not love men) will always mean something.

Throughout this book, I have sought to make the history of lesbian fashion visible, and to expand the boundaries of what lesbian fashion may be. People don't need to have explicitly used the label 'lesbian' to be recognised as part of this history, nor do their clothes need to be considered particularly 'fashionable'. Any kind of queer past is full of silences; clothing, so often, acts as the wearer's voice. We might not be able to speak to many of the figures who appear within this book, but the clothes they wore, preserved in letters, interviews, photographs, or paintings, can help us understand them. Though many fashion historians study the clothes worn by everyday people (as opposed to the elite), and many more research the divergences from or rebellions against mainstream fashion, lesbian fashion history can offer fresh perspectives on such divergences and rebellions. And lesbians and lesbian-adjacent people themselves are important, no matter what they might have worn.

As I said in this book's introduction, all histories are written in the present. This perspective is what unites all of you who are reading, though your experiences may differ vastly. I didn't write this book as an objective observer; I wrote it because I wanted it. Because as a lesbian and a fashion historian I was desperate to discover a history that I was at the end of. I wanted that end to be open and inclusive, because history is not a closed door. In the billions of human lifetimes across the entirety of the world, there have been other people who felt what we feel today, and innumerable moments when clothing has been chosen or changed to reflect those feelings. These eighteen chapters offer only a beginning, an exploration of what lesbian fashion can be and what it might mean.

In this book, we have seen lesbian fashions or styles that have been incredibly specific to their place and age, and others that have re-emerged and been reinvented time and time again. Anne Lister, though called 'the first modern lesbian', gained the title because her diaries showed the world that lesbian possibility existed far earlier than its presumed historical beginning. Earlier still is Sappho, but her legacy stretches over centuries and strongly into the present day.

In the 1920s, lesbian fashion was ready to be seen, a 'coming out' in the debutante sense if not the brazenly queer one. From the pages of British *Vogue* and Natalie Clifford Barney's literary salon to the lesbian and trans communities of Berlin and the rent parties of

Harlem, it was a roaring fire, but in some cases it left behind only embers. Lesbian fashion history is not linear; all too often, its development has been cut short, whether by state suppression and record-burning as in Nazi Germany, or by larger-than-life figures like Gladys Bentley taking off their outfits and folding them away. Yet in the lesbian bars of the mid-century it was written anew, informed by the folklore of what came before. Various kinds of lesbian masculinity, too, grew out of scattered seeds from the past, with female husbands or suited celebrities creating a space for lesbian possibility—all the way from the pamphlets of eighteenth-century Britain to the dazzling drag scenes of the 2000s.

In a world where lesbians do not always live freely and are not universally accepted, which is still the world we see today, being a lesbian remains a political stance. Here again, the threads between past and present are there to be seen by those who search for them, from exhibitions about 'queer looks', to t-shirts emblazoned with 'LAVENDER MENACE', to the 'hideous' outfits of suffragette Ethel Smyth. We hear so often that 'love is not a choice' and that LGBTQ people are 'born this way'. Perhaps this is true… but when we dress, we do make choices. We don difference, we embrace the unacceptable, we reach out to others like us. These are lesbian actions, each a new branch in the language of fashion whose etymological roots are the foundations of this book.

It is my hope that all kinds of lesbian fashion histories will continue to be explored both by myself and by others, interpreted differently as we go. I hope that lesbians and lesbian-adjacent people might see themselves and their choices reflected in the clothes worn in the past by individuals and communities who were something like them. I hope that lesbian lives and loves, or at least the possibility of them, grow increasingly evident when we look back on all kinds of histories. I hope that studying clothing helps to make them visible. In many ways, a history of lesbian fashion is about the joy of discovery. It's a kind of detective work, a hunt for connections in material and ephemeral evidence that was not made to be combed through so thoroughly. One clue can lead us to another and after each one lesbian history widens, framed by the clothes that decorate its characters. Fashion is a lens through which to see people and their worlds, their motivations and their tastes,

and lesbians have spent too long out of view. A history of lesbian fashion opens the closet. It tugs its contents into the world, suit after gown, ready to be seen.

ACKNOWLEDGEMENTS

To my amazing agent Gyamfia Osei, and my editor Lara Weisweiller-Wu, who were instrumental in getting *Unsuitable* into the world: a million thank-yous, both. Thank you to anyone who shared resources or articles with me—my friend Charlotta Ruotanen for her help with Queen Christina, Jane Hattrick for showing me Anne Lister's 1840 clothing inventories, and everyone who helped me figure out the history of trans lesbians in Weimar Berlin, including those at the Lesbische Lebenswelten research project and Bianca Walther of the Frauen von Damals podcast.

Thank you to everyone who had a hand in the creation of this book, whether you've been in the trenches or on the outskirts, fine-tuning or encouraging from afar. To every reader of Dressing Dykes—you literally made this book possible, and I might have given up long ago if not for your kind words. To the staff who served me endless iced lattes at the Tokyo café where I wrote whole chapters. To every teacher, from school up to university, who ever encouraged me. To my family, but especially Nana Olive, who would've shown this book to everyone she knew. To Lilith, always, obviously. Thank you for bleaching my hair and buying me Crocs when I'm sad. Thank you for believing in me.

NOTES

INTRODUCTION

1. Elizabeth Wilson, 'What Does a Lesbian Look Like?', in *A Queer History of Fashion: From the Closet to the Catwalk*, Valerie Steele, ed. (New Haven: Yale University Press, 2013), 167.
2. Monique Wittig, 'One Is Not Born a Woman', in *What is Gender Nihilism?: A Reader* (Seattle: Contagion Press, [1981] 2019), 31.
3. Kit Heyam, *Before We Were Trans: A New History of Gender* (London: Basic Books, 2022), 26.
4. Emma Donoghue, *Passions Between Women* (London: Bello, [1993] 2014), 8.
5. Judith M. Bennett, '"Lesbian-Like" and the Social History of Lesbianisms', *Journal of the History of Sexuality* 9.12 (2000): 13.
6. Ibid., 14.
7. 'Transmasculine' refers to people who were assigned female at birth but are masculine and understand themselves as trans, whether as a man, non-binary, or otherwise (genderqueer and genderfluid are other alternative identities).
8. Heyam, *Before We Were Trans*, 158.
9. Martha Vicinus, 'The History of Lesbian History', *Feminist Studies* 38.3 (2012): 576.

1. TUNICS AND VIOLETS: SAPPHO AND HER AFTERLIVES

1. Sappho, 'Fragment 94', in *If Not, Winter*, Anne Carson, trans. (Virago: Great Britain, 2003), 185–7.
2. Sappho, 'Fragment 29C', idem, 57.
3. Sappho, 'Fragment 92', idem 181; 'Fragment 98A', idem, 195.
4. Sappho, 'Fragment 21', 39; 'Fragment 30', 61; 'Fragment 103', 205.
5. Ella Haselswerdt, 'Re-Queering Sappho', EIDOLON, 8 Aug. 2016, eidolon.pub (last accessed 16/05/23).
6. Ibid.
7. Arthur S. Way, *Sappho: Vigil of Venus* (London: Macmillan and Co., Limited, 1920), xiv.
8. Ibid., xv.

9. Laura Darling, 'Sappho: The Poetess', Making Queer History, 4 March 2016, makingqueerhistory.com (last accessed 10/11/23).

10. Quoted in Judith P. Hallett, 'Sappho and Her Social Context: Sense and Sensuality', *Signs* 4.3 (1979): 448.

11. Flora Doble, 'Sapphic Sexuality: Lesbian Myth and Reality in Art and Sculpture', Art UK, 27 July 2020, artuk.org (last accessed 10/11/23).

12. Aaron Poochigan, 'Introduction', in Sappho, *Stung With Love: Poems and Fragments*, Aaron Poochigan, trans. (London: Penguin, [2009] 2015), xii–xiii.

13. Ibid., xiii.

14. Sappho, *Poems & Fragments*, Josephine Balmer, trans. (Hexham: Bloodaxe Books, [1984] 1992), 41.

15. Gill Perry, '"The British Sappho": Borrowed Identities and the Representation of Women Artists in Late Eighteenth-Century British Art', *The Oxford Art Journal* 18.1 (1995): 44.

16. Ibid., 45.

17. Emma Donoghue, '"Random Shafts of Malice?": The Outings of Anne Damer', *Lesbian Dames: Sapphism in the Long Eighteenth Century*, John C. Beynon and Caroline Gonda, eds. (London and New York: Routledge, [2010] 2016), 127.

18. Ibid., 130.

19. Olivia Bladen, 'Anne Seymour Damer: The "Sappho" of Sculpture', Art UK, 7 Feb. 2020, artuk.org (last accessed 10/11/23).

20. Ibid.

21. Donoghue, *Passions Between Women*, 274.

22. Ibid., 292.

23. Jeffrey Merrick, 'The Marquis de Villette and Mademoiselle de Raucourt: Representations of Male and Female Sexual Deviance in Late Eighteenth-Century France', *Homosexuality in Modern France*, Jeffrey Merrick and Bryant T. Ragan, eds. (Oxford: Oxford University Press, 1996), 41.

24. H. J. E. Champion, 'Remembering Sappho: Transatlantic "Lesbian Nations" in the Long Nineteenth Century', *Women's History Review* 31.1 (2022): 9.

25. Diana Souhami, *No Modernism Without Lesbians* (London: Head of Zeus, 2020), 223–4.

26. Ibid., 238.

27. Ibid., 239.

28. Champion, 'Remembering Sappho', 20.

29. Ibid., 22.

30. Morna McMurty, 'A Decade of Sappho in Lesbian Herstory', [n.d.]

Glasgow Women's Library, womenslibrary.org.uk (last accessed 10/11/23).

31. Jill Johnston, *Lesbian Nation: The Feminist Solution* (New York City: Simon & Schuster, 1973).

32. Rebecca Jennings and Liz Millward, 'Introducing Lesbian Nation', *Women's History Review* 31.1 (2022): 5.

33. Champion, 'Remembering Sappho', 23.

34. Eleanor Medhurst, 'From Lavender to Violet: The Lesbian Obsession with Purple', 20 August 2021, Dressing Dykes, dressingdykes.com (last accessed 10/11/23).

35. Frankie Cosmos (Greta Kline), 'Sappho' (2016), genius.com (last accessed 10/11/23).

2. CHRISTINA OF SWEDEN, GIRL KING

1. Quoted in Veronica Buckley, *Christina, Queen of Sweden* (New York: Harper Perennial [2004] 2005), 72.

2. Quoted in François Kermina, *Christine de Suèdè* (Paris: Perrin, 1995), 67.

3. Buckley, *Christina, Queen of Sweden*, 71.

4. Ibid., 72.

5. Quoted in Georgina Masson, *Queen Christina* (London: Secker and Warburg, 1968), 263–4.

6. Quoted in Buckley, *Christina, Queen of Sweden*, 210.

7. Buckley, *Christina, Queen of Sweden*, 312.

8. Sarah Waters, 'A Girton Girl on a Throne: Queen Christina and Versions of Lesbianism, 1906–1933', *Feminist Review* 46 (1994): 41–60.

9. Inga Lena Ångström Grandien, '"She was Naught… of a Woman except in Sex": The Cross-Dressing of Queen Christina of Sweden', *The Journal of Dress History* 2.1 (2018): 3.

10. Philip Hollingworth, trans., *The History of the Intrigues and Gallantries of Christina, Queen of Sweden. And of Her Court, Whilst She Was at Rome. Faithfully Render'd into English, from the French Original* (London: The Cayme Press, [1697] 1927), 217.

11. Buckley, *Christina, Queen of Sweden*, 95.

12. Julia Holm, 'How to Dress a Female King: Manifestations of Gender and Power in the Wardrobe of Queen Christina of Sweden', *Sartorial Politics in Early Modern Europe: Fashioning Women*, Erin Griffey, ed. (Amsterdam: Amsterdam University Press, 2019), 202.

13. Buckley, *Christina, Queen of Sweden*, 124.

14. Holm, 'How to Dress a Female King', 193.

15. Ångström Grandien, '"She was Naught… of a Woman except in Sex"', 6.

16. Judith (Jack) Halberstam, *Female Masculinity* (Durham and London: Duke University Press, 1998), 67–8.

17. The painting, *Christine of Sweden on Horseback*, is available to view on the website of Madrid's Museo del Prado: https://www.museodelprado. es/en/the-collection/art-work/christine-of-sweden-on-horseback/ 3060d326-6185-4cb4-b0cf-e1a225c19d7d.

18. Ångström Grandien, '"She was Naught… of a Woman except in Sex"', 7.

19. Quoted in Ivan Gobry, *La Reine Christine* (Paris: Pygmalion, Gérard Watelet, 2001), 20–34.

20. Quoted in Buckley, *Christina, Queen of Sweden*, 213.

21. Buckley, *Christina, Queen of Sweden*, 213.

22. Quoted in Oskar Garstein, *Rome and the Counter-Reformation in Scandinavia* (Leiden: EJ-Brill, 1992), 703.

23. Holm, 'How to Dress a Female King', 187; 195.

24. Buckley, *Christina, Queen of Sweden*, 222.

25. Madame de Motteville, *Mémoires*, quoted in ibid., 223.

26. Buckley, *Christina, Queen of Sweden*, 302.

27. Waters, 'A Girton Girl on a Throne', 43.

3. ANNE LISTER: DIARIES AND DRESS

1. Trish Rafa, 'Anne Lister's Mines—History and Development', Packed With Potential (20 Dec 2021), packedwithpotential.org (last accessed 10/11/23).

2. Anne Lister, 29 January 1821, in Helena Whitbread, ed., *The Secret Diaries of Miss Anne Lister* (London: Virago, [1988] 2010), 161.

3. Helena Whitbread, *I Know My Own Heart: The Diaries of Anne Lister 1791–1840* (New York and London: NYU Press, 1988).

4. Anne Lister, 12 Feb. 1834 and 27 Feb. 1834, quoted in Jill Liddington, *Female Fortune: Land, Gender and Authority* (London: Rivers Oram Press, [1988] 2019), 93; 95.

5. Halberstam, *Female Masculinity*, 46.

6. Heyam, *Before We Were Trans*, 93.

7. Jessica Campbell, 'Can We Call Anne Lister a Lesbian?', *Journal of Lesbian Studies* 26.4 (2022): 355; 364.

8. Whitbread, *The Secret Diaries of Miss Anne Lister*, 24.

9. Officially, the Regency era only spanned the years 1811–1820, but when it comes to culture, 'Regency' often describes a much longer period: c. 1795–1837.

10. Dominique Grisard, '"Real Men Wear Pink"? A Gender History of Color', in *Bright Modernity: Color, Commerce and Consumer Culture*, Regina

Lee Blaszczyk and Uwe Spiekermann, eds. (London and New York: Palgrave Macmillan, 2017), 80; Lou Taylor, *Mourning Dress: A Costume and Social History* (George Allen & Unwin: London, 1983), 248.

11. John Harvey, *Men in Black* (London: Reaktion Books, [1995] 2013), 23.

12. Rebecca Jennings, *A Lesbian History of Britain: Love and Sex Between Women Since 1500* (Oxford: Greenwood World Publishing, 2007), 45.

13. Whitbread, *The Secret Diaries of Miss Anne Lister*, 267.

14. Although this dress boasts a slightly lower waist and larger sleeves than typical dresses of the early 1820s, it is a good example of colour being embraced in women's clothing.

15. Lucy Johnston, *Nineteenth-Century Fashion in Detail* (London: V&A Publications, [2005] 2009), 50.

16. Whitbread, *The Secret Diaries of Miss Anne Lister*, 89.

17. Ibid., 146.

18. Ibid., 184.

19. Historic England, 'Anne Lister and Shibden Hall', [n.d.] historicengland.org.uk (last accessed 10/11/23).

20. Caroline Derry, 'Lesbianism and the Criminal Law of England and Wales', The Open University, 10 Feb. 2021, open.edu (last accessed 10/11/23).

21. Campbell, 'Can We Call Anne Lister a Lesbian?', 360–1.

22. Dannielle Orr, '"I Tell Myself to Myself": Homosexual Agency in the Journals of Anne Lister (1791–1840)', *Women's Writing* 11.2 (2004): 212.

23. Anna Clark, 'Anne Lister's Construction of Lesbian Identity', *Journal of the History of Sexuality* 7.1 (1996): 45.

24. Whitbread, *The Secret Diaries of Miss Anne Lister*, 76.

25. Ibid., 94.

26. Clark, 'Anne Lister's Construction of Lesbian Identity', 42.

27. Whitbread, *The Secret Diaries of Miss Anne Lister*, 9.

28. *The Englishwoman's Domestic Magazine* (1840), quoted in 'Braces (1840–1850)', Summary, V&A Online Collections, Victoria and Albert Museum, London [n.d.], vam.ac.uk/collections (last accessed 10/11/23).

29. Anne Lister, clothing inventories from travels in Europe, 1840, 4 pages. Shibden Hall, SH:7/ML/MISC/9, Calderdale Museums, Calderdale, United Kingdom.

30. Tom Pye, 'Q&A: Costuming Gentleman Jack', Willow and Thatch, 30 May 2019, willowandthatch.com (last accessed 10/11/23).

31. Alison Matthews David, 'Elegant Amazons: Victorian Riding Habits and the Fashionable Horsewoman', *Victorian Literature and Culture* 30.1 (2002): 179.

32. Whitbread, *The Secret Diaries of Miss Anne Lister*, 60.
33. Leila J. Rupp, *Sapphistries: A Global History of Love Between Women* (New York and London: Duke University Press, [2009] 2011), 22.
34. Whitbread, *The Secret Diaries of Miss Anne Lister*, 368.
35. Ibid., 369.
36. Anne Lister, 'General Inventory', January 1840. Shibden Hall, SH:7/ML/MISC/9, Calderdale Museums, Calderdale, United Kingdom.
37. Whitbread, *The Secret Diaries of Miss Anne Lister*, 258–9.
38. Anne Lister, 4 October 1832, in 'Anne Lister Coded Diary Entries', annelister538400391.wordpress.com (last accessed 10/11/23); Liddington, *Female Fortune*, 64.
39. Anne Lister, 26 September 1826, in Whitbread, *The Secret Diaries of Miss Anne Lister*, 289.
40. Anne Lister, 12 September 1825, ibid., 182.
41. Ibid., 215.
42. Chris Roulston, 'The Revolting Anne Lister: The U.K.'s First Modern Lesbian', *Journal of Lesbian Studies* 17 (2013): 276.
43. Whitbread, *The Secret Diaries of Miss Anne Lister*, 220.
44. Ibid., 258.
45. Ibid., 261.
46. Ibid., 278.

4. LITERARY LOVERS: 1910s JAPAN

1. Cynthia Green, 'The Surprising History of the Kimono', Jstor Daily, 8th Dec 2017, daily.jstor.com (last accessed 10/11/23).
2. Ibid.
3. Wu Peichen, 'Performing Gender Along the Lesbian Continuum: The Politics of Sexual Identity in the Seito Society', *U.S.-Japan Women's Journal. English Supplement* 22 (2002): 69.
4. Women's *yukata* are usually made from bright, often floral fabrics, while those intended for men are usually darker colours like navy blue. *Obi*—a sash or belt—are worn at the waist by women and at the hips by men. Though there are gendered differences in the way that *yukata* are worn, they didn't carry the gendered responsibility of the kimono in the early twentieth century.
5. YABAI Writers, 'Hakama, the Traditional Japanese Trousers', YABAI, 21 May 2017, Yabai.com (last accessed 10/11/23).
6. Nanba Tomoko, 'Breaking the Dress Code: The Changing Role of Japanese School Uniforms', Nippon.com, 6 Nov. 2018 (last accessed 10/11/23).
7. Wu, 'Performing Gender Along the Lesbian Continuum', 71–2.

8. Alexandra Loop, 'Literary Lesbian Liberation: Two Case Studies Interrogating How Queerness Has Manifested in Japanese Value Construction Through History', Thesis, McMaster University, 2020. Via MacSphere.

9. Comparable English terms for these Japanese words are 'sodomy' (*danshoku*) and 'homosexuality' (*dōseiai*), recognising the modern shift in conceptions of queerness in the early twentieth century, often based in sexology. Though *dōseiai* was not specifically a term for lesbians, it could be used to describe love and sex between women in a way that *danshoku* could not. See Wu, 'Performing Gender Along the Lesbian Continuum', 68.

10. Including Havelock Ellis' *Sexual Inversion* (1896) and Richard von Krafft-Ebing's *Psychopathia Sexualis* (1886).

11. Rupp, *Sapphistries*, 64.

12. Loop, 'Literary Lesbian Liberation', 58–9.

13. Wu, 'Performing Gender Along the Lesbian Continuum', 72.

14. Jan Bardsley, 'The New Woman Meets the Geisha: The Politics of Pleasure in 1910s Japan', *Intersections: Gender and Sexuality in Asia and the Pacific* 29 (2012).

15. Wu, 'Performing Gender Along the Lesbian Continuum', 68; Rupp, *Sapphistries*, 171. This contests the point made by Bardsley (in 'The New Woman Meets the Geisha') that 'despite being seen as masculine, [hakama] had become the uniform of the time for girl students.'

16. Hiratsuka Raichō, *In the Beginning, Woman Was the Sun*, Teruko Craig trans. (New York: Columbia University Press, 2006), 95.

17. Ibid., 96.

18. Wu, 'Performing Gender Along the Lesbian Continuum', 76.

19. For further discussion on the use of 'lesbian' within this context, see ibid., 66.

20. Ibid., 79.

21. Hiratsuka Raichō, 'Marumado Yori', Seitō 2.4 (1912), 83, quoted in ibid., 79.

22. Ibid., 89.

23. Otake Kōkichi, 1912, in Watanabe Sumiko, *Seito no Onna: Otake Kōkichi den* (Tokyo: Fuji shuppan, 2001), 46. Quoted in Loop, 'Literary Lesbian Liberation', 56.

24. Otake Kōkichi, 1912, 'Returning from Asakusa (To Raichō)', in *Sparkling Rain: And Other Fiction from Japan of Women Who Love Women*, Barbara Summerhawk, ed. & trans. (Victoria: New Victoria Publishers, 2008), 41.

25. Loop, 'Literary Lesbian Liberation', 59; 63.

26. Itō Noe, 'Zatsuon', *Ito Noe Zenshu* (Tokyo: Gakugei Shorin, 1970), 18. Quoted in ibid., 65.

27. Loop, 'Literary Lesbian Liberation', 57.

28. Quoted in Michiko Suzuki, *Love and Female Identity in Prewar Japanese Literature and Culture* (California: Stanford University Press, 2010), 30.

29. Loop, 'Literary Lesbian Liberation', 83.

30. Ibid., 84.

31. Watanabe, *Seito no Onna*, 226, quoted in ibid., 80.

32. Loop, 'Literary Lesbian Liberation', 82.

33. Otake Kōkichi, quoted in Raichō, *In the Beginning, Woman Was the Sun*, 173.

34. Ibid., 174–5.

35. Wu, 'Performing Gender Along the Lesbian Continuum', 79.

36. Loop, 'Literary Lesbian Liberation', 82.

37. Raichō, *In the Beginning, Woman Was the Sun*, 175.

5. PARIS LESBOS: THE SAPPHIC CAPITAL

1. Souhami, *No Modernism Without Lesbians*, 249.

2. Ibid., 251.

3. Natalie Barney, qted in ibid., 213.

4. Souhami, *No Modernism Without Lesbians*, 251.

5. Berthe Cleyrergue, in Gloria Feman Orenstein and Berthe Cleyrergue, 'The Salon of Natalie Clifford Barney: An Interview with Berthe Cleyrergue', *Signs* 4.3 (1979): 486.

6. Ibid., 488.

7. Ibid., 487.

8. Sarah Prager, 'Four Flowering Plants that Have Been Decidedly Queered', Jstor Daily, 29 Jan. 2020, daily.jstor.org (last accessed 10/11/23).

9. Published by Brentano's Publishers, New York, in 1926.

10. *Harper's Bazaar*, quoted in Dawn B. Sova, *Banned Plays: Censorship Histories of 125 Stage Dramas* (New York: Infobase Publishing, 2004), 39.

11. Mabel Hampton, quoted in Joan Nestle, 'The Bodies I Have Lived with: Keynote for 18th Lesbian Lives Conference, Brighton, England, 2011', *Journal of Lesbian Studies* 17.3/4 (2013): 225.

12. Sappho, *If Not, Winter*, Anne Carson, trans., 185. Another translator, Josephine Balmer, names these 'wreaths of violets' that 'you placed around your slender neck'. (Sappho, *Poems & Fragments*, Josephine Balmer, trans., 46). Aaron Poochigan, translating in 2009, chose the phrase 'I looked on as you / Wove a bouquet into a diadem' (Sappho, *Stung with Love*, Aaron Poochigran, trans., 25).

13. Janette Ayachi, 'Jealous Love: Natalie Barney & Renée Vivien', Poetry School, 2015, poetryschool.com (last accessed 10/11/23).

14. Quoted in George Wickes, 'A Natalie Barney Garland', *The Paris Review*, 61 (Spring 1975), theparisreview.org (last accessed 10/11/23).

15. Ceri, quoted in Katrina Rolley, 'The Lesbian Dandy: The Role of Dress and Appearance in the Construction of Lesbian Identities, Britain 1918–39', Master's thesis (Middlesex University, 1995), 144.

16. Truman Capote, quoted in Souhami, *No Modernism Without Lesbians*, 259.

17. Laura Doan, 'Passing Fashions: Reading Female Masculinities in the 1920s', *Feminist Studies* 24.3 (1998): 664; 688.

18. Cleyrergue, 'The Salon of Natalie Clifford Barney', 494.

19. *The Penny Illustrated Paper and Illustrated News*, quoted in Marius Hentea, 'Monocles on Modernity', *Modernism/Modernity* 20.2 (2013): 228.

20. Doan, 'Passing Fashions', 681.

21. Eleanor, quoted in Rolley, 'The Lesbian Dandy', 144.

22. Barbara Bell, quoted in S. Davies, 'Fantastic Life: An Interview with Barbara Bell', *Queer Tribe* 4 (1988): 20.

23. Rupp, *Sapphistries*, 164. 'Ohaikara' means 'fashion'/'fashionable' in Japanese, but I don't think it's a coincidence that high collars are associated with lesbian culture in both contexts.

24. BBC News, 'Paris Women Finally Allowed to Wear Trousers', BBC, 4 February 2013, bbc.co.uk (last accessed 10/11/23).

25. Cleyrergue, 'The Salon of Natalie Clifford Barney', 495.

26. Souhami, *No Modernism Without Lesbians*, 295.

27. Ibid., 297.

28. Cleyrergue, 'The Salon of Natalie Clifford Barney', 489.

29. Souhami, *No Modernism Without Lesbians*, 22.

30. Pablo Picasso, quoted in ibid., 20–21.

31. Andrew Stephenson, '"Our jolly marin wear": The Queer Fashionability of the Sailor Uniform in Interwar France and Britain', *Fashion, Style & Popular Culture* 3.2 (2016): 157–72.

32. D. J. Taylor, *Bright Young People: The Rise and Fall of a Generation, 1918–1940* (London: Random House, 2010).

33. Holly Williams, 'The "most painted woman in the world"', BBC Culture, 13 November 2017, bbc.com (last accessed 10/11/23).

34. Stephenson, '"Our jolly marin wear"', 6.

35. Williams, 'The "most painted woman in the world"'.

36. Stephenson, '"Our jolly marin wear"', 6.

37. Hugh Ryan, *When Brooklyn Was Queer* (St. Martin's Griffin, New York: 2019), 8.

6. THE QUEER MODERNISM OF BRITISH *VOGUE*

1. Nina-Sophia Miralles, *Glossy: The Inside Story of Vogue* (London: Quercus, [2021] 2022), 54; Holly A. Baggett, *Dear Tiny Heart: The Letters of Jane Heap & Florence Reynolds* (New York: New York University Press, 2000), 6.

2. Rebecca West, 1972, quoted in Lisa Cohen, '"Frock Consciousness": Virginia Woolf, the Open Secret, and the Language of Fashion', *Fashion Theory* 3.2 (1999): 164.

3. In 1928 all women over age twenty-one finally gained the right to vote, a right which had been granted to all British men in 1918.

4. Keith Laybourn, 'Twenties Britain (Part Two): Decade of Conflict, Realignment and Change?', The National Archives, [n.d.] web., 29 Sept. 2023.

5. Christopher Reed, 'A *Vogue* That Dare Not Speak its Name: Sexual Subculture During the Editorshop of Dorothy Todd, 1922–26', *Fashion Theory* 10.1/2 (2006): 46–7.

6. Havelock Ellis (1924), 288, quoted in Rolley, 'The Lesbian Dandy', 70.

7. Eleanor, quoted in ibid., 99.

8. Katrina Rolley, 'Cutting a Dash: The Dress of Radclyffe Hall and Una Troubridge', *Feminist Review* 35 (1990): 55.

9. Richard Omrod, *Una Troubridge, The Friend of Radclyffe Hall* (London: Hammond, 1984), 247.

10. Patience Ross, quoted in Michael Baker, *Our Three Selves* (London: Hamish Hamilton, 1985), 202.

11. Rolley, 'Cutting a Dash', 63.

12. Lisa Cohen, *All We Know: Three Lives* (New York: Farrow, Straus and Giroux, [2012] 2013), 242–4.

13. Ibid., 204; 238.

14. Madge Garland to Flora Groult, interview, London, 26 July 1986, quoted in ibid., 231.

15. Miralles, *Glossy*, 59.

16. Ibid., 59–60.

17. Madge Garland to Hilary Spurling, London, 29 March 1989, quoted in Cohen, *All We Know*, 247.

18. West, quoted in Cohen, '"Frock Consciousness"', 164.

19. Anne Pender, '"Modernist Madonnas": Dorothy Todd, Madge Garland and Virginia Woolf', *Women's History Review* 16.4 (2007): 522–3.

20. Peter Quennell, 1976, quoted in ibid., 522.

21. Cohen, *All We Know*, 242.

22. Miralles, *Glossy*, 58.

23. David Sassoon, quoted in Cohen, *All We Know*, 305.

24. Miralles, *Glossy*, 61.

25. Cohen, *All We Know*, 258.

26. Dorothy Todd, 'Early Paris Openings and Brides', *Vogue* (British), April 1925, quoted in Miralles, *Glossy*, 56.

27. Christopher Reed, 'Design for (Queer) Living: Sexual Identity, Performance and Decor in British *Vogue*, 1922–1926', *GLQ* 12.3 (2006): 381–2.

28. Rosalind Jana, 'The Forgotten Reign of Radical British Vogue Editor Dorothy Todd Paved the Way for LGBTQIA+', *Vogue*, 30 May 2020, vogue.co.uk (last accessed 10/11/23).

29. Reed, 'Design for (Queer) Living', 382.

30. Ibid., 383–4.

31. Madge Garland, *Britannia and Eve*, 1930, quoted in Cohen, *All We Know*, 280.

32. 'The Small Neat Coiffure Is the Favourite of the Mode', *Vogue* (British), December 1923, quoted in Reed, 'Design for (Queer) Living', 383.

33. Phyllis Tortora and Keith Eubank, *A Survey of Historic Costume* (New York: Fairchild Publications, 1989), 299.

34. Reed, 'Design for (Queer) Living', 383.

35. Miralles, *Glossy*, 62.

36. Pender, 'Modernist Madonnas', 529; ibid.

37. Cohen, *All We Know*, 267.

38. Madge Garland, 1982, quoted in ibid., 266.

39. Ibid., 276.

40. Cohen, *All We Know*, 344.

41. *The New Interior Decoration* was co-authored by Raymond Mortimer.

42. Miralles, *Glossy*, 58; 64.

43. *Harper's Bazaar*, quoted in Cohen, *All We Know*, 303.

44. Cohen, '"Frock Consciousness"', 169.

7. THE COMPLETE APPEARANCE OF A LADY: TRANS LESBIANS IN WEIMAR BERLIN

1. Julia Hümer, 'Lebensumstände lebischer Frauen in Österrich und Deutschland—von den 1920er Jahren bis zur NS-Zeit', Diploma Thesis, Universität Wien, 2010, 16.

2. Robert Beachy and Terry Gross, 'Between World Wars, Gay Culture Flourished in Berlin', Audio Interview, NPR, 17 Dec. 2014, npr.org (last accessed 16/05/23).

3. Cyd Sturgess, '"Die Zarte Haut einer schönen Frau": Fashioning Femininities in Weimar Germany's Lesbian Periodicals', *Edinburgh German Yearbook Volume 10: Queering German Culture*, Leanne Dawson, ed. (Martlesham: Boydell & Brewer, 2018), 63.

4. Katie Sutton, *The Masculine Woman in Weimar Germany* (New York and Oxford: Berghahn Books, 2011), 3.

5. *Garçonne* had previously used the alternating titles of *Frauenliebe* and *Liebende Frauen*.

6. Sutton, *The Masculine Woman in Weimar Germany*, 7.

7. Clayton Whisnant, *Queer Identities and Politics in Germany: A History, 1880–1945* (New York and York: Harrington Park Press, 2016), 96.

8. Angeles Espinaco-Virseda, '"I feel that I belong to you": Subculture, *Die Freundin* and Lesbian Identities in Weimar Germany', *spacesofidentity* 4.1 (2004): 85.

9. *Der Transvestit* ('The Transvestite') in *Frauenliebe* and *Die Welt der Transvestiten* ('The World of Transvestites') in *Die Freundin*. See Sturgess, '"Die Zarte Haut einer schönen Frau"', 72.

10. Espinaco-Virseda, '"I feel that I belong to you"', 109.

11. Ibid., 89.

12. Ibid., 92.

13. *Die Freundin*, 'Die Welt der Transvestiten' (8 Aug. 1924), quoted in Sturgess, '"Die Zarte Haut einer schönen Frau"', 72.

14. Sturgess, '"Die Zarte Haut einer schönen Frau"', 65.

15. Ibid., 66–7.

16. Ibid., 71.

17. *Frauenliebe* was published at this time under *Liebende Frauen*.

18. Marg Arnold, 'Der Bubikopf', *Liebende Frauen* 4.10 (1929), Spinnboden Lesbenarchiv und Bibliothek e.V., Meta-Katalog, 2.

19. Sutton, *The Masculine Woman in Weimar Germany*, 105.

20. 'Die Transvestiten und die Polizei', *Der Transvestit*, *Die Freundin* 1.6 (1924), Spinnboden Lesbenarchiv und Bibliothek e.V., Meta-Katalog.

21. Maria Jung, 'Wie soll sich der Transvestit kleiden?', *Frauenliebe* 3.7 (1928), Spinnboden Lesbenarchiv und Bibliothek e.V., meta-katalog.

22. Ibid.

23. Maria Jung, 'Praktische Winke für Transvestiten', *Liebende Frauen* 3.21 (1928), Spinnboden Lesbenarchiv und Bibliothek e.V., meta-katalog.

24. Sutton, *The Masculine Woman in Weimar Germany*, 117.

25. Espinaco-Virseda, '"I feel that I belong to you"', 91.

26. Emmy Müller, 'Der Lebenslauf eines Transvestiten', *Liebende Frauen* 4.18 (1929), Spinnboden Lesbenarchiv und Bibliothek e.V., meta-katalog.

27. Ibid.

28. Ibid.

29. Ibid.

30. Damenklub Violetta, advert, *Frauenliebe* 3.7 (1928), 12.

31. Whisnant, *Queer Identities and Politics in Germany*, 111.

32. Ibid., 84.

33. Damenklub Violetta, advert, *Frauenliebe* 3.31 (1928).

34. Ruth Roellig, *Berlins Lesbische Frauen* (1928, 17), quoted in Hümer, 'Lebensumstände lebischer Frauen in Österrich und Deutschland', 18.

35. Sturgess, '"Die Zarte Haut einer schönen Frau"', 72.

36. The photographs' alleged dates range from 1926 to 1933, but the fashions point more convincingly to the latter.

8. IN THE LIFE: LADY LOVERS OF THE HARLEM RENAISSANCE

1. Eric Garber, 'A Spectacle in Color: The Lesbian and Gay Subculture of Jazz Age Harlem', *Hidden from History: Reclaiming the Gay and Lesbian Past*, Martin Bauml Duberman, Martha Vicinus and George Chauncy, Jr., eds (London: Penguin Books [1989] 1991), 318.

2. Mabel Hampton (interviewee) and Joan Nestle (interviewer), 'Mabel Hampton, 1988 (Tape 1)', Lesbian Herstory Archives, AudioVisual Collections.

3. Ma Rainey, lyrics to 'Prove It on Me Blues', Genius, [1928] 2017, genius.com (last accessed 10/11/23).

4. Jonathan Ned Katz, 'Ma Rainey's "Prove It On Me Blues," 1928', OutHistory [n.d.], outhistory.org.web (last accessed 10/11/23).

5. Gwen Thompkins, 'Forebears: Bessie Smith, the Empress of the Blues', NPR Music, 5 Jan. 2018, npr.org.web (last accessed 10/11/23).

6. Lillian Faderman, *Odd Girls and Twilight Lovers: A History of Lesbian Life in Twentieth-Century America* (New York: Penguin Books: [1991] 1992), 74.

7. Allison K. Hammer, '"Just like a natural man": The B.D. Styles of Gertrude "Ma" Rainey and Bessie Smith', *Journal of Lesbian Studies* 23.2 (2019): 281.

8. Anonymous, 'Moms Mabley: She Finally Makes The Moves', *Ebony*, April 1974, 87.

9. Ibid., 90.

10. Norma Miller, quoted in Lou Chibbaro Jr., 'Meet the Legendary Queer Comedian "Moms" Mabley', LGBTQ Nation, 8 August 2017, www.lgbtqnation.com (last accessed 16/05/23).

11. Mary Jones was first identified as Edna in a footnote in Henry L. Minton's *Departing from Deviance: A History of Homosexual Rights and Emancipatory Science in America* (2001). This is expanded by George Hutchinson in *In Search of Nella Larsen: A Biography of the Color Line* (2006) and an article by Jonathan Ned Katz, 'Edna Thomas ("Mary Jones"): "a tenderness I have never known"', (2015) on Outhistory, outhistory.com (last accessed 16/05/23).

12. Edna Lloyd Thomas, quoted in Katz, 'Edna Thomas ("Mary Jones")'.

13. Ibid.

14. Ruth goes unnamed for most of Mabel's testimony, understandably overshadowed in Mabel's memory by her later love Lillian Foster, who she met in 1932.

15. Mabel Hampton (interviewee), Joan Nestle (interviewer), and unnamed interviewer. 'Mabel Hampton Interviews (Tape 1)', 1983. Lesbian Herstory Archives, AudioVisual Collections.

16. Ibid.

17. Ibid.

18. Ibid.

19. Ibid.

20. Ibid.

21. Garber, 'A Spectacle in Color', 322.

22. Ibid.

23. Leila J. Rupp, *Sapphistries*, 185.

24. Hampton, 'Mabel Hampton, 1988 (Tape 1)'.

25. Ibid.

26. Ibid.

27. Mabel Hampton (interviewee), Joan Nestle (interviewer), 'Mabel Hampton, undated (Tape 1)', Lesbian Herstory Archives, AudioVisual Collections.

28. Ryan, *When Brooklyn Was Queer*, 109.

29. Hampton, 'Mabel Hampton, 1988 (Tape 1)'.

30. Garber, 'A Spectacle in Color', 318.

31. Faderman, *Odd Girls and Twilight Lovers*, 73.

32. Hampton, 'Mabel Hampton, 1988 (Tape 1)'. This church may either have been Mount Neboh Baptist Church or All Souls Episcopal Church, both open at the time, though neither appears to have record of a Reverend Monroe. See Mount Neboh Baptist Church of Harlem, 'Pastoral Legacy Page', [n.d.], mountnebohharlem.org, web. 2 Aug. 2022; Anonymous, 'All Souls Episcopal Church', [n.d.] NYC AGO, nycago.org, web. 2 Aug 2022 (last accessed 10/11/23).

33. Hampton, 'Mabel Hampton, 1988 (Tape 1)'.

34. Ibid.

35. Saidiya Hartman, *Wayward Lives, Beautiful Experiments* (London: Serpent's Tail, [2019] 2021), 17.

PART THREE: A BUTCH/FEMME INTERLUDE

1. See, for instance: Elizabeth Lapovsky Kennedy and Madeline Davis, *Boots of Leather, Slippers of Gold: The History of a Lesbian Community* (New York: Routledge, [1993] 2014); Sally R. Munt, ed., *Butch/Femme: Inside Lesbian Gender* (London and Washington: Cassell, 1998); Ivan E. Coyote and

Zena Sharman, *Persistence: All Ways Butch and Femme* (Vancouver: Arsenal Pulp Press, 2011).

2. Devon Abelman, 'LGBTQ People Are Upset with Urban Outfitters and H&M's Femme Tees', Allure, 10 May 2017, allure.com (last accessed 10/11/23).

3. The phrase 'transfeminine non-binary person' describes someone who does not identify with the sex assigned to them at birth but embraces femininity and is read in a feminine way. This would include transgender women and feminine non-binary people. The term exists to make space for people under the trans umbrella who are feminine but do not necessarily identify with womanhood.

4. Kesiena Boom, 'Why the Popular Phrase "Women and Femmes" Makes No Sense', Slate.com, 16 March 2018 (last accessed 10/11/23).

5. Lapovsky and Davis, *Boots of Leather, Slippers of Gold*, 49; Mignon R. Moore, 'Lipstick or Timberlands? Meanings of Gender Presentation in Black Lesbian Communities', *Signs* 32.1 (2006): 126.

9. LOOKING 'RIGHT': THE MID-CENTURY LESBIAN BAR

1. Mary McGarry and Fred Wasserman, *Becoming Visible: An Illustrated History of Lesbian and Gay Life in Twentieth-Century America* (New York: Penguin Studio, 1998), 76.

2. Alix Genter, 'Appearances Can Be Deceiving: Butch-Femme Fashion and Queer Legibility in New York City, 1945–1969', *Feminist Studies* 42.3 (2016): 617.

3. Rusty Brown (1983), interviewed by Lee Evans, quoted in Ryan, *When Brooklyn Was Queer*, 242.

4. Ibid.

5. Faderman, *Odd Girls and Twilight Lovers*, 162.

6. Genter, 'Appearances Can Be Deceiving', 609.

7. Ibid., 610.

8. Ibid., 611.

9. Ibid., 605.

10. Ibid., 606.

11. Joan Nestle, 'Butch-Fem Relationships', *Heresies* 12 (1981), Canadian Lesbian and Gay Archives, Gale Primary Sources: 24.

12. Joan Nestle, 'The Femme Question', in *The Persistent Desire: A Femme-Butch Reader*, Joan Nestle, ed. (Boston: Alyson Publications, 1992), 138.

13. Faderman, *Odd Girls and Twilight Lovers*, 167.

14. Jane Traies, *Now You See Me: Lesbian Life Stories* (Machynlleth: Tollington, 2018), 135.

15. Jill Gardiner, *From the Closet to the Screen: Women at the Gateways Club, 1945–1985* (London, Sydney & Chicago: Pandora, 2003), 82.
16. René, quoted in ibid., 48.
17. Gardiner, *From the Closet to the Screen*, 49.
18. Esme, quoted in ibid., 162.
19. Jo, ibid., 49.
20. Sam, ibid., 163–4.
21. Lesley, ibid., 50 (Lesley's outfit can be seen in a hand-drawn self-portrait on this page of Gardiner's book).
22. Jane, ibid., 59–60.
23. Jo, ibid., 54.
24. Ricky, ibid., 50–1.
25. James, ibid., 116.
26. Sandy Martin, ibid., 51.
27. Sheila, ibid., 66.
28. Kathy the dancer, ibid., 116.
29. Tash, ibid., 116.
30. Bea, ibid., 227.
31. Faderman, *Odd Girls and Twilight Lovers*, 160.
32. Jo, quoted in Gardiner, *From the Closet to the Screen*, 17.
33. Betty, quoted in Faderman, *Odd Girls and Twilight Lovers*, 182.
34. Jo, quoted in Gardiner, *From the Closet to the Screen*, 81.
35. David K. Johnson, *The Lavender Scare: The Cold War Persecution of Gays and Lesbians in the Federal Government* (Chicago and London: University of Chicago Press, [2004] 2006), 2.
36. Nestle, 'Butch-Fem Relationships', 23; 26.
37. Lisa Ben, 'Protest', *Vice Versa* (1948), quoted in Faderman, *Odd Girls and Twilight Lovers*, 179.
38. Nestle, 'Butch-Fem Relationships', 22.
39. Betty Luthor Hillman, '"The Clothes I Wear Help Me to Know My Own Power": The Politics of Gender Presentation in the Era of Women's Liberation', *Frontiers: A Journal of Women's Studies* 34.2 (2013): 155–185.
40. Rebecca Jennings, *A Lesbian History of Britain*, 56.
41. Faderman, *Odd Girls and Twilight Lovers*, 165.

10. A NOTE ON FEMMES

1. Rhea Ashley Hoskin and Katerina Hirschfeld, 'Beyond Aesthetics: A Femme Manifesto', *Atlantis Journal* 39.1 (2018): 86.
2. Rhea Ashley Hoskin, 'Can Femme Be Theory? Exploring the Epistemological and Methodological Possibilities of Femme', *Journal of Lesbian Studies* 25.1 (2021): 12.

3. Hampton, 'Mabel Hampton, 1988 (Tape 1)'; Hampton, 'Mabel Hampton, undated (Tape 1)'.

4. Elizabeth Wilson, 'What Does a Lesbian Look Like?', *Queer Style*, Adam Geczy and Vicki Karaminas, eds. (London and New York: Bloomsbury, 2013), 190.

5. Madeline Davis, 'Epilogue, Nine Years Later', in *The Persistent Desire*, 270.

6. McGarry and Wasserman, *Becoming Visible*, 76–7.

7. Inge Blackman and Kathryn Perry, 'Skirting the Issue: Lesbian Fashion for the 1990s', *Feminist Review* 34 (1990): 68.

8. Silva, quoted in Traies, *Now You See Me*, 184.

9. Nestle, 'The Femme Question', 142.

10. Jewelle Gomez, 'Femme Erotic Independence', in *Butch/Femme: Inside Lesbian Gender*, 107.

11. Kerry Macneil, 'Bathroom Lines, Ky-Ky Girls, and Struggles', *Journal of Lesbian Studies* 1.3/4 (1997): 84.

12. Audre Lorde, *Zami: A New Spelling of My Name* (Trumansburg, N.Y.: Crossing Press, 1982), 224.

13. See Keeanga-Yamahtta Taylor, ed., *How We Get Free: Black Feminism and the Combahee River Collective*, (Chicago: Haymarket Books, 2017); Valerie Mason-John and Ann Khambatta, *Lesbians Talk: Making Black Waves*, (London: Scarlet Press, 1993).

14. Arlene Istar, 'Femme-dyke', in *The Persistent Desire*, 381.

15. Ibid.

16. Genter, 'Appearances Can Be Deceiving', 629–30.

17. Ibid., 630.

18. Paula Austin, 'Femme-inism', in *The Persistent Desire*, 364.

PART FOUR: MIRACULOUS MASCULINITY

1. Jen Manion, *Female Husbands: A Trans History* (Cambridge and New York: Cambridge University Press, 2020).

11. BREECHES ROLES AND FEMALE HUSBANDS: CROSS-DRESSED BRITAIN IN THE 1700s

1. Norena Shopland, *A History of Women in Men's Clothes: From Cross-Dressing to Empowerment* (Yorkshire and Philadelphia: Pen & Sword History, 2021), vii.

2. As discussed in this book's introduction, though the scope of this research is limited to 'throughout Europe' it does not mean that public representations of cross-dressing women/people perceived as women do not exist across the world, in many unique contexts.

3. Rebecca Jennings, *A Lesbian History of Britain*, 34.

4. Lou Taylor, *The Study of Dress History* (Manchester and New York: Manchester University Press, 2002), 95.

5. Vern L. Bullough and Bonnie Bullough, *Cross Dressing, Sex, and Gender* (Pennsylvania: University of Pennsylvania Press, 1993), 125.

6. Shopland, *A History of Women in Men's Clothes*, vii; Halberstam, *Female Masculinities*; Ula Lukszo Klein, *Sapphic Crossings: Cross-Dressing Women in Eighteenth-Century British Literature* (Charlottesville and London: University of Virginia Press, 2021), 56.

7. Klein, *Sapphic Crossings*, 158.

8. Robert Hitchcock, *An Historical View of the Irish Stage, from the Earliest Period Down to the Close of the Season 1788*, 2 vols (Dublin: 1788–94), 107. Itals original.

9. Quoted in Jennings, *A Lesbian History of Britain*, 22.

10. Mary D. Sheriff, *Moved by Love: Inspired Artists and Deviant Women in Eighteenth-Century France* (Chicago: University of Chicago Press, 2004), 197.

11. Quoted in Rupp, *Sapphistries*, 119.

12. Merrick, 'The Marquis de Villette and Mademoiselle de Raucourt', 45.

13. Qted in ibid., 43.

14. Hugh Chisholm, 'Raucourt, Mlle', *Encyclopaedia Britannica 22*, 11th Edition (Cambridge University Press, 1911).

15. Ria Brodell, *Butch Heroes* (London and Massachusetts: MIT Press, 2018), 18.

16. Giovanni Bianchi, *The True History and Adventures of Catherine Vizzani* (London: W. Reeve, Fleet Street, 1755), in Rictor Norton, 'The Case of Catherine Vizzani, 1755', in Norton, ed., *Homosexuality in Eighteenth-Century England: A Sourcebook*, 1 Dec. 2005, rictornorton.co.uk (last accessed 16/05/23).

17. 'The Case of Catterina Vizzani (1751): Transgender Life in the Eighteenth Century', *The Anatomy of Difference*, vizzanibordoni.omeka. net (last accessed 16/05/23).

18. Jen Manion, *Female Husbands*, 41.

19. Ibid., 21.

20. Qted in Jennings, *A Lesbian History of Britain*, 33.

21. Qted in Manion, *Female Husbands*, 20.

22. Manion, *Female Husbands*, 20.

23. Henry Fielding, *The Female Husband: or, the Surprising History of Mrs. Mary, alias Mr. George Hamilton, Who was Convicted of Having Married a Young Woman of Wells and Lived with Her as Her Husband*, 1746. Published by the University of Adelaide Library, South Australia, 2015.

24. Manion, *Female Husbands*, 31.

25. *London Chronicle*, 'The FEMALE HUSBAND; or a circumstantial Account of the extraordinary Affair which lately happened at POPLAR; with many interesting Particulars, not mentioned in the publick Papers', (7–9 August 1766), in Rictor Norton, ed., 'Mary East, the Female Husband', *Homosexuality in Eighteenth-Century England: A Sourcebook*, 6 Dec. 2003, rictornorton.co.uk (last accessed 16/05/23).
26. Ibid.
27. Ibid.

12. VARIETY: MUSIC HALL, MALE IMPERSONATION AND A TURNING CENTURY

1. Gillian M. Rodger, *Just One of the Boys: Female-to-Male Cross-Dressing on the American Variety Stage* (Chicago: University of Illinois Press, 2018), 93.
2. Ibid., 27.
3. Ken Vegas and Mo. B. Dick, '1870–1908 Ella Wesner', Drag King History, [n.d.] dragkinghistory.com (last accessed 10/11/23).
4. *New York Sun*, 27 Dec. 1891, 13.
5. Rodger, *Just One of the Boys*, 73–4.
6. Ibid., 31.
7. *Buffalo Evening News*, 'The Wife of a Woman', 2 Jan. 1892. Digital Transgender Archive, contributed by Hugh Ryan.
8. *New York Clipper*, 12 June 1886, 198.
9. *Buffalo Evening News*, 'The Wife of a Woman'.
10. *Chicago Daily Tribune*, 'A Wedded Puzzle', 18 July 1892.
11. Rodger, *Just One of the Boys*, 212.
12. Ibid., 196.
13. *New York Clipper*, 'Variety Halls', 30 March 1872.
14. Rodger, *Just One of the Boys*, 63.
15. Ibid., 90.
16. *New York Sun*, 1891, quoted in ibid., 56.
17. Qted in Ryan, *When Brooklyn Was Queer*, 54.
18. *New York Clipper*, 'City Summary', 6 Aug. 1870.
19. Laurence Senelick, *The Changing Room: Sex, Drag and Theatre* (London: Routledge, 2002), 340.
20. *Detroit Free Press*, 24 April 1892, 14.
21. *The Tennessean*, 'Has Her Valet', 18 Oct. 1896, 21.
22. Rodger, *Just One of the Boys*, 43; Hugh Ryan, 'themstory: This Black Drag King Was Once Known as the Greatest Male Impersonator of All Time', them, 1 June 2018, www.them.us (last accessed 10/11/23).
23. Rodger, *Just One of the Boys*, 43.

24. Kathleen B. Casey, *The Prettiest Girl on Stage is a Man: Race and Gender Benders in American Vaudeville* (Knoxville: University of Tennessee Press, 2015).

25. Drag King History, '1890–1906 Florence Hines', [n.d], dragkinghistory.com (last accessed 10/11/23).

26. Ryan, *When Brooklyn was Queer*, 58.

27. *Cincinnati Enquirer*, 1892, quoted in ibid.

28. Sarah Waters, *Tipping the Velvet* (London: Virago, [1998] 2018), 20.

29. Allison Neal, '(Neo-)Victorian Impersonators: Vesta Tilley and *Tipping the Velvet*', *Neo-Victorian Studies* 4.1 (2011): 61.

30. Elaine Aston, 'Male Impersonation in the Music Hall: The Case of Vesta Tilley', *New Theatre Quarterly* 4.15 (1988): 255.

31. Neal, '(Neo-)Victorian Impersonations', 63.

32. Sheila, quoted in Gardiner, *From the Closet to the Screen*, 5.

33. Tom Vallance, 'Obituary: Josephine Hutchinson', *The Independent*, 13 June 1998.

34. Devoney Looser, 'Queering the Work of Jane Austen is Nothing New', *The Atlantic*, 21 July 2017.

35. Deborah Sugg Ryan, 'Gwen Lally', English Heritage [n.d.], www.english-heritage.org.uk (last accessed 10/11/23).

36. Maria Petts, 'Exploring Egham's LGBTQ+ history: The Story of Gwen Lally, Pageant Master and Queer Historical Figure?', Egham Museum [n.d.], eghammuseum.org (last accessed 10/11/23).

37. Ryan, 'Gwen Lally'.

38. George Bernard Shaw, quoted in ibid.

13. GLADYS BENTLEY: A SARTORIAL HISTORY

1. Saidiya Hartman, *Wayward Lives, Beautiful Experiments*, 197.

2. Gladys Bentley, 'I Am a Woman Again', *Ebony*, Aug. 1952, JD Doyle Archives, via queermusicheritage.com, 93–4.

3. Ibid., 94.

4. Hartman, *Wayward Lives, Beautiful Experiments*, 194.

5. Alfred Duckett, 'The Third Sex', *The Chicago Defender* (National Edition), 2 March 1957. ProQuest Historical Newspapers: Chicago Defender, 7.

6. Bentley, 'I Am a Woman Again', 93.

7. Ibid., 94.

8. Regina V. Jones, 'How Does a Bulldagger Get Out of the Footnotes? Or Gladys Bentley's Blues', *Awakening* 1.31 (2012): 4.

9. Bentley, 'I Am a Woman Again', 93.

10. Duckett, 'The Third Sex', 7.

11. Bentley, 'I Am a Woman Again', 93.

12. Jones, 'How Does a Bulldagger Get Out of the Footnotes?', 9.

13. Steven J. Niven, 'Blues Singer Gladys Bentley Broke Ground with Marriage to a Woman in 1931', The Root, 11 Feb. 2015, theroot.com (last accessed 10/11/23).

14. Bentley, 'I Am a Woman Again', 94.

15. Monique Wittig, 'One Is Not Born a Woman', 31.

16. Ibid., 35.

17. Bentley, 'I Am a Woman Again'.

18. Hartman, *Wayward Lives, Beautiful Experiments*, 199.

19. Ibid., 337.

14. STORMÉ DELARVERIE AND THE DAWN OF THE DRAG KING

1. Stormé DeLarverie, *A Stormé Life*, In The Life Media, YouTube, 1 July 2009, 1:07–1:18, https://www.youtube.com/watch?v=XgCVNEiO wLs (last accessed 11/11/12).

2. Grace Chu, 'An Interview with Lesbian Stonewall Veteran Stormé DeLarverie', After Ellen, 5 June 2018, afterellen.com; Lisa Cannistraci, quoted in William Yardley, 'Stormé DeLarverie, Early Leader in the Gay Rights Movement, Dies at 93', *New York Times*, 29 May 2014; Chris Brennan Starfire, 'Who's Stormé?', Stormé DeLarverie, 2020–2022, http://storme-delarverie.com/Biography/ (last accessed 11/11/23).

3. Chris Brennan Starfire, @S_DeLarverie, 'Hi Eleanor, Yes, I believe that change was a choice & made over time. Per a copy of a document I have, Stormé was using 1921 as her year of birth in 1955. By the time she was interviewed & photographed by Avery Willard in the mid-late but pre-Stonewall 60s, she was using 1920', communication on Twitter, 12 Jan. 2023.

4. Starfire, 'Who's Stormé?'

5. Yardley, 'Stormé DeLarverie, Early Leader in the Gay Rights Movement, Dies at 93'.

6. Starfire, 'Who's Stormé?'

7. Ibid.

8. Evan Mitchell Schares, 'Witnessing the Archive: Starfire, Stormé DeLarverie and Queer Performance Historicity', *Text and Performance Quarterly* 40.3 (2020): 250–67.

9. Starfire, 'Who's Stormé?'

10. DeLarverie, *A Stormé Life*, 3:02–3:18.

11. Starfire, 'Who's Stormé?'

12. Robert West, 'Stormé DeLarverie: In a Storm of Indifference, She's Still a Jewel', Huffpost, 26 March 2013, huffpost.com (last accessed 11/11/23).

13. Lisa Cannistraci, quoted in Yardley, 'Stormé DeLarverie, Early Leader in the Gay Rights Movement, Dies at 93'; West, 'Stormé DeLarverie'.
14. West, 'Stormé DeLarverie'.
15. Starfire, 'Who's Stormé?'; DeLarverie, quoted in Avery Willard, *Female Impersonation* (New York: Regiment Publications, 1971), 62.
16. Paul DeRienzo and Miss Joan Marie Moossy, 'A Drag Summit', Let Them Talk: Kings and Queens of NYC, YouTube, Paul DeRienzo, 7 June 2011, https://www.youtube.com/watch?v=JjUGrlovcXQ (last accessed 11/11/23). 'Werk' is a term of appreciation, mostly used in modern drag communities.
17. Willard, *Female Impersonation*, 62.
18. DeLarverie, *A Stormé Life*, 2:12–2:23.
19. Schares, 'Witnessing the Archive', 255.
20. DeLarverie, quoted in Willard, *Female Impersonation*, 62.
21. Audre Lorde, *Zami: A New Spelling of My Name*, 226.
22. Stormé DeLarverie (interviewee) and Kirk Klocke (interviewer), 'Stonewall Veteran's Wisdom on "Ugliness"', Vimeo, 10 May 2012, https://vimeo.com/41947368 (last accessed 11/11/23).
23. West, 'Stormé DeLarverie'.
24. Willard, *Female Impersonation*, 62.
25. Schares, 'Witnessing the Archive', 12.
26. West, 'Stormé DeLarverie'.
27. Nestle, 'Butch-Fem Relationships', 22; Vito, quoted in Gardiner, *From The Closet to the Screen*, 68; Rolley, 'The Lesbian Dandy', 179–80.
28. Beau Jangles, quoted in Georgeous Michael, 'In Search of Stormé DeLarverie with Beau Jangles', *Louche* 1 (2019), 95.

15. THE LESBIAN THREAT OF THE SUFFRAGETTES

1. Sonja Tiernan, *Eva Gore-Booth: An Image of Such Politics* (Manchester: Manchester University Press, 2012), 96.
2. This chapter, unfortunately, does not discuss the racism and ableism in most acknowledged suffragette histories. This is because the overlap of prominent suffragettes of colour and disabled suffragettes with those who can arguably be placed in a lesbian history is limited. To read more about Indian suffragettes (due to British colonisation of India, there was and remains a large Indian population in the UK) see Anita Anand, *Sophia: Princess, Suffragette, Revolutionary* (London: Bloomsbury, 2015); Sumita Mukherjee, *Indian Suffragettes: Female Identities and Transnational Networks* (Oxford: Oxford University Press, 2018). To find out about disabled suffragettes, including Rosa May Billinghurst and Adelaide Knight, see Katie Fox, 'Rosa May Billinghurst: Suffragette, Campaigner,

"Cripple"', The National Archives, 22 Dec. 2017, blog.nationalarchives. gov.uk (last accessed 11/11/23); Ella Braidwood, 'The Queer, Disabled, and Women of Color Suffragettes History Forgot', Vice, 6 Feb. 2018, vice.com (last accessed 11/11/23).

3. Katarzyna Kociolek, 'London's Suffragettes, Votes for Women, and Fashion', *Angelica: An International Journal of English Studies* 27.1 (2018): 85.

4. Vanessa Thorpe and Alec Marsh, 'Diary Reveals Lesbian Love Trysts of Suffragette Leaders', *The Observer*, 11 June 2000.

5. Annie Kenney, quoted by Hilary McCollum, 'Sapphic Suffragettes', The National Archives, OUTing the Past: The National LGBT History Festival, 20 Feb. 2017, audio recording, available at: https://media. nationalarchives.gov.uk/index.php/outing-past/ (last accessed 11/11/23).

6. Lyndsey Jenkins, 'Annie Kenney and the Politics of Class in the Women's Social and Political Union', *Twentieth Century British History* 30.4 (2019): 500.

7. Sarah-Joy Ford, 'Queering Suffrage: Embroidering the Lesbian Life of Vera Holme', *MAI: Feminism & Visual Culture* 8 (2021), maifeminism.com (last accessed 16/5/23).

8. June Purvis, *Emmeline Pankhurst: A Biography* (London and New York: Routledge, 2002), 4.

9. Ibid., 4–5.

10. Ibid., 391.

11. Ibid., 160; Virginia Woolf, quoted by Christopher Wiley, '"When a Woman Speaks the Truth About Her Body": Ethel Smyth, Virginia Woolf, and the Challenges of Lesbian Auto/biography', *Music and Letters* 85.3 (2004): 395.

12. McCollum, 'Sapphic Suffragettes'.

13. Sylvia Pankhurst, 'Women's Dress', *Votes For Women*, 23 Sept. 1910, 825.

14. Cally Blackman, 'How the Suffragettes Used Fashion to Further Their Cause', Stylist, 2018, https://www.stylist.co.uk/fashion/suffragette-movement-fashion-clothes-what-did-the-suffragettes-wear/188043 (last accessed 11/11/23).

15. Kociolek, 'London's Suffragettes, Votes for Women, and Fashion', 94.

16. Blackman, 'How the Suffragettes Used Fashion to Further Their Cause'.

17. Ibid.

18. Katrina Rolley, 'Fashion, Femininity and the Fight for the Vote', *Art History* 13.1 (1990): 56.

19. 'Perhaps She Is One!', *Votes for Women*, 12 June 1914, 569.

20. Rolley, 'Fashion, Femininity and the Fight for the Vote', 53.

21. Purvis, *Emmeline Pankhurst*, 160.

22. Ibid.

23. Sylvia Pankhurst, *The Suffragette Movement: An Intimate Account of Persons and Ideals* (Longmans, 1931), 377.

24. Jenkins, 'Annie Kenney and the Politics of Class', 483.

25. Millicent Price, *This World's Festival*, unpublished autobiography, London, LSE Library Collections, 7/MPR/01. Quoted in ibid., 485.

26. Katherine Connelly, *Sylvia Pankhurst: Suffragette, Socialist and Scourge of Empire* (London: Pluto Press, 2013).

27. Rolley, 'Fashion, Femininity and the Fight for the Vote', 62.

28. Ibid.

29. Ibid., 63.

30. Ibid., 67.

31. Kociolek, 'London's Suffragettes, Votes for Women, and Fashion', 85.

32. McCollum, 'Sapphic Suffragettes'.

33. Martha Vicinus, 'Fin-de-siécle Theatrics: Male Impersonation and Lesbian Desire', *Borderlines: Genders and Identities in War and Peace 1970–1930*, B. Melman ed. (London and New York: Routledge, 1998), 183.

34. Woolf, quoted in Wiley, 'When a Woman Speaks the Truth About Her Body', 395–6.

35. Whitbread, *The Secret Diaries of Miss Anne Lister*, 369.

36. Anna Kisby, 'Vera "Jack" Holme: Cross-dressing Actress, Suffragette and Chauffeur', *Women's History Review* 23.1 (2014): 121.

37. Ibid., 122.

38. Jack Holme, Vera Holme's diary, 13 April 1903. Papers of Vera 'Jack' Holme, The Women's Library at London School of Economics, 7VJH/6/01. Qted in ibid., 124.

39. Kisby, 'Vera "Jack" Holme', 127.

40. Ibid., 132.

41. Ibid., 132; 134.

42. Ford, 'Queering Suffrage'.

43. Ibid.

44. Sonja Tiernan, 'Challenging Presumptions of Heterosexuality: Eva Gore-Booth, A Biographical Case Study', *Historical Reflections/Réflexions Historiques* 37.2 (2011): 58.

45. Tiernan, *Eva Gore-Booth*, 30–36.

46. Esther Roper, ed., *Poems of Eva Gore-Booth: Complete Edition* (London: 1929), 65.

47. Tiernan, 'Challenging Presumptions of Heterosexuality', 63.

48. Holly (interviewer) and Susannah Mayor (interviewee), 'Edith Craig, Chris St. John and Tony Atwood—The Love Story at the Heart of Smallhythe Place', Past Loves—A History of The Greatest Love Stories,

podcast transcript, April 2022, pastlovespodcast.co.uk (last accessed 16/05/23).

16. UNIFORMS OF THE SECOND WAVE: LESBIAN FEMINIST DRESS CODES

1. Line Chamberland, 'The Place of Lesbians in the Women's Movement', in *Lesbian Feminism: Essays Opposing Global Heteropatriarchies*, N. Banerjea, K. Browne, E. Ferreira, M. Olasik, J. Podmore, eds. (London: Zed Books, 2019), 187.
2. Gardiner, *From the Closet to the Screen*, 111.
3. Faderman, *Odd Girls and Twilight Lovers*, 200.
4. Karla Jay, 'Tales of the Lavender Menace', in *The Stonewall Reader*, New York Public Library, ed. (New York: Penguin Books, 2019).
5. Niharika Banerjea, Kath Browne, Eduarda Ferreira, Marta Olasik and Julie Podmore, 'Introduction: Transnational Ruminations on Lesbian Feminism', *Lesbian Feminism*, 4.
6. Hillman, '"The Clothes I Wear Help Me to Know My Own Power"', 162.
7. Silva, quoted in Traies, *Now You See Me*, 183.
8. Jo Dunn, 'Jo Dunn: Full Interview', interview recorded by Nicola Hargrave, 22 Jan. 2019, West Yorkshire Queer Stories, https://wyqs.co.uk/stories/dungarees-and-docs/jo-full-interview/ (last accessed 11/11/23).
9. Nan, quoted in Faderman, *Odd Girls and Twilight Lovers*, 231.
10. Anon., 'Notes on Cutting My Hair,' *Ain't I a Woman?* 1.11 (1971): 2.
11. Melissa Hobbes, 'My Lesbian Life', *The Sunday Times*, 17 Oct. 2004.
12. Silva, quoted in Traies, *Now You See Me*, 184.
13. Sabrina, quoted in 'The Fashion', Rebel Dykes History Project, CiC, 2020, rebeldykeshistoryproject.com
14. Faderman, *Odd Girls and Twilight Lovers*, 255.
15. Sue Katz, 'Working Class Dykes: Class Conflict in the Lesbian/Feminist Movements in the 1970s', *The Sixties* 10.2 (2017): 284.
16. Barbara Smith, interviewed by Making Gay History, 'Season 6: Episode 3: Barbara Smith', Making Gay History Podcast [n.d.], Makinggayhistory.com (last accessed 16/05/23).
17. Ibid.
18. Kathy Rudy, 'Radical Feminism, Lesbian Separatism, and Queer Theory', *Feminist Studies* 27.1 (2001): 201.
19. Taylor, *How We Get Free*, 4.
20. Ibid.
21. Ibid.
22. Mason-John and Khambatta, *Lesbians Talk: Making Black Waves*, 9.
23. Ibid., 56–9.

24. Blackman and Perry, 'Skirting the Issue: Lesbian Fashion for the 1990s', 73. The authors' analysis is based on personal conversations with lesbians about their clothing.

25. Unnamed interviewee, *Gay Black Group 1983*, 1983, UK. BFI Player, from 23:30.

26. Dorothea Smartt, interviewed in *Under Your Nose*, 'Under Your Nose— The Story of the First Black Lesb', Twice as Proud, 17 Aug. 2013, YouTube, https://www.youtube.com/watch?v=CKH1–2X47SU (last accessed 11/11/23).

27. Victoria and Albert Museum, 'Clio (Portrait of Dorothea Smartt)', https://collections.vam.ac.uk/item/O82944/clio-portrait-of-doro-thea-smartt-photograph-sulter-maud/ (last accessed 11/11/23).

28. I believe that the shawl in question is made from hand-painted adire cloth (*àdìrẹ eleko*), a material from Nigeria which was popularised in the early twentieth century.

17. T-SHIRTS: THE BILLBOARDS OF THE BODY

1. Lynn S. Neal, 'The Ideal Democratic Apparel: T-shirts, Religious Intolerance, and the Clothing of Democracy', *Material Religion: The Journal of Objects, Art and Belief* 10.2 (2014): 186–7.

2. Matthew Riemer and Leighton Brown, *We Are Everywhere: Protest, Power and Pride in the History of Queer Liberation* (California & New York: Ten Speed Press, 2019), 92.

3. German Lopez, 'The Reagan Administration's Unbelievable Response to the HIV/AIDS Epidemic', Vox, 1 Dec. 2016, https://www.vox.com/2015/12/1/9828348/ronald-reagan-hiv-aids (last accessed 11/11/23).

4. Colin Clews, *Gay in the 80s: From Fighting for Our Rights to Fighting for Our Lives* (Leicester: Matador, 2017), 258.

5. Ian Lucas, *OutRage! An Oral History* (Carsell: London and New York, 1998), 23.

6. Ibid., 18.

7. 'Dyke With Attitude' T-Shirt, c. 1990, Bishopsgate Institute, London (Lesbian and Gay Newsmedia Archive).

8. Jay, 'Tales of the Lavender Menace', 190.

9. Ibid.

10. Ibid., 191.

11. Riemer and Brown, *We Are Everywhere*, 151.

12. Kelly Cogswell, 'An Incomplete History…', The Lesbian Avenger Documentary Project, [n.d.], lesbianavengers.com

13. Elizabeth Ashburn, *Lesbian Art: An Encounter with Power* (Sydney: Craftsman House, 1996), 13.

14. Wendy Chapkis, *Beauty Secrets: Women and the Politics of Appearance* (London: The Women's Press, 1986), 83.

15. Cogswell, 'An Incomplete History...'.

16. Diana Chapman, quoted in *Inventing Ourselves: Lesbian Life Stories*, Hall Carpenter Archives Lesbian Oral History Group, eds. (London and New York: Routledge, 1989), 53.

17. Leo, quoted in Traies, *Now You See Me*, 38–9.

18. Judy Grahn, *Another Mother Tongue: Gay Words, Gay Worlds* (Boston: Beacon Press, 1984), 135–7.

19. Mason-John and Khambatta, *Lesbians Talk: Making Black Waves*, 40.

20. Teresa de Laurentis, 'Sexual Indifference and Lesbian Representation', in *The Lesbian and Gay Studies Reader*, Henry Abelove, Michele Aina Barale, David Halperin, eds. (Abingdon: Routledge, 1993), 150.

21. Linda Chapman, Mary Patierno, Ana Maria Simo, 'San Francisco Dyke March and Gay Pride Footage, 1995', Lesbian Herstory Archives, LHA Herstories: Audio/Visual Collections of the LHA.

22. *Queer Nation Manifesto*, passed out by hand, New York City Pride, 1990. Reproduced by History is a Weapon, historyisaweapon.com

23. Sara Ahmed, 'Lesbian Feminism', in *Lesbian Feminism*, 306.

24. Eleanor Medhurst, 'Lesbian Activism and Crafted Fashion', in *Crafted with Pride: Craft and Activism in Contemporary Britain*, Daniel Fountain, ed. (Bristol: Intellect, 2023), 24.

25. Claudia Schoppmann, *Days of Masquerade: Life Stories of Lesbians During the Third Reich*, Allison Brown, trans. (New York: Columbia University Press, 1996), 21.

26. Ibid., 1; 23.

27. Robert D. McFadden, 'Edith Windsor, Whose Same-Sex Marriage Fight Led to Landmark Ruling, Dies at 88', 12 Sept. 2017, *New York Times*.

28. Lesbian Herstory Archives (@lesbianherstoryarchives), Instagram, 1 June 2019.

18. THE FASHION OF LIBERATION

1. Elizabeth Wilson, 'Deviant Dress', *Feminist Review* 35 (1990): 67.

2. Ibid., 67.

3. Jodi R. Schorb and Tania N. Hammidi, 'Sho-Lo Showdown: The Do's and Don'ts of Lesbian Chic', *Tulsa Studies in Women's Literature* 19.2 (2000): 259.

4. Ibid.

5. Kelly L. Reddy-Best and Elaine L. Pederson, 'The Relationship of Gender Expression, Sexual identity, Distress, Appearance, and Clothing Choices for Queer Women', *International Journal of Fashion Design, Technology and Education* 8.1 (2015): 56; Ashitha Nagesh, 'Hate Crimes Recorded by

Police Up by More than a Quarter', BBC News, 6 Oct. 2022, https://www.bbc.co.uk/news/uk-631 57965 (last accessed 11/11/23).

6. Nagesh, 'Hate Crimes Recorded by Police Up by More than a Quarter', BBC News; HRC Foundation, 'Fatal Violence Against the Transgender and Gender Non-Conforming Community in 2022', Human Rights Campaign, 2022, https://www.hrc.org/resources/fatal-violence-against-the-transgender-and-gender-non-conforming-community-in-2022 (last accessed 11/11/23).

7. Jane Hattrick, 'Using "dress appearance [...] to define who I am to others": Everyday Fashion and Subjectivity Among White lesbians in Brighton 2005–2015', *Fashion, Style & Popular Culture* 3.2 (2016): 173–191.

8. Caroline Huxley, Victoria Clarkes and Emma Halliwell, 'Resisting and Conforming to the "Lesbian Look": The Importance of Appearance Norms for Lesbian and Bisexual Women', *Journal of Community & Applied Social Psychology* 24.3 (2014): 205–219; Reddy-Best and Pederson, 'The Relationship of Gender Expression, Sexual Identity, Distress, Appearance, and Clothing Choices for Queer Women', 54–65.

9. Kelly L. Reddy-Best and Dana Goodin, 'Queer Fashion and Style: Stories from the Heartland—Authentic Midwestern Queer Voices Through a Museum Exhibition', *The Journal of the Costume Society of America* 46.2 (2020): 115–140. This exhibition took place at Iowa State University in 2018. Its development included the interviewing of ten queer women and the subsequent loan or donation of selected garments or outfits from their wardrobes.

10. Huxley, Clarke and Halliwell, 'Resisting and Conforming to the "Lesbian Look"', 212.

11. Rachel, quoted in ibid.

12. Philios, quoted in ibid., 211.

13. Hattrick, 'Using "dress appearance [...] to define who I am to others"', 22; 13.

14. Tracy S., quoted in ibid., 13.

15. Andy, quoted in ibid., 15.

16. Sally, quoted in Huxley, Clarke and Halliwell, 'Resisting and Conforming to the "Lesbian Look"', 211.

17. Rani Kawale, 'Inequalities of the Heart: The Performance of Emotion Work by Lesbian and Bisexual Women in London, England', *Social & Cultural Geography* 5.4 (2004): 567.

18. Ibid., 575.

19. Reddy-Best and Pedersen, 'The Relationship of Gender Expression, Sexual Identity, Distress, Appearance, and Clothing Choices for Queer Women', 58.

20. Ibid., 60.
21. Reddy-Best and Goodin, 'Queer Fashion and Style', 124.
22. Emma, quoted in ibid., 127.
23. Ibid., 128.
24. Reddy-Best and Goodin, 'Queer Fashion and Style', 125; 128; 130.
25. Shaun Cole, 'From Lesbian and Gay to Queer: Challenging the Hegemony in Collecting and Exhibiting LGBT Fashion and Dress', *Fashion Curating: Critical Practice in the Museum and Beyond*, Annamari Vänskä and Hazel Clarke, eds. (London: Bloomsbury, 2018), 138.
26. Penny Sparke, *As Long as It's Pink: The Sexual Politics of Taste* (London: Pandora, 1995); Dominique Grisard, '"Real Men Wear Pink"? A Gender History of Color', in *Bright Modernity: Color, Commerce and Consumer Culture*, Regina Lee Blaszczyk and Uwe Spiekermann, eds. (London and New York: Palgrave Macmillan, 2017).
27. Eleanor Medhurst, 'Subverting Pink: Queer Reclamations of Hyper-Feminine Dress', unpublished dissertation: University of Brighton, 2019.
28. Eleanor Medhurst, 'Carabiners and Violet Tattoos: The Desire for Nostalgia in Online Lesbian Space', in *Queer Desire: Lesbians, Gender and Subjectivity*, Roisin Ryan-Flood and Amy Tooth-Murphy, eds. (Abingdon: Routledge, 2024).
29. Ibid.
30. Ibid.
31. Jill Gutowitz, 'Sapphic Style is Going Mainstream', Harper's Bazaar, 10 Mar. 2022, https://www.harpersbazaar.com/culture/features/a39357585/sapphic-style-is-going-mainstream/ (last accessed 11/11/23).
32. '"Dressing like a lesbian" Is Sexy, "powerful" New Trend, Fashion Expert Says', *New York Post*, 15 Mar. 2022, https://nypost.com/2022/03/15/dressing-like-a-lesbian-is-fashionably-sexy-for-straight-women/ (last accessed 11/11/23).
33. Eleanor Medhurst (@dressingdykes), Instagram, 16 Mar. 2022.
34. Anita Dolce Vita, '*New York Post* Calls Lesbian Fashion "New" Trend, Misses Point', DapperQ, 10 April 2022, https://www.dapperq.com/2022/04/new-york-post-calls-lesbian-fashion-new-trend-misses-point/ (last accessed 11/11/23).

AFTERWORD

1. Raichō, *In the Beginning, Woman Was the Sun*, 175.
2. Istar, 'Femme-dyke', in *The Persistent Desire*, 381.
3. Halberstam, *Female Masculinity*, 67–8.

SELECT BIBLIOGRAPHY

A

Ångström Grandien, Inga Lena. '"She was Naught… of a Woman except in Sex": The Cross-Dressing of Queen Christina of Sweden'. *The Journal of Dress History* 2.1 (2018): 2–13.

Anon. 'The FEMALE HUSBAND; or a circumstantial Account of the extraordinary Affair which lately happened at POPLAR; with many interesting Particulars, not mentioned in the publick Papers'. London *Chronicle*. 7–9 August 1766. In Rictor Norton, ed., 'Mary East, the Female Husband'. *Homosexuality in Eighteenth-Century England: A Sourcebook*. 6 Dec. 2003, rictornorton.co.uk (last accessed 16/05/23).

Anon. 'The Wife of a Woman'. *Buffalo Evening News*. 2 Jan. 1892. Digital Transgender Archive, contributed by Hugh Ryan, digitaltransgender-archive.net (last accessed 16/05/23).

Anon. 'Notes on Cutting My Hair'. *Ain't I a Woman?* 1.11 (1971): 2.

Anon. 'Moms Mabley: She Finally Makes the Moves'. *Ebony*. April 1974.

Anon. 'The Case of Catterina Vizzani (1751): Transgender Life in the Eighteenth Century'. *The Anatomy of Difference* [n.d.], vizzanibordoni.omeka.net (last accessed 16/05/23).

Aston, Elaine. 'Male Impersonation in the Music Hall: The Case of Vesta Tilley'. *New Theatre Quarterly* 4.15 (1988): 247–57.

B

Baker, Michael. *Our Three Selves*. London: Hamish Hamilton, 1985.

Banerjea, N., K. Browne, E. Ferreira, M. Olasik, J. Podmore, eds. *Lesbian Feminism: Essays Opposing Global Heteropatriarchies*. London: Zed Books, 2019.

Bardsley, Jan. 'The New Woman Meets the Geisha: The Politics of Pleasure in 1910s Japan'. *Intersections: Gender and Sexuality in Asia and the Pacific* 29 (2012).

Beachy, Robert and Terry Gross. 'Between World Wars, Gay Culture Flourished in Berlin'. Audio Interview. NPR. 17 Dec. 2014, npr.org (last accessed 16/05/23).

Bennett, Judith M. '"Lesbian-Like" and the Social History of Lesbianisms'. *Journal of the History of Sexuality* 9.12 (2000): 1–24.

Bentley, Gladys. 'I Am a Woman Again'. *Ebony*. Aug. 1952. JD Doyle Archives, via queermusicheritage.com (last accessed 16/05/23).

Bianchi, Giovanni. *The True History and Adventures of Catherine Vizzani*. London: W. Reeve, Fleet Street, 1755. In Rictor Norton, ed. 'The Case of Catherine Vizzani, 1755'. *Homosexuality in Eighteenth-Century England: A Sourcebook*. 1 Dec. 2005, rictornorton.co.uk (last accessed 16/05/23).

Blackman, Cally. 'How the Suffragettes Used Fashion to Further Their Cause'. Stylist, 2018, https://www.stylist.co.uk/fashion/suffragette-movement-fashion-clothes-what-did-the-suffragettes-wear/188043 (last accessed 11/11/23).

Blackman, Inge and Kathryn Perry. 'Skirting the Issue: Lesbian Fashion for the 1990s'. *Feminist Review* 34 (1990): 67–78.

Brennan Starfire, Chris. 'Who's Stormé?', http://storme-delarverie.com/Biography/ (last accessed 11/11/23).

Brodell, Ria. *Butch Heroes*. London and Massachusetts: MIT Press, 2018.

Buckley, Veronica. *Christina, Queen of Sweden*. New York: Harper Perennial, [2004] 2005.

Bullough, Vern L. and Bonnie Bullough. *Cross Dressing, Sex, and Gender*. Pennsylvania: University of Pennsylvania Press, 1993.

C

Callahan, April and Cassidy Zachary. 'Fashion Lovers: Dorothy Todd & Madge Garland'. Dressed: The History of Fashion Podcast. 11 Dec. 2018.

Campbell, Jessica. 'Can We Call Anne Lister a Lesbian?'. *Journal of Lesbian Studies* 26.4 (2022): 354–366.

Casey, Kathleen B. *The Prettiest Girl on Stage is a Man: Race and Gender Benders in American Vaudeville*. Knoxville: University of Tennessee Press, 2015.

Champion, H. J. E. 'Remembering Sappho: Transatlantic "Lesbian Nations" in the Long Nineteenth Century'. *Women's History Review* 31.1 (2022): 8–27.

Chapkis, Wendy. *Beauty Secrets: Women and the Politics of Appearance.* London: The Women's Press, 1986.

Chibbaro Jr., Lou. 'Meet the Legendary Queer Comedian "Moms" Mabley'. LGBTQ Nation. 8. Aug 2017, www.lgbtqnation.com (last accessed 16/05/23).

Clark, Anna. 'Anne Lister's Construction of Lesbian Identity'. *Journal of the History of Sexuality* 7.1 (1996): 23–50.

Clews, Colin. *Gay in the 80s: From Fighting for Our Rights to Fighting for Our Lives.* Leicester: Matador, 2017.

Cohen, Lisa. '"Frock Consciousness:" Virginia Woolf, the Open Secret, and the Language of Fashion'. *Fashion Theory* 3.2 (1999): 149–174.

Cohen, Lisa. *All We Know: Three Lives.* New York: Farrow, Straus and Giroux, [2012] 2013.

Cole, Shaun. 'From Lesbian and Gay to Queer: Challenging the Hegemony in Collecting and Exhibiting LGBT Fashion and Dress'. In *Fashion Curating: Critical Practice in the Museum and Beyond.* Annamari Vänskä and Hazel Clarke, eds. London: Bloomsbury, 2018.

Coyote, Ivan E. and Zena Sharman. *Persistence: All Ways Butch and Femme.* Vancouver: Arsenal Pulp Press, 2011.

D

Darling, Laura. 'Sappho: The Poetess'. Making Queer History. 4 March 2016, makingqueerhistory.com (last accessed 10/11/23).

Davies, S. 'Fantastic Life: An Interview with Barbara Bell'. *Queer Tribe* 4 (1988): 20–23.

DeLarverie, Stormé. *A Stormé Life.* In The Life Media. YouTube. 1 July 2009, https://www.youtube.com/watch?v=XgCVNEiOwLs (last accessed 11/11/12).

DeLarverie, Stormé (interviewee) and Kirk Klocke (interviewer). 'Stonewall Veteran's Wisdom on "Ugliness"'. Vimeo. 10 May 2012, https://vimeo.com/41947368 (last accessed 11/11/23).

DeRienzo, Paul and Miss Joan Marie Moossy. 'A Drag Summit'. Let Them Talk: Kings and Queens of NYC. YouTube, Paul DeRienzo. 7 June 2011, https://www.youtube.com/watch?v=JjUGrlovcXQ (last accessed 11/11/23).

Doan, Laura. 'Passing Fashions: Reading Female Masculinities in the 1920s'. *Feminist Studies* 24.3 (1998): 663–700.

Doble, Flora. 'Sapphic Sexuality: Lesbian Myth and Reality in Art and Sculpture'. Art UK. 27 July 2020, artuk.org (last accessed 10/11/23).

Dolce Vita, Anita. '*New York Post* Calls Lesbian Fashion "New" Trend, Misses Point'. DapperQ. 10 April 2022, https://www.dapperq.com/2022/04/new-york-post-calls-lesbian-fashion-new-trend-misses-point/ (last accessed 11/11/23).

Donoghue, Emma. *Passions Between Women*. Bello: London, [1993] 2014.

Duckett, Alfred. 'The Third Sex'. *The Chicago Defender* (National Edition). 2 Mar. 1957. ProQuest Historical Newspapers: Chicago Defender.

Dunn, Jo. 'Jo Dunn: Full Interview'. Interview recorded by Nicola Hargrave. West Yorkshire Queer Stories. 22 Jan. 2019, https://wyqs.co.uk/stories/dungarees-and-docs/jo-full-interview/ (last accessed 11/11/23).

E

Espinaco-Virseda, Angeles. '"I feel that I belong to you": Subculture, *Die Freundin* and Lesbian Identities in Weimar Germany'. *spacesofidentity* 4.1 (2004): 83–113.

F

Faderman, Lillian. *Odd Girls and Twilight Lovers: A History of Lesbian Life in Twentieth-Century America*. New York: Penguin Books, [1991] 1992.

Fielding, Henry. *The Female Husband: or, the Surprising History of Mrs. Mary, alias Mr. George Hamilton, Who was Convicted of Having Married a Young Woman of Wells and Lived with Her as Her Husband*. 1746. Published by the University of Adelaide Library, South Australia, 2015.

Ford, Sarah-Joy. 'Queering Suffrage: Embroidering the Lesbian Life of Vera Holme'. *MAI: Feminism & Visual Culture* 8 (2021), maifeminism.com (last accessed 16/5/23).

G

Garber, Eric. 'A Spectacle in Color: The Lesbian and Gay Subculture of Jazz Age Harlem'. *Hidden from History: Reclaiming the Gay and Lesbian Past*. Martin Bauml Duberman, Martha Vicinus and George Chauncy, Jr., eds. London: Penguin Books, [1989] 1991.

Gardiner, Jill. *From the Closet to the Screen: Women at the Gateways Club, 1945–1985*. London, Sydney & Chicago: Pandora, 2003.

Genter, Alix. 'Appearances Can Be Deceiving: Butch-Femme Fashion and Queer Legibility in New York City, 1945–1969'. *Feminist Studies* 42.3 (2016): 604–631.

Grahn, Judy. *Another Mother Tongue: Gay Words, Gay Worlds*. Boston: Beacon Press, 1984.

Grisard, Dominique. '"Real Men Wear Pink"? A Gender History of Color'. In *Bright Modernity: Color, Commerce and Consumer Culture*. Regina Lee Blaszczyk and Uwe Spiekermann, eds. London and New York: Palgrave Macmillan, 2017.

H

Halberstam, Judith (Jack). *Female Masculinity*. Durham and London: Duke University Press, 1998.

Hallett, Judith P. 'Sappho and Her Social Context: Sense and Sensuality'. *Signs* 4.3 (1979): 447–464.

Hammer, Allison K. '"Just like a natural man": The B.D. Styles of Gertrude "Ma" Rainey and Bessie Smith'. *Journal of Lesbian Studies* 23.2 (2019): 279–293.

Hartman, Saidiya. *Wayward Lives, Beautiful Experiments*. London: Serpent's Tail, [2019] 2021.

Harvey, John. *Men in Black*. London: Reaktion Books, [1995] 2013.

Haselswerdt, Ella. 'Re-Queering Sappho'. EIDOLON. 8 Aug. 2016, eidolon.pub (last accessed 16/05/23).

Hattrick, Jane. 'Using "dress appearance [...] to define who I am to others": Everyday Fashion and Subjectivity Among White Lesbians in Brighton 2005–2015'. *Fashion, Style & Popular Culture* 3.2 (2016): 173–191.

Heidegger, John James. *Heydegger's letter to the Bishop of London*. London: Printed for N. Cox in Story's passage, going out of St. James' Park, 1724. Gale Primary Sources.

Hentea, Marius. 'Monocles on Modernity'. *Modernism/Modernity* 20.2 (2013): 213–237.

Heyam, Kit. *Before We Were Trans: A New History of Gender*. London: Basic Books, 2022.

Hillman, Betty Luthor. '"The Clothes I Wear Help Me to Know My Own Power": The Politics of Gender Presentation in the Era of Women's Liberation'. *Frontiers: A Journal of Women's Studies* 34.2 (2013): 155–185.

Hiratsuka, Raichō. *In the Beginning, Woman Was the Sun*. Teruko Craig, trans. New York: Columbia University Press, 2006.

Holm, Julia. 'How to Dress a Female King: Manifestations of Gender and

Power in the Wardrobe of Queen Christina of Sweden'. In *Sartorial Politics in Early Modern Europe: Fashioning Women*. Erin Griffey, ed. Amsterdam: Amsterdam University Press, 2019.

Hoskin, Rhea Ashley. 'Can Femme Be Theory? Exploring the Epistemological and Methodological Possibilities of Femme'. *Journal of Lesbian Studies* 25.1 (2021): 1–17.

Hoskin, Rhea Ashley and Katerina Hirschfeld. 'Beyond Aesthetics: A Femme Manifesto'. *Atlantis Journal* 39.1 (2018): 85–87.

Huxley, Caroline Victoria Clarkes and Emma Halliwell. 'Resisting and Conforming to the "Lesbian Look": The Importance of Appearance Norms for Lesbian and Bisexual Women'. *Journal of Community & Applied Social Psychology* 24.3 (2014): 205–219.

J

Jay, Karla. 'Tales of the Lavender Menace'. *The Stonewall Reader*. The New York Public Library, ed. New York: Penguin Books, 2019.

Jenkins, Lyndsey. 'Annie Kenney and the Politics of Class in the Women's Social and Political Union'. *Twentieth Century British History* 30.4 (2019): 477–503.

Jennings, Rebecca. *A Lesbian History of Britain: Love and Sex Between Women Since 1500*. Oxford: Greenwood World Publishing, 2007.

Jennings, Rebecca and Liz Millward. 'Introducing Lesbian Nation'. *Women's History Review* 31.1 (2022): 1–7.

Johnson, David K. *The Lavender Scare: The Cold War Persecution of Gays and Lesbians in the Federal Government*. Chicago and London: The University of Chicago Press, [2004] 2006.

Johnston, Lucy. *Nineteenth-Century Fashion in Detail*. London: V&A Publications, [2005] 2009.

Jones, Regina V. 'How Does a Bulldagger Get Out of the Footnotes? Or Gladys Bentley's Blues'. *Awakening* 1.31 (2012): 1–17.

K

Katz, Jonathan Ned. 'Edna Thomas ("Mary Jones"): "a tenderness I have never known"'. Outhistory. 2015, outhistory.com (last accessed 16/05/23).

Katz, Sue. 'Working Class Dykes: Class Conflict in the Lesbian/Feminist Movements in the 1970s'. *The Sixties* 10.2 (2017): 281–89.

Kawale, Rani. 'Inequalities of the Heart: The Performance of Emotion

Work by Lesbian and Bisexual Women in London, England'. *Social & Cultural Geography* 5.4 (2004): 565–81.

Kennedy, Elizabeth Lapovsky and Madeline Davis. *Boots of Leather, Slippers of Gold: The History of a Lesbian Community*. New York: Routledge, [1993] 2014.

Kisby, Anna. 'Vera "Jack" Holme: Cross-dressing Actress, Suffragette and Chauffeur'. *Women's History Review* 23.1 (2014): 120–36.

Kociolek, Katarzyna. 'London's Suffragettes, Votes for Women, and Fashion'. *Angelica: An International Journal of English Studies* 27.1 (2018): 81–95.

L

Liddington, Jill. *Female Fortune: Land, Gender and Authority*. London: Rivers Oram Press, [1988] 2019.

Loop, Alexandra. 'Literary Lesbian Liberation: Two Case Studies Interrogating How Queerness Has Manifested in Japanese Value Construction Through History'. Thesis, McMaster University. 2020. Via MacSphere.

Looser, Devoney. 'Queering the Work of Jane Austen is Nothing New'. *The Atlantic*. 21 July 2017.

Lorde, Audre. *Zami: A New Spelling of My Name*. Trumansburg, N.Y.: Crossing Press, 1982.

Lucas, Ian. *OutRage! An Oral History*. Carsell: London and New York, 1998.

Lukszo Klein, Ula. *Sapphic Crossings: Cross-Dressing Women in Eighteenth-Century British Literature*. Charlottesville and London: University of Virginia Press, 2021.

M

Macneil, Kerry. 'Bathroom Lines, Ky-Ky Girls, and Struggles'. *Journal of Lesbian Studies* 1.3–4 (1997): 75–87.

Manion, Jen. *Female Husbands: A Trans History*. Cambridge and New York: Cambridge University Press, 2020.

Mason-John, Valerie and Ann Khambatta. *Lesbians Talk: Making Black Waves*. London: Scarlet Press, 1993.

Mayor, Susannah (interviewee) and Holly (interviewer). 'Edith Craig, Chris St. John and Tony Atwood—The Love Story at the Heart of Smallhythe Place'. Past Loves—A History of The Greatest Love

Stories. Podcast transcript. April 2022, pastlovespodcast.co.uk (last accessed 16/05/23).

McCollum, Hilary. 'Sapphic Suffragettes'. OUTing the Past: The National LGBT History Festival. 20 Feb. 2017. The National Archives. Audio recording, available at: https://media.nationalarchives.gov.uk/index.php/outing-past/ (last accessed 11/11/23).

McGarry, Mary and Fred Wasserman. *Becoming Visible: An Illustrated History of Lesbian and Gay Life in Twentieth-Century America*. New York: Penguin Studio, 1998.

Medhurst, Eleanor. 'Lesbian Activism and Crafted Fashion'. In *Crafted with Pride: Craft and Activism in Contemporary Britain*. Daniel Fountain, ed. Bristol: Intellect, 2023.

Medhurst, Eleanor. 'Carabiners and Violet Tattoos: The Desire for Nostalgia in Online Lesbian Space'. In *Queer Desire: Lesbians, Gender and Subjectivity*. Roisin Ryan-Flood and Amy Tooth-Murphy, eds. Abingdon: Routledge, 2024.

Merrick, Jeffrey. 'The Marquis de Villette and Mademoiselle de Raucourt: Representations of Male and Female Sexual Deviance in Late Eighteenth-Century France'. In *Homosexuality in Modern France*. Jeffrey Merrick and Bryant T. Ragan, eds. Oxford: Oxford University Press, 1996.

Miralles, Nina-Sophia. *Glossy: The Inside Story of Vogue*. London: Quercus, [2021] 2022.

Moore, Mignon R. 'Lipstick or Timberlands? Meanings of Gender Presentation in Black Lesbian Communities'. *Signs* 32.1 (2006): 113–139.

Munt, Sally R., ed. *Butch/Femme: Inside Lesbian Gender*. London and Washington: Cassell, 1998.

N

Neal, Allison. '(Neo-)Victorian Impersonators: Vesta Tilley and Tipping the Velvet'. *Neo-Victorian Studies* 4.1 (2011): 55–76.

Neal, Lynn S. 'The Ideal Democratic Apparel: T-shirts, Religious Intolerance, and the Clothing of Democracy'. *Material Religion: The Journal of Objects, Art and Belief* 10.2 (2014): 182–207.

Nestle, Joan. 'Butch-Fem Relationships'. *Heresies* 12 (1981): 21–4. Canadian Lesbian and Gay Archives, Gale Primary Sources.

Nestle, Joan, ed. *The Persistent Desire: A Femme-Butch Reader*. Boston: Alyson Publications, 1992.

Nestle, Joan. 'The Bodies I Have Lived with: Keynote for 18th Lesbian Lives Conference, Brighton, England, 2011'. *Journal of Lesbian Studies* 17.3–4 (2013): 215–39.

O

Orenstein, Gloria Feman and Berthe Cleyrergue. 'The Salon of Natalie Clifford Barney: An Interview with Berthe Cleyrergue'. *Signs* 4.3 (1979): 484–96.

Orr, Dannielle. '"I Tell Myself to Myself": Homosexual Agency in the Journals of Anne Lister (1791–1840)'. *Women's Writing* 11.2 (2004): 201–222.

P

Pankhurst, Sylvia. *The Suffragette Movement: An Intimate Account of Persons and Ideals*. London: Longmans, 1931.

Pender, Anne. '"Modernist Madonnas": Dorothy Todd, Madge Garland and Virginia Woolf'. *Women's History Review* 16.4 (2007): 519–33.

Purvis, June. *Emmeline Pankhurst: A Biography*. London and New York: Routledge, 2002.

Q

Queer Nation. *Queer Nation Manifesto* (passed out by hand, New York City Pride, 1990). Reproduced by History is a Weapon, historyisaweapon. com (last accessed 16/05/23).

R

Reddy-Best, Kelly L. and Dana Goodin, 'Queer Fashion and Style: Stories from the Heartland—Authentic Midwestern Queer Voices Through a Museum Exhibition'. *The Journal of the Costume Society of America* 46.2 (2020): 115–140.

Reddy-Best, Kelly L. and Elaine L. Pederson. 'The Relationship of Gender Expression, Sexual Identity, Distress, Appearance, and Clothing Choices for Queer Women'. *International Journal of Fashion Design, Technology and Education* 8.1 (2015): 54–65.

Reed, Christopher. 'A *Vogue* That Dare Not Speak its Name: Sexual Subculture During the Editorship of Dorothy Todd, 1922–26'. *Fashion Theory* 10.1–2 (2006): 39–72.

Reed, Christopher. 'Design for (Queer) Living: Sexual Identity,

Performance and Decor in British *Vogue*, 1922–1926'. *GLQ* 12.3 (2006): 377–403.

Riemer, Matthew and Leighton Brown. *We Are Everywhere: Protest, Power and Pride in the History of Queer Liberation*. California & New York: Ten Speed Press, 2019.

Rodger, Gillian M. *Just One of the Boys: Female-to-Male Cross-Dressing on the American Variety Stage*. Chicago: University of Illinois Press, 2018.

Rolley, Katrina. 'Cutting a Dash: The Dress of Radclyffe Hall and Una Troubridge'. *Feminist Review* 35 (1990): 54–66.

Rolley, Katrina. 'Fashion, Femininity and the Fight for the Vote'. *Art History* 13.1 (1990): 47–71.

Rolley, Katrina. 'The Lesbian Dandy: The Role of Dress and Appearance in the Construction of Lesbian Identities, Britain 1918–39'. Master's thesis, Middlesex University. 1995. Middlesex University Research Repository.

Roulston, Chris. 'The Revolting Anne Lister: The U.K.'s First Modern Lesbian'. *Journal of Lesbian Studies* 17 (2013): 267–78.

Rudy, Kathy. 'Radical Feminism, Lesbian Separatism, and Queer Theory'. *Feminist Studies* 27.1 (2001): 191–222.

Rupp, Leila J. *Sapphistries: A Global History of Love Between Women*. New York and London: Duke University Press, [2009] 2011.

Ryan, Hugh. 'themstory: This Black Drag King Was Once Known As the Greatest Male Impersonator of All Time'. them. 1 June 2018, www.them.us (last accessed 10/11/23).

Ryan, Hugh. *When Brooklyn Was Queer*. New York: St Martin's Griffin, 2019.

S

Sappho. *Poems & Fragments*. Josephine Balmer, trans. Hexham: Bloodaxe Books, [1984] 1992.

Sappho. *If Not, Winter*. Anne Carson, trans. London: Virago, 2003.

Sappho. *Stung With Love: Poems and Fragments*. Aaron Poochigan, trans. London: Penguin, [2009] 2015.

Schoppman, Claudia. *Days of Masquerade: Life Stories of Lesbians During the Third Reich*. Allison Brown, trans. New York: Columbia University Press, 1996.

Schorb, Jodi R. and Tania N. Hammidi. 'Sho-Lo Showdown: The Do's and Don'ts of Lesbian Chic'. *Tulsa Studies in Women's Literature* 19.2 (2000): 255–268.

Schares, Evan Mitchell. 'Witnessing the Archive: Starfire, Stormé DeLarverie and Queer Performance Historicity'. *Text and Performance Quarterly* 40.3 (2020): 250–267.

Sheriff, Mary D. *Moved by Love: Inspired Artists and Deviant Women in Eighteenth-Century France*. Chicago: University of Chicago Press, 2004.

Shopland, Norena. *A History of Women in Men's Clothes: From Cross-dressing to Empowerment*. Yorkshire and Philadelphia: Pen & Sword History, 2021.

Smith, Barbara, interviewed by Making Gay History. 'Season 6: Episode 3: Barbara Smith'. Making Gay History Podcast [n.d.], makinggayhistory.com (last accessed 16/05/23).

Souhami, Diana. *No Modernism Without Lesbians*. London: Head of Zeus, 2020.

Sova, Dawn B. *Banned Plays: Censorship Histories of 125 Stage Dramas*. New York: Infobase Publishing, 2004.

Stephenson, Andrew. '"Our jolly marin wear": The Queer Fashionability of the Sailor Uniform in Interwar France and Britain'. *Fashion, Style & Popular Culture* 3.2 (2016): 157–72.

Sturgess, Cyd. '"Die Zarte Haut einer schönen Frau": Fashioning Femininities in Weimar Germany's Lesbian Periodicals'. In *Edinburgh German Yearbook Volume 10: Queering German Culture*. Leanne Dawson, ed. Martlesham: Boydell & Brewer, 2018.

Sugg Ryan, Deborah. 'Gwen Lally'. English Heritage [n.d.], www.english-heritage.org.uk (last accessed 10/11/23).

Sutton, Katie. *The Masculine Woman in Weimar Germany*. New York and Oxford: Berghahn Books, 2011.

T

Taylor, D. J. *Bright Young People: The Rise and Fall of a Generation, 1918–1940*. London: Random House, 2010.

Taylor, Keeanga-Yamahtta, ed. *How We Get Free: Black Feminism and the Combahee River Collective*. Chicago: Haymarket Books, 2017.

Taylor, Lou. *Mourning Dress: A Costume and Social History*. George Allen & Unwin: London, 1983.

Taylor, Lou. *The Study of Dress History*. Manchester and New York: Manchester University Press, 2002.

Thorpe, Vanessa and Alec Marsh. 'Diary Reveals Lesbian Love Trysts of Suffragette Leaders'. *The Observer*. 11 June 2000.

Tiernan, Sonja. 'Challenging Presumptions of Heterosexuality: Eva Gore-Booth, A Biographical Case Study'. *Historical Reflections / Réflexions Historiques* 37.2 (2011): 58–71.

Tiernan, Sonja. *Eva Gore-Booth: An Image of Such Politics*. Manchester: Manchester University Press, 2012.

Tortora, Phyllis and Keith Eubank. *A Survey of Historic Costume*. New York: Fairchild Publications, 1989.

Traies, Jane. *Now You See Me: Lesbian Life Stories*. Machynlleth: Tollington, 2018.

V

Vegas, Ken and Mo. B. Dick. '1870–1908 Ella Wesner'. *Drag King History*, [n.d.] dragkinghistory.com (last accessed 10/11/23).

Vicinus, Martha. 'Fin-de-siécle Theatrics: Male Impersonation and Lesbian Desire'. In *Borderlines: Genders and identities in War and Peace 1970–1930*. B. Melman, ed. London and New York: Routledge, 1998.

Vicinus, Martha. 'The History of Lesbian History'. *Feminist Studies* 38.3 (2012): 566–96.

W

Waters, Sarah. 'A Girton Girl on a Throne: Queen Christina and Versions of Lesbianism, 1906–1933'. *Feminist Review* 46 (1994): 41–60.

Waters, Sarah. *Tipping the Velvet*. London: Virago, [1998] 2018.

Way, Arthur S. *Sappho: Vigil of Venus*. London: Macmillan and Co., Limited, 1920.

West, Robert. 'Stormé DeLarverie: In a Storm of Indifference, She's Still a Jewel'. *Huffpost*. 26 Mar. 2013, huffpost.com (last accessed 11/11/23).

Whisnant, Clayton. *Queer Identities and Politics in Germany: A History, 1880–1945*. New York and York: Harrington Park Press, 2016.

Whitbread, Helena. *I Know My Own Heart: The Diaries of Anne Lister 1791–1840*. New York and London: NYU Press, 1988.

Whitbread, Helena, ed. *The Secret Diaries of Miss Anne Lister*. London: Virago, [1988] 2010.

Wickes, George. 'A Natalie Barney Garland'. *The Paris Review* 61 (Spring 1975), theparisreview.org (last accessed 10/11/23).

Wiley, Christopher. '"When a Woman Speaks the Truth about Her Body": Ethel Smyth, Virginia Woolf, and the Challenges of Lesbian Auto/biography'. *Music and Letters* 85.3 (2004): 388–414.

Willard, Avery. *Female Impersonation*. New York: Regiment Publications, 1971.

Wilson, Elizabeth. 'Deviant Dress'. *Feminist Review* 35 (1990): 67–74.

Wilson, Elizabeth. 'What Does a Lesbian Look Like?'. *A Queer History of Fashion: From the Closet to the Catwalk*, Valerie Steele, ed. New Haven: Yale University Press, 2013.

Wittig, Monique. 'One Is Not Born a Woman'. *What is Gender Nihilism?: A Reader*. Seattle: Contagion Press, [1981] 2019.

Wu, Peichen. 'Performing Gender Along the Lesbian Continuum: The Politics of Sexual Identity in the Seito Society'. *U.S.-Japan Women's Journal. English Supplement* 22 (2002): 64–86.

Y

Yardley, William. 'Stormé DeLarverie, Early Leader in the Gay Rights Movement, Dies at 93'. *The New York Times*. 29 May 2014.

Unpublished

Anon. 'Die Transvestiten und die Polizei'. *Der Transvestit*, *Die Freundin* 1.6 (1924). Spinnboden Lesbenarchiv und Bibliothek e.V., meta-katalog.

Arnold, Marg. 'Der Bubikopf'. *Liebende Frauen* 4.10 (1929). Spinnboden Lesbenarchiv und Bibliothek e.V., meta-katalog.

Hampton, Mabel (interviewee), Joan Nestle (interviewer) and unnamed interviewer. 'Mabel Hampton Interviews (Tape 1)'. 1983. Lesbian Herstory Archives AudioVisual Collections. Lesbian Herstory Archives, Brooklyn, New York, USA.

Hampton, Mabel (interviewee) and Joan Nestle (interviewer). 'Mabel Hampton, 1988 (Tape 1)'. Lesbian Herstory Archives AudioVisual Collections. Lesbian Herstory Archives, Brooklyn, New York, USA.

Hampton, Mabel (interviewee), Joan Nestle (interviewer). 'Mabel Hampton, undated (Tape 1)'. Lesbian Herstory Archives AudioVisual Collections. Lesbian Herstory Archives, Brooklyn, New York, USA.

Jung, Maria. 'Praktische Winke für Transvestiten'. *Liebende Frauen* 3.21 (1928). Spinnboden Lesbenarchiv und Bibliothek e.V., meta-katalog.

Jung, Maria. 'Wie soll sich der Transvestit kleiden?' *Frauenliebe* 3.7 (1928). Spinnboden Lesbenarchiv und Bibliothek e.V., meta-katalog.

Lister, Anne. Clothing inventories from travels in Europe, 1840, 4 pages. Shibden Hall, SH:7/ML/MISC/9, Calderdale Museums, Calderdale, United Kingdom.

Lister, Anne. 'General Inventory', January 1840. Shibden Hall, SH:7/ ML/MISC/9, Calderdale Museums, Calderdale, United Kingdom.

Medhurst, Eleanor. 'Subverting Pink: Queer Reclamations of Hyper-Feminine Dress'. Unpublished dissertation: University of Brighton, 2019. Brighton, United Kingdom.

Müller, Emmy. 'Der Lebenslauf eines Transvestiten'. *Liebende Frauen* 4.18 (1929). Spinnboden Lesbenarchiv und Bibliothek e.V., meta-katalog.

INDEX

ACT UP, 188

activism, 7, 56, 161–2, 165, 173, 187, 189–92, 194, 196

Ahmed, Sara, 194

Aidi, Jeanette, 140

AIDS, 188

Ain't I a Woman? (journal), 178

Alcaeus of Mytilene, 15

Allen, Mary, 166

Alma-Tadema, Lawrence, 15

Andrews, Kathy, 179

androgyny, 117, 142, 176, 178, 204

Arbus, Diane, 153, 155

Arena Three, 20, 112, 175

Arnold, Marg, 85

Ashton, Frederick, 74

Atwood, Tony, 173

Austen, Jane, 141

Austin, Paula, 116

Azzolino, Decio, 25

'B.D. women', 92–4, 97, 99, 144

Barney, Natalie Clifford, 19–20, 21, 59–60, 62, 64, 65, 114, 189, 202

Barrett, Rachel, 166

bars, 7, 103–112

Bay Ridge High School, Brooklyn, 105, 116, 201

Beach, Sylvia, 61, 66

Beaton, Cecil, 76

Beau Jangles, 159

Bell music bar, London, 179

Bell, Barbara, 64

Ben, Lisa, 111

Bennett, Johnstone, 132, 136–7

Bennett, Judith, 3

Bentley, Gladys, 7, 93, 118, 143–9

Berlin, Germany, 5, 6, 57, 58, 81–9

Berlins Lesbische Frauen (Roellig), 82

Berry, Mary, 17

Bianchi, Giovanni, 125

bias-cut dresses, 67

Biba, 202

Biren, Joan E. (JEB), 158

Birkenstocks, 201

bisexuality, 18, 51

black (colour), 36–7, 117

Black Lesbian and Gay Centre, London, 182–4

Black Lesbian Group, 182

Black (identity), 5
 femme identity and, 115
 Harlem Renaissance (1920s–30s), 6, 7, 48, 57–8, 61–2, 91–9, 143–9, 193

INDEX